What Is Public History Globally?

What Is Public History Globally?

Working with the past in the present

Edited by

**Paul Ashton
and Alex Trapeznik**

BLOOMSBURY ACADEMIC
LONDON · NEW YORK · OXFORD · NEW DELHI · SYDNEY

BLOOMSBURY ACADEMIC
Bloomsbury Publishing Plc
50 Bedford Square, London, WC1B 3DP, UK
1385 Broadway, New York, NY 10018, USA

BLOOMSBURY, BLOOMSBURY ACADEMIC and the Diana logo are trademarks of
Bloomsbury Publishing Plc

First published in Great Britain 2019

Cover design: Dani Leigh
Cover image: The New Guardhouse/Central Memorial of the Federal Republic of
Germany to the Victims of War and Dictatorship, Berlin. (© Luis Davilla/Getty Images)

A catalogue record for this book is available from the British Library.

A catalog record for this book is available from the Library of Congress.

ISBN: HB: 978-1-3500-3328-3
PB: 978-1-3500-3329-0
ePDF: 978-1-3500-3326-9
eBook: 978-1-3500-3327-6

Typeset by Newgen KnowledgeWorks Pvt. Ltd., Chennai, India
Printed and bound in Great Britain

To find out more about our authors and books visit www.bloomsbury.com
and sign up for our newsletters.

Contents

Figures

Contributors

Paul Ashton is adjunct professor at Macquarie University, the University of Canberra and the University of Technology Sydney where, in 1999, he co-established the Australian Centre for Public History. Co-editor and founder of the journal *Pubic History Review*, his publications include *Public History and Heritage Today*, which he co-edited with Hilda Kean, and *Once Upon a Time: Australian Writers on Using the Past*, co-edited with Anna Clark and Robert Crawford.

Amritha Ballal is an architect and urban planner, and a founding partner at Space Matters, a multidisciplinary, Delhi-based design studio. Amritha teaches at the School of Planning and Architecture, Delhi, and is the co-editor of *Bhopal 2011 – Landscapes of Memory*, which explores themes of spatial memory through the case of the Union Carbide tragedy site in Bhopal. Amritha has been nominated for the Rolex Arts Foundation Mentor Protégé Initiative in 2014 and named in the annual international shortlist of emerging woman architects *Architecture Journal*, UK, in 2013. She has collaborated on urban research projects with the School of Planning and Architecture, Bhopal; Research Council of Norway; University of Tokyo; and University of Gothenburg. Amritha's works also include 'The City Is Our Home' on urban homelessness. Her ongoing research includes documentation and study of traditional wood-carving techniques of *Likhai* in the Kumaon region of India.

Jeannette A. Bastian is a professor at the School of Library and Information Science, Simmons College, where she directs their Archives Management concentration. Formerly Territorial Librarian of the United States Virgin Islands from1987 to 1998, she holds an MPhil from the University of the West Indies (Mona, Jamaica) and a PhD from the University of Pittsburgh. She has widely published in the archival literature, and her books include *West Indian Literature: A Critical Index, 1930–1975* (1982), *Owning Memory: How a Caribbean Community Lost Its Archives and Found Its History* (2003), *Archival Internships* (2008), *Community Archives: The*

Shaping of Memory (co-edited with Ben Alexander, 2009), and *Archives in Libraries: What Librarians and Archivists Need to Know to Work Together* (with Megan Sniffin-Marinoff and Donna Webber, 2015). She is currently compiling and co-editing a Caribbean Archives Reader to support a new Masters in Archival Studies at the University of the West Indies.

Anne Brædder has a master's degree in history and cultural encounters from Roskilde University Denmark (2009) and a PhD in history from Aarhus University Denmark (2017). Before writing her PhD dissertation she has worked at different museums and in local archives. She continued working with her interest in museums in her PhD dissertation on World War II re-enactment and living history in open-air museums in Denmark. Her main research areas include uses of the past, memory, public history and gender studies. She has published articles on the role of the body in World War II re-enactment, authenticity in re-enactment and memories of the 1970s' women's liberation movement in Denmark. She is currently coordinator of the research program Uses of the Past at Aarhus University and part-time lecturer at Roskilde University, mostly teaching within the area of uses of the past and gender studies.

Kresno Brahmantyo was a senior lecturer at the Department of History and Australian Studies Centre, University of Indonesia (UI) from 1992 to 2017. During this time he has spent three years at the Australian Centre for Public History at the University of Technology Sydney and has co-chaired the first public history conference in Indonesia in 2012 at UI. His work has appeared in publications including the *Oxford Handbook of Public History* (2017) and the journal *Public History Review*. Kresno is currently establishing an independent centre for public history in Indonesia.

Denis Byrne is a senior research fellow at the Institute for Culture and Society, Western Sydney University. He is an archaeologist and specialist in heritage studies whose work has been in the fields of Indigenous and migrant heritage in Australia as well as in the history and cultural politics of heritage conservation in Southeast Asia and China. His books, *Surface Collection* (2007) and *Counterheritage* (2014), challenge Western-derived heritage practices in Asia and explore new ways of writing archaeology. He is currently exploring the history and archaeology of coastal reclamation in Australia and Asia, seeing them as key artefacts of the Anthropocene.

Christopher J. Castañeda is professor of history at California State University, Sacramento. He is the author of 'Times of Propaganda and Struggle: *El Despertar* and Brooklyn's Spanish Anarchists, 1890–1905', in *Radical Gotham: Anarchism in New York City from Schwab's Saloon to Occupy Wall Street* (edited by Tom Goyens, 2017) and a forthcoming chapter titled '"Yours for the Revolution": Cigar Makers, Anarchists and Brooklyn's Spanish Colony, 1878–1925', in *Hidden Out in the Open: Spanish Migration to the United States (1875–1930)* (co-edited by Phylis Martinelli and Ana Varela-Lago). He is currently working on a co-edited volume with Montse Feu López that is tentatively titled *Transnational Libertad: Hispanic Anarchism in the United States.* Previously, he has authored numerous books and articles related to business history as well as contributed to and co-edited *River City and Valley Life: An Environmental History of the Sacramento Region* (2013).

Thomas Cauvin is Assistant Professor of History at Colorado State University. His teaching, research and projects are based on three principles: international comparison, public participation and the application of history to present-day issues. In 2018, he became the president of the International Federation for Public History that works at changing the way historians research, communicate and share history in/with the public. His publications include *Public History: A Textbook of Practice* (Routledge), the first single-authored public history textbook in North America.

Indira Chowdhury is the founder director of the Center for Public History at the Srishti Institute of Art, Design and Technology, Bengaluru. Awarded the Commonwealth Scholarship in 1989, she has completed her PhD in history from the School of Oriental and African Studies, London (1993). Indira taught at Jadavpur University until 2002. Her book, *The Frail Hero and Virile History* (1998), was awarded the Tagore Prize in 2001. From 2007 she began to dedicate herself to creating archives and founded Archival Resources for Contemporary History in Bengaluru. She was awarded the New India Foundation Fellowship in 2006 for her book *Growing the Tree of Science: Homi Bhabha and the Tata Institute of Fundamental Research* (2016). Indira is a founding member of the Oral History Association of India and has been its president. She has also been president of the International Oral History Association.

Mark Donnelly is a principal lecturer in history at St Mary's University, Twickenham, London. He has set up the university's MA in Public

History in 2015 and continues to teach on the course. He is a co-director of the Research Centre for Philosophy of History at St Mary's. He is also one of the co-conveners of the Institute of Historical Research's Public History seminar. His recent books are *Doing History* (co-authored with Claire Norton, 2011), *Mad Dogs and Englishness: Popular Music and English Identities* (co-edited with Lee Brooks and Richard Mills, 2017), and *Liberating Histories: Truth, Power, Ethics* (co-authored with Claire Norton, 2018).

Michael Dove holds an MA in public history and a PhD in history from Western University in London, Ontario, Canada. He is active in both the masters and undergraduate minor programs in public history at Western University, serving as both the acting director and the internship coordinator of the MA Public History program. A specialist in Canadian maritime business, social and cultural history, his research and teaching interests include public history, early modern shipping, and pirates and piracy. Collaborative projects include the War of 1812 smartphone app for Southwestern Ontario Region Bicentennial 1812, a major oral history study with the Canadian Museum of Immigration at Pier 21 on the topic of American immigration to Canada during the Vietnam War, and the Labatt Breweries Collection Virtual Exhibit with Labatt Breweries of Canada and Western University Archives.

Mark Dunn is a public historian based in Sydney. He has worked in history, heritage and archaeology for over twenty years, wherein he has worked on sites across Australia. Mark is currently the historian on the NSW Heritage Council and chair of the Professional Historians' Association of New South Wales.

Tanya Evans is an associate professor at Macquarie University in Sydney, Australia, where she teaches Australian history and public history. Tanya is director of the Centre for Applied History. She is also president of the History Council of New South Wales. Her books include *Fractured Families: Life on the Margins in Colonial New South Wales* (2015), *Swimming with the Spit: 100 Years of the Spit Amateur Swimming Club* (2016), *Sinners, Scroungers, Saints: Unmarried Motherhood in Modern England* (with Pat Thane, 2012), and *'Unfortunate Objects': Lone Mothers in Eighteenth-Century London* (2005).

Meg Foster is a PhD candidate in history at the University of New South Wales. Under the supervision of Grace Karskens and Lisa Ford, Meg is investigating the 'other' bushrangers (those who were not white men) in Australian history and social memory. After completing her honours thesis on Indigenous-bushrangers at the University of Sydney in 2013, Meg has worked as a researcher with the Australian Centre of Public History at the University of Technology Sydney. She is the recipient of numerous awards and prizes, and was the inaugural winner of the Deen De Bortoli Award in Applied History for her article 'Online and Plugged In? Public History and Historians in the Digital Age' featured in *Public History Review* (2014). Meg also works as an historical consultant and has a particular interest in making connections between history and the contemporary world.

Anna Green is an associate professor in the Stout Research Centre for New Zealand Studies at Victoria University of Wellington, New Zealand. Her current research project, 'The Missing Link' (2016–19), builds on earlier research in the UK investigating the role of family memory in shaping personal and collective historical consciousness. She is currently recording oral history interviews with a random sample of fifty multigenerational families in New Zealand, descendants of those who migrated from Europe during the nineteenth century. She is co-author of *The Houses of History* (2016). Her other publications include 'Intergenerational Family Stories: Private, Parochial, Pathological?', *Journal of Family History* (2013) and 'Family Memory, "Things" and Counterfactual Thinking' (with Kayleigh Luscombe), *Memory Studies* (2017).

Michelle A. Hamilton is a public historian who focuses on historical and contemporary issues surrounding museums and heritage, social memory and commemoration, the history of anthropology, cultural identity and issues of representation and repatriation, usually in regard to First Nations peoples in Canada. Hamilton also has extensive experience at museums across Canada. Since 2008, she has been director of the MA Public History at the University of Western Ontario.

Paula Hamilton is adjunct professor of history at both the University of Technology Sydney (UTS) and Macquarie University, Sydney. She was involved in setting up the public history program at UTS, which ran between 1989 and 2005 and was co-director of the Australian Centre for Public History until 2013. Paula is a cultural historian who has published

widely in oral history and memory studies. She has also collaborated in a range of historical projects with community groups, museums and libraries. Her most recent published book is *The Oxford Handbook of Public History* (co-edited with James Gardner, 2017).

Sue Hodges is a public historian who has specialized in heritage interpretation. Her venture, SHP, works on developing, designing and producing heritage interpretation in built form and digital media in Australia and internationally. Sue is president of the ICOMOS International Scientific Committee for the Interpretation and Presentation of Cultural Heritage Sites, a member of the Sites of Memory Working Group and a past president of Interpretation Australia (2010–13). She is also studying for a PhD on the 'economic, social and cultural value of heritage interpretation' at the University of Technology Sydney. Sue has provided specialist advice on the role of history in heritage interpretation at the 2015 and 2016 World Heritage Meetings in Australia, Japan, Korea, Vanuatu, Europe, India, Greece and Malaysia.

Tracy Ireland is associate professor of Cultural Heritage and Head of the Discipline of Creative and Cultural Practice at the University of Canberra in Australia. Before joining the University of Canberra in 2009, Tracy has headed the Canberra office of GML Heritage and worked for the New South Wales Heritage Council. She publishes on historical archaeology, heritage and conservation, and their entanglement with nationalism, colonialism and the politics of memory and identity. Her books include *The Ethics of Cultural Heritage* (with John Schofield) and *Object Lessons: Archaeology and Heritage in Australia* (with Jane Lydon). She is currently researching and writing about significance and values, the conservation of colonial archaeological remains and the heritage of Australian aviation cultures.

Moulshri Joshi is trained as an architect and currently serves as an assistant professor at the School of Planning and Architecture, New Delhi. She represents the International Committee for Conservation of Industrial Heritage in India and coordinates the National Scientific Committee on Industrial Heritage within ICOMOS India. As a member of the Scientific Committee of the forthcoming ICOMOS General Assembly, she will co-chair the session on the role of cultural heritage in building peace and reconciliation. Her current collaborative work, 'The Tenth Delhi', looks at contemporary urban development in Delhi and the complex lexicon

of typologies within which the city operates. She is the associate editor of *Bhopal 2011: Landscapes of Memory* and founding partner of the award-winning design practice Space Matters.

Jaya Keaney is a PhD candidate in gender and cultural studies at the University of Sydney. Her PhD research is an interview-based study of how queer families approach race when conceiving a child through reproductive technologies. Jaya's research interests include science and technology studies, reproductive technologies, queer theory, feminist ethnographic methods and social memory practices. She has previously worked as a researcher at the Australian Centre for Public History at University of Technology Sydney.

Stephanie Krauss is currently working as the library and archives specialist at Historic New England. She is completing her masters in library science and her masters in history at Simmons College. Stephanie graduated from the College of William and Mary in 2015 with a bachelor's in history. She is greatly interested in how archives are connected to public history, community identity and collective memory.

Thorsten Logge is an assistant professor of public history at the University of Hamburg. He studied history, psychology and political science at the Universities of Hamburg and Gießen. As a doctoral candidate at the University of Gießen, Logge has received a full scholarship of the German Research Foundation and was both a fellow of the graduate school 'Transnational Media Events from Early Modern Times to the Present' and the 'Graduate Centre for the Study of Culture'. His dissertation *Zur medialen Konstruktion des Nationalen: Die Schillerfeiern 1859 in Europa und Nordamerika (On the Medial Construction of the Nation: The Schiller Centenary 1859 in Europe and Northern America)* was published 2014. His recent research examines the production, representation, distribution and perception of history in public spheres drawing on the example of the Battle of Gettysburg cycloramas. His working fields are public history, nation and nationalism, media history and the theory of history.

Srijan Mandal, a historian by training and temperament, specializes in the Constitution of India, specifically the right to freedom of speech and expression enshrined therein. It was the subject of his PhD thesis at the University of Hyderabad. Beyond the Constitution and legal history, in

general, he is also interested in the philosophy of history and historiography, which was the subject of his MPhil dissertation, also at the University of Hyderabad. He has presented his research both in India and abroad: at the Centre for the Study of Developing Societies in New Delhi, at the University of Aberdeen in Scotland, and twice at the Library of Congress in Washington, DC. But, what he is passionate about is the effective communication of historical scholarship to an audience beyond academia. He teaches at the Center for Public History in the Srishti Institute of Art, Design and Technology, Bengaluru.

Lisa Murray is a public historian and works at the City of Sydney Council where she heads the history program. She is an award-winning author of planning and community histories, a curator of physical and digital exhibitions, and producer of walking tours, activations, podcasts and smartphone apps.

Na Li (Lina) is a Research Fellow at the Department of History, Zhejiang University. She is Editor for Public History, a National Journal of Public History, International Consulting Editor for The *Public Historian*. She serves on the Board of Directors for the National Council on Public History. Her research focuses on public history and urban preservation. Author of *Kensington Market: Collective Memory, Public History, and Toronto's Urban Landscape*, her articles appear in *The Public Historian, Public History Review, The Oxford Handbook of Urban Planning*, and a number of premier Chinese journals. She is International Affiliate of the Centre for Oral History and Digital Storytelling at Concordia University and an Associate of Australian Centre for Public History at University of Technology Sydney. Lina is at a forefront to research and establish public history in China. She organized the first National Public History Conference in China (Suzhou, 2013) and the second in Hangzhou (2018) and the first (Shanghai, 2014) and second (Chongqing, 2015) Public History Faculty Training Program in China.

Nico Nolden is a teaching and research assistant for public history at the Universität Hamburg. He has studied history, East European studies and political science in Hamburg and worked as a research assistant for late medieval projects until 2014. His doctoral thesis, due for submission in early 2018, analyzes historical staging and commemorative cultures in Massively Multiplayer Online Role-Playing Games. At Public History Hamburg, Nolden is responsible for the working field digital games and history. He

supervises the Hamburg GameLab, a unit which scientifically researches and analyzes digital games and the corresponding games collection 'Ludothek'. In his blog 'Keimling', Nolden has been continuously discussing scientific perspectives on history and digital games since 2009. He is a founding member of the nationwide 'Arbeitskreis Geschichtswissenschaft und digitale Spiele', the working committee for historical sciences and digital games, and is head of the local work group 'History Matters' on history and games.

Serge Noiret, PhD, a Belgian citizen, has published widely on the crisis of the Italian liberal state after the First World War the history of political parties, electoral systems and the impact of new technologies on the craft of historians. His present research activities focus on the history of public history, digital (public) history, digital humanities and information literacy. He is a member of the scientific council of Italian academic history journals and of the *Réseau national des Maison des Sciences de l'Homme* in France. He has contributed to the foundation of the International Federation for Public History in 2011 and has been its first president from 2012 to 2018. He has founded the Italian Association of Public History in 2016, of which he has been president from 2017. A list of his publications is available in his blog, *Digital & Public History* (dph.hypotheses.org). He is co-editor of the *Encyclopaedia of Digital Public History* (with Mark Tebeau, 2018–19).

Keir Reeves is professor of Australian history and founding director of the Collaborative Research Centre in Australian History at Federation University Australia. He is the current historian member on the Public Records Advisory Council for the Public Records Office of Victoria, Australia, and is an executive member of AusHeritage. In recent years he has also served on the Heritage Council of Victoria, where he has chaired the Maritime Heritage Advisory Committee and also the boards of Goldfields Tourism and the Museum of Chinese-Australian History. He has served as an expert witness on heritage hearings and has supported community groups in developing cultural heritage strategies. Keir has received many research grants, including six from the Australian Research Council, with a prolific number of publications in heritage, public history and community identity.

Alex Trapeznik is associate professor of history at the University of Otago, New Zealand. His research focuses on historical and cultural heritage management issues in New Zealand and globally. He is the editor of *Common*

Ground? Heritage and Public Places in New Zealand (2000), a key text that helped establish public history as a discipline in New Zealand.

Julia C. Wells is Head of the Isikhumbuzo Applied History Unit (IAHU) at Rhodes University. IAHU specializes in community history activities which use creative arts to help tell unrecorded stories from the past. Wells's recent research interest lies in ways that uses the past work towards positive change in society. She uses the Solms-Delta wine estate as an example of how confronting the past has brought about meaningful changes (2017). Her most recent book, *The Return of Makhanda: Exploring the Legend* (2012), provides an analysis of the 1819 battle of Grahamstown as a product of land contestation rather than primitive superstition, as previously alleged. Other publications deal with cases of historic interracial marriages and black women's resistance to law enactment in South Africa. She has also served as a founding member of the National Heritage Council and three terms as a local government councillor representing the African National Congress.

Jacqueline Z. Wilson is an associate professor in the Centre for Collaborative Research in Australian History at Federation University Australia. She is a graduate of La Trobe University, where she was awarded the David Myer University Medal, and has been awarded a PhD (Monash University). She has authored over forty scholarly publications and is the sole author, editor and/or co-editor of five books, with research interests that broadly focus on heritage, activism and the representation of Australia's historic welfare and justice systems. Jacqueline is currently a chief investigator on several collaborative research projects funded by the Sidney Myer Fund and the Australian Research Council Discovery Awards. She is the lead editor for the *Palgrave Handbook of Prison Tourism* (2017).

Acknowledgements

The editors would like to express their immense gratitude to the contributors who, with their ready and willing cooperation, against the rigors of a strict word count and time frame, have made this volume possible. We would also like to thank Beatriz Lopez and Emily Drewe of Bloomsbury Academic Press for bringing *What Is Public History Globally? Working with the Past in the Present* to print; the University of Otago; the University of Technology Sydney's Australian Centre for Public History and Macquarie University's Centre for Applied History for supporting this project.

We would like to also convey our thanks to our colleagues who have, over the years, helped shape our views of public history, especially James Gardner, Paula Hamilton, Hilda Kean and the late Jann Warren-Findley. We appreciate, also, Austin Gee for his sage advice and attention to details.

Finally, we would like to give our thanks to, especially, Alistair Thompson; the five anonymous referees who have greatly assisted in facilitating the original proposal with their positive endorsements and encouragement; and Pauline O'Loughlin for her support.

Introduction
The Public
Turn: History Today

Paul Ashton and Alex Trapeznik

During the production of this book, one of our contributors wrote:

> The past few years of working in Chinese universities has convinced me that public history, though still vaguely defined and rigorously debated, is here to stay [in China].[1]

A generation ago, this could have been written about the condition of public history in countries such as Australia, Canada, New Zealand and the United States. This nascent field was discussed and defined from the second half of the 1970s primarily by academic historians and their graduate students, initially in the United States. Unsurprisingly, early definitions were clear-cut. Robert Kelley, an environmental historian at the University of California, Santa Barbara, famously pronounced that 'public history' referred 'to the employment of historians and historical method outside of academia'.[2] Much 'attention [too] was ... focused on the legitimacy of public history'.[3] And as Kelley's definition denotes, the field was described, sometimes negatively, in terms of its relationship to academic practice. Times, by and large, have changed over the intervening four decades.

Public history has evolved into a nuanced and complex field of theory and practice. There has been a long boom since the 1970s in the quantity and range of activities that fall under the rubric of public history. This was fuelled, among other things, by the rise of cultural tourism, the heritage

industry, technology, social movements, post-colonialism, mass education and the decline of traditional history departments. Public history, however, had a far longer lineage than immediately admitted by the definers of the 'new' movement. In 1981, Ronald Grele, an American community and oral historian, argued strenuously that public history was 'not de novo'. For him and many others it was

> moving into fields long occupied by practicing non-academic historians … Because the public history movement has ignored these debates, it seems to have accepted a much narrower idea of the profession.[4]

Grele also saw in public history the possibility of a participatory historical culture, one in which people generally had a firm hand in the making of their own pasts. In the same year, Howard Green, later to become president of the American Oral History Association and commissioner of the New Jersey Historical Commission, described in *Radical History Review* the way in which community historians felt belittled by their supposed professional betters.[5]

Public history can be linked to the rise of the nation state, which is usually associated with nineteenth-century developments in Europe, with the construction of traditions, public rituals, museums, landscapes, monuments and memorials, all of which contributed to the construction of national and other narratives. And the nation state certainly underwrote the evolution of history with a public purpose through massive investments in cultural institutions and universities. As American historian David Thelen observed, 'Modern professional historical scholarship grew up alongside the nation-state. Its mission to document and explain the rise, reform, and fall of nation-states. And professional history developed a civic mission to teach citizens to contain their experience within nation-centred narratives.'[6] David Christian, an early exponent of Big history, has also pointed to the huge political and financial backing nationalist governments have given historians to construct public histories 'to inspire loyalty'.[7] But the contemporary public history movement has been fragmented and too often viewed through a North American lens. While the professional stream of the public history movement took off in the United States from the late 1970s, other tributaries emerged at different times across the world.

In Britain, the term public history was slower to emerge than in the United States. On one level this commenced in the mid-1990s, marked by Raphael Samuel's creation of an MA in Public History at Ruskin College,

Oxford, a trade union–based adult education institution, in 1996.[8] (The first British international public history conference was convened by Hilda Kean at this college in September 2005.) But these public history practices were part of a radical tradition which took root in labour, local, oral and community history. And it was alive in the History Workshop Movement which Samuel cofounded in the late 1960s.[9] This squarely 'countered the intellectual and political conservatism of the dominant historical profession, setting up an alternative means for producing historical knowledge which had roots deep in the subordinate groups of British society'.[10] People, rather than just trained professionals, were active agents in making histories. And a whole range of materials was drawn upon to create these. As Hilda Kean, Paul Martin and Sally Morgan point out,

> What is seen and what is experienced in our everyday lives is as likely to be as significant in our understanding and creation of history as the reading of books and archives.[11]

National surveys of how people create, use and make sense of the past in the present confirmed this view.[12] These explore historical production, consumption[13] and consciousness. The latter concerns historical sensibilities – feelings for and about the past and its uses. The most recent of these, which surveyed 3,419 people and was published as *Canadians and Their Pasts*, observed:

> Throughout our lives the past is with us, from the most trivial of experiences to the most profound. Its legacies include our DNA and the scars on our bodies, the cultural traditions that bind our families and communities, and the laws that govern the public sphere. We are reminded of the past in street names and license plates; we see images from the past in museum halls and movie theatres; and we hear voices of the past in today's arguments over rights reclaimed and wrongs to be redressed.[14]

Tributaries have multiplied and the global ocean of public history has swollen. Tidal flows, back and forth, of knowledges and practices have seen different approaches to public history influencing its development across the world. In many countries, including Australia, Canada, China, Germany, India, Indonesia, New Zealand and the Scandinavian states, both the American and the British streams have had major impacts in public practice and in the academy.[15]

The leftist British experience, with its concern for social and political change, had an impact on public uses of the past in countries such as South

Africa and Ireland. The role of the past in the present, for example, was central to the work of the post-Apartheid Truth and Reconciliation Commission.[16] Activists and advocates tend not to identify with the professional public history movement. Those who work with the past in courtrooms, film-making and public art are generally not professional historians.[17] Indigenous rights movements also involve transnational circulations of ideas and people.[18] International exchanges at conferences, in publications and over the internet have led to developments such as the creation of an International Federation for Public History in 2010 and broader perspectives on public history.[19]

In the academy, public history programs tended, and continue, to run across a spectrum. At one end, they prepare postgraduate students to skill up and ship out into government, communities or professional roles. At the other, they can be 'defiant intellectual project[s] on "an impossible to categorise" area (sociology, history, anthropology) that … [are] essential to understanding the great interest and passion for history in many different forms within the broader population'. Some are a mixture of these activities.[20] But in recent years the global tertiary environment has shifted dramatically. Tertiary institutions are under increasing pressure to meet competing goals. In countries such as Australia, Britain and New Zealand, which have experienced national research assessment processes, with disastrous consequences in Britain for the humanities and social sciences, universities are pressurized to produce large quantities of original research in 'top drawer' academic venues – primarily elite and often expensive academic journals – and to show peer esteem. But they also have to demonstrate broad relevance, impact and social benefit.

Across the globe, postgraduate public history programs and the supervision of higher research degrees such as doctoral studies have made, and continue to make, critical contributions to the field. But tertiary education environments have been in flux for some time. As Geoffrey Boulton, author of the report *What Are Universities For?*, has noted:

> In the last two decades, higher education worldwide has moved from the periphery to the centre of governmental agendas. Universities are now seen as crucial national assets in addressing many policy priorities, and as: sources of new knowledge and innovative thinking; providers of skilled personnel and credible credentials; contributors to innovation; attractors of international talent and business investment; agents of social justice and mobility; contributors to social and cultural vitality; and determinants of health and well-being.[21]

In this challenging environment – as universities move through the final stage of corporatization, while their public funding dwindles and state-funded services decline in 'hard times'[22] – there is an expectation that academics should engage with various external communities and partners.

Community–university engagement is by no means new. But more and more fields are going 'public'. This can be seen in the rise of areas such as public archaeology and public law, the latter of which looks at laws concerning the relationship between citizens and the state.[23] The public turn has also seen a move away from positivist epistemology, 'facts', scientific method and gendered, in particular masculinized, research cultures to an emphasis on meaning and democratization of knowledge production.[24] Lawrence S. Bacow, who was Chair of the Steering Committee of the international Tallories Network, which promotes university engagement, has noted positively of this trend:

> In universities around the world, something extraordinary is underway. Mobilizing their human and intellectual resources, institutions of higher education are directly tackling community problems – combating poverty, improving public health, and restoring environmental quality. Brick by brick around the world, the engaged university is replacing the ivory tower.[25]

Others have similarly argued that this public turn is increasingly providing 'an alternative strategy for higher education, which might allow it to better fulfil its role as a public good' as it works through a crisis of perspective.[26]

Public historians, whether based in communities, universities, government, business or a combination of these, have been engaging in different ways with a broad range of people for a long time. They have been consultants, collaborators, advisors, advocates and activists. The contexts in which they have worked, however, varied greatly. Public historians in Indonesia, as noted in a chapter in this volume, have struggled against past state repression which, although now officially lifted, has left a lingering culture of fear. Those working in China have to constantly keep in mind official dictates. Some sites of public history are hotly contested. In December 1984, a methyl isocyanate leak at Union Carbide's pesticide plant in Bhopal, the capital of the Indian state of Madhya Pradesh, killed over 3,700 people. Plans by the Government of India to memorialize the site, as noted in Chapters 6 and 24, have caused a strong community backlash. Sites of conscience everywhere – in a gulag in the former Soviet Union; in slave plantations in America's 'deep South'; in a museum in Cambodia which

memorializes, somewhat controversially, the terror of the Pol Pot regime – tragically highlight the critical importance and the need to remember the past in both the present and the future.

Our publisher suggested *What Is Global Public History?* as a title for this book. We politely resisted this, suggesting instead *What Is Public History Globally?* For us, there is no particular global mode or practice of public history. Like culture, public history comes from somewhere: it is local; it is from 'around here' – a locality, region, state or nation. But it is open to transnational flows and international developments. As to the word 'public', debate and redefining have become hardy annuals. Nevertheless, as historian Ludmilla Jordanova has said:

> Whatever the complexities of 'public', public history is a useful label, in that it draws attention to phenomena relevant to the discipline of history, but too rarely discussed in undergraduate courses.[27]

We would like to think that contemporary history-making has, from the second half of the twentieth century, taken a slow public turn and that public history is an integral part of the house of history. As historian Marnie Hughes-Warrington has written about history on film, 'there is no "history" apart from historical practices. Nor … is there any logical, universal or unchanging reason to talk about one practice as "more historical" than another.'[28]

Notes

1. Na Li, personal email correspondence to Paul Ashton, 16 May 2017.
2. Robert Kelley, 'Public History: Its Origins, Nature and Prospects', *Public Historian* 1, no. 1 (1978): 16.
3. Paul Ashton and Paula Hamilton, *History at the Crossroads: Australians and the Past* (Sydney: Halstead Press, 2010), p. 126.
4. Ronald J. Grele, 'Whose Public? Whose History? What Is the Goal of a Public Historian?', *Public Historian* 3, no. 1 (1981): 44–6. See also Ian Tyrrell, *Historians in Public: The Practice of American History, 1890–1970* (Chicago: University of Chicago Press, 2005).
5. Howard Green, 'A Critique of the Professional Public History Movement', *Radical History Review* 25, no. 28 (1981): 164–71.
6. David Thelen, 'The Nation and Beyond: Transnational Perspectives on United States History', *Journal of American History* 86, no. 3 (1999): 965.

7. David Christian, 'History and Global Identity', in *The Historian's Conscience: Australian Historians on the Ethics of History*, ed. Stuart Macintyre (Melbourne: Melbourne University Press, 2004), p. 149.
8. www.history.org.uk/resources/public_resources_75.html (accessed 16 May 2017).
9. http://ncph.org/cms/wp-content/uploads/Ruskin-College-Oxford-GUIDE-2013-Oct-23.pdf (accessed 19 August 2015).
10. Bill Schwarz, 'History on the Move: Reflections on History Workshop', *Radical History Review* 57 (1993): 203–20. *Radical History Review* has a section devoted to public history.
11. Hilda Kean, Paul Martin and Sally Morgan (eds), *Seeing History: Public History in Britain Now* (London: Francis Boutle, 2000), p. 15.
12. Roy Rosenzweig and David Thelen, *The Presence of the Past: Popular Uses of History in American Life* (New York: Columbia University Press, 1998); Paula Hamilton and Paul Ashton (eds), *Australians and the Past*, special issue of *Australian Cultural History* 22 (2003); and Paul Ashton and Paula Hamilton, *History at the Crossroads: Australians and the Past* (Sydney: Halstead Press, 2010).
13. Jeremey de Groot, *Consuming History: Historians and Heritage in Contemporary Popular Culture* (Abingdon and New York: Routledge, 2009).
14. Margaret Conrad, Kadriye Drickan, Gerald Friesen, Jocelyn Lé Tourneau, Delphin Musise, David Northrup and Peter Seixas, *Canadians and Their Pasts* (Toronto: University of Toronto Press, 2013), p. 3.
15. See, for example, Thorsten Logge, 'Public History in Germany: Challenges and Opportunities', *German Historical Studies* 39, no. 1 (2016): 141–53; Graeme Davison, 'Paradigms of Public History', in *Packaging the Past? Public Histories*, ed. John Rickard and Peter Spearritt (Melbourne: Melbourne University Press, 1991), pp. 4–15 – a special issue of *Australian Historical Studies* 24, no. 96 (1991); and Daniel J. Walkowitz and Lisa Maya Knauer (eds), *Contested Histories in Public Space: Memory, Race, and Nation* (Durham and London: Duke University Press, 2009).
16. Sean Field, 'Imagining Communities: Memory, Loss, and Resilience in Post-Apartheid Cape Town', in *Oral History and Public Memories*, ed. Paula Hamilton and Linda Shopes (Philadelphia: Temple University Press, 2008), pp. 107–24.
17. See, for example, David Ritter and N. A. Flanagan, 'Stunted Growth: The Historiography of Native Title Litigation in the Decade after Mabo', *Public History Review* 10 (2003): 21–39.
18. See, for example, Dorothy L. Hodgson, 'Introduction: Comparative Perspective on the Indigenous Rights Movements in Africa and the Americas', *American Anthropologist* 104, no. 4 (2002): 1037–49.
19. http://ifph.hypotheses.org (accessed 13 January 2016).

20. Paul Ashton and Paula Hamilton, *History at the Crossroads: Australians and the Past* (Sydney: Halstead Press, 2010), p. 7. See also Andrew Hurley, *Beyond Preservation: Using Public History to Revitalize Inner Cities* (Philadelphia: Temple University Press, 2010), pp. 35–9.
21. Geoffrey Boulton, *University World News* 69 (29 March 2009). www.universityworldnews.com/article.php?story=20090326200944986 (accessed 15 May 2017).
22. See, for example, Sheila Slaughter and Gary Rhoades, *Academic Capitalism and the New Economy: Market, State and Higher Education* (Baltimore: Johns Hopkins University Press, 2009).
23. See, for example, the journal *Public Archaeology* via www.tandfonline.com/loi/ypua20 (accessed 26 May 2017); and Andrew Lynch (ed.), *Great Australian Dissents* (Melbourne: Cambridge University Press, 2016).
24. See, for example, Randy Stoecker, *Research Methods for Community Change: A Project-Based Approach* (Thousand Oaks and London: Sage, 2005).
25. 'Foreword', in *The Engaged University: International Perspectives on Civic Engagement*, ed. David Watson, Robert M. Hollister, Susan E. Stroud and Elizabeth Babcock (New York and London: Routledge, 2011), p. xx.
26. Ronaldo Munck, Lorrain Mellrath, Budd Hall and Rajesh Tandon (eds), *Higher Education and Community-Based Research: Creating a Global Vision* (New York: Palgrave Macmillan, 2014), p. vii. See also Lorraine McIlrath, Ann Lyons and Ronaldo Munck (eds), *Higher Education and Civic Engagement: Comparative Perspectives* (New York: Palgrave Macmillan, 2012).
27. Ludmilla Jordanova, *History in Practice* (London: Arnold, 2000), p. 141.
28. Marnie Hughes-Warrington, *History Goes to the Movies: Studying History on Film* (Abingdon and New York: Routledge, 2007), p. 32.

Part I

Background, Definitions and Issues

1

Public History in Australia: History in Place

Lisa Murray and Mark Dunn

Australia is a country haunted by its history. In mid-2017 this was brought vividly to life with a graffiti attack on two statues in Sydney's Hyde Park: one of Captain Cook erected over a hundred years ago and one of Governor Macquarie barely five years old. Inspired by the removal of statues commemorating the Civil War in America's south, the tagged colonial markers in Sydney reignited, if only briefly, the raging debates about Australia's past that had fuelled the history wars in the early 2000s. For a nation, where a common lament is that we have very little history, scratching at the scab of the colonial past quickly put paid to that. The story of public history in Australia is one of highs and lows, as Australians grapple with the legacies of the British colonial enterprise. Public history in Australia has been shaped by the different dynamics and by initiatives and organizations of each state, so that it is sometimes hard to give a sense of a national agenda or narrative for public history.

The assumption of history's value or benefits underlies the work of all historians, but particularly public historians. The benefits of history are many. The past is frequently invoked by public institutions for the lessons it teaches. Understanding our history can guide us, tells us where we have been, how we have got to where we are, and if we understand this, can help the community in planning for the future. History can confirm and enhance identity, while also challenging it. It allows people to acquire and sustain roots, it can inspire, console and condemn.

History can also be a burden. While it can reinforce traditions and social values, history can also be a form of cultural amnesia. People often lament: 'Why didn't we know?'; 'Why wasn't I taught this?' History can sometimes work to help us to forget, rather than remember. History can also be oppressive and stifle innovation. The misuse of history, even its abuse, can be a threat. Public historians in Australia often get embroiled in local or national politics and need to remain vigilant and critical.[1]

A public historian in Australia may be narrowly defined as a professional, trained historian who often works outside the academy and whose historical skills are utilized producing histories for a general audience, rather than exclusively for their academic peers. And these histories are consumed and discussed in the public realm of our communities, rather than being exclusively a conversation between academics. There is a strong contingency of freelance historians, especially in the eastern states of New South Wales (NSW) and Victoria. Their clients are private as well as public and professional institutions. The output of professional historians can also feed into work that is not necessarily directly for public consumption, but influences decisions that affect the public more broadly. Historians engaged in heritage projects, in policy-making, in court work, in land titles and land claims and other institutional applications all produce work and reports that influence decision making around historical issues.

But public history in Australia may be conceived in wider terms. British historian John Tosh has described public history as a broad umbrella that covers the varied ways historians make a public impact, raise the profile of the profession with the public and contribute to the level of historical knowledge in society.[2] This statement is as true for Australia as it is for Britain. You will find public historians in Australia working in museums and libraries, archives and government departments, in broadcast radio, film and television, as well as in the allied fields of archaeology, heritage and historic conservation. In this broader definition encompassing community-led historical production, public history has been practiced for over a hundred years. The Royal Australian Historical Society (RAHS) was formed in 1901; Charles Bertie, the first city librarian in Sydney, was appointed in 1909 and contributed historical articles to newspapers; and Charles Bean, a journalist, was writing Australia's First World War history from 1919. Professional historians are also increasingly becoming involved with community history groups as well as long established historical societies such as the RAHS. This chapter charts the development of public history as a profession in Australia.

The emergence of professional historians

Public history developed as a recognized form in Australia, as it did in the United States, Britain and elsewhere in the later 1970s and early 1980s. Although historians had been producing work for the public since long before this, the application of the term reflected the way that historians outside of the academy sought to professionalize their work in the late 1970s and 1980s. In Australia, it was the formation of the Professional Historians Association (PHA) that was a key step in this process. South Australia was the first to establish an association in 1981, followed four years later by NSW, with the other states following over the next decade or so.[3] The PHA sought to define the professional skills of public historians and increase the visibility of their work and their contribution to historiography. The setting of fees, model contracts and accreditation levels provided a form of collective bargaining on a state level that pursued institutional recognition and professionalization. The federation of the state professional associations in the mid-1990s encouraged cross-state dialogue, however with an uneven distribution of working historians in NSW and Victoria compared to the remaining states, it has done little to support the development of public history in Australia.[4]

Public history practice has also been shaped by various courses offered at universities in the different states. Among the earliest were public history master's programs at Monash University in Melbourne and the University of Technology Sydney (UTS), both established in 1988. These courses explored the practice and theory of public history through oral history, museum and exhibitions, heritage, media and the use of digital and traditional source material. Graduates were well placed to take advantage of increasing opportunities for historians in the capital cities. Both these coursework degrees have since closed, leaving some cause for concern over the training of public historians in the future. Nevertheless, the Australian Centre for Public History (established 1998) continues at UTS and Macquarie University launched the Centre for Applied History in 2016, so there is some room for optimism. Undergraduate semester courses in public history also survive at the University of Sydney and the University of Melbourne.

An important industry that supported the professionalization of public historians was the heritage industry. From the early 1970s, the passing of a series of Commonwealth and State heritage acts established a framework for the development of a heritage industry within which historians were

to become a central component. Heritage legislation began to appear in each state from the early 1970s.[5] These acts introduced a new government agency – a Heritage Council – with historians included as members in NSW, Victoria, Tasmania and Queensland.

At the core of each of these pieces of legislation was a system of assessing heritage with history identified as an essential element. Although in the early years of this process considerable weight was placed on the architectural significance of the built environment, as the industry matured the space for professional historians to work within it expanded as more complex sites and issues were brought forward for consideration.[6] The influence of social history, oral history and 'history from below' has seen increasing numbers of 'ordinary' places be accepted onto heritage registers. Factory sites, fibro houses, railway bridges, miners' camps, woolsheds and corner stores have all been added to state heritage registers through the process of careful historical research, coupled with community involvement. Heritage sites and their associated interpretation is how many people within the Australian community connect with public history.

It was the growth of the heritage industry, particularly in the capital cities, that led to a growing confidence among historians that they might be able to support themselves professionally outside of academia. This growing confidence, in turn attracted more historians to the field, which stimulated historians to push the boundaries of how history can inform the heritage estate. The approach in assessing many heritage sites encouraged multidisciplinary teams of historians, architects, archaeologists and other related professionals to work together. Although cross-disciplinary studies are still in its infancy with many academic historians, it has long been a staple of public history practice in Australia.

Other key moments in the 1990s demonstrate the growth of public history profession in Australia. The founding of the journal *Public History Review* in 1992, through the support of the PHA (NSW) and other practitioners, provided a national forum in which public and professional historians could debate, discuss and reflect on public history practice, as well as providing a platform for publication and academic discussion. The establishment of the History Council of NSW in 1996, a first in Australia, brought together professionals and institutions practicing history under the one umbrella, to advocate for history in our cultural life, and build the capacity of the history sector. The History Council, through its promotion of History Week, the community and academic history festival first held in 1997, as well as its speaker programs in which academic and public historians travel to regional

areas to present their work, has managed to expand the audience for public history beyond the main cities and institutions. The presentation of an Annual History Lecture, as well as history awards and an Annual History Citation, shared between academic and public historians, has further strengthened the position of history and historians in public discourse. NSW is often regarded as the 'History State' in Australia. Under the tutelage of Premier Bob Carr, the Premier's History Awards were established in 1997. As the only state-sponsored awards for history they are the envy of historians around the country. With a Community and Regional History Prize and a Multimedia History Prize, these awards provide important recognition for historians working in the public realm. In contrast, the Prime Minister's Award for History was not established until 2008 and has been marred by political controversy.

Employers and audiences

Critical thinking and analysis is one of the key attributes of a public historian. And it is this very attribute, according to public historian and former city historian Shirley Fitzgerald, that has made history unpopular in the late twentieth century: 'Not because it's boring or irrelevant or useless: But because it's a potentially dangerous tool for developing a critical capacity to analyse and therefore to act.' The contested nature of much of the public debate that has arisen around our history recently attests to this ongoing truism.[7]

This may well help to explain the lack of public historians within government departments. There are historians working in government agencies, such as the Australian War Memorial and the National Museum of Australia, and local, regional and metropolitan museums. But departmental historians with government bureaucracies are few and far between. South Australia has had a state historian, and it still has the History Trust of South Australia. This government agency runs three museums and generally supports the practice of history. NSW is yet to have a state historian although it does employ historians in its Sydney Living Museums. Nevertheless, in all states across Australia, government departments still commission historians to undertake departmental histories or overview studies of disappearing services.

Local government, with its grassroots focus on community services, is where many public historians find commissions and, sometimes, full-time

work. Many local studies librarians, found within municipal council libraries across the country, have tertiary history qualifications. Currently, only three municipal councils in NSW – the city of Sydney, North Sydney and the Northern Beaches – and Brisbane City Council in Queensland employ full-time historians. Historians in local government feed into strategies, policies, planning, and legal cases, as well as heritage, cultural expression and place making. In these formats, public history in Australia fosters public memory, community and cultural identity.

The existence of a history program and the employment of two public historians full-time at the Sydney City Council is a powerful statement of the city's confidence in the value of history. The city's history program emerged from a six-year engagement, from 1987 to 1993 of historian Shirley Fitzgerald by the city to publish a series of books leading up to the city's sesquicentenary in 1992. At the completion of this first seven-year commission, Fitzgerald was then engaged as the first city historian in 1997 and helped the city of Sydney to recognize history as a foundation and catalyst for policy reform and effective governance. Their commitment was shown in the continuation of the role after Fitzgerald retired in 2009.

Reaching out to audiences is a key goal of public history. However, a recent survey undertaken by the History Council of NSW in 2013 demonstrates that many historians struggle to define and reach their audience. Of over 700 respondents, 34 per cent were associated with a university, 11 per cent with a community organization and 10 per cent with a cultural institution. Respondents were asked to describe the outcomes of their organization's work. Research was the top outcome (67 per cent). Teaching and learning (57 per cent) and publication of historical works (45 per cent) were also significant. Then down at 33 per cent was exhibitions and events. Many of the outcomes identified – teaching, exhibitions and events – were directed at audiences. But when the question came: Who is the audience for your work? The responses were simplistic. Fifty-four per cent of respondents simply said 'everyone'. And 22 per cent said their audience was tertiary educated. Eleven per cent admitted their work had 'no specific audience'. Only a small number of respondents segmented their audience in terms of age groups.[8]

In 2015 city of Sydney historians commissioned an audience development strategy, which identified three key audiences: the skimmers, the delvers and the divers. This division of audience might sound facile, but it accurately summarizes how most people consume history in Australia. In contrast to the social and community history focus of the city of Sydney historians, the historian position at Brisbane City Council

mainly focusses upon history within the context of heritage listings. In Australia, the shaping of historical practice to meet the needs of different audiences is more often covert rather than overt. The history community, both academics and public historians, needs to be thinking more about their audiences and how different programs and media formats can reach different audiences.

History turns digital

The rapidly changing forms of communication and technology in the twenty-first century is another ongoing challenge for public historians, not just in Australia, but around the world. The complex relationship between historians, audiences and public institutions is shifting and distorting as digital technology enables broader audience participation in the production of history. Digitization projects are revealing historical sources to a much wider audience, providing greater accessibility and encouraging more people to go the next step and use the sources to participate in historical production. The federated search capabilities of the National Library of Australia's Trove, along with its digitized resources such as newspapers and government gazettes, are making more detailed research feasible, while private companies such as Ancestry are also digitizing vast quantities of genealogical records in public and private collections. TV shows such as 'Who Do You Think You Are' are popularizing family history and displaying the range of historical resources that are available for this research to a broad audience. However, historical research is not always a click away; digitization is expensive and institutions prioritize what will be digitized and when. The challenge for professional and community public historians is to not just rely on what is digitally available just because this is the easiest recourse in an increasingly time-poor industry.

The democratization of historical practice through digital tools and publishing means that historians are no longer the privileged producers of historical knowledge. Tosh has argued that the critical function of public history is the dissemination of a historical perspective on weighty or contentious issues.[9] While some members of the profession continue to challenge public perceptions of the past, many public historians are just as active presenting the past in new and innovative ways to engage with audiences, do their family histories, inform their societies or present a good yarn. The nexus between public history and community history

can be parochial, inclusive, or trivial, with little sense of historical perspective, context, or significance, but it also creates a fertile field for new scholarship, and exposes new sources and methodologies that can be utilized by others.[10]

This has always been the tension between amateur or popular history and professional history. One public history initiative that has sought to bring together historical production at all levels of the community is the Dictionary of Sydney (www.dictionaryofsydney.org). This born-digital project was launched to the public in 2009 and embraces both professional and community writers. Despite its inclusive approach, the tensions between popular history and professional history still mark its production and its relationships with the community: some community writers resent their work being edited, while some professional writers are shunning the platform for its lack of peer review and academic publishing status.[11]

The history wars and public statues

Public historians are becoming increasingly involved in the process of place-making, through the development of street names and suburb names as part of new developments, particularly across redeveloped industrial sites in inner city areas. They are working more and more in Indigenous history and the post-contact entanglements across many sites and places previously approached with a European-only focus. Historians are also being called on for anniversaries, war memorials and even in the debates around the provision and sale of public housing, all of which are a source of often-heated public debate, conflict and political agendas. Too often these debates over our history are seen through the prism of an increasingly partisan point of view, a legacy of the bitter history wars of the last two decades which have dominated popular historical consciousness in this country.

As historian Anna Clark has argued, 'national narratives have been contested for as long as they have been written'.[12] But what was different in the late twentieth century was that 'the increasing politicization of Australia's past fundamentally changed the way that history was perceived and employed'.[13] In hindsight, we should not be surprised that politicians waded into the telling of history, as the way we remember our past reflects how we see ourselves in the present.

The Bicentenary celebrations in 1988 was the first major challenge to the contemporary narrative in a public arena, debated and discussed

not just by historians, but by politicians, journalists and the broader community. Protestors reminded Australians that 'White Australia has a Black History too'. Such public statements questioning and realigning the historical narrative reflected the broadening historiography of Aboriginal histories, social histories and feminist histories which had been researched from the 1960s.

How did the history wars come about in Australia? The 'black armband' debate was born in 1993 when Geoffrey Blainey drew up a balance sheet of the divide in Australian historiography. Conservatives and progressives took up the cause on either side, pushing alternative national narratives about colonization and invasion, citizenship, wars and the forging of a nation. This crude polarization of Australian history writing into 'three cheers' and 'black armband' did more harm than good, stripping historical critical analysis of its context, pitting historians against each other, and undermining the value of history and turning historical research and debate into a 'contest over national collective memory'.[14] The history wars were a shock for many Australians. It revealed to the public that history is not set in stone. What a puzzle: history is about 'facts', isn't it? While the history wars played out mostly in public rather than academic historical circles initially, what was interesting, considering the centrality of Aboriginal history to the debate, is that the debates of the 1990s and early 2000s did not involve many Aboriginal voices.[15]

Public statues and memorials, such as the Captain Cook statue in Hyde Park, are an example of how history is used to forge a collective memory. This is the role of memorials – they keep the memory of the dead alive. And it is not just statues in parks that have this role. All the headstones in cemeteries around the country are a way in which our ancestors and communities have put on the public record a statement of their family's history, connections and identity.

Similarly, public statues and memorials are a deliberate didactic statement about a society's history and identity. They are planned, organized by a community group or committee and often paid for by public subscription.[16] Historians Paul Ashton and Paula Hamilton have looked at the nature of public memory and public history in a series of studies on memorials and historical consciousness in Australia. They argue in *Places of the Heart: Memorials in Australia* that the changing form of memorials, and the changing attitudes towards the validity and meaning of memorials, all reflect shifts in public remembering and people's relationship to the past.[17]

The latest debates around public statues and the telling of history reflects the Australian community's changing understanding of the past. Figurative statues are representative of an older, more traditional way of remembering the past. Mostly of men, the golden days of public statuary in Australia were the later years of the nineteenth century. They predominately reflected a colonial view, one where the Australian colonies, largely ignoring an Aboriginal past stretching back over 60,000 years, instead looked to European classical traditions where tangible reminders of their past and their heroes looked down on them from public squares, parks and buildings.[18] They were a solid reassurance of the importance of their history and their heroes.

The tension that arises from the current reinterpretation of history involves the voices of Aboriginal people. Public statues in Australia rarely include representation of Aboriginal people or the trauma of the colonial past that they endure. They are contesting the validity of certain expressions of the national historical narrative in material culture such as public statues, as well as the meaning of Australia Day. Words such as 'discovered', as inscribed on the Captain Cook statue in Hyde Park, are extremely hurtful to Aboriginal people and do not reflect their long connection to their land nor that they have occupied it for more than 60,000 years. Their country was not discovered; it was invaded and their sovereignty has been ignored ever since. When viewed from this perspective, it is not surprising that statues can become contested by different parts of the community.

Rebalancing the memorial landscape will not simply be achieved by pulling all the statues down. Memorials by their very role in collective remembering, have shifting meanings for the community. Historians are always reinterpreting statues, relics and records to make them more comprehensible. There are plenty of examples where extra plaques have been added to a statue. But that does not mean either that we should just add another plaque to the memorial, redressing earlier 'mistakes' or 'omissions'. As a society, we are always re-evaluating history, researching and rewriting. The critical questions are: How can we redress history without erasing? And what is the public historian's role in all of this? There is no easy answer to the current debates, but Australian public historians – and the community – should not be afraid of the discussions. They are a sign that critical historical practice is alive and kicking and that the social values associated with remembering the past are shifting.

Many of the challenges faced by our peers in the 1980s remain the same for public historians in Australia today. Public historians still seek

recognition of their skills in the wider community. The federated body is still debating accreditation levels, and there are tensions in the gap between the public's historical consciousness and the practice of history in the public and academic domains. The history wars continue to bubble along, and public historians – many of whom have been largely absent from the debate – are going to have to step up and engage in the debate about history, its value and its role in the present. If we are ever to achieve reconciliation with Australia's First Peoples, we must as a community and a nation consider our history and recognize its ongoing influence in the present.

Notes

1. See David Lowenthal, *The Past Is a Foreign Country* (Cambridge: Cambridge University Press, 1985); Graeme Davison, *The Use and Abuse of Australian History* (Sydney: Allen & Unwin, 2000).
2. John Tosh, *In Pursuit of History* (Harlow: Pearson, 2010), p. 51.
3. PHAs were established in South Australia during 1981; Victoria in 1983 (as part of the History Institute of Victoria, self-determining from 1991); New South Wales, 1985; Western Australia, 1989; Queensland, 1990; Tasmania, 1992; and the Northern Territory in 2001. See Paul Ashton, 'Going Public', *Public History Review* 17 (2010): 10.
4. Ashton, 'Going Public'.
5. Graeme Davison, 'The Meanings of "Heritage"', in *A Heritage Handbook*, ed. Graeme Davison and Chris McConville (Sydney: Allen & Unwin, 1991), pp. 1–4.
6. NSW Heritage Office, *Assessing Heritage Significance* (Sydney, 2001).
7. Shirley Fitzgerald, 'History? You Must Be Joking', NSW History Council Annual History Lecture, 2000.
8. History Council of NSW, *Executive Summary: History Sector – State of Play Survey* (Sydney, 2013). http://nla.gov.au/nla.arc-143084.
9. Tosh, *The Pursuit of History*, 51.
10. Grace Karskens, 'Public History: Academic History: The Common Ground', *Public History Review* 1 (1992): 20; Meg Foster, 'Online and Plugged In? Public History and Historians in the Digital Age', *Public History Review* 21 (2014).
11. Lisa Murray and Emma Grahame, 'Sydney's Past, History's Future: The Dictionary of Sydney', *Public History Review* 17 (2010).
12. Anna Clark, *Private Lives Public History* (Melbourne: Melbourne University Press, 2016), p. 98.

13. Anna Clark, 'The History Wars', in *Australian History Now*, ed. Anna Clark and Paul Ashton (Sydney: NewSouth, 2013), p. 153.
14. Ibid., 160.
15. Ibid., 162.
16. Graeme Davidson, *The Use and Abuse of Australian History* (Sydney: Allen & Unwin, 2000), p. 39.
17. Paul Ashton, Paula Hamilton and Rose Searby, *Places of the Heart: Memorials in Australia* (Melbourne: Australian Scholarly Publishing, 2012).
18. Davidson, *Use and Abuse*, 37.

Public History in Britain: Repossessing the Past

Mark Donnelly

The most imaginative, socially inclusive and politically engaged uses of the past in Britain today belong to forms of public history practice or vernacular past-talk. Admittedly, visitor numbers for the country's major museums and galleries have declined recently, a trend that might be explained in part by fears about potential security threats or the way in which the squeeze on school budgets has produced a fall-off in educational visits. But many other cultural forms that are used to reference the past are in better health. Judges for the Walter Scott Prize for historical fiction, for example, described 2017 as one of the best years that they had seen for the award. This was in response to a short list of contenders that included such critically acclaimed works as Sebastian Barry's *Days without End*, Francis Spufford's *Golden Hill*, Charlotte Hobson's *The Vanishing Futurist* and Jo Baker's *A Country Road, A Tree*.

In British cinemas, *Dunkirk* was one of the most commercially successful films of 2017, notwithstanding historian Hugh Sebag-Montefiore's complaints about its factual inaccuracies. 'Classic Album Sundays', at which selected vinyl albums are played in their entirety, accompanied by talks, interviews and discussion, have become a fixture in venues around the country, surfing a popular fascination with retro culture. Meanwhile the celebrity genealogy series, *Who Do You Think You Are?* (*WDYTYA?*), has completed its fourteenth season on BBC television, sustaining a level of

public interest that supports both a tie-in magazine and a *WDYTYA?* live event at Birmingham's major exhibition centre.

On a smaller scale, some homeless and vulnerably housed people have found ways of using past-talk to simultaneously generate income, develop self-confidence and provide a setting in which they can narrate their own experiences of social marginalization. 'Invisible Edinburgh Tours', for example, is a social enterprise that organizes historical walks around Scotland's capital, led by people who have been affected by homelessness; the current themes for these walks are crime and punishment, inspirational women and Edinburgh's festival culture. London's 'Unseen Tours' is a similar type of not-for-profit organization, hosting walks that explore the untold or forgotten histories of the city's Brick Lane, Camden and Shoreditch districts. Using walking tours about the past to draw attention to a current sociopolitical issue has equivalents in the field of historical re-enactments. The Wigan Diggers' Festival, now in its seventh year, uses re-enactment as a way of keeping alive Gerrard Winstanley's mid-seventeenth-century ideas about opposing private property and living off common land.

Taking a more recent episode from the past, Jeremy Deller's project 'The Battle of Orgreave' in 2001 re-enacted one of the most violent confrontations between police and striking miners in Sheffield during the labour dispute of 1984–5. Deller went on to work with Rufus Norris to produce 'We're Here Because We're Here', a re-enactment in which some 1,400 (always silent) volunteers appeared as First World War soldiers in locations around the country on 1 July 2016 – the centenary of the first day of the Battle of the Somme. Ian Kirkpatrick's 'A Graphic War' sculptures similarly took the First World War as a theme. Originally conceived as part of the artist's residency with Leeds Museums and Galleries, the large-scale sculptures were displayed in public spaces across Leeds such as shopping centers, markets and the City Museum itself. They were also temporarily displayed in the National Archives in London, demonstrating one of the ways in which a public history project can be welcomed inside one of the most important institutional settings for conventional historical research.

Public history is in fact now increasingly accepted into mainstream academic history's organizational culture in Britain. However, such acceptance happened late in this country by international standards, with its various practices cohering into sustainable institutional forms only within the last decade or so. Introducing a British-themed edition of the journal *Public Historian* in 2010, Holger Hoock drew attention to the 'rudimentary infrastructure' for public history in the UK, noting, for example, the absence

of its own specialist journal.[1] Writing at a time when there were only two master's degree courses on the subject in the country, Hoock observed that public history in Britain 'may only be beginning to emerge as a field'.[2]

Less than a decade later this field has expanded to include twelve postgraduate programs, with public history modules also frequently embedded into otherwise conventional undergraduate and postgraduate history degrees.[3] Among the current master's programs, the universities of York and Hertfordshire have made particular efforts to use public history as a way of reaching beyond the academy via the Institute for the Public Understanding of the Past and the Heritage Hub respectively.[4] In addition to the work that is being done at individual universities, the Historical Association brought together academics, media professionals, archivists and heritage specialists from numerous organizations to form a Public History Committee in 2009.[5] A few years later a public history seminar was set up at London's Institute of Historical Research in 2013. This seminar from the outset has had strong connections with the History and Policy Network, a group which has sought since 2002 to bring a 'historical perspective' to contemporary government policy making.[6] As a result, Faye Sayer's claim that public history has shifted from its position on the outskirts of orthodox academic history 'into an integrated and essential element of the subject's research and communication' now applies as much to Britain as elsewhere.[7]

However, despite what looks like a story of success over recent years, public history's comparatively late development in Britain suggests that academic historians had to be pressed to drop their indifference or even resistance to what it represented. It was no accident that public history was brought into the disciplinary mainstream around the same time that political pressure was intensifying for historians to justify their work – and hence their funding – in relation to the agendas of public engagement and vocational skills.[8] Forging and cultivating connections beyond the academy was an important part of historians' defence against growing criticism that the humanities were an expendable curriculum luxury in (post)modern universities.

Against such a background, public history had the advantage of being easily aligned with the 'business ontology' that has come to dominate British universities. In 2012 an official review of business–university collaboration described universities as 'an integral part of the supply chain to business'.[9] Two years later a joint publication from Universities UK and the UK Commission for Employment and Skills noted that employers were actively involved in the development of content and regular reviewing of the

curriculum in 130 out of 161 British higher education institutions.[10] As the marketization of university education in Britain was consolidated in 2012 with a steep increase in tuition fees, history degree courses became as likely as any other to reference the 'human capital' gains that they could offer to students. This is a principal reason why public history courses – including the one I teach in – typically emphasize their vocational orientation with opportunities for student work placements in museums, archives, galleries and heritage sites featuring prominently in course marketing literature.

Public history's growing institutional presence also owed something to the fact that a political project to exploit the 'heritage dividend' has gathered pace since the millennium.[11] This project has sought to use the cultural heritage sector as an ally in efforts to promote social cohesion, economic regeneration of post-industrial sites and the (re)articulation of British national identities.[12] One of the key contributors to this project has been the Heritage Lottery Fund (HLF), which has distributed £7.7 billion across more than 42,000 heritage projects throughout the UK since 1994.[13] In the foreword to the HLF's second strategic plan in 2002, Liz Forgan pushed hard the idea that heritage was indispensable to notions of contemporary citizenship and social cohesion. 'The lives of individuals and of communities,' she contended, 'can be changed by ... [heritage] not least in those very places where poverty or decay are paramount.'

Britain today is facing big questions – about its role in a global society, about our identity as a nation, as communities, as individuals. Our once rigid social and cultural groupings are dissolving. Our demographic mix is being transformed. 'Who do we think we are?' becomes an insistent question for our future which cannot be properly answered without access to the heritage of our past.[14]

The National Trust, which is the largest membership organization in Britain, made a similar point in 2006 when it stated: 'Heritage is acknowledged to make a valuable contribution to society through its contribution to national identity and well-being as well as for its intrinsic value and its role in delivering social and economic progress.'[15] In 2005 the then Culture Secretary Tessa Jowell described what she saw as the benefits of heritage in more specific and instrumental terms. 'The historic environment and wider heritage,' she wrote, 'contributes to a wide range of Government ambitions to cut crime, promote inclusion, improve educational achievement ... and help slay that poverty of aspiration which holds so many people back from fulfilling their potential.'[16] Many of us oppose using heritage as a tool for achieving social management goals. We might reasonably ask whether the admittedly

more difficult political challenge of reducing economic inequalities might be a better route to social cohesion or whether places in which 'poverty or decay are paramount' need serious and sustained investment more than heritage projects in order to produce jobs and good public services. But far from resisting the way in which Jowell positioned cultural (heritage) policy as a tool for improving 'social capital', representatives of Britain's historical profession echoed it in their own policy statements.

In the History Benchmark statement of 2014 it was taken 'as self-evident that the acquisition of knowledge and understanding of the human past is of incalculable value both to the individual and to society at large', principally it seems as a means for developing an appreciation of cultural difference and the fostering of 'critical yet tolerant personal attitudes'. So confident were its authors that 'possession of a history degree is a public good', the statement made only a cursory reference to the idea that historians should scrutinize the assumptions behind and the possible consequences of their own practices.[17] Indeed, the statement allocated more space to explaining the apparent importance of teaching by lectures than it did to discussing why students should be required to think critically about what it is that historians actually do.[18]

Given the nexus between a dominant political vision for heritage and the history profession's confidence in their own practices as a source of (unquestioned) public good, it is hardly surprising that historians have sought to impose these practices on heritage and public history projects more generally. In what they stated was the first review of public history in Britain in 2000, Hilda Kean, Paul Martin and Sally Morgan wrote about the importance of 'bridging the gap' between academic and popular history. But they made it clear that their position was grounded on a conventional understanding of public history as 'an umbrella, under which the historical mind can be brought to bear on areas of research and thought which are too often seen as mutually exclusive'.[19] In a second review of the field in Britain in 2010, Madge Dresser wrote that 'in the end, considered historical judgement based on a nuanced assessment of often-contradictory evidence, must form the bedrock of even the most populist public history project'.[20] Such confidence in the assumed virtues of the 'historical' mind or judgement contrasts sharply with, say, the warnings that historians often issue about the dangers of collective memory practices or their complaints about 'distorted' representations of the past in popular media form. This is why if one asks a historian to discuss the term public history they will invariably interrogate various meanings of the word 'public' – and rightly so. But they are likely to

regard the term 'history' as a given that needs no critical discussion at all. Why does this matter?

Despite their recent talk of methodological pluralism and transdisciplinary openness, historians are reluctant to let go of their ideological capacity to regulate what counts as legitimate talk about the past. As Hayden White wrote recently, historians tend to regard the past as *only* historical and will therefore measure any other way of constituting a past against what they see as the 'pure past' of this history.[21] Confident that their discipline protocols can best be trusted to establish the 'facts of the matter' in relation to the past, most historians continue to see themselves as guardians of what Martin Davies describes as a '*social practice that not only organizes the world in the shape of past events, but imposes its practice as the sole, exclusive way of organizing it*'.[22] Writers such as White, Davies, Elizabeth Ermarth, Sande Cohen, Keith Jenkins, Alun Munslow, Kalle Pihlainen, Claire Norton and others have exposed at length the various shortcomings in orthodox history's epistemological assumptions. But historians have largely ignored these critiques – which invoke post-metaphysical models of knowledge – in favour of a business-as-usual approach.[23] Consequently, problematizing how history works as a discourse is something that now happens only on the far edges of the profession.

This state of affairs should be a source of concern because of the issues that it raises about democracy and about access to discursive spaces in which political and social movement activists might want to work. Academic history still embodies essentialist values that contemporary projects for horizontal democracy seek to reject and resist.[24] As writers such as Todd May, Saul Newman, Andrew Koch and Mark Bevir have argued, post-foundational theories of knowledge have proven to be the ones that are most compatible with the democratic and anti-authoritarian political projects that characterize the most vital forms of progressive political activism today. As a point of principle, if any among such activists should choose to invoke the past for whatever reason, it follows that the epistemological practices they use to do so should be commensurate with their political ones. This means that there should be a discursive prefiguration of the political values they seek to realize in the methods and forms that they use to invoke the past. Or to put it another way, it would be inconsistent – even self-refuting – for anyone engaged in non-hierarchical and anti-representationalist political projects to insist that one semantic system was *the* correct discourse for invoking the past, particularly academic history, which habitually seeks to

produce the kind of interpretive closures that emancipatory political work aims to disturb and disrupt.[25]

There are also issues of personal autonomy and responsibility at stake when it comes to constituting the past as an object of thought. As White argued towards the end of *Metahistory*, people had to be regarded as free to conceive of the past as they wished, and to tell whatever *kinds* of stories they wanted to about it in whatever ways they believed were most compatible with their 'moral and aesthetic aspirations'.[26] What mattered in the end, for White, was people's animating moral or social vision of the past, not adherence to the academic disciplinary protocols that regulated what counted as a 'historical' version of it. Making such a choice about how to define oneself in relation to the past was part of people's wider freedom to 'to accept full responsibility for the meaning of their lives and the moral values they want to promote'.[27]

If historians were to contribute to intellectual cultures that were attuned to the needs of the present – if history was to be studied *at all* for anything other than personal edification or displays of erudition and connoisseurship – White advised them to use their discursive competence and imaginations as means to inspire new visions for living. He emphasized that human choices rather than impersonal historical processes determined social and political relations – albeit choices made within a given set of material and hegemonic conjunctures within space and time. Only by doing so, White argued, could humans free themselves from the 'burden of history', and instead use the study of the past as a means to help them accomplish 'an ethically responsible transition from present to future'.[28] In these terms, any attempt to argue for a singular reading of the past – or indeed for a singular discursive *method* to read it – would be regarded as authoritarian and anti-democratic. It would seek to deny on ostensibly epistemological grounds people's freedom to relate to the past in their own ways, or what White called their freedom to choose a past in the same way that they choose a present.[29]

There is no good reason to think that conventional academic historians are likely to respond positively to the kind of arguments that White has been making for some fifty years now. But the relatively new field of public history in Britain *could* choose to develop its capacity to open up spaces for people to produce imaginative, non-authoritarian and socially accessible forms of past-talk, free from the coercive oversight of academic history. It could endorse the ways in which activists and campaigners of many different types use forms of vernacular past-talk to unsettle those temporary fixings of 'common sense' that limit thinking about current political and social

problems. It could explore how journalists, artists, curators, filmmakers and performers have been adept at referencing the past in their practices of advocacy, without benchmarking them against history's disciplinary norms. It could support the ways in which grassroots archivists help to challenge the power of authorized institutional archives to determine what gets to count as a demonstrable feature of the past. It could lend its weight to the idea that only the most inclusive, accessible and democratic practices for producing past-talk are capable of overcoming the political and semantic problems of representationalism.

There are public history projects now underway that can be seen as contributing to these kinds of agendas. One example is Warwick University's 'People's History of the NHS' project, which has been collecting people's stories, memories and objects about Britain's National Health Service (NHS) as it approaches its seventieth anniversary in 2018. By encouraging contributions from patients, staff and health service trade unions, the project helps to inform and encourage public debate about the NHS's future, as well as leaving behind a grassroots record of a key national institution.[30] In somewhat related fashion, London's Bishopsgate Library in 2017 agreed to provide a permanent home for a DIY archive that documents twenty-five years of grassroots movements for social change. This ensures open access to a collection of materials that has been carried from one temporary location to another for two decades, covering protests relating to climate justice, anti-war and anti-arms trade campaigns, land rights, squatting and Occupy London.[31]

There are good reasons to welcome public history's recent acceptance into Britain's academic infrastructures. But equally we need to qualify this by recognizing that at the general level institutional endorsement is usually bought at a price. As a way of appreciating the cost involved, we might note how public history's development in Britain has followed a similar trajectory to the one that Joan Scott described for feminist history in the United States and beyond. Looking back at how feminist history has been absorbed into universities since the publication in 1974 of Banner and Hartman's *Clio's Consciousness Raised*, Scott noted how the achievement of 'legitimacy, for those who began as revolutionaries, is always an ambiguous accomplishment'.[32] Scott rightly acknowledged that the last several decades have seen women's stories and experiences written into academic histories and female historians admitted in sizeable numbers to the profession (albeit not as equal participants). But she also recognized that victory could be read simultaneously as a let-down. As the discipline of academic feminism

gained credibility inside universities, so its links with the political feminism that had inspired it appeared to weaken. 'No longer insurgents, we have become disciplinarians,' argued Scott, 'and I suspect that inevitably there's something of a let-down in this change of identity.'[33] On one reading of its genealogy, British public history could reasonably claim to have set out with similarly insurgent intentions to its feminist counterpart. Its early formation drew on the organizational energies and ambitions of the History Workshop movement, which from 1967 onwards sought to use historical research as a form of oppositional political practice. History Workshop existed to democratize historical practices, a mission that was fully commensurate with its roots in adult and trade union education and its alignment with the New Left's cultural eclecticism. As Raphael Samuel explained, History Workshop was aligned with the 1960s' cultural revolts that seemed to carry all before them at that time. Politically, it coincided with radicalisms of varying type: the rise in worker-militancy across Britain and Europe in the late sixties; the student uprisings of 1968; and the emerging feminist movement.[34] Fifty years on it is important that public history does not lose sight of its association with History Workshop's original democratic project. If it were to do so, it would be difficult to define what gives public history in Britain a separate identity to heritage work and 'public facing' but otherwise orthodox historical practices.

Thus public history's absorption into the 'disciplined, polite and non-contrarian discourse'[35] of academic history risks representing the loss of something important. Academic histories – those produced by professional or institutionally accredited historians – carry sizeable cultural authority. But they are usually disconnected from discussions of 'what is to be done' in response to contemporary social, political and ethical challenges. If public history settles down to performing a role as a subdiscipline of academic history it will have lost the opportunity to connect past-talk to present-day concerns. Public historians who take for granted history's epistemic authority are apt to become champions of a particular disciplinary code for dealing with the past 'properly.'[36] But rather than seek to consolidate academic history's coercive presence in the public sphere, public historians can choose instead to be part of a wider project to democratize how various forms of past-talk function and are regarded.

There are good reasons to do this. Take just one. In her critique of Habermas's theorization of the bourgeois public sphere, Nancy Fraser drew attention to the importance of what she called 'subaltern counterpublics', which were 'parallel discursive arenas where members of subordinated

social groups invent and circulate counterdiscourses to formulate oppositional interpretations of their identities, interests and needs.[37] Instead of conceptualizing the public sphere as a singularity, Fraser wrote about multiple and differentially empowered publics that were engaged in forms of discursive contestation, as well as acts of withdrawal that allowed subordinated groups to reflect and deliberate on where they thought their identities and interests currently stood.[38]

Public history practices could be used to function as an alternative space in which historians' collective disciplinary power was contested and politically empowering counter discourses were invented, welcomed and supported. But for this to be realized, those of us who work in the field of public history will need to be modest enough to recognize that the past is too important to leave to historians.

Notes

1. Holger Hoock, 'Introduction', *Public Historian* 32, no. 3 (2010): 9.
2. Ibid., 10. The two Public History MAs were at Royal Holloway (London) and Ruskin College (Oxford).
3. Public History MAs are currently taught at the following British universities: Birkbeck (London), Central Lancashire, Derby, Hertfordshire, Huddersfield, Manchester Metropolitan, New College of the Humanities, Royal Holloway (London), St Mary's Twickenham, Swansea and York. There is also a PG Certificate Program at Newman Birmingham. In addition, there are a number of MA History courses elsewhere in the country that contain public history modules (including Bristol, Lancaster, Manchester, Plymouth and Southampton).
4. See www.york.ac.uk/ipup/ and www.herts.ac.uk/heritage-hub for their current activities.
5. Details of the committee's original aims, ambitions and personnel are recorded in the minutes of its first meeting. www.history.org.uk/historian/categories/868/resource/2804/1st-meeting-of-the-public-history-committee-19-may (accessed 12 September 2017).
6. See the network's self description, available at www.historyandpolicy.org/who-we-are (accessed 12 September 2017). For a good discussion of historians' public roles and their potential for contributing to government policy-making, see Alix Green, *History, Policy and Public Purpose: Historians and Historical Thinking in Government* (Basingstoke: Palgrave Macmillan, 2016).

7. Faye Sayer, *Public History: A Practical Guide* (London: Bloomsbury, 2015), p. 1.

8. Ibid., pp. 12–13.

9. Department of Business, Innovation and Skills, *Business-University Collaboration: The Wilson Review* (London, 2012), p. 1.

10. Universities UK and the UK Commission for Employment and Skills, *Forging Futures: Building Higher Level Skills through University and Employer Collaboration* (London, 2014), p. 9.

11. Martin Davies argues that the 'heritage dividend' simultaneously historicizes the everyday world 'subjectively' in the form of historical consciousness, and 'objectively' through its role in economic regeneration schemes. See his *Imprisoned by History: Aspects of Historicized Life* (Abingdon: Routledge, 2010), p. 22.

12. See, for example, how Gordon Brown (at the time UK Chancellor of the Exchequer) attempted to articulate a historically informed vision of contemporary 'Britishness' in his speech to the Fabian Society on 14 January 2006. A text of the speech is available online, at www.britishpoliticalspeech. org/speech-archive.htm?speech=316 (accessed 18 September 2017). Brown developed his thinking further at a seminar at the Commonwealth Club on 27 February 2007.

13. www.hlf.org.uk/about-us (accessed 18 September 2017).

14. Heritage Lottery Fund, *Broadening the Horizons of Heritage: The Heritage Lottery Fund Strategic Plan 2002–2007* (London, 2002), p. 2. Similar rhetoric continued to appear in the 2008 strategic plan: 'We believe that understanding, valuing and sharing our diverse histories changes lives, brings people together and provides the foundation of a confident, modern society.' See also Heritage Lottery Fund, *Valuing Our Heritage: Investing in Our Future. Our strategy 2008–2013* (London, 2008), p. 3.

15. The National Trust + Accenture, *Demonstrating the Public Value of Heritage* (London, 2006), p. 9, cited in Davies, *Imprisoned by History*, 25.

16. Tessa Jowell, *Better Places to Live. Government, Identity and the Value of the Historic and Built Environment* (London: Department for Culture, Media and Sport, 2005), pp. 23–4, cited in Davies, *Imprisoned by History*, 26.

17. Quality Assurance Agency, *Subject Benchmark Statement: History*, December 2014, pp. 6 and 8. www.qaa.ac.uk/publications/information-and-guidance/publication?PubID=2874#.Wv6klIiFPIU. In the UK the Quality Assurance Agency is the main agency responsible for producing and monitoring academic audit culture. The 2014 statement for history was produced by a review group of eighteen academics and one student, and it provides an articulation of what a history graduate should be expected to know, understand and be able to do at the end of their studies.

18. In a 2006 survey of the history profession, Gunn and Rawnsley confirmed that historians were reluctant to reflect critically on their own disciplinary habits. The authors argued that the majority of history programs preferred 'a traditional, empirically-based model of history', and that the post-modern and theoretical turn had had a limited impact on university history teaching which 'was dominated by traditional concerns with "coverage", subject specialisation and the lecture/seminar format'. See Simon Gunn and Stuart Rawnsley, 'Practising Reflexivity: The Place of Theory in University History', *Rethinking History* 10, no. 3 (2006): 376, 384. There is little evidence that anything has significantly changed since 2006.

19. Hilda Kean, Paul Martin and Sally J. Morgan (eds), *Seeing History: Public History in Britain Now* (London: Francis Boutle, 2000), p. 13.

20. Madge Dresser, 'Politics, Populism and Professionalism: Reflections on the Role of the Academic Historian in the Production of Public History', *Public Historian* 32, no. 3 (2010): 63.

21. Hayden White, *The Practical Past* (Evanston, IL: Northwestern University Press, 2014), pp. 18–19.

22. Martin Davies, *Historics: Why History Dominates Contemporary Society* (Abingdon: Routledge, 2006), p. 3, original emphasis.

23. As the editor of a collection of essays about the state of the history discipline wrote recently: 'By and large, practicing historians have rejected the nihilistic tendencies of postmodernism in favor of a commonsensical approach to their craft…they do not lose sleep over epistemological matters.' See Donald A. Yerxa (ed.), *Recent Themes in Historical Thinking: Historians in Conversation* (Columbia: University of South Carolina Press, 2008), p. 3.

24. For a discussion of how post-structuralist theories of knowledge are most compatible with radical democratic politics today, see, for example, Mark Bevir, 'Post-foundationalism and Social Democracy', in *Rewriting Democracy: Cultural Politics in Postmodernity*, ed. Elizabeth Deeds Ermarth (Aldershot: Ashgate, 2007), pp. 48–63; Todd May, *The Political Philosophy of Poststructuralist Anarchism* (University Park: Pennsylvania State University Press, 1994); Saul Newman, *Unstable Universalities: Poststructuralism and Radical Politics* (Manchester: Manchester University Press, 2007), pp. 166–202.

25. Disavowing the context-transcendent truth claims of orthodox history's epistemology does not lead to 'nihilism' or 'anything goes' because there are other grounds on which people can be asked to justify what they say about the past. Asking people to consider the possible ethico-political consequences of their choice to invoke the past makes at least as much sense as asking them for epistemological justifications.

26. Hayden White, *Metahistory: The Historical Imagination in Nineteenth-Century Europe* (Baltimore: John Hopkins University Press, 1973), p. 434.

27. Herman Paul, 'Hayden White and the Crisis of Historicism', in *Re-figuring Hayden White*, ed. Frank Ankersmit, Ewa Domanska and Hans Kellner (Stanford, CA: Stanford University Press, 2009), p. 56.

28. Hayden White, 'The Burden of History', in *Tropics of Discourse: Essays in Cultural Criticism* (Baltimore: John Hopkins University Press, 1978), p. 41.

29. Hayden White, 'What Is a Historical System?', in *The Fiction of Narrative: Essays on History, Literature and Theory, 1957–2007*, ed. R. Doran (Baltimore: John Hopkins University Press, 2010), p. 135.

30. See http://peopleshistorynhs.org/

31. The 'Phoenix Archive' at Bishopsgate Library is part of a wider and continually developing 'Resistance Archive' which is gradually being made available online, currently via archive.org.

32. Joan W. Scott, 'Feminism's History', in *The Fantasy of Feminist History* (Durham and London: Duke University Press, 2011), p. 25.

33. Ibid., p. 25.

34. Raphael Samuel (ed.), *History Workshop Journal: A Collectanea 1967–1991* (Oxford: History Workshop, 1991).

35. Kalle Pihlainen, 'Historians and "the Current Situation"', *Rethinking History* 20, no. 2. (2016): 151.

36. For example, the idea that public historians are first and foremost committed to the disciplinary codes of academic history is repeatedly expressed in Thomas Cauvin, *Public History: A Textbook of Practice* (New York: Routledge, 2016).

37. Nancy Fraser, 'Rethinking the Public Sphere: A Contribution to the Critique of Actually Existing Democracy', in *Habermas and the Public Sphere*, ed. Craig Calhoun (Cambridge, MA: MIT Press, 1992), p. 123. For a complementary discussion, see Chantal Mouffe, 'For an Agonistic Public Sphere', in *Radical Democracy: Politics between Abundance and Lack*, ed. Lars Tonder and Lasse Thomassen (Manchester: Manchester University Press, 2005), pp. 123–32.

38. Luke Good, *Jürgen Habermas: Democracy and the Public Sphere* (London: Pluto Press, 2005), p. 46.

3

Public History in Canada: Public Service or public service?

Michael Dove and Michelle A. Hamilton

Beginning in 2006, The Pasts Collective, an alliance of academic researchers, collaborators, universities and community partners, conducted a national survey of Canadians to explore the role of history in their lives. The study followed a contentious period referred to as 'The History Wars'. A survey conducted a decade earlier found widespread public ignorance of Canadian history, which prompted a damning indictment of the country's historians, claiming that the teaching, learning and practice of history had been effectively 'killed' by special interest groups, to the detriment of a national narrative informed by political, military and diplomatic history.[1] The grim proclamation sparked widespread media, popular and academic attention to the issue of history in the public sphere. This led to increased support for numerous cultural initiatives, including the web-based education project 'Great Unsolved Mysteries of Canadian History' and the widely popular CBC TV series 'Canada: A People's History', and prompted academic historians to review their methods, tools and audiences.[2] The Pasts Collective's survey found that support for 'public' history, as in 'the institutions and media that support citizen engagement with the past', had been one of the most remarkable features of the past two decades.[3]

Public history in Canada certainly matured over this period. Fuelled by the establishment of the United States National Council on Public History (NCPH) and its peer-reviewed journal, *The Public Historian*, the Canadian

public history movement gained further traction when the University of Waterloo hosted the NCPH's annual meeting in 1983. Though programs and courses have gradually developed at universities across the country – the oldest being the University of Western Ontario's MA Public History program – uncertainty among academics and community institutions remains regarding public history's definition, value and legitimacy. While the former increasingly encourage, assist and even marvel at the ways in which public historians engage with diverse audiences, many also express concerns over the extent of federal government direction and funding support. Public Service jobs remain the most coveted by public historians, while federally financed projects drive the work associated with archives, museums and historical research consulting. Community institutions are sometimes unaware of the practical experience and transferable skills carried by public history graduates, and recruit from specialized programs in museology, archives, cultural management and public administration.

The future, however, appears bright for public historians in Canada. Courses and programs are proliferating across the country and public history, as a specialization, is appearing alongside other traditional educational qualifications in job advertisements. There also exists a deep-seated concern for improving Canadians' historical consciousness. Though public historians have always worked closely with communities and embraced their professional responsibility to inform and shape broader understanding of current issues and policies, this notion of public engagement appears to be regaining value and support among university historians. Public history in Canada, therefore, may become less associated, and dependent upon, the vagaries of Public Service investments, and more a function of the growing desire and necessity for historians to provide a public service to Canadians.

While the professional public history movement emerged in Canada by the early 1980s, the spirit and practice of putting history to work in the country can be traced a century earlier with the rise of historical societies and antiquarian organizations and the practice of collecting and preserving artefacts and archival materials. As experienced in most of the West, commemorations, monuments, landmarks, memorials and museums became the apparatus of the nation-state as it served to build 'better citizens'. Further impetus for organization and action by those concerned with protecting the nation's past arose in response to the Dominion government's perceived attack on Canadian heritage, particularly contentious as Quebec's tercentenary neared in 1908. Inspired by the Royal Society of Canada, there were other moves to protect and preserve landmarks and sites deemed

significant to the country's early history. Steered by Montreal lawyer William D. Lighthall, several local historical societies combined to form the Historic Landmarks Association (HLA).[4]

There was a simultaneous effort to professionalize the discipline of history. This process raised core questions relating to the purpose of history, how it should be practiced and who should do so. Initially an American movement marked by the founding of the American Historical Association (AHA), Canadian universities gradually featured autonomous history departments led by those with advanced historical training. Professor George M. Wrong, an Anglican clergyman without formal historical training, felt that historians should be taught skills useful to public life. He founded both the University of Toronto's History Department and the *Review of Historical Publications Relating to Canada*, the precursor to the *Canadian Historical Review*, the country's first scholarly history journal. Facing redundancy by the creation of the Historic Sites and Monuments Board in 1919 to advise the federal government on matters of historical preservation and interpretation, the HLA moved towards becoming a more scholarly organization akin to the AHA as it transformed into the Canadian Historical Association (CHA) in 1922.[5] Much like its American counterpart, the CHA sought to serve the interests of professional historians and those later associated with public history. Its objectives were 'to encourage research and public interest in history and to promote the preservation of historic sites and buildings, documents, relics and other significant heirlooms of the past'.[6]

Over the following decades, however, the CHA became more scholarly in membership and focus – both its journal and its annual meetings became an exclusive preserve for university historians.[7] In the meantime, many students of history began to join the ranks of an expanding federal bureaucracy, which sought generalists over narrow specialists.[8] Professional historians thus became increasingly detached from the wider community. The pursuit of scholarship produced rigorous standards of research and publication, but it came at the cost of 'privatizing history'. Some CHA members pointed to potential serious repercussions, lest the historian's role would fall 'into other hands'.[9] Though it attempted to improve its connections with the non-professional community though its Local History Committee (1947) and Historical Booklet Series (1951), the CHA proved elitist and authoritarian; the booklet audience consisted 'almost entirely of university professors and their students'.[10] Mounting divisions between and within disciplines effectively fractured academia and enlarged the gulf between professionals and the public.[11]

The federal government continued to create jobs for historians in the Public Service. In response to the Massey Commission's examination into the state of Canadian arts and culture, it created the Canada Council, the National Library of Canada and several new national museums. Support for a national network of museum professionals led to the founding of the Canadian Museums Association in 1947. As pressures of French Canadian independence and American mass media were felt amid the lead-up to the country's centennial celebrations in 1967, Ottawa became wedded to the creation of a national culture as buttressed by concepts of multiculturalism. Prime Minister Pierre Trudeau's government made significant investments in the country's museums, archives and libraries, all of which became workplaces for historians.[12]

The decades of the 1960s and 1970s witnessed a pronounced shift within the historical profession away from the dominant political and intellectual tradition to one espousing 'history from below'. Social and urban history, with their attention to the everyday pasts of those traditionally excluded from the governing narrative, attracted Canadian historians as they employed interdisciplinary methods and collaborated with individuals and organizations outside of academia to examine and produce histories of labour, ethnicity, women and Aboriginal groups.[13] There was resistance. Groups feeling marginalized from the mainstream narrative began to object to the telling of their stories. In the 1980s, black and Aboriginal Canadians respectively protested two major museum exhibitions, *Into the Heart of Africa* (Royal Ontario Museum) and *The Spirit Sings* (Glenbow Museum). In the 1990s, veterans questioned their less than noble portrayal in the Second World War documentary miniseries *The Valour and the Horror* and at the new national Canadian Museum of War. These controversies covered the front pages of major Canadian newspapers.[14]

Though academic historians assumed alternative perspectives, Canadians had turned to other sources for the past. Popular historians such as Pierre Berton became the authorities on Canadian history and culture. Berton became a household name, regularly appearing on national radio and television. Known as 'Canada's storyteller', he wrote bestselling books focusing on those milestone events in the national narrative, including the Canadian Pacific Railway, the War of 1812 and the Battle of Vimy Ridge. Berton earned widespread praise for his driving narrative and emphasis on the human dimension, though most professional historians readily dismissed him and his ilk for sacrificing scholarship for celebrity.[15] The public appetite for history, especially Canadian history, was large and growing. But

professional historians refused to come to the table, thus sacrificing public relevance for scholarship. Those from outside the academy with a passion for history sat at the table and feasted. Problematic, too, was an inclination by federal Royal Commissions to exclude historians from the process. In response to the Royal Commission on Corporate Concentration in Canada (1975–8), business historian Michael Bliss lamented that 'the whole effort might have been improved if the commissioners and their research staff had not considered historians irrelevant to their work'.[16]

As academic isolation from the populace grew, greater numbers of history graduates faced fewer employment prospects at Canadian universities. Practicing history in the public sphere became 'Plan B'. Many moved into the civil service to fill the federal government's new classification of 'historical researcher'. Graduates also found work in museums, archives, historic sites and in private consulting, where they acquired additional skills on the job.[17] This group, commonly referred to as 'failed academics' by their university counterparts, found themselves seeking a professional association that could provide guidance, direction and promotion of their work. Many turned their attentions south.

The dominant stream affecting the professional field of public history in Canada was, and remains, American. In less than a decade of its emergence in the United States, there were three programs at Canadian universities offering public history programs. In 1980, Doug Cole and Michael Fellman at British Columbia's Simon Fraser University laid the groundwork for an undergraduate-level Certificate Program in Public History. In 1983, faculty members at the Universities of Waterloo and Western Ontario invited the NCPH to move its annual meeting outside of the United States for the first time in its short existence. This marked a turning point in the modern Canadian public history movement. That year John English championed Canada's first MA public history program at the University of Waterloo, while Bruce Bowden and George Metcalf outlined plans to create an alternate MA stream in Public History at the University of Western Ontario. Through the efforts of a small few, these programs managed to succeed despite grappling with heavy internal criticism as being second-rate due to their applied nature.[18]

Persisting throughout this period was the need for courses and projects dedicated to the acquisition of speciality skills beyond those already learned by historians. In 1988, to obtain a clearer sense of teaching gaps, the CHA's newly formed Public History Group undertook a national survey of history departments. It found that the three universities with public history

programs offered a similar array of interdisciplinary courses as required options including methods in archaeology, archives, museums and heritage preservation, though many of the applied courses were offered by other departments. Six other universities offered either undergraduate or graduate courses in fields related to public history. Perhaps the most favourable results included eight history departments offering courses in which student research projects applied history in non-academic settings; six departments that offered work-study; and twelve departments spread across Canada that identified faculty members whose academic interests aligned with public history. Though the survey's response rate was only 42 per cent, it provided a baseline for future surveys, signs of encouragement and a sense of the work that remained.[19]

The CHA's newsletter doubted that specialties ranging from material culture and exhibit design to the built environment could 'be covered in a graduate course in "public history" that purports to prepare someone with a first degree for employment in any or all of the public services mentioned'.[20] This pointed to one of the most pressing challenges for the continued survival of these programs: the lack of commitment from their respective departments and faculties. Since their inception, programs were overseen by existing full-time and contingent faculty, usually on a yearly basis. Short-term solutions included more intensive workshops by 'outside experts', better working relationships across disciplines to create suitable courses and to constrict or even suspend operations altogether. But a few new programs emerged. In 2002, Ottawa's Carleton University established a two-year master's program and in 2006 Montreal's Concordia University, under the direction of a Canada Research Chair in Public History, launched the country's first honours BA in public history.

As we near Canada's fifth decade of public history programs, with declining undergraduate enrolment in history courses, administrators view public history as a method to attract new students by solving the age-old question: 'what do you do with a history degree?' Unlike the United States, where MA programs are proliferating, in Canada this trend has been manifested in the creation of undergraduate courses. Burdened with higher tuition and bleak employment prospects for most of the past decade, students seek career options. In 2007, it was reported that fifteen of the fifty-two undergraduate history programs at Canadian universities offered public history courses.[21] At York University faculty are implementing the first certificate in Public History; Carleton University began a Bachelors of Arts Degree in Public History; and the University of Western Ontario introduced

a Public History minor. The University of Victoria launched the only new graduate program in 2017. Unlike the US experience, there is a dearth of trained public historians with doctoral degrees and field experience to lead these individual classes and program modules. The new courses will promote the field in Canada. But despite its history, 'public history' remains a little-known term even, surprisingly, among practitioners.

For some, being a public historian in Canada has again become 'Plan B' due to the severe job crisis for history PhDs and the rise in doctoral students overall. The discussion has arisen within the CHA and in journals of higher education. Once again, albeit following a period of federal austerity in culture and heritage since the mid-1990s, the Public Service is being promoted as a workplace for those with doctoral degrees.[22] In Canada, however, a doctorate does not adequately prepare graduates to be public historians, nor should it necessarily do so. The idea that a successful PhD can simply *become* a public historian with no additional or specialized training or experience is deeply problematic for the field and the students. For nearly forty years, public historians in Canada have received specialized training in the methods and challenges of working within the public realm, which in effect places opportunities to practice history outside of an academic setting beyond the reach of traditionally trained historians.[23] The problem is exacerbated when faculty output is not weighed the same by tenure and promotion committees. Engaging with the public is almost always not through the medium of academic monographs and journals, thus faculty public historians often find their work devalued by their university as simply 'community service'.

There is still no professional organization for Canadian public historians. In 2007, the Public History Group was formally re-established as an affiliated group within the CHA. It seemed propitious timing. The CHA's conference theme that year touted 'Bridging Communities: Making Public Knowledge; Making Knowledge Public'. And the presidential address commented on

> the rise of public history as a profession and field of study over the past three decades, the efforts of the ... CHA ... to reach a broader public ... [and raised] questions about the role of academic historians in general and of the CHA in particular in bridging what on the surface seems to be the divergent interests of academic and public history.[24]

Many participants noted an encouraging tone in the sessions, as if 'the ground shifted'.[25] In part, the current CHA's mandate 'seeks to encourage the integration of historical knowledge and perspectives in both the scholarly and public spheres'.[26] The Public History Group's path, however, has been

rocky at best. Seemingly, the divide between university public historians – those who mostly attend the annual meeting of the CHA – and practitioners at museums, archives and within the Public Service, is too wide. Conference funding for practitioners is also lacking. As a result, for example, museologists choose to attend the Canadian Museums Association annual conference and archivists prioritize the Association of Canadian Archivists' meeting over that of the CHA. The most successful meetings of the Public History Group have occurred when the CHA has gathered in Ottawa, due to its critical mass of practitioners.

Some Canadians established an international task force within the NCPH in 2009, which after several years became the independent sister organization, the International Federation for Public History (IFPH).[27] In 2013, the NCPH and the IFPH held their first joint conference in Ottawa and the IFPH has consequently hosted several independent conferences across the globe. However, what started as a potentially representative group for Canadians is now dominated by Europeans. Again we find ourselves in-between, although the IFPH encourages the formation of national committees for public historians. ActiveHistory.ca is a partial solution. Modelled after the British History and Policy website, ActiveHistory offers a social media platform run by both academics and public history practitioners who comment on contemporary issues in politics and history, largely in a Canadian context. It encourages historians to engage with today's problems and collaborate with communities to inform and influence policy development.[28]

In recent years, the main Canadian academic funding organization, the Social Sciences and Humanities Council (SSHRC), has incorporated many core values of our field in its granting programs. 'Cluster grants', or community–university research alliance grants, placed primacy on scholars collaborating with public, private or voluntary organizations, working together equally towards large project-oriented goals that met the needs of all partners.[29] For example, sixteen community organizations and more than a dozen researchers from North America, Africa and Europe joined together in 2006 as the *Promised Land Project*, which questioned the idea of Canada as a romanticized racial oasis at the end of the underground railroad.[30] It revealed the everyday lives of people and families, showing cross-border moves to end slavery. The Past Collective's findings – that the public was greatly interested in history but learned most of it outside of the classroom and preferred to do so – mirrored earlier studies conducted by Rosenzweig and Thelen in the United States and Ashton and Hamilton in Australia.[31]

Currently, SSHRC emphasizes the 'mobilization' and 'co-creation' of knowledge that is the application of specialized academic research and making it relevant to practitioners, policy makers and the public. These goals fit well with public history's emphasis on collaboration, experiential learning and making academic research more broadly relevant.

Outside academe, public history is flourishing. Canada's National History Society publishes the popular magazine *Canada's History* and assists teachers with experiential and historical thinking projects; the Juno Beach Centre Association operates the Juno Beach Centre in France; and Historica Canada produces Heritage Minutes for television and the internet, runs the online *Canadian Encyclopedia* and offers various historical programs for students. Canada's museums have also expanded and received recent widespread public enthusiasm.[32] Yet their work is partly bounded by political goals and associated budgets. Under Prime Minister Harper's government (2006–15), the national archives staff was gutted to the point that preservation and collection work all but stopped, while funding to celebrate the bicentenary of the War of 1812 was bountiful, with a return to the flawed nation-building myth that the War of 1812 'made' Canada a country.[33] Under Harper, the Canadian Museum of Civilization was remade into the Canadian Museum of History, leading many to fear a return of the traditional military and political narrative to its Canada Hall that had accentuated social and cultural history.

The celebrations of 1812 were quickly followed by the centennial of the First World War, with particular emphasis on the Battle of Vimy Ridge, another purported nation-building event. Occurring at the same time as Canada150, or the sesquicentennial of Confederation (1867), these three anniversaries were bound in terms of funding and programing despite their different timings and purposes. Perhaps one of the most challenging issues facing Canadian public historians are the recommendations of the 2015 Truth and Reconciliation Commission report *Honouring the Truth, Reconciling for the Future*. Examining the abuses of the Indian residential school system – established by the federal government and churches in the nineteenth century – the final report is much more wide ranging and calls upon Canadians to recognize the colonial legacy of government–First Nations relations and to incorporate this history into all aspects of society.[34]

Such developments point to Canadians' shared sense that history is highly relevant to their present and future.[35] From popular debates over who should be named 'The Greatest Canadian' as well as 'The Worst Canadian', the representation of females on Canadian currency and the renaming of

those schools carrying the name of Canada's first prime minister due to his association with the residential schools program, Canadians actively exhibit robust and complex historical sensibilities. And they are making their own pasts. International scholar Na Li worked with Toronto's Kensington Market vendors and visitors to understand its built heritage through an ethnic sense of place. In 2016, the Canadian Museum of Immigration at Pier 21 in Halifax partnered with the University of Western Ontario's MA Public History program to conduct oral histories on the theme of American immigration to Canada with members of the LGBTQ community and Vietnam War–era draft dodgers and conscientious objectors. To celebrate Canada150, the *Lost Stories Project*, a group of scholars, public individuals and heritage organizations, crowdsourced 'little known stories about the Canadian past', ranging from a 1920s' court case allowing a Chinese restaurant owner to hire white women, to the founding of Montreal's Mackay School for the Deaf. Artists transformed these stories into 'site-specific works of public art', a process documented through short films.[36]

These are encouraging signs. And they led The Pasts Collective to boldly claim that the 'expansion of public history in Canada and throughout the world is one of the important developments of the last century'.[37] Within our universities, too, there appears to be serious interest in developing courses and programs to equip students with the skills and experience necessary to put history to work in the world. Whether this is a temporary measure to help stem the tide of decreasing enrolments or a genuine commitment to engage with various external communities and partners is yet to be seen. While the federal government remains a chief contributor to the development of public history through institutional funding and employment, communities and the private sector are increasingly turning to the country's public historians. As collaborators, consultants, advisers, advocates, activists, professors and teachers, public historians in Canada will continue to occupy the area between Public Service and public service.

Notes

1. J. L. Granatstein, *Who Killed Canadian History?* (Toronto: Harper Collins, 1998); Margaret Conrad, Jocelyn Létourneau and David Northrup, 'Canadians and Their Pasts: An Exploration in Historical Consciousness', *Public Historian* 31, no. 1 (special issue 2009): 15–16.

2. Ruth Sandwell, 'Introduction', in *To the Past: History Education, Public Memory, and Citizenship in Canada*, ed. Ruth Sandwell (Toronto: University of Toronto Press, 2006), pp. 3–5; Nicole Neatby and Peter Hodgins (eds), *Settling and Unsettling Memories: Essays in Canadian Public History* (Toronto: University of Toronto Press, 2012), pp. 9–10, 13.

3. 'About the Project', *Canadians and Their Pasts*. http://www.canadiansandtheirpasts.ca/about.html

4. Donald Wright, *The Professionalization of History in English Canada* (Toronto: University of Toronto Press, 2005), pp. 8–27; Gerald Killan, *Preserving Ontario's Heritage: A History of the Ontario Historical Society* (Ottawa: Ontario Historical Society, 1976), pp. 4–5, 127, 134, 162; C. J. Taylor, *Negotiating the Past: The Making of Canada's National Historic Parks* (Montreal-Kingston: McGill-Queen's University Press, 1990), pp. 3–60; Cecilia Morgan, *Commemorating Canada: History, Heritage, and Memory, 1850s-1990s* (Toronto: University of Toronto Press, 2016), pp. 44–73.

5. John R. English, 'The Tradition of Public History in Canada', *Public Historian* 5, no. 1 (1983): 50–1; Wright, *Professionalization*, pp. 28–51, 65–6; Carl Berger, *The Writing of Canadian History: Aspects of English-Canadian Historical Writing: 1900-1970* (Toronto: Oxford University Press, 1976), pp. 1–31.

6. Donald Wright, *The Canadian Historical Association: A History* (Ottawa: Canadian Historical Association , 2003), p. 5.

7. Wright, *Professionalization*, pp. 66–69; Berger, *The Writing of Canadian History*, pp. 47–52.

8. English, 'The Tradition of Public History', 52–4.

9. Wright, *Canadian Historical Association*, pp. 12–13, 19; Wright, *Professionalization*, pp. 82–95, 168–9, 240 (fn.98).

10. Wright, *Canadian Historical Association*, pp. 20–2.

11. Ibid., pp. 14–15.

12. Taylor, *Negotiating the Past*, pp. ix, 138–49, 169–90; Jonathan Vance, *A History of Canadian Culture* (Toronto: Oxford University Press, 2009), pp. 308–34, 358–64, 377–97; Lyle Dick, 'Public History in Canada: An Introduction', *Public Historian* 31, no. 1 (special issue 2009): 8.

13. Berger, *The Writing of Canadian History*, pp. 261–4.

14. Neatby and Hodgins, *Settling and Unsettling Memories*, p. 7; Graham Carr, 'Rules of Engagement: Public History and the Drama of Legitimation', *Canadian Historical Review* 86, no. 2 (2005): 317–54.

15. A. B. McKillop, *Pierre Berton: A Biography* (Toronto: McClelland & Stewart, 2008).

16. Michael Bliss, 'Review of Report of the Royal Commission on Corporate Concentration and of Research Studies', *Canadian Historical Review* 60, no. 4 (1979): 529, 553; English, 'The Tradition of Public History', 48–50.

17. English, 'The Tradition of Public History', 58.
18. Treena Hein, 'History for the People: The Field of "Public History" Gains Ground in Canada', *University Affairs*, 9 October 2007.
19. The Public History Special Interest Group of the Canadian Historical Association, Survey, 'The Teaching of Public History in Canadian Universities', 29 May 1989.
20. F. J. Thorpe, 'Public History: What Every Public Historian Must Know', *Canadian Historical Association Newsletter* (Winter 1989): 3.
21. Hein, 'History for the People'.
22. Dick, 'Public History', 8–9.
23. Ian Milligan, 'The Situation for Recent History Graduates: The Job Market, Rethinking the Idea of "Plan B", and Some Ideas for the Future', *Canadian Historical Association Bulletin* 38, no. 1 (2012): 36–7; Thomas Cauvin, *Public History: A Textbook of Practice* (New York: Routledge, 2016), p. 11.
24. Margaret Conrad, 'Public History and Its Discontents or History in the Age of Wikipedia', *Journal of the Canadian Historical Association* 18, no. 1 (2007): 1.
25. Hein, 'History for the People'.
26. 'What Is the CHA?', *Canadian Historical Association*. www.cha-shc.ca/english/about-the-cha/what-is-the-ha.html#sthash.baNM8Cy2.dpbs.
27. *International Federation for Public History*. http://ifph.hypotheses.org/.
28. Jim Clifford, 'What Is Active History?', *Left History* 15, no. 1 (2010): 12–36.
29. 'Community-University Research Alliances', *SSHRC*. www.sshrc-crsh.gc.ca/funding-financement/programs-programmes/cura-aruc-eng.aspx.
30. Boulou Ebanda de B'Béri, 'The Politics of Knowledge: The Promised Land Project and Black Canadian History as a Model of Historical "Manufacturation"', in *The Promised Land: History and Historiography of the Black Experience in Chatham-Kent's Settlements and Beyond*, ed. de B'Béri, Nina Reid-Maroney and Handel Kashope Wright (Toronto: University of Toronto Press, 2014), pp. 17–29.
31. The Pasts Collective, *Canadians and Their Pasts* (Toronto: University of Toronto Press, 2013), pp. 6–9; Paul Ashton and Paula Hamilton, *History at the Crossroads: Australians and the Past* (Sydney: Halstead Press, 2010).
32. Andrée Gendreau, 'Museums and Media: A View from Canada', *Public Historian* 31, no. 1 (special issue 2009): 35–45.
33. Mark Bourrie, *Kill the Messengers: Stephen Harper's Assault on Your Right to Know* (Toronto: Harper Collins, 2015), pp. 149–56, 194–9.
34. Truth and Reconciliation Commission of Canada, *Honouring the Truth, Reconciling for the Future*, 2015. www.trc.ca/websites/trcinstitution/index.php?p=890.
35. Morgan, *Commemorating Canada*, pp. 7, 180–4.

36. Na Li, *Kensington Market: Collective Memory, Public History, and Toronto's Urban Landscape* (Toronto: University of Toronto Press, 2015); *CMIP21*. www.pier21.ca/research/oral-history/immigration-from-the-united-states-of-america-during-the-vietnam-war; *The Lost Stories Project*. http://loststories.ca/.

37. The Pasts Collective, *Canadians and Their Pasts*, p. 12.

4

Public History in China: Past Making in the Present

Na Li

The past is enormously popular in China, as elsewhere. Instead of a spontaneous engagement with mindless masses, being popular means an appeal to a socially stratified public with critical thinking capability. The idea of the 'public' has also transformed in space and time. Among the changing dynamics of 'public' emerge groups of educated, thoughtful and socially responsible citizens. They actively participate in interpreting and presenting the past and their writings impinge on public historical consciousness at a different scale. The past is also fast attaining the attributes of a commodity. The recent heritage mania manifests a sweeping enthusiasm. The ancient and the old are packaged and sold for the present, the sacred exploited for the profane. Heritage tourism, irrespective of historians' preference, is booming. In this cultural engineering, the past acquires an entertaining dimension that seems offensive to many professional historians.

If there is a single agency that transforms the historical landscape, it would be the revolution in electronic technology. The expansion of the internet has fundamentally shortened the distances and altered the ways in which people communicate with each other. It makes it possible to construct a myriad of virtual communities. The technology also makes previously inaccessible historical materials accessible. A relative openness in the digital age has yielded information that allows both ordinary people to get in touch with history, and scholars to refine their ideas about history. The language and style of mass communication revolutionizes ways and means of acquiring knowledge. Knowledge, both official and unofficial, has accumulated and

flourished outside the quarantined academy. The public makes a fetish of unofficial sources, which does not mean, compared with archive-based research, that their efforts are less taxing and the research less rigorous. We see people trawl their own resources, especially in family and local archives; they write history with local subjects and familial tones; they travel freely down memory lane; they creatively use all sorts of media to back hunches and take risks.

Here history interacts with heritage, ministering to the growing appetite for roots; it appears in a form of visual displays, and the visuals often become public history; histories well up from the lower depth, the nether world, where memory and myth intermingle, where the imaginary rubs shoulder with the real. This kind of history provides more points of access to ordinary people and a more inclusive form of belonging. It challenges, or seems to challenge, a taken-for-granted hierarchical constitution of knowledge, and a very restricted one. It juxtaposes past and present iconoclastically. Here we see a thousand different hands, as Raphael Samuel famously put it, splicing together different sets of evidence, following different lines of inquiry, driven by various movements and motives and by new technologies.[1]

But technology simply facilitates access. A broader social and cultural context gets us closer to the hard reality. Public history in China does not rise like the sun at an appointed time. It is present at its own making. It sprang up over the past two decades, cheek by jowl, with a deteriorating, if not total collapsed of national identity. The connection, by no means accidental, owes its origin to a quintessentially Chinese, somewhat brazen, cultural tradition. 'The function of a national identity,' writes Michael Ng-Quinn, 'is to sustain the state by unifying the population, at least psychologically.'[2] More succinctly, national identity is the relationship between nation and state that obtains when the people of that nation identify with the state.[3] It embodies an ongoing process, a fluid and enduring relationship and a sense of its uniqueness. Small wonder we cannot understand public history in China, or in any culture, if we interpret or judge it against a universal standard. The bits and pieces of it scattered over the landscape only makes sense in this framework.

The landscape of public history

The notion, expressed by Samuel, that history is not, as traditionally viewed, just a discipline or profession, but 'a social form of knowledge' is an incredibly liberal one in this context.[4] Whether this line of inquiry leads to

new constructions of knowledge depends on how knowledge is defined. It does, however, open up a whole new territory of historical inquiry.

Following the historical signposts scattered across the Chinese terrain, the past is expressed in various verisimilitudinous ways including old photographs, intimate family ephemera, architecture, carefully designated natural and historical walks, historical games and purposefully emotive oral testimony. These have caught the public imagination in an invigorating way, helping to give these activities a human face and whet the public's appetite for the past.

Oral history, for example, has clear liberal intentions, is couched in various formats and has attracted practitioners and audiences from diverse backgrounds. Oral history has long played an important part in collecting and transmitting historical knowledge in China, but its sudden surge of popularity merits serious consideration. In some cases, projects are funded with government money. Preserving national heritage through oral history has recently gained momentum. A series of symbols, rituals and myths, under the aegis of 'national essence', reinforce national identity. Their connotative capacity indicates a unifying power.

An oral history collection on intangible heritage run by the Tian Jing Intangible Heritage Conservation Centre is one example. The project claims to preserve disappearing tradition and culture, including traditional arts and folk cultural forms unique to China. The centre has interviewed ninety-two interviewees and has gathered approximately 400 hours of oral history. The centre continued its effort in 2017, with more scholarly intervention, including an interpretive performance of the vanishing folk songs and audio publications. It strives to situate all of this in the officially recognized historical and cultural context and make it accessible to the general public to add to the vitality and influence of traditional Chinese culture.

In other cases, oral histories have a local or familial nature and also contribute to the official narrative. These projects are mostly privately funded, volunteer-based and largely populist and attracts the tech-savvy and visually literate younger generations. Home-Spring-Autumn is the title of the 'College Student Oral History Video Documentary Projects' which is funded by multiple non-profit organizations.[5] Full of literal and metaphorical meanings, the name has a richly embodied appeal. Home (*jia*) in the Chinese language connotes an emotional attachment to family, hometown and the nation (*guo*). Spring and autumn (*ChunQiu*) take two seasons and mean a flow of time, memory and history. The projects primarily targets college and university students.

Another window into Chinese public history involves investigations into sensitive, difficult or ignored chapters in the past. These cases reveal professional energy and rigor, nuanced judgment and intellectual complexity. They engage with different primary sources – in some cases creating primary sources – and a distinct line of inquiry with a particular assiduity. In some cases, they complement the official narrative; in others, they circumvent, challenge or even subvert official interpretations. Unlike the case in an open democracy, these works remain 'unofficial'. Confucius says: if traditional belief is lost, seek help among the folks (*shili er qiu zhuye*). Phrased another way, when some historical truths are missing or glossed over in the official records, they are revealed in the unofficial ones. The recent waves of study on the Cultural Revolution exude such rigor.

Another way of analysing the unofficial landscape would involve considering the burgeoning number of non-profit organizations engaging in activities about the past in the present. Their origins remain promiscuous, their nature and size vary but private funds usually play an inseparable part. History enthusiasts, socially responsible and historically minded citizens engage with these organizations in a myriad of ways. What surprises is the enormous energy, creativity and breath-taking freshness that emanate from these organizations. One example is the New History Cooperation (NHC).

As a collaborative forum dedicated to recording and communicating history, NHC is a privately funded cooperative specializing in professional historical products and services. Its slogan – 'We care about history; We are dedicated to communication; We stick to historical truths; We seek for answers; We reflect upon the past; We look into the future' – has a strong public history bent and delivers a clear message: history has social and cultural utility. NHC produces a range of products under the name OurHistory – historical books, documentaries, television and radio programs and digital magazines, to name but a few. The presentations, in all their freshness, interweave intellect with passion, animating the inanimate. The message – history is marketable – is bold.

History and memory merge in public history projects, most of which address how national symbol systems work for national identity building. At the national level, two projects, coincidentally with the same name, China Memory, stand out. The first is a Documentary of National Cultural Heritage, a four-hour program by CCTV marking the first China Cultural Heritage Day on 10 June 2006, run by the State Council. It includes eight examples from the World Heritage List, both tangible and intangible: Kunqu (昆曲), Guqin (古琴), Tan School Opera (谭派京剧), Muqam (木卡姆),

Yin Ruins (殷墟), Jinsha Ruins Relics (金沙), porcelain (陶瓷), Kaiping Blockhouse (开平碉楼), all epitomizing national memory and identity. Another, by the National Library of China, is based on the key events and personality of contemporary China and draws on its extensive collections, with the addition of oral history and video/image materials. It is part of a comprehensive database-building project, extending the traditional boundaries of the library to sharing individual and collective memory while pioneering new territories of citizen education. Both projects, generously funded by the government, explicitly serve the national interest.

At the urban level, memory projects have their origins in recording disappearing historic architecture, districts and cities in the process of modernization. The quickening pace of urbanization in the twenty-first century destroyed many designated historical and cultural cities, causing disruption to urban memories. The projects delve into how historic architecture, districts, and landscapes are intimately linked with urban history. Municipal archives are the key drivers and practitioners in preserving the urban memories. Qingdao Archives pioneered this work in 2002. It started systematically documenting the city's landscape and creating a large-scale urban archive. Other cities, including Wuhan, Guangzhou, Shanghai, Dalian, Jinan, Chongqing and Dandong, followed. The waves of urban memory projects record the changing urban landscapes, interpret urban history through memory, build permanent archives and present this work to the public in various modes including exhibitions, seminars and other public events. At a more grassroots level, we see memory and history umbilically linked, through family and local communities.

Living in an increasingly visual culture, people become visually literate from a very young age. Information comes to us in a form of visual display. Visual representations can pose entirely different questions, inviting different paths of historical inquiry. 'The Photographical Memory of China, 1951–2011' by the *China Youth Daily* demonstrates how photographs can evoke a yearning for a return to the past, for the worlds we have lost. Historical photographs have exciting historiographical potential and they can also portray the traumatic, the marginalized and the people and groups that have been excluded from official narratives. In some cases, the tone is extolling, yet even set-up photography still captures the real emotion of both the photographers and the photographed. In other cases, the grammar of the photograph reveals inglorious episodes of the glorious history, such as the bleak situation of laid-off workers after the opening-up policy in the 1980s; the Three Gorges Dam Project, which displaced an alarming number

of residents; and the devastating impact on communities of recent high-speed train projects.

In *Chinese and the Pasts*, a recent study on historical consciousness of ordinary Chinese, the most frequently identified historical activity (over 80 per cent) was taking photographs and videos – with looking at family photographs as a subcategory – and watching movies, including documentaries and TV programs (just over 87 per cent).[6] Collecting family photographs organically has restored and reaffirmed family roots. Photographs, travelling between reality and imagination, embody what Roland Barthes calls 'the power to astonish, amaze, and disconcert'.[7]

The idea of heritage has been progressively broadened in China. It is an aesthetic, educational, pedagogical, ideological, political and cultural hybrid, travelling between the tangible and intangible, the real and the imaginative, the material and the symbolic. Heritage helps to create space for public history in museums, historical districts and landscapes and tourism. As a renewed source of soft power,[8] national heritage is intimately linked with the 'China dream', which manifests in three strategic venues: political values, culture and foreign policies.

A glance over contemporary urban landscapes opens another window to the past. Make-believe architecture, largely untroubled by the cult of authenticity, supply the visitors with a historical experience. Newly historicized built environments reflect a constantly updated version of the past. Living history plays an increasingly important role. Historical re-enactment, even culinary culture, for example, to revisit years of Great Famine, has drawn a huge crowed. Many restaurants offer reminiscence meals. Here, history is controlled and constructed, yet the feelings are palpably genuine. The motes and beams, bricks and mortars, mostly fabricated, represent a serious intention of resuscitating a vanished and vanishing culture.

History is marketed and sold and heritage commercialized. Just recently, the Chinese government launched the new Belt and Road project.[9] The Silk Road has long been a part of China's proud ancient heritage. Harnessing ancient achievement does the present a great service: re-engaging the glorious past as a way to instil patriotism and provide a suitable historical backdrop for the 'China dream' of the great rejuvenation of the Chinese nation. The reasons for this sudden surge for the ancient and the old, the historical and the cultural, remain uncertain. In one place, it represents nostalgia for the irrevocable; in another, with the collapse of a national identity, the public yearns for new paths for individual and collective belonging.

Heritage fever forms a stark contrast to the intentional destruction objects, buildings and places since the nation was founded in 1949. In the 1960s and 1970s, the 'Four Olds' – customs, culture, habits and ideas – constituted a total rejection of the past. Across the country state-sponsored vandals destroyed city wall, architecture, historic sites, temples and paintings, among other things. Marching into modernity, the 1980s and 1990s saw the massive destruction of great swathes of the cultural, historic and natural environments. Even officially recognized historical and natural assets faced imminent threat. Some were just abandoned. Current political leaders gloss over this chaos and destruction and urban heritage is often grossly commodified. The inconsistent attitudes towards and selective use of the past have long been part of a cultural and political strategy. What surprises us today is its intensity and scale.

Past in the present

The past remains very much in China's present. Out of a bewildering array of activities has emerged a passion for recovering a national past and an urge for reinterpreting and archiving national history. Public history is used for social cohesion and identity building. The quest for national identity is fuelled and sustained by populist nationalism. Robert Wiebe reminded us that

> Nationalism is the desire among people who believe they share a common ancestry and a common destiny to live under their own government on land sacred to their history. Nationalism expresses an aspiration with a political objective. Behind that aspiration lies a sense of kinship that is simultaneously fictional and real – that is, culturally created, as all kin systems are, yet based in some measure on an overlapping of customs, histories, and genealogies.[10]

State sponsored public history projects, such as commemoration, re-enactment and living history, enjoy a widespread appeal. The dates, or dating, of major commemorations demonstrate how history is reinterpreted, and traditions invented, for contemporary purposes. Rituals and symbols of all description help to hold a unified culture together. Ordinary people play a critical role. The national symbol system – the national essence (*guocui*) – includes an ensemble of symbols collected to connote a spiritual collectivity. Deep in this inventive process, origin

stories matter. When ancient materials are used for novel purpose, they expand the national culture. A yearning for roots, for a return to worlds we have lost, runs deep in Chinese culture. 'Things,' Confucius wrote, 'have their root and their branches. Affairs have their end and their beginning.'[11] Kin-based connectedness, real or fictional, feeds on the sentiment of ancestry, origin and sacred soil. For example, the journal *Root* – read mostly by people outside the academy – is premised on the idea that all Chinese share the same culture and blood, the same responsibility of enhancing a national culture. And there is a collective obligation to pass this on to future generations.[12]

A linear conception of time has long dominated Chinese culture, as historical process as a progression, and public history breaks this sense of time, with an emancipatory power, initiate a new mode of historical change. Traditionally, history is essentially cyclical, dominated by the rise and fall of dynasties, by the repetition of public rituals, and a strong sense of harmony between people and cosmic order. Yet modern public histories face up a set of problems. First, public history wells from below. The conundrum with such a grassroots impulse is a celebratory mode, backed by a sense of entitlement, especially by those who are historically or culturally swept to the margin. Such histories, fuelled by passion, can easily evoke sympathy, not esteem.

Under the aegis of authority sharing, some chapters of history can be retrospectively dignified. Second, as there is no ready-made source material, nor research questions in public history inquiry, it is up to those who are engaged to recognize, to collect, and to analyse. When E. P. Thompson wrote his master narrative of the early English working class, he also posed moral questions about the past, questions derived from radical politics, humanist values and socialist theories. 'History is more than a reading of past experience, more than a telling of heroic stories. The historians needed to interrogate past experience, to engage it with informed questioned honed by theoretical inquiry.'[13] Most public history projects in China fail to pose bigger questions, or locating the narratives in historical contexts. Third, even there is a conscious effort to collect these primary sources, they have not yet stimulated enough methodological thinking and systematic analysis.

With these challenges in mind, the burgeoning field of public history in China has started to disturb the quiet, insulate and slow-moving professional world. A number of public history research centres have been established across China. Come concentrate on public history research, practices and training. For example, the Centre for Public History at Zhejiang University,

founded by a few visionary public historians, strives to provide the public with reliable historical products. Aiming to break down disciplinary and other boundaries, it engages with a range of activities and projects, such as lab for historical data and new media, oral history, historical video recording, corporate and local history, high quality training programs and historical NGO project planning. It recently started *Public History: A National Journal of Public History*, the first Chinese scholarly journal of public history.

Oral history centers have also been established including the Oral History Research Centre at Fudan University, the Centre for Oral History and Museum at Communication University of China and the Centre for Oral History at Wenzhou University. Public history projects have also led to the creation of centres. The Centre for Research on Comfort Women at Shanghai Normal University is an outstanding example. It came into being through the comfort women projects led by an eminent local historian. His unflagging devotion to collecting stories and memories from the surviving comfort women brings the centre much national and international attention.

An official public history program is yet to be established in China. But a few public history courses have emerged, including courses on History and Games in two prestigious universities, Peking University and Beijing Normal University. The courses are a response to increasing demand from students, though the idea of playing with the past remains offensive to most traditional academics. Another course on History and Memory, taught by historians at Nanjing University, also breaks the ground. More ambitious were the two National Public History Faculty Training Programs which I organized at Shanghai Normal University and Chongqing University in 2014 and 2015. The programs were designed to accommodate a growing demand for teaching public history in Chinese universities and to train the first generation of Chinese public history educators.[14]

A small group of scholars have ventured beyond their own research interests, applying their skills and knowledge to a larger public purpose. As David Kyvig has written, 'all are concerned … with the audience for history, serving it, enlarging it, satisfying its future as well as present needs'.[15] These socially responsible, capable and visionary scholars offer probably the best hope for developing pubic history in China.

Why does modern public history have such a massive appeal in China, welcomed as it is at grassroots, state and national level? For me, it meets a felt – though vaguely understood – need, and fills an emotional – though not necessarily a historical – void among various groups of people. And it speaks directly to the concerns of the public. That the government represents

the interest of the public remains a national myth. The history of ordinary people, both at an individual and collective scale, is rarely represented in official accounts. Nor, by and large, is it recognized in academic history. This glaring absence helps to explain public history's enormous popularity in China which will continue to grow.

Notes

1. Raphael Samuel, *Theatres of Memory* (London and New York: Verso, 1995), p. 8.
2. Michael Ng-Quinn, 'National Identity in Premodern China: Formation and Role Enactment', in *China's Quest for National Identity*, ed. Lowell Dittmer and Samuel S. Kim (Ithaca, NY: Cornell University Press, 1993), p. 32.
3. Ibid., p. 17.
4. Samuel, *Theatres of Memory*, p. 23.
5. Including Beijing Yongyuan Foundation, Zhejiang Dunhe Foundation, My History NGO, China Salvation Foundation and CuiYongyuan Oral History Center at Communication University of China.
6. Na Li, 'Chinese and the Pasts: Exploring Historical Consciousness of Ordinary Chinese: Initial Findings from Chongqing', in *Contemplating Historical Consciousness: Notes from the Field (Making Sense of History)*, ed. Anna Clark and Carla Peck (New York and London: Berghan Books, forthcoming).
7. Roland Barthes, *Camera Lucida: Reflections on Photography* (London: Fontana Paperbooks, 1984).
8. Joseph S. Nye, *Soft Power: The Means to Success in World Politics* (New York: Public Affairs, 2004).
9. The Belt and Road project ($124bn/£96bn), which aims to expand trade links between Asia, Africa, Europe and beyond, was first unveiled in 2013. Part of the massive funding boost, which is aimed at strengthening China's links with its trading partners, includes 60bn yuan ($9bn/£7bn) in aid to developing countries and international institutions that form part of the Belt and Road project.
10. Robert H. Wiebe, *Who We Are: A History of Popular Nationalism* (Princeton: Princeton University Press, 2002), p. 5.
11. Confucius, *The Great Learning*, written c. 500 BCE, p. 1.
12. The journal features things such as cultural heritage, vernacular photographs, tracing the routes of immigration, family history, genealogy, family/place names, place attachment and folklore.

13. E. P. Thompson, 'The Politics of Theory', in *People's History and Socialist Theory*, ed. Raphael Samuel (London: Routledge and Kegan Paul, 1981), p. 406.

14. Na Li and Martha A. Sandweiss, 'Teaching Public History: A Cross-Cultural Experiment: The First Public History Faculty Training Program in China', *Public Historian* 38, no. 3 (2016): 78–100; Na Li, 'Nearby History: The Second Public History Faculty Training Program in China' (in Chinese), *Public History* 1, no. 1 (2017).

15. David E. Kyvig, 'Public or Perish: Thoughts on Historians' Responsibilities', *Public Historian* 13, no. 4 (1991): 23.

5

Public History in Germany: Opening New Spaces

Thorsten Logge and Nico Nolden

Public history, while still a new term and field in Germany, has nonetheless managed to establish itself on a small but relevant scale. Starting with a master's program at the Freie Universität Berlin (FU) in 2008, it has in less than a decade become an emerging field in the tertiary sector. Public history in Germany can now, at the very least, be considered a promising subdomain of both academic history and history didactics. Although the future of the field as an independent section of academic history remains uncertain, public history has ample potential to integrate academic and lay historiography, historical science and history didactics, academia and the numerous fields of activity for historians outside academia, ranging from museums and the management of historical sites to history marketing.

German public history stands out for its heterogeneity and touches several unsettled questions of history and historiography in the twenty-first century concerning employability and knowledge transfer or the responsibility to engage in public discourse. As some of the most relevant job markets for historians in Germany are accessible via dedicated educational programs, there is less demand for academic public history to directly provide those job markets with graduates. Thus it can focus on developing research approaches and theories for public history as an academic field of study.

This chapter aims to chart the current situation of public history in Germany at the end of 2017, including a short overview on professorships

and public history programs that have emerged in the last few years.[1] This cannot be comprehensive, especially considering the countless projects and initiatives that are not affiliated with any university department or institution. More importantly, this account will need to be re-evaluated in a few years' time, as a considerable number of the newly established professorships are not tenured and we do not have evaluation results or alumni studies yet. It can, however, be safely said that public history in Germany is a vibrant and dynamic field that is opening new spaces for experiments in research and teaching and moving history into different media. The field's profile is still (and hopefully will remain) undecided. In this regard, our chapter emphasizes potentials and opportunities to expand and fortify public history as an interdisciplinary field of cultural science in research and study. The ambiguity and heterogeneity of public history in Germany can either be lamented or be seen as an opportunity for academic historiography. As players and stakeholders in the field, we have opted for a more optimistic perspective.

Public history in Germany: A success story...

Public history's development in Germany can be seen as a success story with great prospects. In under ten years, the field has established at least four study programs, staffed about six professorships, founded an open working group in the German Historical Association and a scientific network, launched a book series, published a German-language introduction to public history, released the multi-lingual scientific online periodical, *Public History Weekly* (*PHW*), and successfully integrated Web 2.0 as a new tool for the proliferation of histories and discourse about history on the internet. All in all, there are numerous distinct signs that entitle us to proclaim the genesis and institutionalization of public history as a new academic sub-discipline in Germany.

The first master's program in public history started in 2008 at the FU. This pioneer program is jointly coordinated by FU and the Center for Contemporary Studies in Potsdam.[2] A second program was launched at the Universität zu Köln in 2015 after Christina Gunderman, former coordinator of the Berlin program, had been appointed assistant professor (*Juniorprofessor*) for public history in Cologne in 2014.[3] The newest public

history program was developed at the Ruhr-Universität Bochum and is being coordinated by Christian Bunnenberg, assistant professor for the didactics of history.[4] The BA/MA program 'Fachjournalistik Geschichte' at the Justus-Liebig-Universität Giessen, with a clear focus on history and journalism, can be seen as yet another public history program with a more distinct focus on prospective employment.[5] Besides these full-time study programs, several MA programs in history offer public history projects and seminars as part of their regular curriculum, such as Public History Heidelberg; or in regular supplementary practice modules, including Public History Hamburg.

Other history departments have teaching assignments for public history projects such as 'Aus den Akten auf die Bühne' ('Staging Files', Universität Bremen) or sporadically offer projects and seminars as part of the usual range of courses on offer. Today, public history can be studied in full MA programs at the Universities of Berlin, Bochum and Cologne, and, with a focus on journalism, in Giessen. Public history seminars often aim at job orientation or provide practical experiences within the framework of career-field orientation in more or less coordinated programs. Academic history is generally rethinking pathways of knowledge transfer and outreach to the public: public history offers handy tools and new ideas to span the gap between academia and the broad history market in Germany. This includes online exhibitions, such as one about the colonial backgrounds of the Hamburg Völkerkundemuseum,[6] the development of new permanent exhibitions, like the Heidelberg Public History project 'Ordensburg Vogelsang',[7] exhibition and museum chat guides,[8] audio walks such as the Berlin project 'kudamm31',[9] theatre projects like 'Aus den Akten auf die Bühne' and its successors, Twitter projects carried out by project groups like 'Digital Past', @9Nov38 or 'Als der Krieg nach Hause kam' ('When War Came Home') or biographical research as part of the art project and decentralized NS memorial 'Stolpersteine' (stumbling stones) that has already produced numerous biographies of NS victims in Hamburg,[10] Berlin,[11] Cologne[12] and elsewhere.

While the first public history program in Berlin still lacks an assigned public history professorship, six teaching chairs have been established in Germany since 2012 with public history as part of their official remit, or at least responsibility for public history programs. Cord Arendes was appointed the first German public history professor at the Ruprecht-Karls-Universität in Heidelberg in 2012. Christina Gundermann was appointed assistant professor for public history at the Universität zu Köln in 2014, followed by Michele Barricelli as Professor for didactics of history and public history

at the Ludwigs-Maximilians-Universität München. Astrid Schwabe became assistant professor for public history and historical learning in general studies (*Sachunterricht*) at the Europa Universität Flensburg during 2016. In 2017, Christian Bunnenberg took up the position of assistant professor for didactics of history at the Ruhr-Universität Bochum. In the same year, Thorsten Logge became professor of public history (*Juniorprofessur*) at the University of Hamburg. These professorships show a vast expansion of public history in German academia in only five years.

There are other professorships without an explicit remit for public history, especially in the didactics of history, that deal with public history topics, such as cultures of memory, historical consciousness, history cultures and historical learning in and outside of schools. In Germany, academic history and history didactics have a long tradition of separation and even run separate professional associations. Nonetheless, steps towards building joint networks have already been taken. In 2017, Christine Gundermann obtained a grant from the German Research Foundation (Deutsche Forschungsgemeinschaft) to organize the first scientific network in in the field of public history in Germany.[13] The group aims to discuss and develop the 'Theory and Methodology [of Public History as] a New Sub-Discipline of History' with a view to publishing a handbook with a focus on theories and methods of the field for students and public historians.

This scientific network is a necessary academic addition to the working group 'Angewandte Geschichte/Public History' ('Applied History/Public History') at the German Historical Association. The working group was founded in 2012 and aims to bring together public historians from inside and outside academia, has been organizing semi-annual workshops since 2012 and held sections at the Biennial Meetings of German Historians in 2014 and 2016.[14] Additional workshops mainly for students are being organized by a next-generation sub-division of the working group, the 'Students and Young Professionals', founded in 2015.[15] An association that will unite protagonists of public history of all sides, inside and outside academia, and across disciplines, still needs to be founded – and is urgently needed to spearhead public history as a whole.

In 2013, *PHW* started as an international scientific blog journal for public history, history didactics and political didactics.[16] The journal is published in Open Access and fosters discourse and interactivity by permanently enabling user comments on the page and engaging authors to answer on the

comments made. With Marko Demantowsky as managing director, *PHW* is an important interface that serves to bring together public historians worldwide. In the field of publications, Irmgard Zündorf (Potsdam) and Stefanie Samida (Heidelberg) recently launched the book series 'Public History: History in Practice'.[17] This series aims to present and discuss fields of practice that deal with history outside academia and schools. The volumes are written by academics and practitioners with insights into the fields discussed. The first volumes of the series discuss history in film and television and history in the political sphere. A brand-new German-language introduction to public history by Irmgard Zündorf and Martin Lücke, professor for the didactics of history at FU Berlin, will be published in early 2018. As early as 2013, Juliane Tomann and Jacqueline Nießer's anthology 'Angewandte Geschichte' (Applied History) presented approaches to, inter alia, public history as civic engagement.[18]

The 2016 anthology *Doing History* by Sara Willner, Georg Koch and Stefanie Samida accentuates a more scientific view on the performativity of history cultures. This approach potentially disengages public history from contemporary history and is strongly committed to a cross-era approach.[19] Other German publications from recent years discuss aspects of employability,[20] history marketing,[21] ethical aspects and the writing of company history as a key market for history agencies[22] or aspects of citizen science and open science in relation to the changing role of historical science in that setting.[23] In a nutshell, public history in German-speaking countries of Europe has greatly extended its publication activities in the last few years – and there is no end in sight. The University of Vienna is working on a *Handbook for Public History* which will be published in 2018.[24] Several other book projects and dissertations are in the making or already in preparation for publication in the near future. However, theory production and methodological considerations are still desiderata. It remains an open task and duty for the newly appointed professors as well as the Gundermann network to contribute to this field soon.

In terms of knowledge transfer and the exploitation of new means of communication for historians to have outreach, theatre seems to be an important partner for public history in Germany. The Bremen project 'Staging Files' combines university-based project and research learning with theatrical performances and public stagings of primary sources, conducted by the 'bremer Shakespeare company'.[25] In 2017, Staging Files celebrated its tenth anniversary with the interdisciplinary conference

'History in the Spotlight: The Staging of Historical Sources in Theatre' in Bremen.[26] Offshoots of the project have already followed and adapted the Bremen approach, for example, in Heidelberg and Hamburg. And there are several other theatrical projects using files and primary sources of all kind to present historical topics to a broader public in staged readings or historical performances. The connection between theatre studies and public history is promising. As Stefanie Samida and others have already stressed, performativity may be a key term to develop methodical and theoretical approaches: take, for example, the idea of transferring Freddie Rokem's concept of actors as 'hyper-historians' to all historiographers – apart from the media their historiographies are represented in.[27]

In the last few years, public historians in Germany successfully explored social media as an outstanding opportunity to disseminate historical topics and content to broader – and younger – audiences. In 2013, the Twitter project *@9Nov38* tweeted a chronicle of local, regional and national events that together would eventually become known as the 'Reichspogromnacht' of 1938.[28] In the aftermath of this project, the authors organized as *@digitalpast* and in 2015 started their second, highly acclaimed project, '70 Years Ago Today'.[29] This project covered the last months and the downfall of Nazi Germany in 1945. Both projects reached more than 11,000 followers during their project periods and attracted a great deal of attention in the national and international press. Providing primary sources and additional information on a corresponding website, the project gave interested readers direct access to primary sources and to the underlying historiography, thus providing materials to dig deeper into the topics covered. Funded by the German Federal Agency for Political Education, the project 'GeschichtsCheck' used Twitter and Facebook from 2016 to early 2017 to identify and analyse historically based hate speech on the internet and to provide information and argumentative help for counter speech on social media as well as in workshops. The project was carried out by 'OpenHistory e.V.', a registered association that aims to foster the promotion of historical sciences, the public promulgation of their outcomes and the networking of academics and historically interested people.

OpenHistory organizes the 'histocamp', an annual history barcamp – or international network focused on technology and the web – with low barriers to participation that started in 2015.[30] The 'first regular German-speaking live public history talk show' was launched in 2017: 'Geschichtstalk im Super 7000' ('History Talkshow at the Super 7000') is an online talk show, moderated by Georgios Chatzoudis. It brings

together historians as experts on various epochs to discuss current topics from public history with the public. Streamed live from the project website and on YouTube, the format includes discussions on Twitter, Facebook and the project blog, thus using Web 2.0 as a natural resource and tool for discourse about history. Topics in 2017 were 'Election Campaigns as Historical Battles? Politics Seen Historically', 'New Narratives: Streamed Fiction Series' and 'A Matter of Faith? Certainty Seen Historically'. More shows have been scheduled for 2018.[31]

Overall, public history in Germany is on the brink of becoming an institutionalized part of the historical sciences. With a strong connection to university teaching and employability, academic public history now faces the task of developing and implementing its own research program in order to prove itself as a research-based sub-discipline that can also provide theoretical and methodological output. There is good reason to think that this goal could be achieved in coming years. As a common field of research and practice, public history is now poised to overcome old and well-groomed tensions and academic turf warfare between historical sciences and history didactics. The International Federation for Public History may soon bring together a broader variety of stakeholders in the field by founding a national branch in Germany. Representing historians in all related working fields, public history could then unite professional historians from academia, museums, archives and the media as well as laypeople from history workshops or private researchers.

... Or a flash in the pan?

Public history in Germany can also be told as a story of short-term success, based on the energetic idealism of a few protagonists in precarious positions up to the freshly created professorships. From this perspective, there is a high risk of the field vanishing in a few years, with a great number of temporary professorships not being continued. Indeed, the professorships at Cologne, Bochum and Hamburg are non-tenured, six-year appointments. Astrid Schwabe in Flensburg has a tenure track professorship, but is to a great extent rooted in didactics with the corresponding obligations in teaching and research. Michele Baricelli's chair in Munich is (partly) flagged as a public history professorship but does not really focus on the field. Giessen runs a special interest program with no crucial interdependence to the other public history locations. This program existed long before anyone suggested

that public history might be of any importance to German academia, and can well be continued independently.

The public history programs in Berlin and Cologne are currently successful and attract good numbers of students. Bochum may also appeal to the zeitgeist with its new program. On the other hand, all programs will need to prove their usefulness in a few years. Do graduates really qualify for the targeted job markets? Will employers approve of the skills offered by the graduates and value them, especially in comparison to other history programs? How do graduates retrospectively rate the usefulness of the programs and the skills acquired? Because most study programs and professorships were introduced in a relatively short period of time, their evaluation will also be carried out over a short period. This could prove fatal to the field, as there will be little to no time to learn from problematic developments or failure. And if public history is unable to prove its usefulness soon, there will be virtually no funding to advance the field.

In terms of employability, the situation in Germany differs from that in the United States and elsewhere. History teachers do not need public history to qualify for a school teaching career. Public history seminars may contribute to the teaching profile of those students. But a degree in public history is not sufficient to qualify as a school teacher in history or other subjects. State archives and libraries in Germany run their own educational programs with on-the-job training. Public history programs may serve as good propaedeutics for those fields. But they do not qualify students directly for a career as an archivist or librarian in state or communal archives and libraries. Museums or historical sites are a prospective job market for graduates of history programs in general and execute more or less structured training programs, mostly run as voluntary services and on-the-job training. Other than this, there are many history agencies in Germany and a great number of freelance historians in the fields of history marketing, communications and services, for whom specialized public history programs could be an asset.

Public history in Germany, however, is not yet prepared to serve as a serious provider to these fields. If progress is to be made, skill-oriented job profiles need to be identified and developed in direct collaboration with them. These profiles can than serve as a foundation for the development of skill-oriented public history programs at universities. For now, public history in Germany is lacking both: direct access to important job markets and sound knowledge about desires and needs of employers in different

fields. Whether the working group 'Angewandte Geschichte/Public History' or a future German International Federation for Public History branch could be a moderator for this process remains unclear.

All current experiments on the internet and in social media are temporary projects with limited funding. They are carried out by more or less precarious public historians. In the long run, public history needs to provide jobs with perspectives for those now project-based practitioners. In academia, public history will only settle permanently if degree papers in the field are recognized as being of equal value and allow one to continue scientific work in other areas of academic history. Academic public history needs to clarify emphatically that it is not a PR service unit for history departments, nor some sort of 'history police', but a field of research and teaching that deals with public representations of history from production to transmission and reception. Public history successfully blurs the boundaries of historical science, history didactics, popular cultures, historical anthropology, media and communications studies, history agencies, history services, interested laypeople, history workshops and the like. However, while the ability to bridge or even close the gap between universities and non-academic fields of history is an advantage, it brings with it the risk of not being taken seriously by the established historical sciences. These could sit comfortably by as the current momentum of public history in Germany peters out. To ensconce itself permanently in Germany, public history needs to develop its potentials soon, and in a sustainable way.

Research potential: Understanding historiographies and their media

All history appears in certain forms of media and most of the history produced today is not manufactured in academia. Movies and TV shows, exhibitions, museums, historical sites, comics, documentaries, history magazines, re-enactments, music, digital games, images and much more, all contribute to the production of historical consciousness in society and influence the expectations that are then directed back at academic historiography. While literary studies have long considered popular literature an approved object of investigation, historical sciences in Germany – with the exception of history didactics – have not yet widely

acknowledged popular historiographies as valid, relevant and pertinent forms of history for specific target groups. This, however, is gradually beginning to change. Nonetheless, some professional historians still deliberately disqualify popular historiographies as inferior; some are even disconcerted when academic historians deal with them seriously. Public history has the potential to overcome such views by situating popular historiographies as 'history types'. These can be systematically analysed concerning their mediality and performativity, as well as their functioning and their contributions to specific history cultures or the production of historical consciousness through time and space. Public history set up in this way could contribute to the history and theory of historiography alike, work out and systematize the particularities of the different history types in a historical perspective and thus provide knowledge for public history teaching.

Analysing digital games as historiography in Hamburg

Digital games are a potential medium for the analysis of historical staging with a strong user-centred perspective. Studying digital games may also provide a better understanding of theatrical performances, exhibitions, controllable simulations, virtual reality, woven digital text forms, soundscapes and atmospheres. Their specific constitution as a medium also enables reflections about scientific methods and theories of digital games as historiography in general. Moreover, the rapidly growing field of massive multiplayer games represents new and almost unexplored virtual forms of commemorative cultures, and thus is an important field in which to study cultural histories in digital media societies.

Although digital games are now being played in large parts of society by all age groups and social classes, historical sciences have not yet developed a systematic approach to this form of historiography. Pioneering work is being done by Angela Schwarz at the University of Siegen, who holds the only professorship in this field.[32] Most of the researchers who have significant influence in the field are or have been PhD candidates with few chances of being able to continue their work as academics. This has had consequences for the scientific discourse.

In the field of academic history game studies, Public History Hamburg is pursuing combined strategies in research, infrastructure and young academics. Among other German-speaking researchers, Nico Nolden, whose thesis connects online role-playing games with commemorative cultures, established a working group for historical science and digital games.[33] This community unites more than sixty researchers, students, teachers, games journalists and games industry stakeholders who share a keen interest in history and digital games. This German-language group intends to find common positions to establish history game studies as a research field in Germany. On its homepage, the *AKGWDS* provides events, calls, current projects, scientific articles and commentaries. It also serves as social hub, linking all members and their core fields for collaboration and cooperation. Annual conferences conduct groundwork in the field, discussing recommendations for scientific studies in areas such as historical imaginations, feedback loops of contemporary history, a techno-cultural historiography, or epistemic systems and commemorative cultures.

Nico Nolden and Thorsten Logge also developed a game lab called the Ludothek and game library as a ground-breaking scientific facility in 2014. This infrastructure provides suitable hardware and software for different gaming platforms and a high-end personal computer for academic usage. The core device of the system is a recording unit that allows the recording of live gaming experiences, providing researchers with reliable evidence and primary sources which can be referenced scientifically. The Ludothek currently contains about 400 games that can be researched online via the University of Hamburg library system.[34] With new opportunities opened up by this scientific facility, fresh challenges also emerged: methodological standards and source-critical instruments must be developed and deployed, for example, for videographic referencing. Technological solutions for sustainable preservation and accessibility are also crucial for scientific use of video games.

In order to move forward in this domain, Nolden created the local work group 'history matters'. It aims to foster scientific research on digital games as historiography and to create networks between academia and the local games industry. Participants learn to deal with methodological obstacles in the field, analyse how historical elements are composed into games. And they develop and experiment with their own prototypes, thus actively composing historiographies in the medium of digital games

on the basis of sound knowledge about this distinct history type and its medial logics and needs.

Active and passive history type competence: A common ground for research and teaching?

By dealing intensively with the logics of the specific media in which histories are represented, public history has opened a path for history reviews that analyse histories of all kind in their respective context without assigning pre-eminence to academic practice. Gaining an understanding of different types of history can also be useful for the development of skill-oriented public history programs. While passive history competence would provide theories and methods to identify, analyse and review historiographies of all kinds and with respect to their prospective audiences, active history competence would mean the ability to produce historiographies in various forms, from scientific text to documentaries and video games.

Thus, academic public history could provide the means to a more reflective and robust approach for dealing with non-academic history and equip graduates with the competences needed for different historical practices. Strengthening analytical skills and broadening the number of recognized types of history should be one of the key issues of academic public history in Germany in the immediate future. At the same time, stakeholders inside and outside academia must strive together to develop study programs that meet the needs of employers in relevant historical fields, taking into account the use of modern media technology and, above all, remain rooted in historical science.

Notes

1. Thorsten Logge, 'Public History in Germany: Challenges and Opportunities', *German Studies Review* 39, no. 1 (2016): 141–53.
2. Freie Universität Berlin, 'Public History Master'. www.geschkult.fu-berlin. de/e/phm/index.html (accessed 15 November 2017). Irmgard Zündorf, 'Public History an der Freien Universität Berlin', in *Projektlehre im*

Geschichtsstudium, ed. Ulrike Senger, Yvonne Robel and Thorsten Logge (Bielefeld: W. Bertelsmann, 2015), pp. 94–104.

3. Universität zu Köln, 'Studienrichtung Public History im MA Geschichte 1-Fach'. http://histinst.phil-fak.uni-koeln.de/1072.html (accessed 15 November 2017).

4. Ruhr-Universität Bochum, 'Masterstudiengang Public History and der Ruhr-Universität Bochum'. www.ruhr-uni-bochum.de/public-history/index.html (accessed 15 November 2017).

5. Ulrike Weckel, 'Verstehen wollen und erzä hlen kö nnen. Fachjournalistik Geschichte an der JLU Gieß en', *Gießener Universität sblätter* 47 (2014): 71–8. https://fachjournalistik-geschichte.org/wp-content/uploads/2016/09/weckel_fachjournalistik_geschichte.pdf (accessed 15 November 2017). Ulrike Weckel and Eva Maria Gajek, 'Historische Bildung, wissenschaftliches Arbeiten und Medienpraxis. Das Studienfach Fachjournalistik Geschichte an der Justus-Liebig-Universitä t Gieß en', in *Projektlehre im Geschichtsstudium*, pp. 117–27.

6. Museum für Völkerkunde, Professur für Globalgeschichte (Afrika) an der Universität Hamburg, 'Koloniale Hintergründe: Das Museum für Völkerkunde Hamburg'. www.google.com/culturalinstitute/beta/exhibit/koloniale-hintergründe-das-museum-für-vör-völkerkunde-hamburg/3gLSWkBQpqlsLw?hl=de (accessed 15 November 2017).

7. Heidelberg Public History, 'NS-Dokumentation Vogelsang'. www.uni-heidelberg.de/fakultaeten/philosophie/zegk/histsem/forschung/HPH_Vogelsang.html (accessed 15 November 2017).

8. Deutsches Historisches Museum, 'Chatguide Deutsches Historisches Museum'. www.dhm.de/whatsapp.html (accessed 15 November 2017).

9. Christine Bartlitz and Sebastian Brü nger, 'kudamm'31 – Ein Audiowalk zwischen Klangkunst und Geschichtswissenschaft', in *Projektlehre im Geschichtsstudium*, pp. 143–55.

10. Stolpersteine Hamburg, 'Stumbling Stones in Hamburg'. www.stolpersteine-hamburg.de/index.php (accessed 15 November 2017). The biographies in Hamburg are also accessible via smartphone app and in classic print.

11. *Stolpersteine in Berlin*. www.stolpersteine-berlin.de/en (accessed 15 November 2017).

12. NS-Dokumentationszentrum der Stadt Köln, 'Stolpersteine | Erinnerungsmale für die Opfer des Nationalsozialismus'. https://museenkoeln.de/ns-dokumentationszentrum/default.aspx?s=1194 (accessed 15 November 2017).

13. Deutsche Forschungsgemeinschaft, 'Public History: Theorie und Methode einer neuen geschichtswissenschaftlichen Subdisziplin'. http://gepris.dfg.de/gepris/projekt/352650773?language=en (accessed 15 November 2017).

14. Verband der Historiker und Historikerinnen Deutschlands, 'AG Angewandte Geschichte/Public History'. www.historikerverband.de/arbeitsgruppen/ag-angewandte-geschichte.html (accessed 15 November 2017).

15. *Studierende und Young Professionals der AG Angewandte Geschichte Public History.* https://syp.hypotheses.org (accessed 15 November 2017).

16. *Public History Weekly.* https://public-history-weekly.degruyter.com (accessed 15 November 2017).

17. *Reihe: Public History – Geschichte in der Öffentlichkeit.* www.utb-shop.de/utbseries/serie/index?utb_series=6608 (accessed 15 November 2017).

18. Jacqueline Nießer and Juliane Tomann (eds), *Angewandte Geschichte. Neue Perspektiven auf Geschichte in der Öffentlichkeit* (Paderborn: Schöningh, 2014).

19. Sarah Willner, Georg Koch and Stefanie Samida (eds), *Doing History: Performative Praktiken in der Geschichtskultur* (Münster: Waxmann, 2016).

20. Mareike Menne, *Berufe für Historiker* (Stuttgart: Kohlhammer, 2015); *Brotgelehrte. Andere Perspektiven für Geisteswissenschaftlerinnen* (Salzkotten: editionBrotgelehrte, 2016); *Brotgelehrte 2. Perspektiven für GeisteswissenschaftlerInnen* (Borchen: Eire Verlag, 2017); Margot Rühl, *Berufe für Historiker* (Darmstadt: Wissenschaftliche Buchgesellschaft, 2004).

21. Wolfgang Hardtwig (ed.), *History sells: Angewandte Geschichte als Wissenschaft und Markt* (Stuttgart: Steiner, 2009).

22. Cord Arendes and Angela Siebold, 'Zwischen akademischer Berufung und privatwirtschaftlichem Beruf. Für eine Debatte um Ethik- und Verhaltenskodizes', *Geschichte in Wissenschaft und Unterricht* 66, no. 3 (2015): 152–66.

23. Cord Arendes, 'Historiker als "Mittler zwischen den Welten"? Produktion, Vermittlung und Rezeption historischen Wissens im Zeichen von Citizen Science und Opten Science', *Heidelberger Jahrbücher Online* 2 (2017): 19–58. http://heiup.uni-heidelberg.de/journals/index.php/hdjbo/article/view/23691 (accessed 15 November 2017).

24. Thomas Wallach, 'CfA: Handbuch Public History'. www.hsozkult.de/event/id/termine-34234 (accessed 15 November 2017).

25. Eva Schöck-Quinteros and Sigrid Dauks, '"Am Anfang habe ich schon nach Luft geschnappt!" – Das Projekt "Aus den Akten auf die Bühne" an der Universität Bremen', in *Projektlehre im Geschichtsstudium*, pp. 130–42.

26. *Aus den Akten auf die Bühne.* www.sprechende-akten.de (accessed 15 November 2017).

27. Freddie Rokem, *Performing History* (Iowa City: University of Iowa Press, 2000). German translation published 2012.

28. *Digital Past.* http://digitalpast.de/9nov38/ueber-9nov38/ (accessed 15 November 2017); Noam Cohen, 'History Comes to Life with Tweets from Past', *New York Times*, 17 November 2013. www.nytimes.com/2013/11/18/business/media/history-comes-to-life-with-tweets-from-the-past.html (accessed 15 November 2017).
29. *Als der Krieg nach Hause kam.* https://twitter.com/digitalpast_EN; http://digitalpast.de/als-der-krieg-nach-hause-kam/ (accessed 15 November 2017).
30. *Open History e.V.* www.openhistory.de (accessed 15 November 2017).
31. *GeschichtsTalk im Super 7000.* https://gts7000.hypotheses.org/about-us-english (accessed 15 November 2017). Super7000 is a co-working space in Düsseldorf.
32. *Professor Dr Angela Schwarz.* www.uni-siegen.de/phil/geschichte/lehrstuehle/neueregeschichte/ (accessed 15 November 2017).
33. *Arbeitskreis Geschichtswissenschaft und Digitale Spiele.* http://gespielt.hypotheses.org (accessed 15 November 2017).
34. *Campus-Katalog Hamburg.* https://kataloge.uni-hamburg.de/DB=1/SET=2/TTL=1/MAT=/NOMAT=T/CLK?IKT=20&TRM=H60+Computerspiel (accessed 15 November 2017).

6

Public History in India: Towards a People's Past

Indira Chowdhury and Srijan Mandal

Public history, as it is practised in India, defies easy attempts at classification. This is partially because hardly anything that would be recognized as public history is identified as such. Despite its ever-increasing acceptance outside India as a discipline and a practice distinct from history, it has yet to gain any currency within India. Any attempts to identify works that are self-consciously public history in the Indian context are not likely to yield much fruit. Nor will borrowing any of its many definitions from the West and trying to find works that adhere to it in India. Instead, this chapter will try to highlight the myriad forms that public engagements with the past have taken place in India.

In India, there exist practices that actively engage with the past. Sometimes these are seen as resources that historians might use. But more often they are viewed as resources that belong not to history but to anthropology and folklore. This may have to do with the mechanisms that established history as an academic discipline in India. Many practices that engage actively with the past use songs, performances and puppetry. The records kept at pilgrimage sites or genealogical tables preserved in memory by communities such as the *Manganiyar* in Rajasthan are consulted by people to understand family history.[1] The tradition of the *Kavaad*, or the story-telling box that uses a wooden box that opens out to reveal the story, very often incorporates genealogy.

There have been a few attempts in recent years to engage with and document these practices through film. Filmmaker Nina Sabnani has used indigenous aesthetics and forms of story-telling to depict a community's engagement with the Partition and the wars between India and Pakistan in her animated film *The Stitches Speak* (2009).[2] Sabnani brings together older traditions of engagements with the past with new ways of presenting the past. But this has not been engaged with by historians except as a resource or a source of information. A robust public history program is needed to engage with such modes of representation of the past. At the Centre for Public History in Bengaluru – which is the only institution in India to anchor two master's programs in oral history and in public history and heritage interpretation – we make an attempt to do so. We shall discuss this later in our chapter. But these resources are often ignored by mainstream university departments as not being proper resources for the academic discipline of history which was introduced during the colonial period.

History – or 'the academic discipline that we research, teach, and study in universities … that was invented in Western Europe in the early part of the nineteenth century'[3] – did not become a subject of postgraduate study until 1919, when the University of Calcutta established a department for the study of medieval and modern history. Other universities followed suit over the next two decades.[4] Thus until about a century ago there were no Indian historians formally trained in the discipline, at least not in a university. Yet, by the time history became a subject of postgraduate study, it had already been around and flourishing for a few decades as history had developed in the public sphere in the hands of amateurs amid a public 'hunger for history', a phrase that the famous Indian author Rabindranath Tagore had used in 1899 to describe his times.[5]

These amateurs debated the ways that the past can be studied in a 'scientific' manner, an approach that had become available to them through the agency of colonialism and the colonial attempts to 'scientifically' study the precolonial Indian past. However, they were not satisfied to merely study the past 'scientifically'. They also wanted to publicize it 'among ordinary people in accordance with scientific methods', otherwise history would be little more than 'mere argumentation among the learned'. In other words, 'they thought of the historian as a custodian of the nation's or the people's memories'.[6] This conception of the historian as custodian has continued to this day. Accordingly, the public role that historians have sought for themselves is that of adjudicating 'disputes relating to the past [that] arise in the domain of popular culture'.[7] However, this role has not been offered to

them by the public; most attempts by historians to assume it for themselves has made little difference in the outcome of public disputes about the past. Despite that, historians continue to try to find a place for themselves in the wars over history that engulf the country from time to time.

Publics and their pasts

It could thus be said that public history in India is as old as the discipline of history itself. But it came into prominence in 1990 when the faculty of the Centre for Historical Studies at the Jawaharlal Nehru University in New Delhi published a pamphlet refuting the claims that were being made about the Babri Masjid–Ram Janmabhoomi dispute over the site of Rama's birthplace.[8] The pamphlet presented historical evidence to refute the communal beliefs that were being treated as history and used in the perpetuation of communal politics. In the following year, an edited volume that expanded upon the pamphlet and provided contextual depth was published.[9] While this unprecedented intervention did garner some attention, it failed to affect public perception of the Babri Masjid, which was ultimately torn down by hundreds of kar sevaks – Sangh Parivar activists – on 6 December 1992.

The most prominent historical voice to emerge in the debate was that of Romila Thapar. This was not the first time Thapar had found herself fighting against the political abuse of history in the public sphere. In the late 1970s, she and some of her colleagues had to defend the textbooks that they had written for the National Council of Educational Research and Training in the 1960s. That was because the same activists had taken exception to their historical interpretation and, with Prime Minister Morarji Desai's blessing, sought to stop their use.[10] The battle over textbooks was reignited in the early years of this century when the Sangh Parivar was back in power through its political wing, the Bharatiya Janata Party. Yet again, Thapar and her colleagues had to defend the discipline of history from the political distortions that were sought to be imposed upon it.[11] In other words, Thapar has been playing the role of a public historian for over half a century without ever identifying as a public historian.

However, her attempts and those of others to adjudicate public disputes about the past or promote historical method have recently met with resistance from an altogether different quarter: the *Dalit Bahujan Samaj* – society of the oppressed and the majority. For them, 'the past has been an integral and constitutive element of identity assertion and also a medium

for coping with the oppressive present'.[12] The discipline of history, the feeling goes, is not equipped to do that, and public history derived from this conception of the discipline is irrelevant to such an enterprise. Here, an 'alternative history' is sought to be created 'as a form of dissent' through 'the use of dissenting cultural resources like myths, legends, local heroes and histories'.[13] The purpose of such a history is Dalit mobilization for political power that is sought through raising Dalit consciousness.[14]

So, whether it is the caste Hindu public or the Dalit-Bahujan public, the past serves a political purpose in the present and, as such, must be projected in a manner that serves that public's political purposes. For such a task, of course, neither the discipline of history nor the public role of adjudicator that a professional historian may want to assume is equal, which is why historians tend to be so marginal in public contestations about the past.

Colonial curiosities and the postcolonial museum

Museums present one way of engaging the public with the past. Calcutta, the first capital of British India, was home to Asia's first museum. The Museum of the Asiatic Society began in 1814 and had a very diverse collection. As in other colonies, museums in India were seen as part of the machinery of civilization through which colonial subjects could understand and access their past through a scientific lens. The museum, one of the earliest tools of public history, had a slightly different educational agenda in the colonies. Through the objects on display, colonial subjects, who occupied a lower position on the evolutionary ladder, could view their own glorious past which contrasted sharply with their worn-out and depleted present.[15] The early history of the museum shows how the collection of archaeological, botanical and zoological objects was organically linked to the expeditions undertaken, wars fought and excavations conducted. The museum soon expanded and became what we now know as the Indian Museum in Kolkata. It also moved to its present premises, an imposing neoclassical building designed by Walter Granville, in 1878.

If the colonial state saw museums as places to display the geographical boundaries of the empire, the coming of Indian Independence in 1947 brought with it new dilemmas. The Indian Museum became one of the sites where 'the drama of decolonization was played out with all its contradictions

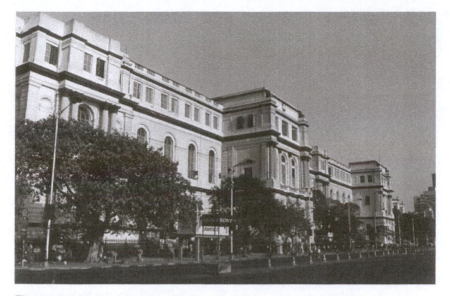

Figure 6.1 Indian Museum, Kolkata, c. 1990. Photo Indira Chowdhury.

and paradoxes'.[16] Since Indian Independence came with the Partition of British India into India and Pakistan, old artefacts and objects of historical significance were redistributed between the two countries. Between 1947 and 1948, an exhibition of Indian art with selections from museum artefacts as well as works by contemporary artists was put up in Burlington House, London, as part of the Royal Academy Exhibition of Indian Art. When the artefacts returned to India, they were displayed at the Raj Bhavan, the official residence of the President of India, which until 1947 was the Viceregal Palace. This exhibition was not very successful in London but it was 'destined to have a far more significant afterlife in Delhi' as the artefacts borrowed from various museums went on to form the core collection of what came to be the National Museum.[17]

This celebratory moment resulted in a conflict between the older Indian Museum and the newly assembled National Museum. The Indian Museum refused to part with some of its artefacts. The oldest and the largest museum in India was not identified as the National Museum but recognized as an institution of national importance. The creation of the National Museum in the capital became 'an act of great symbolic importance after independence', and the new museum was seen as celebrating the 'ancient culture of the young state'.[18] The creation of the new museum thus signalled the creation of a new narrative of the state. It was this narrative that was replicated in

different museums and showcased especially for schoolchildren who visited regularly. Museums thus became pedagogic sites for the new citizens to understand their past.

Reimagining museums in India

The desert museum of Rajasthan

Reflecting on public history more than three decades ago, Ronald J. Grele had argued that the term itself calls for a redefinition of the role of the historian, as public history 'conjures up images of a new group of historical workers interpreting the past of heretofore ignored classes of people'.[19]

The Arna Jharna, or the Desert Museum of Rajasthan, run by the Rupayan Sansthan, attempts a similar redefinition of the role of the historian by reimagining the museum as a space where the link between land and livelihood, cropping patterns and cultural ethos, material culture and tools can be investigated and examined by the visitors. Envisioned by Rupayan's founding director, Komal Kothari, Arna Jharna presents his idea of Rajasthan as being divided into three cropping zones – the

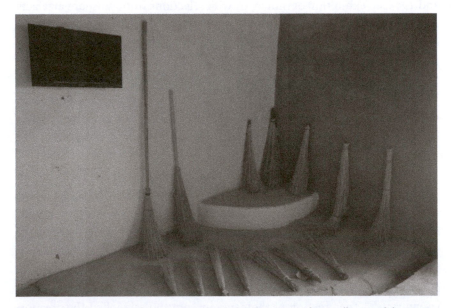

Figure 6.2 Display of brooms used outdoors at Arna Jharna Museum. Photo Indira Chowdhury.

millet zone, the wheat zone and the sorghum zone with distinctive environments, food items, tools as well as different cultural practices. All exhibitions at the museum are arrived at through this process of focussing on the zone and understanding environment, food, material culture and traditions. The first exhibition project on brooms was undertaken by the museum and directed by writer, academic and cultural critic Rustom Bharucha who had earlier published *Rajasthan: An Oral History* based on extensive interviews with Komal Kothari. The broom exhibition with 350 brooms, classified according to use and place of origin, focuses on the environment and natural resources, modes of production, lives of the broom-makers who belong to marginalized caste groups, myths, beliefs and symbolic dimensions of the broom and the economy of the broom.[20] As Rustom Bharucha puts it, the museum is thus able to focus on unheard histories: 'Our social function as a museum is in terms of making the inaudible audible; making the invisible visible … we are serious about calling attention to their practice and predicament.'[21]

Remember Bhopal Museum

The Remember Bhopal Museum, proclaimed as 'the first museum of the world's worst industrial disaster', is unique in the annals of public history in India in being a 'survivor-led effort', 'collectively curated by a community of survivors and activists'.[22] In that sense, it is truly a manifestation of a people's past – a past that is not only *of* a people, but also *by* those people.

The museum was inaugurated in December 2014, on the thirtieth anniversary of the Bhopal Gas Disaster of 3 December 1984, when forty tons of the lethal methyl isocyanate had escaped into the air, killing about 15,000–20,000 people and leaving half a million more exposed to its harmful effects. It is an act of resistance, standing as an impassioned indictment of corporate crime, of state apathy and of the survivors' resilient struggle against both. It is also a sharp condemnation of the government's idea of creating a memorial at the factory site.[23]

The museum accepts no government or corporate funding, surviving instead through small donations from individuals and contributions from environmental activist groups in India and abroad.[24] Its galleries are accordingly curated to evoke in the audience's mind a range of emotions – from horror to anger to despair, all achieved through the deft use of images, voices, objects and text. Alongside the images in each room is a bank of

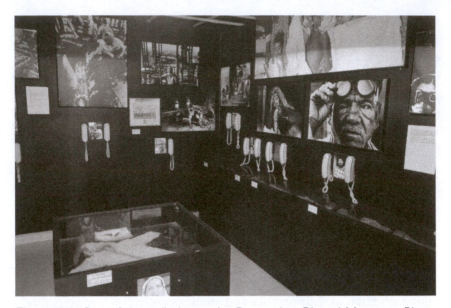

Figure 6.3 One of the galleries at the Remember Bhopal Museum. Photo Indira Chowdhury.

wall phones, each containing the haunting voices of those who survived and those who continue to fight a seemingly losing battle against corporate crime to this day. The use of oral history alongside objects and photographs come together to give meaning to the everyday objects of ordinary people that are also on display in each gallery. Contextualized thus, something as commonplace as a child's clothing takes on a tragic meaning, as does the stethoscope of a doctor. They are all representative of the havoc that the leaked gas wreaked on the residents of Bhopal.

By thus challenging the monopoly of the state in memorializing the past, the Remember Bhopal Museum has managed to not only commemorate a movement for justice, but also continue it through the four walls of a museum.

The Partition Museum

Half a million people killed, 75,000 women violated and 10 million refugees created:[25] these are some of the staggering, yet ultimately sanitized, statistics of the retributive genocide that followed the partition of British India. Yet,

for almost seventy years after this cataclysmic event, 'no memorial, no designated space, no commemoration of any kind'[26] had been established to mark the momentous migration that accompanied the birth of these two nations. The Partition Museum was formally inaugurated on 17 August 2017, the seventieth anniversary of the announcement of the Radcliffe Award, which demarcated the border between India and Pakistan.

Oral history interviews play a central role in the museum. Carefully chosen excerpts from these interviews are played through headphones on LED screens. Accompanying many of these interviews are personal objects – for instance, a letter, a suitcase, a piece of clothing – that are either referenced in the excerpts or are relevant to the person's memory of partition.

Despite the traumatic events that it depicts, the museum has made a curatorial choice to not dwell on barbarities that people committed in the name of avenging their co-religionists in the aftermath of partition. Instead, it has chosen to highlight acts of compassion, of courage, of even joy like a wedding; ordinary acts that became extraordinary by virtue of the circumstances in which they occurred. The feeling that the exhibits leave one with is of hope – that even in those dark times, there were some who survived the ordeal with their humanity intact. In keeping with this theme, the museum ends with the tree of hope. From it hangs messages from visitors of their impression of the museum. The gallery has also uplifting stories of how survivors of partition, without a penny in their pocket, became successful in this new country that they now had to call home. Through such curatorial decisions, the Partition Museum has chosen to commemorate the truth of partition, to be sure, but have also tried to pave a path towards reconciliation.

As the editors of this volume have pointed out, 'the nation state certainly underwrote the evolution of history with a public purpose through massive investments in cultural institutions and universities'.[27] All the museums discussed here are public engagements that are very different in scope and character from the traditional museums in India, holding up for interrogation the idea of the past and how it should be represented.

Public history interventions and the Indian academic context

Public history interventions in India, as elsewhere, have often come from outside academia. Although there has been no local history movement in

India, organizations such as the Indian National Trust for Art and Cultural Heritage (INTACH) have one of the largest networks of heritage activists, artists, art historians, architects and amateur historians. Its members have been intervening in educating the youth and the public about heritage through the Heritage Education and Communication Service, which was established in 1998. INTACH has also been undertaking numerous conservation projects. Although INTACH has never been recognized by academia, it has contributed the largest number of student volunteers to work on heritage sites and has engaged with the historical interpretation of these sites. In 2012, INTACH set up the INTACH Heritage Academy, giving a formal structure to the work it had been doing in training, research and capacity building on heritage.

However, in recent years, there have been several attempts towards building sustainable public history engagements with recent history from within academic spaces. Many of these engagements have focused on community history and attempted to present the voices of those who had not been included in mainstream history until now. From 2013 onwards, the Centre for Community Knowledge (CCK) at the Ambedkar University in Delhi created several neighbourhood museums, engaging with local history and local communities within the city. The neighbourhood museums are temporary displays that exhibit collected narratives from marginalized populations. Viewing 'documentation as an act of intervention', CCK raises questions about 'ascribed identities in the city'.[28] It has created three such 'museums' to date – at Shadi Khampur, Nizamuddin and Shadipur Shani Bazar. The 'museums' are set up for a month, some times longer, and use oral history, photographs and material from the community. The museum site, usually a gallery space, becomes a space for dialogue with the community and between disciplines. The neighbourhood museums have been using the process itself as a pedagogic tool through which students can learn to collect and interpret diverse historical resources and curate them meaningfully.

The Centre for Public History (CPH), which began in 2011, is uniquely located within the Srishti Institute of Art, Design and Technology in Bangalore. The first centre of its kind in India, CPH attempts through its courses and projects to fill the lacuna that exists between historical research and its communication to a wider audience. Committed to the creation of resources for research, CPH has been involved in creating the archives of contemporary institutions. Deeply committed to dissemination of the archives, CPH has developed the concept of the 'archival book' in which

archival documents, photographs and oral history interviews are compiled and exhibited in ways that make them accessible to the general public. CPH has created archives and archival books for the Indian Institute of Management, Calcutta (2012), the Institute of Mathematical Sciences (2016) and the bicentenary commemoration volume for the Indian Museum (2017).

The location of CPH within an institute of design has also created opportunities to work closely with designers and visual communicators, exploring different forms of interpretation that set up relationships between photographs, documents and oral narratives and in the process create new ways of doing history. Connecting with audience experience, CPH has been exploring different forms of interpretation through the realm of performance and audio-visual communication. The Bangalore Storyscapes walks, lead at different points by Avehi Menon, Archit Guha, Priyanka Seshadri and Indira Bharadwaj, have used the city walk to engage with different aspects of Bangalore's layered history, deploying memory, archival documents and photographs. The Bangalore Fort project, called 'The Tiger Comes to Town', was a site-specific intervention that attempted to present a critical perspective of the past and reengage local audiences with events from 1791 at the Bangalore Fort – a heritage site that is preserved and protected today by the Archaeological Survey of India. CPH anchors two master's programs in public history and heritage interpretation, and in oral history. Both degrees are awarded by the University of Mysore. At the time of writing, there has been one student for oral history and none for public history indicating that the discipline will take a while to find its academic roots in India.

Conclusion

A practice around the public engagement with the past exists in India. It has been around for decades and has taken a variety of forms, and it appears to be growing throughout the country. Beginning in state-funded institutions such as museums, the practice seems to be slowly but surely emerging from the shadow of the state and its claims about being the sole representative of the public past. In so doing, the conception of the public as a monolithic entity has also been challenged, and along with it the belief that a singular interpretation of the past is sufficient for the public. The acknowledgement of multiple publics within India has brought with it the recognition that each of these publics engage with a different past and, within themselves, even

different versions of the shared past. As such, any effective engagement with the past must take into account the public whose past it is trying to represent and proceed by making them stakeholders in the process of representation.

What has yet to happen in India, however, is recognition of this thriving collection of practices as public history. The need for such recognition may not seem immediately apparent or even important, but recognition brings with it a formalization of practice, a sharing of practice through recognized platforms and the coming together of practitioners under a common banner. That might make it easier to attract funding for projects – something that most public history projects struggle with – which in turn could create more opportunities for employment. An increase in employment opportunities might make the study of public history as a discipline and a practice more attractive and viable for students who are interested in the past but do not necessarily want to become academic historians. And an increase in the number of well-trained professional public historians would mean more partnerships with many more communities in the country who have hitherto not had their past represented, much less represented in a manner that is meaningful to them.

If all these might's and maybe's can be manifested, then the thriving practice of publicly engaging with the past could be transformed into a public history movement that unleashes the democratic potential inherent in public history and makes the past truly of the people, by the people and for the people.

Notes

We gratefully acknowledge the travel funding received from the Srishti Institute of Art, Design and Technology, Bengaluru, during our research-related site visits to museums and heritage sites in India. We particularly thank Dr Geetha Narayanan, founder-director of Srishti, for her generous support and encouragement.

1. See Rustom Bharucha, *Rajasthan, An Oral History: Conversations with Komal Kothari* (Delhi: Penguin, 2003).
2. www.youtube.com/watch?v=PteCQL6eUVY (accessed 7 September 2017).
3. Dipesh Chakrabarty, 'The Public Life of History: An Argument Out of India', *Postcolonial Studies* 11, no. 2 (2008): 169.
4. Dipesh Chakrabarty, *The Calling of History: Sir Jadunath Sarkar and His Empire of Truth* (Chicago: University of Chicago Press, 2015), p. 38.
5. Chakrabarty, 'The Public Life of History', 170.

6. Ibid., 172.

7. Ibid., 169.

8. Centre for Historical Studies, Jawaharlal Nehru University, New Delhi, 'The Political Abuse of History: The Babri Masjid-Rama Janmabhumi Dispute', *Social Scientist* 18, nos. 1/2 (1990): 76–81.

9. Sarvepalli Gopal (ed.), *Anatomy of a Confrontation: The Rise of Communal Politics in India* (Delhi: Penguin, 1991).

10. Romila Thapar, 'The History Debate and School Textbooks in India: A Personal Memoir', *History Workshop Journal* 67 (2009): 95–6.

11. Romila Thapar, 'In Defence of History', *Seminar* 521 (2003). www.india-seminar.com/2003/521/521%20romila%20thapar.htm (accessed 7 September 2017).

12. Badri Narayan, *Women Heroes and Dalit Assertion in North India: Culture, Identity and Politics* (New Delhi: Sage, 2006), p. 89.

13. Ibid., p. 26.

14. Kancha Ilaiah, 'Productive Labour, Consciousness and History: The Dalitbahujan Alternative', in *Subaltern Studies IX: Writings on South Asian History and Society*, ed. Shahid Amin and Dipesh Chakrabarty (New Delhi: Oxford University Press, 1996), pp. 165–200.

15. See Gyan Prakash, 'Science "Gone Native" in Colonial India', *Representations* 40 (1992): 153–78; and Gyan Prakash, 'Museum Matters', in *Museum Studies: An Anthology of Contexts*, ed. Bettina Messias Carbonell (Oxford: Wiley-Blackwell, 2003), pp. 208–16. See also Tapati Guha-Thakurta, *Monuments, Objects, Histories: Institutions of Art in Colonial and Postcolonial India* (New York: Columbia University Press, 2004).

16. Centre for Public History and ARCH@Srishti, *The Lives of Objects: Stories from the Indian Museum* (Kolkata: Indian Museum, 2017), p. 139.

17. Kavita Singh, 'The Museum Is National', *India International Centre Quarterly* 29, nos. 3/4 (2003): 192.

18. Ibid., 176.

19. Ronald J. Grele, 'Whose Public? Whose History? What Is the Goal of a Public Historian?', *Public Historian* 3, no. 1 (1981): 48.

20. www.arnajharna.org/English/Museum_Concept.aspx (accessed 7 September 2017).

21. Rustam Bharucha, interview with Amanda Fortier, *The Power of Culture*. http://kvc.minbuza.nl/en/current/2009/august/desert-museum (accessed 7 September 2017).

22. http://rememberbhopal.net/overview/ (accessed 7 September 2017). For further details about the curation of the museum, see Rama Lakshmi, 'Curating a Bhopal People's Movement: An Opportunity for Indian Museums', *Museum Journal* 55, no. 1 (2012): 35–50.

23. Lakshmi, 'Curating a Bhopal People's Movement', 38–40.

24. http://rememberbhopal.net/overview/ (accessed 7 September 2017).

25. Urvashi Butalia, *The Other Side of Silence: Voices from the Partition of India* (New Delhi: Penguin Books, 1998), p. 3.

26. Adrian Murphy, 'Partition at 70: World's First Partition Museum Officially Opens in India', *Museums+Heritage Advisor*, 17 August 2017. http://advisor.museumsandheritage.com/news/partition-70-worlds-first-partition-museum-officially-opens-india/.

27. See the Introduction in this volume.

28. www.cckonline.in/neighborhood-museum-programme.html (accessed 7 September 2017).

7

Public History in Indonesia: The Old Disorder?

Paul Ashton, Kresno Brahmantyo and Jaya Keaney

The Republic of Indonesia, the fourth most populous nation in the world, is home to around 260,000,000 people and more than 300 ethnic groups. Geographically, it stretches over 17,500 islands, the largest of which are Sumatra (164,000 square miles), Celebes (67,400 square miles) and Java (48,900 square miles). From the late sixteenth century, Dutch control spread tenuously through what was to become known as the Netherlands East Indies: there was no Indonesia. The earliest nationalist movement, the Budi Utomo, began in 1908, leading to decades of struggle for independence. In August 1945, two days after the Japanese surrender, the nationalist political leaders Sukarno and Muhammad Hatta declared Indonesian Independence, heralding the Indonesian Revolution. On 27 December 1949, Indonesia became a sovereign state. But from this time on its history was to be scarred by regional uprisings in the late 1950s and early 1960s, civil war, economic vicissitudes, corruption and strife between communists and anti-communists. Central to Indonesia's official national history is the coup of 1 October 1965 which provided a 'pretext', as John Roosa has put it, for the murder of at least half a million people, who were mainly communists.[1]

As in other nation-states, public histories were to become critical to galvanizing the new, extremely diverse and unstable Indonesian nation. Indeed, as David Thelen has observed, 'Modern professional historical scholarship grew up alongside the nation-state. Its mission to document and

explain the rise, reform and fall of nation-states. And professional history developed a civic mission to teach citizens to contain their experience within nation-centred narratives.'[2] David Christian has also noted the substantial political and financial support that nationalist governments have provided to historians to craft public histories 'to inspire loyalty' while Jeremy Black has examined 'the role of the state in using history.'[3] Indonesia was no exception. As in many other places, too, the business of constructing national narratives saw some events and people disappear or reappear somehow altered.

Between 1957 and 1966, under the charismatic though increasingly authoritarian leadership of President Sukarno, Indonesia was ruled by a doctrine of 'Guided Democracy'. Giving greater powers to the military, political representation was primarily achieved through groupings such as workers, women and the military. This was a key strategy of the Indonesian Revolution to achieve national unification. A critical glue in this process was national history. As Vickers has written, the regime 'claimed ancient kingdoms as predecessors for the modern state. To this vision of ancient greatness, Sukarno and his ministers added a pantheon of "national heroes".'[4] These were mainly leaders in the nationalist movement as well as a few women and a number of religious figures, thus giving each group a place in the national story. Monuments and memorials were erected to the vision and its champions, new traditions, such as folk dances, were invented and Haussmannian-style thoroughfares were driven through prominent parts of the capital, Jakarta.

Some challenged this revisionist history. Novelist Pramoedya Ananta Toer had earlier and famously written about the people's struggle to achieve independence though the Revolution. While a supporter of national unification and, for a time, Suharto's methods for achieving it, he was imprisoned for his outspoken support for the leftist cause from 1965 to 1978 and spent a further thirteen years under house arrest in Jakarta.[5] The spur to his and many other people's incarceration was the 1965 coup. A watershed in Indonesian history, the coup allowed General Suharto to launch a counter coup and ultimately seize power, ushering in the 'New Order' government from 1966.

This government's ideology was based on the 1945 Constitution and Five State Principles – *Pancasila*. Written by Sukarno, these principles were the belief in one God, just and civilized humanity, national unity, democracy under the wise guidance of representative consultations and social justice for all Indonesians.[6] Sukarno's former principle of Nasakom – nationalism, religion and communism – collapsed after communism was discredited by a massive

post-coup propaganda campaign. Now the 'people were [deemed] the "floating mass" … who needed guidance so they would not be lured into politics'.[7] Strict, official direction was also to be given to how Indonesia's past should be presented and remembered in public. (The 'evidently active and potent, if still murky, role of the United States, Britain and Australia in the events leading up to the great killings of 1965–66' is not addressed in this chapter.[8])

After the fall of the Suharto regime in 1998, public debates over the nature of history proliferated. While focusing on a number of key national events, most notably the 1965 coup and the mass killings – separate but causal events which are often conflated – these debates have raised critical issues over the role or potential role of public history in contemporary Indonesian society. Questions of historical authority are paramount as Indonesian historians, public intellectuals and politicians struggle with a deeply entrenched historical paradigm and narratives of the old 'New Order' which continue to inform history in schools, cultural institutions, the media, literature, personal narratives, public rituals and the academy. This paradigm was based on an unquestioning or reluctant acceptance of official accounts of the past in an environment of fear.

The Sacred Pancasila Monument and the 'coup'

The *Monumen Pancasila Sakti* (Sacred Pancasila Monument) is Indonesia's preeminent piece of public history. Opened in 1969 at Lubang Buaya (Crocodile Hole), the edifice centres on bronze, life-size statues of seven military officers standing in front of a five-metre-tall Garuda, Indonesia's national symbol. A ten-metre-long bas-relief frieze beneath them portrays their violent murder by male members of the 30 September Movement which sought, according to official accounts, to overthrow the government. Almost naked communist women dance demonically around them. The Indonesian Communist Party (*Partaai Komunis Indonesia*, or PKI) is also shown to be force of evil radicalism in postcolonial Indonesia. The story ends in October 1965. The PKI is crushed and Suharto establishes national order. Close by on the same site, this narrative is reinforced in the *Museum Pengkhianatan PKI* (Museum of Communist Treachery) on the same site which shamelessly misrepresents the history of Indonesian communism. Civil regional unrest shown here was largely about labour disputes.

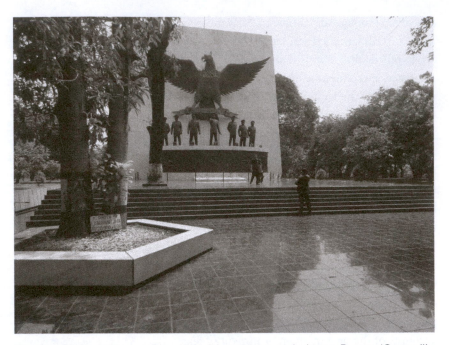

Figure 7.1 The Sacred Pancasila Monument at Lubang Buaya (Crocodile Hole), 2012. Photo Paul Ashton.

This now familiar narrative has become part of the country's social memory. Social memory is concerned with 'an understanding of the meaning the past has for people, whether they experienced it directly or had it recounted to them, or, indeed, read about it in a book'.[9] One Jakarta tourist website, for example, says that this venerated site marked 'a very disastrous and horrific moment in Indonesia's historical timeline'.[10] Indeed, US historian John Roosa has convincingly argued that the 'claim that the PKI organized the movement was, for the Suharto regime, not any ordinary fact; it was *the* supreme fact of history from which the very legitimacy of the regime was derived'.[11] And the state continues to strongly support this interpretation of the coup. Others question it. Why was Suharto the only general to escape execution by the 30 September Movement? Benedict Anderson has also used the official *visum et repertum* made by government medical practitioners to assert that the officers' bodies had not been mutilated.[12] Nevertheless, the 30 September Movement and the coup remain critical to Indonesian historiography and public history. And an annual ceremony marking the events continues to be held on 1 October

for the country and its leaders to reaffirm their faith in Pancasila.[13] As Julia Suryakusuma has written, 'the New Order foundation myth is alive and kicking'.[14] But it is not monolithic.[15]

Instilling the New Order history

The shift of government from civilian authoritarianism under Sukarno to Suharto's military authoritarianism began immediately after the overthrow of the Old Order government. As soon as Suharto took the presidency, he moved to legitimize his government within Indonesia. After the long presidency of the charismatic Sukarno, Suharto had to discredit both his predecessor and the ideology of Guided Democracy. This was done by eliminating the PKI as well as circulating falsified images and accounts of the killing of the generals. The military daily newspaper, *Angkatan Bersendjata* (Armed Forces), played a key role in reporting the communist party's supposed treachery. Next, the regime produced and published the official New Order history textbook of the communist party rebellion, which ends with the hero Suharto forming the New Order.[16] Subsequently, many books that in any way challenged this interpretation were classified by the government as 'threats to national security' and banned, though this process was erratic. Finally, the Pancasila (Five Principles) was legally prescribed as the state ideology and made a compulsory part of moral education for Indonesian citizens.

Under the New Order, tight restrictions were placed on various aspects of political life. The state controlled all media and the education system. Strict limitations were applied to freedom of speech. And elections were manipulated to secure the success of the government party, *Golkar*, at the ballot box. Access to various kinds of historical resources such as newspapers and archives was limited by the government. Communist party newspapers or any others that were considered 'leftist' were banned or categorized as restricted materials. These publications are still kept in the National Library but they are on restricted access. Researchers who wish to use them have to seek permission from the government through the National Intelligence Coordinating Body (*Badan Koordinasi Intelijen Negara*) and the head of the National Library. This is frustrating for researchers, students and prominent Indonesian historians alike who wish to interrogate these sources. History students, for instance, still have to choose undergraduate thesis topics which are considered 'not sensitive' based on governmental criteria.

An official history textbook was also published only forty days after the attempted 'coup'. It relied heavily on the prominent military historian, Nugroho Notosusanto, and an anti-communist ideology which was essential to legitimizing the New Order. As Katharine McGregor put it:

> Of all historical events, representations of the 1965 coup attempt as a communist plot were critical for the regime. The story behind the rush to produce the first published version of the coup in days, the determination to defend this version to the outside world in light of the Cornell Paper [a preliminary analysis of the coup by Benedict Anderson and Ruth McVey[17]] and the progressive and elaborate memorialisation of the well at Lubang Buaya all confirm this claim.[18]

Notosusanto worked as a lecturer at the University of Indonesia from 1964. His first task as a historian was to write an army version of the history of the independence struggle.[19] This commission was in fact an order from General, A. H. Nasution, chief of staff of the armed forces and minister of defence. The aim of this 1964 publication was to challenge a rival history said to be planned by the leftist National Front which the regime believed would leave out an account of the so-called Madiun Affair in 1948, a previous communist revolt against the government,[20] which occurred on 18 September 1948 during the National Revolution in the town of Madiun. Leftist parties, the PKI and the Indonesia Socialist Party (*Partai Sosialis Indonesia*) led an uprising against the leaders of the newly declared Indonesian Republic. The new Republican forces eliminated the uprising.

In 1983, the New Order government released a four-hour film – the filmmaker called it a docu-drama – of the coup entitled *Pengkhianatan G 30 S PKI (The Treachery of the 30 September Movement)*. New students at the University of Indonesia were the first audience to publically see the film. It was part of the indoctrination workshop on Pancasila as the National Ideology at that time. The majority of the students believed that the film fairly reflected the facts of what was shown to be a tragedy perpetrated by the communist party. The docu-drama was then screened across the country and was a box office hit, not because everybody wanted to see it but because it was compulsory to do so. Notosusanto was the key person in the making of the film. He developed a film script based on the government's version of the coup. The film was first screened and checked by various people including the president and senior military figures.[21] It paid attention to the details in reconstruction of the kidnapping of the generals. The kidnapping and the death of each general was portrayed as a 'horror' to the audience, further

demonizing communists.[22] The message of this New Order propaganda to Indonesian youth was that communist party should not be allowed to exist in Indonesia.

Under the New Order, Pancasila moral education was made compulsory throughout the country. The subjects started in state universities in the early 1980s and in high school in the mid-1980s. Youth were indoctrinated against leftist (communist) ideology which was categorized as a danger to national unity. Students attended a lecture on Pancasila as a national ideology and were required to present a paper on it, first in small discussion groups and then to the whole class. At the university level this was a compulsory subject which had to be passed. In later years all government employees had to take Pancasila indoctrination courses. As David Bouchier has observed, this was all aimed at creating a bond of loyalty between the people and the regime.[23] The propaganda was effective since the authoritarian New Order government was the only source of national history. Those who expressed different opinions on the nation's past were considered leftist and a potential threat to national security.

While the New Order foundational myth retains its potency, during the mid-1990s, challenges to this story emerged. The context included the emergence of the international human rights movement which grew out of the civil rights movement in the late 1970s and focused its activities on totalitarian regimes, helping to bring about a human rights law which passed through the Indonesian parliament (*Dewan Perwakilan Rakyat*, or DPR) in 1999; the rise of the internet which made different narratives more accessible and, depending on the source, more authoritative;[24] and economic crisis, brought about in part by deep-seated and widespread corruption in Indonesia. Although Asia was hit by a general financial crisis in 1997, Indonesia was deeply affected by the collapse of the clove industry – then the second largest source of Indonesia's tax revenue – in that year. The monopoly Clove, Support and Marketing Agency (*Badan Penyangga dan Pemasaran Cengkeh*), formed by Tommy Suharto in 1990, was largely responsible for this industry's collapse.[25]

Growing fear and hatred of Suharto and his immediate relatives – derisively referred to as 'the family' – saw Suharto driven out of office by public demonstrations in 1998. He resigned on 21 May. In the immediate years leading up to this backlash, a number of publications appeared about the coup.[26] Some were memoirs. Many were banned. But they continued to be read in private and contributed to destabilizing the New Order version of the coup. After Suharto's fall, works on the coup mushroomed. Contestation over

the official version of the coup grew to a point where, by the end of 1999, the new president, Adburrahman Wahid, attempted publically to address human rights issues and interrogate the New Order history. This, combined with an attempt to revoke the 1966 decree which outlawed Marxism and Leninism, led to political turmoil. Conservative religious leaders slammed Wahid and in April 2000 anti-communist student demonstrations broke out in Jakarta.[27] It was clearly too early for post–New Order Indonesia to radically revise its national past.

Moves to create a Truth and Reconciliation Commission (TRC) from late 2000 also failed. After four years and two presidential administrations, legislation was passed by the DPR which provided the process for the establishment of a TRC. Commissioners were nominated in 2005. A year later the Constitutional Court (*Mahkamah Konstitusi*) ruled that such a body could not entertain claims for 'compensation, restitution, rehabilitation and amnesty ... simultaneously' until it had been proven that 'gross human rights violations had actually occurred'.[28] It was not until July 2012 that the National Human Rights Commission (*Komnas HAM*) declared that the coup was a 'gross human rights violation' and urged that military officials involved should be 'taken to court for various crimes, including mass rape, torture and killings'.[29]

Feminist voices

There has been a strong emerging commitment to democratization and pluralism through critical and revisionist public histories emanating from Indonesia in the wake of the New Order. However, recent work is largely marked by deep-seated gender blindness. This mirrors a long line of literature on Indonesian politics and history that is authored by and focused on the lives of men.[30] Nevertheless, a small group of feminist historians and women's groups are writing women back into the often-universalizing narratives of Indonesian history. In doing so, they recognize the specificities of Indonesian women's diverse experiences and their contributions to projects of nation building, creating a more democratic and inclusive public history landscape in which to ground understandings of Indonesian identity as well as contemporary feminist activism.

Feminist historians face significant challenges in attempting to tell women's histories in public.[31] It is difficult to maintain historical authority in a context where empiricist approaches are easier to accommodate

and often favoured within national histories. This is compounded by the spaces in which women's histories take place – often outside official political realms[32] – making them less accessible and devalued.[33] The evidence available to document women's histories is also sparser and more ephemeral than in other cases, resulting in further undervaluing in a context where empirical approaches still hold historical authority. These factors are exacerbated in the New Order political climate, where women's organizing was actively suppressed and much documentary evidence of past activism destroyed.[34]

Much feminist public history work has tended to focus on the New Order foundation narrative – the 30 September Movement. The official version of the coup specifically positioned Gerwani women, rather than other members of the PKI, as the perpetrators of the murders. Gerwani was the women's organization of the PKI, which was an overtly political feminist voice. Other women's groups primarily focused on social issues, such as marriage and welfare reform, that accorded with the officially sanctioned role of women, the *kodrat*.[35] The Gerwani women were said to have engaged in torture, mutilation and castration prior to the executions, underscored

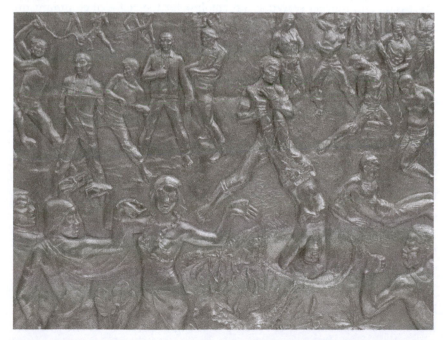

Figure 7.2 Part of the bas-relief frieze on the Sacred Pancasila Monument. Photo Paul Ashton.

by broader insinuations of them as hypersexual, promiscuous and sexually sadistic.[36] They were even purported to have performed the Dance of the Fragrant Flowers – an allegedly obscene and sexualized dance – at the site of the murders. This part of the official narrative is literally enshrined in the frieze at the Sacred Pancasila monument (see Figure 7.2).[37] Testimonies of Gerwani members and the official autopsy reports – signed and approved by Suharto himself – disprove this interpretation.[38]

Despite the centrality of Gerwani women in the official narrative around the coup, mainstream revisionist accounts of it and New Order history have sidelined or ignored this gendered aspect altogether. Women are relegated to what Steven Drakely calls a 'macabre footnote'.[39] The misogyny of this foundation story served in many ways to legitimize the Suharto regime. The positioning of Gerwani as perpetrators served to demonize the group and, by extension, the political party of which they were a part. Moreover, the portrayal of the aggressors as women served to otherize and demonize the PKI even more in comparison to Suharto's forces. As Drakely notes, 'although intrinsically horrifying, the alleged murders, tortures, and mutilations appeared even more so as the acts of women'.[40] The inversion of gender roles in women straying from caring, passive femininity into hypersexuality, aggression and murder served as a metaphor for the chaos of communism and the Sukarno regime. By extension, this promised a return to traditional morality through the New Order. It also created the framework for Suharto's conservative policies on women, what Julia Suryakusuma describes as 'State Ibuism', wherein women were perceived as dependant, domesticated appendages of their husbands.[41]

Conclusion

On 20 April 1975, the massive *Taman Mini Indonesia Indah* (TMII) – park of beautiful Indonesia in Miniature – was opened by President Suharto in East Jakarta. It had been under construction since 1971. Suharto's wife, Tien Suharto, had suggested the idea to engender national pride having visited 'such tourist attractions as Disneyland in the United States and Timland in Thailand'.[42] There was some public disquiet about the deployment of resources into such a scheme, including a few tiny student demonstrations. But most Indonesians opposed to it did their protesting in private.[43] While internal and foreign tourism was part of its function, TMII's principal purpose was ideological. It was a national monument to ethnic diversity which sanitizes

difference. In his address of welcome, later printed in the first official guide to TMII, Suharto said: 'By visiting this Park we will know ourselves better, we will know our nation better and we will love our motherland more. Therefore the "Beautiful Indonesia Park" is also a real effort to strengthen national development, both now and in the future.'[44]

The demise of the New Order in Indonesia has left a historiographical vacuum which individuals and groups from a broad range of perspectives are trying to fill. Some, like Professor Azyumardi Azra, are seeking to straddle the divide between professional and public history. Memory has emerged as a key issue in public debates, attempts have been made at reconciliation between the left and the right, though these faltered, and turf wars have broken out between historians and novelists such as the late Pramoedya Ananta Toer. The movement for freedom of expression, however, did have a victory. On 15 October 2010 the fifty-year-old law allowing the government to ban books deemed 'able to disrupt public order' was lifted.[45] Publications such as John Roosa's *Pretext for Mass Murder* began to circulate legally.[46]

Public history in Indonesia is at a crossroads. New Order history has been successfully challenged but its legacy still holds sway. Public history's future in Indonesia is likely to be a turbid negotiation between state-sanctioned or sponsored accounts of the past and more democratic forms of history.

Notes

1. John Roosa, *Pretext for Mass Murder: The September 30th Movement and Suharto's Coup d'Etat in Indonesia* (Madison: University of Wisconsin Press, 2006). For a general history of Indonesia, see Adrian Vickers, *A History of Modern Indonesia* (Cambridge: Cambridge University Press, 2010).
2. David Thelen, 'The Nation and Beyond: Transnational Perspectives on United States History', *Journal of American History* 86, no. 3 (1999): 965.
3. David Christian, 'History and Global Identity', in *The Historian's Conscience: Australian Historians on the Ethics of History*, ed. Stuart Macintyre (Melbourne: Melbourne University Press, 2004), p. 149; Jeremy Black, *Contesting History: Narratives of Public History* (Bloomsbury: London and New York, 2014), p. 7.
4. Vickers, *A History of Indonesia*, p. 147.
5. See, for example, Nagesh Rao (ed.), *Exile: Pramoedya Ananta Toer in Conversation with Andre Vltchek and Rossie Indira* (Chicago: Haymarket Books, 2006), pp. 32–3. See also a critical account of Pramudya's role in Indonesian historiograhy: Hilmar Farid, 'Pramoedya dan histortiografi

Indonesia', in *Perspektif Baru Penulisan Sejarah Indonesia* (*New Perspective on Indonesian Historiography*), ed. Henk Schulte Nordholt, Bambang Purwanto and Ratna Saptari (KITLV-Jakarta, Pustaka Larasan: Yayasan Obor, 2013), pp. 79–110.

6. Eka Darmaputera, *Pancasila and the Search for Identity and Modernity in Indonesian Society* (The Netherlands: E. J. Brill, 1988), pp. 151–2.

7. Vickers, *A History of Indonesia*, p. 162.

8. Richard Tranter, 'Indonesia's Dangerous Silence', *Inside Story*, 28 April 2011. http://inside.org.au/indonesia-dangerous-silence/ (accessed 29 October 2016).

9. James Fentress and Chris Wickham, *Social Memory* (Oxford: Blackwell, 1992), pp. xi–xii.

10. http://thebigdurian.wordpress.com/2010/10/25/lubang-buaya-memorial-park/ (accessed 29 September 2016); see also http://jakarta.travel/ (accessed 29 September 2016).

11. Roosa, *Pretext for Mass Murder*, p. 7.

12. Benedict Anderson, 'How Did the Generals Die?', *Indonesia* 43 (April 1987): 109–34.

13. See, for example, *Sriwijaya Post*, 30 September 2011.

14. www.juliasuryakusuma.com/column.php?menu_id=1&year=2011& month= 10&column_id=266 (accessed 12 August 2017); reproduced from her article in *Jakarta Post*, 1 October 2011.

15. See Mary S. Zurbuchen, 'History, Memory and the "1965 Incident" in Indonesia', *Asian Survey* 24, no. 4 (2002): 566. Some of the scenarios include Suharto masterminding the events, the involvement of foreign intelligence agencies such as the CIA, a struggle over power between the armed forces and a combination of these.

16. Asvi Warman Adam, 'Pengendalian Sejarah sejak Orde Baru', in *Panggung Sejarah: Persembahan kepada Prof. Dr. Denys Lombard*, ed. Henri Chambert-Loir and Hasan Muarif Ambary (Jakarta: Yayasan Obor, 1999), pp. 567–77.

17. The Cornell Paper concluded that the coup emerged from the internal conflict in the army. See Benedict Andersen and Ruth McVey, *A Preliminary Analysis of the October 1, 1965 Coup in Indonesia* (Ithaca: Cornell University Modern Indonesia Project, 1971).

18. Katharine E. McGregor, *History in Uniform: Military Ideology and the Construction of Indonesia's Past* (Singapore: National University of Singapore Press, 2007), p. 221.

19. Kelompok Kerdja Staf Angkatan Bersendjata, *Sedjarah Singkat Perdjuangan Bersendjata Bangsa Indonesia* (*A Concise History of the Armed Struggle of the Indonesian Nation*) (Jakarta: Staf Angkatan Bersendjata, 1964).

20. Kate McGregor, 'A Soldier Historian', *Inside Indonesia* 68 (2001).

21. McGregor, *History in Uniform*, p. 96.

22. For a detailed account of the film, see McGregor, *History in Uniform*, pp. 96–100.

23. David Bourchier, 'Lineages of Organicist Political Thought in Indonesia', PhD thesis, Department of Politics, Monash University, Clayton, 1996.

24. See Paul Ashton and Paula Hamilton, *History at the Crossroads: Australians and the Past* (Sydney: Halstead Press, 2010), p. 134.

25. Michael Backman, *Asian Eclipse: Exposing the Dark Side of Business in Asia* (Singapore: John Wiley, 2001), pp. 267–72.

26. See Institute for Studies on the Free Flow of Information, *Bayang-Bayang PKI (Shadows of the PKI)* (Jakarta: Institut Studi Arus Balik, 1995).

27. Zurbuchen, 'History, Memory and the "1965 Incident"', 572.

28. *Jurist*, 8 December 2006; Dedy A. Prasetyo, 'Indonesia's Truth and Reconciliation Commission as a Mechanism for Dealing with Gross Violations of Human Rights', LLM (Human Rights) thesis, Faculty of Law, The University of Hong Kong, 2006.

29. *Jakarta Post*, 23 July 2012.

30. Elizabeth Martyn, *The Women's Movement in Post Colonial Indonesia: Gender and Nation in a New Democracy* (Oxon: Routledge Curzon, 2005), p. 8.

31. Saskia Wieringa, *Sexual Politics in Indonesia* (New York: Palgrave, 2002), pp. 16–18.

32. In many mainstream histories, even women's organizations are judged to be outside conventional politics and hence are not documented. For more details, see Martyn, *The Women's Movement*, p. 9.

33. Martyn, *The Women's Movement*, p. 8.

34. Ibid., p. 14. See also 'Indonesia: The Ups and Downs of the Indonesian Women's Movement', *Jakarta Post*, 20 December 2010; Susan Blackburn, *Women and the State in Modern Indonesia* (Cambridge: Cambridge University Press, 2004), p. 19.

35. Wieringa, *Sexual Politics*, pp. 98–9.

36. Ibid.

37. Ibid., p. 25.

38. Helen Van Klinken, 'Coming Out', *Inside Indonesia* 58 (1999). www.insideindonesia.org/edition-58-apr-jun-1999/coming-out-2209692 (accessed 29 September 2016).

39. Steven Drakely, 'Lubang Buaya: Myth, Misogyny and Massacre', *Nebula* 4, no. 4 (2007): 12.

40. Ibid., 23.

41. Julia Suryakusuma, 'The State and Sexuality in New Order Indonesia', in *Fantasizing the Feminine in Indonesia*, ed. Laurie Jo Sears (Durham and London: Duke University Press, 1999), pp. 92–119. See also Julia Suryakusuma, *State Ibuism: The Social Construction of Womanhood in New Order Indonesia* (Komunitas Bambu: Depok, 2011).

42. *Apa dan Siapa Indonesia Indah* (*What and Who Is Beautiful Indonesia*) (Jakarta 1975), p. 21.

43. See, for example, Benedict Anderson, 'Notes on Contemporary Indonesian Political Communication', *Indonesia* 16 (1973): 39–80; and J. Hendy, *The Orient Strikes Back* (Oxford: Berg, 2000).

44. 'Words of Welcome', in Hendy, *The Orient Strikes Back*, 9.

45. *Jakarta Post*, 1 October 2010. www.thejakartapost.com/news/2010/01/10/on-alert-afainst-tampering-with-freedom.html (accessed 25 January 2017).

46. See John Roosa, 'On Book Banning in Indonesia', *VIVanews*, 3 February 2010. http://us.en.vivanews.com/news/read/126605-on_book_banning_in_Indonesia (accessed 12 May 2017).

8

Public History in New Zealand: From Treaty to Te Papa

Alex Trapeznik

Public history is still a relatively unknown term in New Zealand, an island nation in the southwest pacific with a population of around 4.6 million people. Until the late 1980s it was rare for professional historians to practise their profession outside the academy. Most of the few who did were public servants attached to institutions such as the Department of Internal Affairs or the major museums. Expanding work opportunities in the institutional, museum and historic heritage sectors have, however, fostered an increase in the number of freelance historians, some of whom are now participating in the identification, assessment, interpretation and management of New Zealand's historic places. In the 'turf wars' common to new fields of enterprise an 'us and them' approach has given way to a recognition that public and academic historians utilize the same skills in research, analysis and writing that are taught in universities.[1]

The establishment of the Professional Historians' Association of New Zealand/Aotearoa in 1994 has provided a forum for representing and advancing the interests of New Zealand's professional historians. The formation of the Centre for Public History at the University of Otago in 1995, along with several course offerings at other universities, were concrete indicators of the growth of public history in this country.[2] In the early 2000s Victoria University began to offer a master's in public history, and in 2009 the Waikato University Centre for Public History was established to facilitate

and promote public history projects. However, by 2014 the Victoria degree course lapsed and the Waikato Centre had changed its name to the Public History Research Unit and has since become simply the History Research Unit. The New Zealand context has shown that academic programs in public history have only a small niche market and a limited shelf life. Today the focus has turned to heritage and museum studies.[3]

A critical literature devoted to public history developed from 2000 with the publication of key texts such as *Common Ground? Heritage and Public Places in New Zealand* (2000) and *Going Public: The Changing Face of New Zealand History* (2001) were complemented by many scholarly historical works, most of them supported by the state. As Nancy Swarbrick has observed, 'Alongside and underpinning this developing literature, there has been an increased demand for historians and historical analysis beyond the education sector. For some time, the Waitangi Tribunal and the History Group of the Ministry for Culture and Heritage have been major employers of historians and the historical method.'[4] Until 2000, this group had been the Historical Branch (previously the Historical Publications Branch) of the Department of Internal Affairs. In addition to the Waitangi Tribunal which investigates long-standing Maori claims against the state, historians are employed in a number of other government organizations dealing with Treaty of Waitangi issues (the Office of Treaty Settlements, the Crown Forestry Rental Trust and the Crown Law Office). There is also a great deal of historical research conducted at the local level, in museums, archives and historical societies. In addition, there are many freelance and contract historians currently employed across New Zealand on historical projects that speak to audiences beyond the academy.[5] To enhance, stimulate and facilitate public history research in New Zealand the electronic journal the *New Zealand Journal of Public History* first appeared in 2011. It is published intermittently by the History Research Unit at the University of Waikato and is devoted to the discussion, debate and dissemination of ideas about the practice of public history in New Zealand.[6]

Recent scholarship in the field evaluates the potential of a new method of public history by exploring the contemporary meaning of history and the relevance of history, historical knowledge and historical methodology for organizations through a novel adaptation of a consulting methodology, the 'Learning History Approach', to understand what individuals and communities say and do about history. This approach sits at the intersection of interdisciplinary research on historical consciousness, public history and 'learning histories' from organizational studies. It shows how an adaptation

of the original learning history methodology can both fit within and challenge the conceptual frameworks of public history. Raising historical consciousness and engaging more people with the historical discipline is vital for the health of the historical discipline. Therefore, the learning history approach can be an effective means of expanding participatory historical culture. This is because the approach draws participants into reflective and often transformational conversations about historiographical issues such as historical community and heritage. Ultimately, this view reflects the need to build a more participatory historical culture and the active role of academic, professional historians in realizing that culture.[7]

Difficult communications for much of the nineteenth century made European settlement in New Zealand highly localized, and strong regional identities and loyalties persist to the present day. Early local histories were mostly celebratory and sentimental, applauding the achievements of the 'pioneers'. From the late nineteenth century – when the country's population was around 800,000 – jubilees of schools, churches and small towns nearly always produced publications, but these were often small-scale and amateurish by modern academic standards. Publishers began to show interest in more serious works of local history in the 1920s and 1930s, many of which first appeared in serial form in local newspapers. The centenary of the Treaty of Waitangi in 1940 and subsequent provincial centenaries aroused greater public interest in local history. Local and regional history are now well-respected genres of New Zealand history. Several important works appear most years, almost all of them well up to professional scholarly standards.

Since the late nineteenth century local and central government have sponsored many projects in both Māori and Pakeha (non-Māori) history and the study of Māori origins and culture. Emerging at first modestly governmental backing of historical activities expanded significantly from the 1980s. Some landmark government-sponsored history projects from the 1980s include the *Dictionary of New Zealand Biography*, which was published in print in 1990 and digitally in 2001, and the *Bateman New Zealand Historical Atlas*, published in 1997. The latter drew on the expertise of a range of historians and archaeologists as well as cartographers, under the editorship of Malcolm McKinnon of the Historical Branch of the Ministry of Internal Affairs. The atlas 'broke new ground in its spatial representation of history'.[8]

Work on the pioneering reference website *Te Ara: The Encyclopedia of New Zealand* began in 2002, ten 'themes' being released sequentially

until the 'first build' was complete in 2014. By then, the work comprised about a thousand entries making use of 30,000 resources, which included photographs, works of art, sound recordings, film, maps and interactive features. The general editor was Jock Phillips of the Ministry of Culture and Heritage. 'Te ara' in Māori means 'the pathway' and this website offers many pathways to understanding New Zealand. Short essays and multimedia combine to present a comprehensive guide to New Zealand's peoples, natural environment, history, culture, economy and society. It was the world's first 'born-digital' national encyclopedia. Te Ara is also a gateway to cultural information from other institutions, with links to the digital collections of libraries, archives and museums around the country. An important feature of Te Ara is its Māori content. The Māori perspective is presented prominently, and items with substantial Māori content are available in *te reo* (the Maori language). Te Ara also provides access to the 1966 *Encyclopaedia of New Zealand* and the *Dictionary of New Zealand Biography*.

Museums began to employ trained historians as curators from the late 1960s. At the Dominion Museum, for instance, the impending bicentennial of James Cook's discovery of New Zealand led to the appointment of the first 'curator of colonial history' in 1968. Changes to the law governing historic places led to the wider employment of professional historians. Often on short-term contracts, they researched management plans for historic reserves for the Department of Lands and Survey from 1977 on. Historians and archaeologists were also needed from 1975 to carry out research for the Historic Places Trust's new register of pre-1900 archaeological sites. The Trust's role in classifying historic buildings was formalized in 1980 and its regulatory powers extended in 1993. Regional and local authorities were given greater responsibility for identifying and protecting historic places under the Resource Management Act of 1991, and they too often employed historians.[9]

Defining public history is not simple. Leslie H. Fishel, Jr, admits that 'it almost defies definition' but offers 'a stepping stone towards [a] greater understanding' of this definition. For Fishel, 'public history is the adaptation and application of the historian's skills and outlook for the benefit of private and public enterprises'.[10] Some may consider this too narrow. But whatever definition is used, all encompass two important elements.

First, audience is important in public history. It might range from a wide and general one – for example, the audience for TV programs, museum labels or heritage trail guides – to a narrower one, such as an audience for tribunal reports, school centennial histories or government agency reports.

Nevertheless, the audience for public history will almost always be wider than that for academic research. Second, public history is usually undertaken for a particular reason, for instance, to mark a milestone in the history of a group, to promote public understanding of a little-known aspect of history, to advance the legitimacy of a social group or to schedule a historic place. That reason usually forms part of the commissioning process: the group or person commissioning the work will have specific questions to be answered, and specific features upon which focus is to be placed.[11] On the other hand, many groups carry out the research and writing of histories themselves; Jorma Kalela has argued that public historians' 'prime role is to act as consultants who provide expert advice'.[12]

Public historians seek to make history serviceable to the present and the future. They are interested in creating a forum where different elements or perspectives of the historical record, broadly conceived, can be presented and caused to produce their own synthesis. Their products include official or government histories; Treaty of Waitangi–related research; histories of social movements; institutional and business histories; local, community or family histories; museum interpretation; websites; and historic building research and assessment. The reader, viewer or visitor of or to a work of public history is an integral part and participant in this synthesis of the historical record. Local, community and family historians are 'active agents' in breaking down the perception of a 'rigid demarcation between "historians" and "their publics"'.[13] By concerning itself with the presentation of history to a wide audience, public history casts a wide net that covers not only history but also heritage in its many guises. This interrelatedness between history and heritage in a contemporary sense has forced history (and historians) into the marketplace as never before. Nevertheless, instead of defending heritage in purely economic terms, historians, members of one of the few professional groups which studies the past for its own value, find themselves engaging the community as a central component in any synthesis of the historical record. In achieving this new synthesis, our material culture, or that part of it that is comprises historic sites and artefacts, should play a significant part as a source in documenting our past.

In the early twenty-first century the most exploited and misunderstood word or idea in the field of public history is 'heritage'.[14] In a country where land-based heritage or historic places have largely monopolized the term, 'heritage' is widely used as a synonym for 'historic place'. Historic places include archaeological sites, *wahi tapu* – places sacred to the Māori in the traditional, spiritual, religious, ritual or mythological sense – and natural

features with significant human associations. Definitions of heritage and opinions of its cultural value vary considerably. In its broadest sense, 'heritage is the things of value which are inherited'[15] whether on a personal or collective level.

If definitions of heritage remain fuzzy, its move from the private arena to the public is sharply obvious. In its most basic and original form, the concept of heritage was simply conceived as private property, something that could be inherited, bought or sold. Private knowledge and ownership was control. More recently, however, heritage has taken on a new meaning. 'At first yours or mine,' David Lowenthal observes, 'heritage soon becomes inherently collective.'[16] 'Heritage,' he continues, 'more and more denotes what we jointly hold with others – the blessings (and curses) that belong to and largely define a group.'[17] At a national level, collective identity incorporates commonly agreed-upon cultural values. With this sort of collective sense of identity we can speak of 'our' heritage or 'national' heritage. Yet even such broad meanings of heritage are constantly being redefined and reshaped. There exists an ongoing national self-evaluation and introspection by a changing population base. The renaissance of Māori culture, together with migration from continental Europe, the Pacific islands and Asia, has altered perceptions of 'our' national heritage. In the most jarringly obvious example, the naval ensign no longer runs quietly up the flagstaff to close ceremonies marking the national anniversary, Waitangi Day. At Waitangi and elsewhere a number of groups and communities have been asserting their identity within a national framework that has traditionally focused on a British heritage.

Why do we need to preserve the past, and for whose benefit and at what cost? Opinions vary. 'To celebrate their patrons' regimes, Renaissance historians ran down the past in favour of the present,' David Lowenthal observes, 'whereas antiquarians studying ruins and relics magnified past achievements to the detriment of the present.'[18] Preserving evidence of the past is central to individual and collective identity and existence, for it serves as a central point of reference, and contributes to providing life with purpose and meaning. In Māori tradition:

> all elements of the natural world are related through whakapapa (genealogy). The Maori world was created through the union of Ranginui (the Sky Father) and Papatua-nuku (the Earth Mother) ... Traditional Maori attitudes to the natural world reflect the relationships created through Rangi and Papa: all living things are their descendants and are thus related. Further, the sense of interrelatedness between people and nature creates a sense of belonging to

nature, rather than being ascendant to it, as humans are born from 'mother earth' and return to her on their death.[19]

Māori see people, nature and the land as being inextricably intertwined. Their view of history and heritage is based on a shared *whakapapa* in which 'all things are from the same origin and ... the welfare of any part of the environment determines the welfare of people'.[20] Another relevant term is *taonga* (treasured possessions), a concept which includes both tangible and intangible treasures and *korero*. H. M. Mead asserts that to appreciate fully the meaning and cultural significance of *taonga* the word *korero* needs to be introduced. 'All objects that are called taonga have korero attached to them ... [it] means talk associated with creation and production of works of art and particularly with the stories and explanations given by artists and patrons to such works.'[21] More specific places that are *taonga* include *wahi taonga, wahi tapu* and *wahi tupuna*. *Wahi taonga* and *wahi tapu* have been described as places of special value and places of sacred and extreme importance.[22]

It is important to note that tangible objects that are fixed and non-living (the built environment) may include, and often do, intangible qualities. This approach towards understanding our built heritage is very much a Pakeha view and is one that focuses on 'humankind as separate from the landscape'.[23] The Māori notion of heritage sees it as an integral part of the landscape and something that is inseparable from daily life. Aspects of this heritage are recognized as matters of national importance.

In the end, despite statutory requirements and definitions that purport to be rigorous, thorough, qualitative and/or quantitative, the whole process is finally based upon a subjective judgment of significance or value. However, we can identify a number of factors for consideration, albeit tangible ones, that may influence a decision to register a building or building site. Some factors determining significance include rarity, representativeness of building style, the architect, builders, cultural significance, significant owners or occupants, local or regional significance, materials, relative age, condition, integrity of landscape and history of use.[24]

Indeed, it is possible to conclude that historic places offer one of the most promising avenues for public historians. The work of anthropologists and archaeologists has already opened many invaluable windows on the period before Maori–European contact. Without the scholarship of archaeologists and architectural and urban historians, many of the stunning plates of the *New Zealand Historical Atlas* would not have been possible. The challenge for

public historians will be to enter the heritage industry in sufficient numbers to ensure that New Zealand preserves and presents the widest possible range of historic places and to strive to ensure that it clearly and honestly articulates their significance. As the art critic Robert Hughes said while surveying the mess that Sydney has made of part of its historic waterfront, 'the claims of the past do need to be heard'.[25]

Yesterday's ephemera are today's treasures. Relics of the past once consigned to eclectic local museums and antique shops now can be found throughout the entire country in a wide range of contexts. We take solace from the past and its buildings, relics and landscapes. They provide us with comfort and a source of collective identity in a globalized, internet-connected world where points of reference are sometimes obscured. There has been surge in the popularity of history in public, for example, historical and genealogical societies, history on the internet, biography, and history on film and television. But there has been at the same time general disengagement with this phenomenon on the part of the academy.

On the internet, the main useful, informative sites are sponsored by the government. *NZ History* is a website where one can explore New Zealand's culture and society, politics and government, and the impact of war in particular.[26] *DigitalNZ*, launched in 2008, is aimed at making New Zealand digital content easier to find, share and use. To date there are over 25 million digital items available to view from over 120 partner organizations. These include cultural institutions, government departments, publicly funded organizations and educational and research organizations, as well as the private sector and community groups. The contents of *DigitalNZ* include photographs, artworks, newspapers, books, other archival material, journal articles, music, film and data sets.[27] *AncestryDNA* is New Zealand's principal family history research site. There, genealogists can find collections of historical records, historical, and genealogical resources to help them trace their New Zealand ancestors.

New Zealand's government-sponsored First World War centenary program has provided the shared 'WW100' identity for the variety of official, national, community and personal commemorations of New Zealand's role in the First World War from 1914 to 1919. Formal government ceremonies have been organized at battlefields on the Gallipoli Peninsula, on the Western Front and in the Middle East to mark the centenary of key First World War events. The official government legacy projects include Sir Peter Jackson's 'The Great War' exhibition at Te Papa, the national museum and the Pukeahu National War Memorial Park in Wellington and the

development of the Auckland War Memorial Museum's online 'Cenotaph' database of New Zealand service personnel. For those New Zealanders visiting the battlefields of Gallipoli or the Western Front, the Nga Tapuwae New Zealand First World War Trails project has provided site interpretation and information at battle sites and museums together with free apps and online resources. The Ministry of Culture and Heritage is working with Massey University, the New Zealand Defence Force and the Royal New Zealand Returned and Services Association to produce a series of centennial histories on New Zealand and the First World War.

The WW100 program was supported by the New Zealand Lottery Grants Board, which made available more than $25 million between 2013 and 2016 to support community projects. Creative New Zealand, a government-funded arts council, provided $1.5 million to support collaborative arts projects to mark the centennial of the First World War. A landmark national exhibition, realized with the assistance of Lottery Grants Board funding, is the $8 million Te Papa-Weta Workshop's 'Gallipoli: The Scale of Our War'. Eight New Zealanders are depicted in key events during the campaign in 2.4 times life-size dioramas, and the exhibition has already attracted more than one million visitors. Regional and local museums throughout New Zealand continue to mark the centenary of the First World War with exhibitions and events featuring local stories. The Toitu Otago Settlers Museum's exhibition 'Dunedin's Great War 1914–1918' included a popular in-house documentary 'The Journey of the Otagos', and attracted 200,000 visitors in 2014 and 2015. The National Army Museum created the travelling exhibition 'Heartlanders: New Zealanders of the Great War' which toured the country in 2016 while in the same year the Aratoi Wairarapa Museum of Art and History presented the popular exhibition 'Featherston Camp 1916–2016: The Record of a Remarkable Achievement'.

The death of public service broadcasting other than from Maori television has meant the big growth in interest in history seen overseas – notably on PBS, BBC or the History Channel – has largely passed by New Zealand terrestrial television.[28] The *BBC History* magazine, for example, lists a wide range of historical TV and radio programs that rarely make the screen here, and if they do, they are sometimes shown years late and of course are not about New Zealand. A landmark in New Zealand television was historian James Belich's five-part series of the 1990s' *The New Zealand Wars* which took a new look at the history of Māori versus Pākehā armed conflict. This popular series reframed New Zealand history. *The New Zealand Wars* was judged Best Documentary at the 1998 Qantas Media Awards.

Unfortunately, there has been no follow-up series. Occasionally, a foreign series incorporates something about New Zealand. Tony Robinson's *Tour of Duty* (2015) included a segment about New Zealand – Dunedin and Auckland for programs to mark the centenary of the Gallipoli campaign – though it was mostly about Australia. By default, local museum curators have become engaged in historical documentary films. In June 2014, *Toitū* curator Seán Brosnahan embarked on a journey to follow in the footsteps of the Otago Infantry Battalion and Otago Mounted Rifles during the First World War. The resulting documentary – *The Journey of the Otagos* – was the first film ever to be made on solely on the Otagos' participation in the First World War. The eleven documentary episodes were shown in the 'Dunedin's Great War' exhibition at *Toitū* Otago Settlers Museum. There is also his forthcoming documentary about Chinese settlers and their rugged lives in the Otago region.[29] It helps to explain why Dunedin has a Chinese garden, and will be called 'The Journey to Lan Yuan', after the gardens.

Bridget Williams Books is a publisher of historical works aimed at a wider public. Some notable recent examples of books by academic historians include Barbara Brookes's *History of New Zealand Women* (2016), Andrew Sharp's new biography of *Samuel Marsden* (2016) and Ben Schrader's *'The Big Smoke': New Zealand Cities 1840–1920*. The one non-academic historical periodical, other than Heritage New Zealand's *Heritage New Zealand*, is *New Zealand Memories* magazine, a unique and absorbing bimonthly publication promoting New Zealand's heritage.

The sort of public history festivals that attract huge numbers in the America and Britain do not seem to have taken off in New Zealand. Some local examples include the annual Tauranga Medieval Faire and events organized by various military re-enactment societies.

History of technology is catered for by private groups. For example, the Dunedin Gasworks Museum preserves the surviving part of the now closed Dunedin Gasworks, which was New Zealand's first and last gasworks which operated from 1863 until 1987. It is one of only three preserved gasworks museums in the world and is a significant local and world heritage site. Another is Auckland's Museum of Transport and Technology, which is New Zealand's largest transport, technology and social history museum.

Heritage is often confused with nostalgia, a view that equates the past with something that is intrinsically worthwhile and good. It is a view that is safe and secure and that accords with the past being considered a distinctly marketable commodity. Good examples of heritage tourism and how history has become a marketable product are Shanty Town Heritage Park

near Greymouth constructed and opened in the early 1970s. It consists of thirty recreated historic buildings making up a nineteenth-century gold-mining town. Ferrymead Heritage Park in Christchurch, which features an early 1900s (Edwardian) township, has exhibits such as houses, a picture theatre, school classroom, church, jail, railway station, lodge hall, post office, printers, tobacconist, general store and lawyer's office. They promote a view of the past that is comforting and non-confrontational, disseminating a history without context and without people. When history becomes a product it often becomes alienated from the past, bearing no resemblance to what has happened to people in times gone by, yet of commercial necessity claiming to depict accurately all that has previously happened.

Monuments, markers, buildings, plaques and memorials play an important function in providing social cohesion. Their shared stories help individuals within a society connect with each other and provide a shared community heritage. At a national level, collective identity incorporates cultural values that are commonly agreed upon. With this sort of collective sense of identity we can speak of 'our' heritage or 'national' heritage. For instance, Jock Phillips's recent authoritative work on war memorials, *To the Memory* (2016), builds upon widespread interest generated by the centenary of the First World War, whereas his pioneering publication on the subject, *The Sorrow and the Pride*, attracted relatively little public attention on its appearance in 1990.[30] Yet even such broad meanings of heritage are constantly being redefined and reshaped. A changing population base brings with it national introspection and continual self-evaluation. Migration from Europe and Asia and the rise of Maori culture have altered perceptions of national heritage. A range of groups and communities are now asserting their identity within a national framework that has traditionally focussed on a British heritage.

New Zealand retains a unique assemblage of places of cultural heritage value relating to its indigenous and its more recent peoples.[31] Many people feel a common responsibility in trying to safeguard our cultural heritage for present and future generations. Moreover, many people are interested in conserving not only our built heritage but also in understanding their own family or *whanau*, local, regional and national histories. History is not the exclusive prerogative of the professional historian: the interested public can be 'active agents' in creating their own histories.[32] The practice of public history, which deals with the public presentation of the past, takes many forms and accommodates varied perspectives and interests, but the goal of

the professional public historian remains constant – to broaden the public's appreciation and understanding of the past. As Ludmilla Jordanova states, 'Whatever the complexities of "public", public history is a useful label, in that it draws attention to phenomena relevant to the discipline of history, but too rarely discussed in undergraduate courses.'[33]

Notes

I am grateful to Dr Aaron Fox for providing details about centenary First World War celebrations, and Dr Austin Gee for his helpful suggestions and proofreading skills.

1. For a wider discussion of historians and the New Zealand heritage sector, see Gavin McLean, 'It's History Jim, but Not as We Know It: Historians and the New Zealand Heritage Industry', in *Going Public*, ed. Bronwyn Dalley and Jock Phillips (Auckland: Auckland University Press, 2001), pp. 158–74.

2. Nancy Swarbrick, 'Public History', *Te Ara: The Encyclopedia of New Zealand*, 30 September 2014. www.TeAra.govt.nz/en/public-history/print (accessed 14 November 2016).

3. The University of Auckland offers a Master of Arts in Museums and Cultural Heritage' Victoria University a Master of Museum and Heritage Studies; and Massey University a Master of Arts in Museum Studies.

4. Swarbrick, 'Public History'.

5. 'Introduction', *New Zealand Journal of Public History* 1, no. 1 (December 2011): 2.

6. www.waikato.ac.nz/fass/research/centres-units/hru/nzjph (accessed 11 September 2016).

7. M. S. Smith, 'Using the Past: Learning Histories, Public Histories and Possibilities', PhD thesis, University of Waikato, Hamilton, New Zealand. See also Mark Smith, ' "Every Brick a Boy". The Invention of Tradition and the Use of History: Preliminary Observations from a "Learning History" at Southwell School', *New Zealand Journal of Public History* 1, no. 1 (December 2011): 43–59.

8. Swarbrick, 'Public History'.

9. Ibid.

10. Leslie H. Fishel, Jr., 'Public History and the Academy', in *Public History: An Introduction*, ed. Barbara J. Howe and Emory L. Kemp (Malabar, FL: Robert E. Krieger, 1986), p. 12.

11. Based on unpublished seminar notes by Bronwyn Dalley, Historical Branch, Department of Internal Affairs, Wellington, 1997.

12. Jorma Kalela, *Making History: The Historian and Uses of the Past* (Basingstoke: Palgrave Macmillan, 2012), p. 161.

13. Hilda Kean and Paul Ashton, 'Introduction: People and Their Pasts and Public History Today', in *People and Their Pasts: Public History Today*, ed. Paul Ashton and Hilda Kean (Basingstoke: Palgrave Macmillan, 2009), p. 1.

14. The Office of the Parliamentary Commissioner for the Environment's (PCE) landmark report, *Historic and Cultural Heritage Management in New Zealand* (Wellington: PCE, 1996), observed on page two that the word 'heritage' occurs in relevant New Zealand legislation in several places, but its definition (where provided) and usage varies considerably. The PCE accepted that most New Zealanders understand heritage to mean historic places.

15. C. Michael Hall and Simon McArthur, 'Heritage Management: An Introductory Framework', in *Heritage Management in New Zealand and Australia: Visitor Management, Interpretation and Marketing*, ed. C. Michael Hall and Simon McArthur (Auckland: Oxford University Press, 1993), p. 2.

16. David Lowenthal, *The Heritage Crusade and the Spoils of History* (Cambridge: Cambridge University Press, 1998), p. 55.

17. Ibid., p. 60.

18. David Lowenthal, *The Past Is a Foreign Country* (New York: Cambridge University Press), pp. 35–6.

19. Manatu Maori, *He Kakano I Ruia Mai I Rangiatea: Maori Values and Environmental Management* (Wellington: Department of Internal Affairs, 1991), p. 2.

20. T. Tau, A. Goodall, D. Palmer and R. Rau, *Te Whakatau Kaupapa: Ngai Tahu Resource Management Strategy for the Canterbury Region* (Wellington: Department of Internal Affairs, 1990), pp. 3–4.

21. H. M. Mead, 'The Nature of Taonga', in *Taonga Maori Conference: New Zealand 18–27 November 1990* (Wellington: Department of Internal Affairs, 1990), p. 164.

22. Tau, Goodall, Palmer and Rau, *Te Whakatau Kaupapa*, pp. 7–12.

23. Hall and McArthur, 'Heritage Management', 4.

24. Ibid., 10.

25. Robert Hughes, 'A History Forgotten', *Reflections* 3 (1998): 9.

26. www.nzhistory.net.nz/ (accessed 14 November 2016).

27. www.digitalnz.org/ (accessed 14 November 2016).

28. Radio also has a paucity of programs devoted to history, two notable exceptions being the recently defunct Jim Sullivan's Sunday evening show 'Sounds Historical' and Jack Perkins's 'Spectrum' on Radio New Zealand National.

29. From about 1866 until the 1870s, the hills near Roxburgh in Central Otago were home to about 4,500 Chinese miners.

30. Jock Phillips, *To the Memory: New Zealand's War Memorials* (Nelson: Potter & Burton, 2016), a much revised and extended version of Chris Maclean,

Jock Phillips and Debbie Willis, *The Sorrow and the Pride: New Zealand War Memorials* (Wellington: GP Books for the Historical Branch, Department of Internal Affairs, 1990).

31. 'Preamble', *ICOMOS New Zealand Charter for the Conservation of Places of Cultural Heritage Value*, 1993.
32. Kean and Ashton, 'Introduction', 1.
33. Ludmilla Jordanova, *History in Practice* (London: Arnold, 2000), p. 141.

9

Public History in Scandinavia: Uses of the Past

Anne Brædder

Is there such thing as public history in Scandinavia? The immediate answer to that would probably be 'no'. There are no public history classes, programs or lectures at the main Scandinavian universities and scholars do not include the field as an area of teaching or research in their professional profiles. But does the absence of the term public history mean that Scandinavian historians do not care about how the past is present in public or how the public engages with the past? The answer in my view is 'no'. Scandinavian historians are equally interested in the presence of the past in a contemporary context and the past's meaning to the public as historians in other parts of the world. But we do not necessarily identify with public history. We come out of different traditions around history culture and historical consciousness that has its origins in German history didactics. And we have been influenced by the interdisciplinary field of memory studies.[1] We often term our tradition as 'uses of history'. So, if you searched for 'historiebrug' or 'historiebruk' – 'uses of history' in Danish, Swedish and Norwegian – when looking for courses or scholarly profiles at Scandinavian universities the results would be far richer.

Scandinavian interest in how the past is present and being used outside universities sprouted in the 1980s and 1990s. But it did not flower until the late 1990s.[2] This coincided with the re-emergence of interest in the role of memory in the social sciences and the rise of a 'commemorative fever' during these decades.[3] This might lead some to think that the Scandinavian tradition is rooted in memory studies. But I would argue that the Scandinavian tradition concerning uses of history has been influenced by

both public history and memory studies. There has been surprisingly little interaction between these two fields. Due to language barriers there has been even less interaction between the Scandinavian tradition involving the uses of history and public history and memory studies.

This chapter is a first step into multi- and cross-disciplinary work in these entangled fields. First, I introduce different theories about uses of history developed by Scandinavian historians. Then I draw on my own research with living historians concerning former work practices in open-air museums in Denmark to demonstrate how public history and a theoretical comprehension of historical consciousness – strong in a Scandinavian tradition on uses of history – can be a starting point for analysing how people engage with and use the past for entertainment, identity and the questioning of contemporary value systems.

Uses of history: Scandinavian theories and typologies

'Uses of history' is not a foreign concept in Nordic science of history. Since the early twentieth century it has been widely adopted as a scholarly term and as a teaching area, and not only at universities. It has also been adopted in municipal primary and lower-secondary school curriculum for six- to sixteen-year-olds, at least in Denmark.[4] But few historians have tried developing theories and typologies regarding different forms that the use of history can take. These include Swedish historians Klas-Göran Karlsson and Peter Aronsson and Danish historian Bernard Eric Jensen. They have substantially contributed to the development of the field. They refer to each other's work but has never gone into an in-depth discussion on concepts and theories even though their interest in the uses of history and their typologies differ. Jensen was the first to develop a theory that focuses on the role of history outside academia. He did so in the 1980s and 1990s. And his approach relates most closely to public history, as demonstrated in some of his publications which draw on two important books in the field: Raphael Samuel's *Theatres of Memory* (1994) and Roy Rosenzweig and David Thelen's *The Presence of the Past*, which appeared four years later.[5] Thus, I will concentrate on Jensen's work.

Jensen's central concept is historical consciousness with which he wishes to grasp how people live with and use pasts as a part of being human. Living

in time and with time is a part of people's lifeworld. Jensen defines historical consciousness as:

> the interaction that exists between people's interpretation of the past, understanding of the presence and future expectations ... Historical consciousness is based on the circumstance that the past is present in the presence as a memory and as an interpretation of the past, and that the future is present as a set of expectations. The concept thus addresses the attention to the human condition of existence that in a lived present there is always a remembered past as well as an expected future.[6]

The coherence between past, present and future is critical to Jensen's understanding of historical consciousness. His view on history relies on connections between times and he distinguishes this from a more traditional view of history equating to the past – something that is finished. For Jensen, history is not over; only the past is.[7]

Jensen theory of historical consciousness is influenced by the two German historians: Reinhart Koselleck, who works in the field of conceptual history, and Karl-Ernst Jeismann, who works with history didactics. History didactics had until the 1970s been preoccupied with history teaching in school and historical knowledge. But from the end of the 1970s history didactics began also to focus on history outside school. In the Nordic context Jensen played a central role in this paradigm shift. He argued that the study of historical consciousness – its formation and functions – should take into account that historical consciousness is shaped in various situations, not just schools, and that the role of history teaching is also to adapt and further develop children's historical consciousness.[8] It is important to stress that historical consciousness and historical knowledge are not the same. In some of his later work, Jensen developed examples of how historical consciousness is shaped and used. These include historical fiction, cartoons, photographs, paintings, music, songs, theatre, movies, the media, political or social movements, travel, museums, symbols, rituals, life stories and family stories.[9] People meet and engage with the past in a wide spectre of places and situations.

For Jensen it is critical that the past is both present and usable as a lived experience. Historical consciousness conceptualizes the way the past is usable to people: it plays a functional role for people. These functions can be understood as his typology. People use the past when: (1) forming their personal and collective identity – understanding themselves; (2) meeting others and 'otherness' – understanding other people and cultures; (3) using the past as a learning process – learning from the past; (4) using the past to

clarify values, interests, principles and ideologies; (5) studying or working with the past as a profession or as an intellectual and learned activity; and (6) entertaining themselves.[10]

The six different functions can be paired up. Number one and two have to do with identity work. Number three and four have to do with using the past as a sociocultural learning process. The first four are probably the ones that Jensen himself is mostly preoccupied with. The fifth and sixth were added in some of his later work in the new. The different functions are clearly divided in the typology but will often overlap in praxis.

Jensen's concept of historical consciousness has been criticized for being difficult to operationalize.[11] And Jensen is working more philosophically and theoretically than empirically. This is perhaps why Jensen finds Rosenzweig and Thelen's *The Presence of the Past* so inspiring. Empirically, it shows very clearly how people root themselves in pasts regarding their personal and collective identity. Using the six functions as methodological tools is a way one can apply the concept of historical consciousness analytically.

Contrary to Jensen, Klas-Göran Karlsson has developed a theory on uses and typology of history based on empirical work. In the 1990s his research focused on uses of history in post-Soviet societies from which he identified different forms of uses of history.[12] With his colleague Ulf Zander, Karlsson further developed this typology and used it to analyse the Holocaust in European history culture.[13] Karlsson argues that by analysing the uses of history, a history culture and an underlying historical consciousness can be uncovered.[14] The differences between Karlsson and Jensen is not only empirical but conceptual. While Jensen's central concept is historical consciousness – and later the concept's close, almost overlapping connection with uses of history – Karlsson is more concerned with historical culture and uses of history. Jensen is more preoccupied with people's use of pasts and how they live with it; Karlsson is more concerned with the use of pasts in societies and the presence of the past in history cultures. In other words, 'people' are not as visible in Karlsson's theory as in Jensen's.

Karlsson's typology points out seven different forms of uses of history when history is activated in communicative processes to meet different needs and interests. These related to specific users, needs and functions, but he seems to be mainly interested in the needs and functions. In this sense, Karlsson's typology also has to do with different functions pasts have in contemporary contexts: (1) a scientific use of history is practised by

historians and teachers. It serves the need of exploring and reconstructing and in this process, it functions to verify and interpret; (2) an existential use of history is practised by everyone. It serves the need of remembering and forgetting, and in this process it functions to anchor people and as a tool to navigate in life; (3) a moral use of history is practised by intellectuals and the well-educated. It serves the need of re-exploring and in this process, it functions to rehabilitate, restore and reconcile; (4) an ideological use of history is practised by intellectuals and political elites. It serves the need to invent and construct and in this process, the function is to legitimize and rationalize; (5) a non-use of history is also practised by intellectuals and political elites. It serves the need to forget and destroy, and in this process the function is also to legitimize and rationalize; (6) a political-pedagogical use of history is practised by intellectuals, political elites and pedagogues. It serves the need to illustrate, publish and debate, and in this process the function is to politicize; (7) a commercial use of history is practised by people preoccupied with advertising and economics. It serves the need of earning and increasing the value of history and in this process, the function is commercializing.[15]

The third Scandinavian typology on the uses of history was developed by Peter Aronsson in his 2004 book *Historiebruk: att använde det förflutna*. Aronsson differs between two types of uses of history. On the one hand, a non-critical use of select parts of the accumulated history culture. This may occur when people walk around a city or cultural landscape, when they make use of language and gesture, when visiting museums or when participating in a celebration or commemoration. On the other, a goal-oriented, political past or one related to identity politics where certain parts of the accumulated history culture are drawn upon.[16] Aronsson's central concept is history culture. He argues that history culture consists of how history in time and space has left traces in archives, artefacts, rituals, habits and statements with reference to the past.[17] According to Aronsson we have to deal with the uses of history when parts of the history culture – material, visual, linguistic and so forth – are chosen and activated to make sense, legitimate, to handle change based on the relation between the past, present and future or to perform a mixture of these functions.

Like Jensen and Karlsson, Aronsson also has a typology regarding uses of history. This seems to be segregated by users – including people and institutions – rather than different forms or functions: cultural heritage institutions, schools and universities; media, entertainment and consumption; the public and; people's personal stories and artefacts.[18]

Aronsson's own research concerns cultural heritage and he has focused more on materiality and heritage in his research than Karlsson or Jensen.

These three different theories on uses of history have had a great influence on how Scandinavian historians have been working in different ways with history outside academia in the public domain. This does not mean that all research in Scandinavia is done by using one of these theories as analytical tools. But it does mean that attention is often turned to how history is being used by people but often more diffusely in society and the culture without focusing on any specific users or their practices.

Contrary to the move in public history across the world to share historical authority, the Scandinavian tradition about the uses of history is not particularly preoccupied with laymen or ordinary people, and there is no democratic impulse to challenge the hierarchy around academic and lay historians. Neither is there a particular focus on practice. Paying attention to people's active history-making activities when the past is being used is in something that Scandinavian historians could learn from public history in other countries. But public historians elsewhere could also reflect more deeply on people's practices when engaging with the past. And they could consider the application of theories and typologies on uses of history dealt with here by asking questions, as some of them do, such as: How is the past used in people's history-making practices? And in what situations is the past usable? My work with living historians on their history-making practices in open-air museums provides an example.

Living historians reflecting on past and present

There are several national and local open-air museums in Denmark. Most of them show life and work in the countryside in the eighteenth and nineteenth centuries. Some represent life and work in towns in the twentieth century. As part of my PhD dissertation I investigated academically untrained people volunteering at three different open-air museums as living historians because they are interested in history. Simulating the past in open-air museums is not only an embodied history-making practice where living historians communicate how former people lived and worked; this practice involves living historians reflecting on the relation between the past and present and how the past is usable to them

as lived experience. Here, living historians use, shape and reshape their historical consciousness.

I interviewed eighteen living historians while they were simulating different former work practices from the nineteenth and twentieth centuries – for instance, producing wooden tools to be used at farms, bricks, barrels and brewing beer and repairing radios and mopeds. Most of them were male pensioners between fifty-three and eighty years old, though some were still working. But they all shared an interest in the past and in communicating it to others. Simulating the past is a hobby through which they gain pleasure and entertainment. As one of them said, 'I wouldn't go and work at The Danish Museum of Photographic Art ... There's a lot of things we deselect because they don't have our interest.'[19] Several of them emphasized that they had 'grown up with an interest in the past'[20] or developed this interest 'at one's mother's knee.'[21] In this sense, pasts are usable to them in a present context as a meaningful way of entertaining themselves. That is one of Jensen's uses of the pasts. But living historians also use the past for identity purposes and as a sociocultural learning process.

Many of the living historians said that simulating life and work in the different open-air museums had to do with their 'roots' and where they 'come from.'[22] According to one of them, 'we want to know something about our ancestors, right? ... It's a chapter in one's life, and if you don't go in for it ... you are walking completely empty-handed through life without knowing what actually happened before I was here. That ... I can't even imagine.'[23] Living historians form connections with their ancestors, but they also connect to a diffuse collective and national identity. As one of them said, it has to do with 'something about heritage and a national feeling.'[24] When living historians simulate former work in open-air museums they are not simply entertained by the past: they root themselves in it. They feel as if they grew out of the past they are simulating. As Jensen says, they use the past to understand themselves. Their embodied history-making practices have to do with identity work.

Many of the living historians also connect with value systems in the pasts they are simulating. As Jensen has argued, they use the past to clarify or legitimate their values and principles. Bearing in mind the living historians' re-enactments, it is not surprising that they reflect on past and present manufacturing processes. Producing and repairing by hand using old methods and technologies provides a contrast to modern industrial processes. Several of them said that today you just 'push a button';[25] they stressed the importance of knowing where things come from – not everything

'comes from a supermarket'.[26] They seemed to value former manufacturing processes more than to contemporary ones.

Simulating former work practices also moved the living historians to associate the past with many other values they felt connected with and that they uncritically argued are lost in today's society. The simulated past seems to be a reservoir of positive values.[27] One of them said that when he was doing woodwork he was reminded of values 'in the old Danish societies that are worth keeping people aware of'. When I asked him what kind of values he was thinking of he responded: 'respecting different work' and 'helping each other'. He also argued that people today are 'individualists'.[28] Others expressed a dichotomy between past and present and individuality and community. But these were not the only value-based statements. They also argued that in the past people were more 'modest' and 'satisfied with life even though it was hard work';[29] 'things could be done simpler';[30] and today we 'pollute and produce and produce and throw away'[31] instead of repairing. Living historians use the past to argue for their own present values. Their simulations of the past in open-air museums can be seen as a way for them to preserve not only former work practices and national heritage but also what they consider to be more authentic, better values that they consider threatened today.

Conclusion

There is a relationship, yet to be more fully explored, between public history in various countries around the world and the Scandinavian tradition of the uses of history. Scandinavians working with the past outside academia do not necessarily identify with public history, nor do academic historians with interests in historical practices beyond the traditional discipline. But much of the work done in Scandinavia analysing different forms and uses of history can be considered part of the diffuse, global public history movement. Perhaps, more importantly, a fruitful dialogue could develop between the two traditions. From public history, we can learn that history comprises a set of practices and activities and that history-making practices are done by everyone. From a Scandinavian perspective, we can learn to focus not just on people's engagement with the past outside academia, but also ask how people are using history and for what reasons and purposes.

Notes

1. Anette Warring, 'Erindring og historiebrug. Introduktion til et forskningsfelt', *TEMP – tidsskrift for historie* 2 (2011): 6–7.
2. Ibid., 7–8.
3. Barbara A. Misztal, *Theories of Social Remembering* (Berkshire: Open University Press, 2003), p. 2.
4. Warring, 'Erindring og historiebrug', 11.
5. For instance, Bernard Eric Jensen, 'Usable Pasts: Comparing Approaches to Popular and Public History', in *Public History and Heritage Today. People and Their Pasts*, ed. Paul Ashton and Hilda Kean (Basingstoke and New York: Palgrave Macmillan, [2008] 2012), pp. 42–56; Bernard Eric Jensen, 'Historie som erindring – påsporet af menigmands historiebrug', in *At bruge historie i en sen-/postmoderne tid*, ed. Bernard Eric Jensen (Frederiksberg: Samfundslitteratur, 2000), pp. 197–226.
6. (Author's translation). Bernard Eric Jensen, 'Historiebevidsthed og historie – hvad er det?', in *Historieskabte såvel som historieskabende*, ed. Henning Brinckmann and Lene Rasmussen (Gesten: OP-forlag Aps, 1996), pp. 5–6.
7. Bernard Eric Jensen, *Hvad er historie* (København: Akademisk Forlag, 2010), p. 8; *Fortidsbrug og erindringsspor* (Aarhus: Aarhus Universitetsforlag, 2014), p. 13.
8. Warring, 'Erindring og historiebrug', 9.
9. Bernard Eric Jensen, *Hvad er historie* (København: Akademisk Forlag, 2010), p. 14.
10. Jensen, 'Historiebevidsthed og historie', 7; Bernard Eric Jensen, *Historie – livsverden og fag* (København: Gyldendal, 2003), p. 70.
11. Ola S. Stugu, *Historie i bruk* (Oslo: Samlaget, 2008), p. 19; Klas-Göran Karlsson, 'Historiedidaktikkens teori', in *Historien är nu. En introduktion till historiedidaktiken*, ed. Klas-Göran Karlsson and Ulf Zander (Lund: Studentlitteratur), 47f; Bertel Nygaard, 'Tid for historie?', *TEMP – tidsskrift for historie* 11 (2015): 159.
12. Klas-Göran Karlsson, *Historia som vapen: Historiebruk och Sovjetunionens upplösning 1985–1995* (Stockholm: Natur och Kultur, 1999).
13. Klas-Göran Karlsson, 'The Uses of History and the Third Wave of Europeanisation', in *A European Memory?*, ed. Matgorzata Parkier and Bo Stråth (West Sussex: Princeton University Press, 2010), pp. 38–57; Klas-Göran Karlsson and Ulf Zander, *Echoes of the Holocaust. Historical Cultures in Contemporary Europe* (Lund: Nordic Academic Press, 2003); Klas-Göran Karlsson and Ulf Zander, *Historien är nu* (Lund: Studentlitteratur, 2004); Klas-Göran Karlsson and Ulf Zander (eds), *Holocaust Heritage.*

Inquiries into European Historical Cultures (Malmö: Sekel Bokförlag, 2005); Klas-Göran Karlsson and Ulf Zander (eds), *The Holocaust on Postwar Battlefields. Genocide as Historical Culture* (Malmö: Sekel Bokförlag, 2006).

14. Warring, 'Erindring og historiebrug', 25.
15. Karlsson. *Historia som vapen*, pp. 58–60; Karlsson, 'Historiedidaktikkens teori', 52–66.
16. Niels Kayser Nielsen, *Historiens forvandlinger* (Aarhus: Aarhus Universitetsforlag, 2010), p. 16.
17. Warring, 'Erindring og historiebrug', 26.
18. Peter Aronsson, *Historiebruk – att använda det förflutna* (Lund: Studentlitteratur, 2004), p. 44.
19. Ulrikke, 11 October 2015.
20. Lauge, 28 October 2015.
21. Klaus, 28 October 2015.
22. Marie, 2 November 2015; Maja, 11 October 2015; Ulrikke, 11 October 2015; Otto, 4 November 2015; Morten, 11 October 2015.
23. Lauge, 28 October 2015.
24. Maja, 11 October 2015.
25. Kaj, 13 October 2015; Peter, 17 November 2015.
26. Karl, 13 October 2015; Kaj, 13 October 2015.
27. Anette Warring has concluded similarly in her studies of laymen simulating the Iron Age. Anette Warring, 'At rejse i tid – fortidsfamilier i Sagnlandet Lejre', in *Fortider tur retur. Reenactment og historiebrug*, ed. Tove Kruse and Anette Warring (Frederiksberg: Samfundslitteratur, 2015), p. 57.
28. Morten, 11 October 2015.
29. Lauge, 28 October 2015.
30. Marie, 2 November 2015.
31. Peter, 17 November 2015.

10

Public History in South Africa: A Tool for Recovery

Julia C. Wells

It could be that a wave of violent student unrest from 2015 to 2016 provided the impetus to bring public history practice more to the forefront in South Africa's thinking about how to use its troubled past. The protests started with a demand to remove a statue of colonial empire builder, Cecil John Rhodes, from the University of Cape Town (UCT) campus, but escalated into a nation-wide movement demanding free higher education. At the end of 2016, most universities in the country had shut down irregularly, scrambling to salvage a whole academic year. Spear headed by black students who claimed that university environments remained untransformed areas of social exclusion to them, the movement exposed the simmering rage experienced by the youthful generation at the slow pace of change in dismantling the old racially defined social order in South Africa. They never lived under its direct rule, but experience its legacy on a daily basis. The student who started it all by throwing faeces on the statue claimed: 'It is a black cry, a cry of the workers, a cry of the staff and a cry from the students.'[1] What started as a direct attack on a statue as a symbol of 'institutional colonialism' found deep resonance across the entire country.[2]

Professor Mahmood Mamdani, former head of UCT's Centre for African Studies, has become an outspoken voice in outlining what would truly transform the character of South African universities.[3] Using examples from newly independent East Africa in the 1960s, he called for a radical break from western models in the production of knowledge. Universities, he stressed, are a western creation, based on disciplines which each have their own sets of

rules, but function in isolation from each other. To become truly relevant to the African postcolonial context, intellectuals should break through these barriers and work in more interdisciplinary ways, thinking outside of the box and grappling with their own local realities. Too much theorizing from the West should not substitute for hands-on knowledge production.

What Mamdani proposes is familiar terrain for public historians. Public history practice as a methodology has long highlighted the importance of active participation with its intended audiences. Michael Frisch's vision of 'shared authority' has become a starting point for many who accept the value of not only seeking information about peoples' feelings and experiences, but also producing 'scholarship that is at once intellectually trenchant, politically meaningful and shareable with the communities from which it comes'.[4] Thoms Cauvin cautions that while studying the past requires sources and interpretation, historians should not only be writing for each other, but 'also for and with others'.[5] But in South Africa, the skills of the public history professionals have not been widely embraced.

The period since the beginning of democracy in 1994 has been characterized by a deep standoff between 'history' and 'heritage'. Following the British usage, the term 'heritage' overlaps considerably with activities that elsewhere are viewed as 'public history'. Since 1994, government-led initiatives, classified as heritage, exploded in popularity on a level that took most academics by surprise. Many professional historians recoiled from what they saw as superficial, government propaganda, trying to artificially forge a new national identity by controlling how the past was remembered. Some took up the task of critiquing the heritage sector through various forms of new heritage studies.[6] Still others embraced the challenge, using the tools of public history to ensure that the best attributes of academic historical inquiry found a home within the vast new heritage sector.

But academic history generally failed to attract a new generation of young black talent, pre-empting robust debates about society's greatest anguish. Anthropologist Ben Magubane argued, 'We should not forget the deep wounds that it (colonialism) left in the hearts and minds of its victims … History books never confronted what it meant for black folks to be treated as non-persons in the country of their birth.'[7] This heartfelt plea remains largely unaddressed. Historians' focus on international theory, he contended, 'revealed a gross misunderstanding of the African reality and especially the nature of Africans' struggles'.[8] His depiction of black peoples' exclusion from the corridors of knowledge production foreshadowed what would eventually explode in the student unrest in 2015.

As a public historian who served in local government as an elected representative for fifteen years, as well as on the National Heritage Council at its inception, I view the gap between history and heritage as unnecessarily exaggerated. It can be narrowed by reflecting on the evolution of uses of the past during the first two decades or so of democracy and by appreciating the good efforts that have been done by several public historians. The current student upheavals expose the unfinished work of confronting three hundred years of institutionalized racism. Underlying the much-criticized discourses on 'nation-building' and 'commemoration' lies a fundamental need to recover the dignity of the African people. This includes confronting and uprooting painful experiences of racism, taking into full consideration the reality of deeply rooted economic inequality. This is an agenda that remains important, yet has seldom been confronted in academic publishing about uses of the past, while it remains in the forefront of government policy.

Out of my faith in public history practice, I embarked some years ago on an exploratory research exercise to learn what leading practitioners might consider the best examples of public history in the service of the people. This included interviews with colleagues and visits to a few sites. It was not a comprehensive survey, but was intended to serve as a beginning to consider what *does* work in a highly contested terrain, as will be discussed below. This chapter deals with the broad outlines of the history verses heritage confrontation.

Historians in the shadow of heritage

Most within the history profession in South Africa agree that the discipline experienced something of a 'golden era' when it found an active role in the struggle against apartheid during the 1970s and 1980s. The University of the Witwatersrand in Johannesburg set up its own History Workshop, modelled after its British counterpart, working within Marxist social history theoretical frameworks. Starting in 1977, the History Workshop promoted populist and worker histories through new research using much oral history, the production of user-friendly publications, holding conferences and seminars and running cultural days on campus to celebrate the diversity of African cultures.[9] By all definitions this was robust public history, described as 'exhilarating' with 'an air of daring', remembered for opening up new realms of complexity in speaking of the past, while using it to empower people to find the courage to overthrow the oppressive regime of the present.[10]

In Cape Town, people deeply concerned with the history of District Six formed a foundation in 1989 to tell its story in their own way. This was a racially mixed residential area, bulldozed because it did not fit in with the apartheid plans for total segregation. Through tireless efforts, the foundation worked with historians from the University of the Western Cape (UWC) to establish the District 6 Museum 'as a vehicle for advocating social justice, as a space for reflection and contemplation and as an institution for challenging distortions and half-truths'.[11] At every turn, the public participated in special projects and designed the content of the museums' exhibitions. Both the History Workshop and the museum embodied the principles of democratic participation in constructing meaning from the past, particularly by the oppressed. Both started operations under serious threat from the apartheid state, which only heightened the value of their inclusive and democratic principles.

Expectations that history would take off after the start of democracy in 1994, however, were not realized. In fact, the opposite happened. Leslie Witz recalls how when he started teaching at UWC in 1990, history enrolments stood at 3,000 students, but then eventually levelled off at between 200 and 300.[12] Historians scrambled to understand why the disaffection came so quickly and ran so deep. Veteran historian, Colin Bundy, claimed that 'the last decade has been disquieting, even demoralizing – for South African historians'.[13] Historians who had been deeply involved in struggle history found themselves now 'at a loss'.[14] He suggested that the sharp drop in interest in history after 1994 may have been a symptom of a widespread unwillingness to look back, and a tacit agreement to look forward, as articulated by government leaders of the day.

Indeed, government overtook the business of engaging with the past with an energetic pace that left many academics behind. It quickly moved to support a number of innovations, often designed to help forge a new positive national identity under the umbrella term of 'nation-building'. This also affirmed the value and dignity of the pasts of the majority of the African population who had been generally written out of history. Government held high expectations of what could be achieved through a different kind of use of the past to bring 'empowerment, restitution and social justice'.[15] An official definition of what is included in the heritage sector reveals its wide reach:

> The national heritage system in South Africa consists of Museums, Monuments, Heritage Sites and Resources; Geographical Place Names; Heraldry and National Symbols; Archives and Public Records: and Libraries and Information Services. It is made up of tangible and intangible heritage

resources as well as Living Culture in the form of cultural traditions, customs, oral history, performance, ritual, popular memory, social mores and knowledge of nature and divers natural resources.[16]

For members of the general public, the term 'heritage' often reflects the subtle, intangible parts of their own sense of identity. In a recent feature on celebrity views of heritage, Sibongile Khumalo, a prominent singer, said, 'I am deeply attached to my heritage. It helps me understand myself and my positions in the world. It helps me make sense of my past and also shapes my worldview of what is and what can still be.'[17] Chef Siba Mntogana said, 'My heritage is my language, values, morals, view of the world, the food I grew up eating; it's my culture, my traditions, belief systems and customs.'[18] Trumpeter Hugh Masekela claimed, 'My heritage is inborn and indelible.'[19] This deeper understanding of heritage has been largely missed by academic historians who focused more often on its tangible side.

The evolution of the heritage industry and its critics saw a relatively rapid pace of change. The start of a new, democratic dispensation in 1994 required a huge amount of social engineering, as the old regime was replaced by something different. Derek Peterson is one of the few historians who compare South Africa's transition to the experiences of other African countries as they moved out of colonialism.[20] Due to the weight and force of colonial attempts to define African people primarily as 'tribes', whose characteristics were frozen in time, every new African government tackled the need to do some kind of nation-building exercise to build unity and create a new sense of identity.[21] Critiques of South Africa's nation-building agenda view it narrowly as about legitimation of the ruling party, without taking broader needs into consideration. International benchmarking from postcolonial states gives nation-building a more functional profile, related to the profound need for revamping the inherited colonial presence.

During its first few years of democracy, South Africa developed a strong reconciliation discourse to serve the immediate transitional needs. 'Rainbowism', now much maligned as unrealistic and naïve, could be better evaluated in terms of the ways that it contributed to implanting a human rights ethic to replace apartheid repression.[22] The 1996 South African constitution is considered a global model of articulating a human rights discourse, which remains cherished and defended in present times. Related to heritage, the new government speedily produced a new coat of arms, new public holidays and a new flag, among other new symbols of a break from the past.[23] Although no doubt much overused, the official slogan of the Robben

Island Museum – 'the triumph of the human spirit' – provided a storyline of strength in the face of adversity and a positive spin on the cruel past. The 1995 Truth and Reconciliation Commission set the tone of a changed nation by acknowledging the atrocities committed in the past and signalling that they would never be acceptable in the future. Another key feature of the early transition period was a proliferation of a number of heritage 'Legacy' projects.[24] It proved to be much easier to start afresh with something new than to transform old institutions. The whole nation-building task of the new government has come under close scrutiny from historians. But most of these early strides from the era of the Mandela presidency are underrated for their enduring value in rebuilding the nation.

When Thabo Mbeki replaced Nelson Mandela as president of South Africa in 1999, he advocated a strong, fresh commitment to what he called the 'African Renaissance'. This marked a significant departure from the earlier politics of reconciliation by placing much higher emphasis on honouring African achievements and culture. Attention shifted away from the politics of appeasing those (mostly whites) who had lost power under the new democracy to stressing positive characteristics of Africanness. It went much further than simply placing more black people and black experiences in essentially Euro-centric institutions, and also began to move beyond valorizing the anti-Apartheid struggle as the sole highest achievement of the African people. In spirit, it accelerated the process of decolonizing minds from the domination of Eurocentrism and resonates with a long tradition often referred to as 'black consciousness' in South Africa. This shift put the restoration of African dignity centre stage. But in so doing it left many white historians feeling marginalized.[25]

Another important feature of the African Renaissance took the form of identifying and utilizing a wide variety of forms of African Indigenous Knowledge Systems. This movement sought to unearth and document uniquely African forms of knowledge about the natural environment, as well as spiritual values, customs, symbols and languages. The emphasis started with widespread investment in research, but extended to reviewing issues such as intellectual property rights and assisting with economic development grounded in indigenous knowledge. As the emphasis on retrieving the intangible from the African past grew, government also provided funding to build and consolidate oral history, managed through the National Archives. Pursuit of documenting the content of African knowledge and cultural practices remains a high priority of leading government thinkers today.[26]

Today the *National Heritage Act* of 1999 should be seen as the product of the early transition period of reconstruction. Efforts to address the backwardness of the heritage sector when it came to museums and sites of significance, inherited from the apartheid era, tended to be somewhat mechanical and superficial, leaning too heavily on international models of limited relevance. The spirit of wanting to effect radical change was not matched by mechanisms to bring them about. The first round of transformation was revionist, simply making the inherited institutions more inclusive of black peoples' experiences, referred to by Witz, Minkley and Rassool as the 'add-on' complex.[27] The 2016 White Paper on Arts, Culture and Heritage notes that 1996 efforts to legislate an integrated national policy on museums failed to be implemented.[28] 'In practice,' it reported, 'the patchwork of institutions were retained and in some instances renamed, while new structures were also added. This resulted in the retention of the outdated, fragmented and uncoordinated system with all its gaps, overlaps and duplications.'[29] A thorough overhaul is still needed.

By the early 2000s, many academic historians rejected heritage as a form of bogus history. This was sharply discussed at a major conference in Copenhagen in 2002. 'Heritage is a form of public history produced by those outside the professional historical fraternity,' claimed Gary Baines.[30] Carothers viewed heritage as 'quite subordinate to history – like antiquarian, home-made history done by amateurs' whereas 'historians have expertise which make them custodians of the past'.[31] Heritage is often viewed as preserving the past, not studying it.[32] Unlike a careful study of the nuances of history, 'Heritage is often a recreation of the past, an act of remembrance, through the giving of a name, the erection of a monument or the way objects are displayed in a museum.'[33] At its worst, in the eyes of academics, heritage appears to be about 'commodification in pursuit of tourist's spending'.[34] As Hans Eric Stolten has noted, 'The question of how to develop a practice that can enable a constructive combination of scholarly work and political engagement remains a central issue in South African historiography.'[35]

The honeymoon ends

Service delivery protests are said to have started in South Africa in 2004. These were fairly numerous public protests, at times violent, demanding that government deliver promised new services, such as providing water,

electricity, flush toilets, street lights and housing. They have become a permanent feature of South African society, but their start signalled that the honeymoon was over from the initial reconciliatory transition period. The heritage sector also experienced a number of protests. In both Kliptown and Port Elizabeth, major new museum and commemorative projects had to be put on hold due to violent protests from local low-income residents who demanded that their immediate needs for better housing should take priority.[36] In other cases, communities split over issues of ownership and consultation about new heritage sites.[37] It became clear that patience was running out as the hopes for significantly changed lives began to fade. For Meskell, the good intentions of the earlier days were now 'overshadowed by the understandably "greater needs" of fiscal recovery and development'.[38] Sheer poverty left little room for thinking about the meanings of the past. As she says, 'The processing of history, the unmaking and making of heritage, cannot hope to offer the *muti* – the healing or therapy to ameliorate the past and re-enhance the future – without some attention to the specifics of a deeper history'.[39]

When the National Heritage Council (NHC) came into existence in 2004, concerns over the potential for heritage work to fuel economic development and to create jobs ranked high on the agenda. Ten years into the new dispensation, it was clear that economic growth was not what had been projected, as old patterns of economic inequality remained firmly in place. The NHC viewed tourism as holding the potential to both provide financial support for heritage initiatives, as well as create long-term sustainable jobs. South Africa's democracy still remains most threatened by the continuing disparities in income between rich and poor. Job creation is central to the 2016 White Paper on Arts, Culture and Heritage, which conceptualizes a whole creative economy to 'foster income generation, job creation and export earnings while promoting social inclusion, cultural diversity and human development'.[40] Within the heritage sector, job creation is most often linked with tourism, an industry which contributes more to the South African economy than mining. But the limitations of tourism as a sector for developing historical-consciousness is problematic. And the urgency of generating income to offset poverty is likely to remain a complex factor in all forms of public history. It deserves to be treated more sympathetically than it has been to date.[41]

For some historians, the mushrooming heritage sector itself became a new object for study under the label of heritage studies. As Witz, Minkley and Rassool put it, 'Heritage, turned into an object of critical scrutiny, has

become a source of unending case studies, a veritable treasure trove of academic "constructive engagement".[42] They describe the combination of what actually is done in the heritage sector and the critiques of it undertaken through Heritage Studies as the 'Heritage Complex'.[43] Heritage Studies, they claim, tend to perpetuate arms-length speaking for the voiceless, without consulting them. They also feel that heritage only exists to create a new nation-state, saying, 'Heritage is not about any past but rather those pasts related to governmentality and the nation-state, to the national estate.'[44] Much of the Heritage Studies sector focused on providing critiques of both the newly built public memorials, as well as the retention of old ones and museum practices. Issues of how identities get moulded and the role of memory ranked high on the publications agenda. But the main focus was on how government tried to manipulate or control what people should be thinking.

Only a few voices acknowledge the need to affirm Africanness as a form of recovery from racial stereotypes. As Erik Stolten points out, 'It is too easy for the historians just to blame the South African government for the situation. Some historians still seem relatively unconcerned with the legitimate feelings of black communities and their need for counter-histories of the freedom struggle.'[45] In the latter half of the decade of the 2000s, those historians who did engage directly with the public began to report an opening out of topics raised by people, marking a further stage in the evolution of the sector. Deep pains and particularly traumatic experiences began to be discussed, issues other than political struggles received attention, and communities became more interested in developing their own histories. Phil Bonner, the former Director of the History Workshop, pointed out that only in a handful of public history projects were people finding the space to speak out about their personal pain and anguish under apartheid. Otherwise, apartheid is taught in history texts in schools as a series of laws countered by great struggle heroes: 'The lived realities of apartheid were lost ... The dance has yet to begin.'[46] He believes that some things are still too painful to even want to remember, though from the mid-2000s people became more willing to talk about personal and community issues than about the grand narrative of overthrowing apartheid.[47] Similarly, oral historian, Sean Field, observes that he 'leaves many interviews feeling helpless' in the face of deep personal trauma.[48] This has led him to caution oral historians against seeing their work as a replacement for more intensive kinds of therapy.

Historians cannot take the full blame for not using public history methodology enough. The growth of heritage came at the same time as rising

corporatization in universities, a trend that was very anti-collaboration and which instead stressed 'outreach'.[49] The Sinomlando Centre for Oral History and Memory Work at the University of KwaZulu-Natal, pioneered the use of oral history methodologies to address the traumas associated with the HIV/AIDS pandemic.[50] A special Centre for Popular Memory found a home at the University of Cape Town, where it assisted communities to develop their own histories – including video, written and exhibition outputs, archived oral and visual history materials and provided training in public history practices at many different levels.[51] By 2015, both had been closed down by their universities due to the logic of corporatization, which did not see any financial value coming from them.

Conclusion

Clearly, public history practise in South Africa holds out much promise of further things to come. It can close the gulf between history and heritage. The student movement sharply raised the image of universities in crisis, requiring a whole new, more relevant curriculum, questioning western analytical frameworks and rethinking the ways that universities relate to their publics. Public historians can work towards creating spaces for the co-production of knowledge, moving beyond the traditional oral history interview. The divide between academia and communities is huge and needs to be constantly tackled, and open access needs to be provided to the cloistered knowledge of the professional world.[52] Due to their privileged place in society, many historians have been unable or unwilling to engage with the recovery agenda – the massive need for affirmation of African identity, capacity and culture. A handful of dedicated public historians have been exemplary in rolling up their sleeves and boldly engaging with the messy complications of dealing with non-academic communities to produce new forms of historical knowledge based on inclusiveness.

The outlines of the recovery agenda for the post-transition period are evident. The public history sector is diversifying in a number of ways, moving beyond the initial drive to focus primarily on struggle history. The imperative to demonstrate the 'triumph of the human spirit' has not yet run its course, but is likely to take more diverse directions. It can be found in purely African precolonial studies, the targeting of intangible African cultural values and practices and the more inclusive agenda of broader social

histories including sports, religion, education and family history. It is time to tackle the harder tasks of engaging in tough dialogues about the nature of privileges and power, the current manifestations of racially based thinking and practices and finding the courage to talk about deep injuries that have until now been considered buried or taboo. Perhaps more historians will see their way to creating the spaces for shared knowledge production and its popularization for national recovery, without feeling co-opted into a government propaganda machine.

Notes

1. Cynthia Kros, 'Rhodes Must Fall: Archives and Counter-archives', *Critical Arts: A South-North Journal of Cultural and Media Studies* 29, no. 1 (2015): 155.
2. Ibid., 151.
3. 'Professor Mahmood Mamdani Delivers the 8th Annual Thabo Mbeki Africa Day Lecture, 26 May 2017', *University of South Africa in Pretoria*. https://video. search.yahoo.com/yhs/search;_ylt=A0LEVjKpgYVZoG0AzbAPxQt.;_ylu =X3oDMTByMjB0aG5zBGNvbG8DYmYxBHBvcwMxBHZ0aWQDBHN lYwNzYw--?p=thabo+mbeki+memorial+lecture+2017&fr=yhs-adk-adk_ sbyhp&hspart=adk&hsimp=yhs-adk_sbyhp#id=1&vid=5572a68b74355b 8e70e79d671d5482dc&action=view (accessed 5 August 2017); and Idowu Omoyadele, 'Post-colonial Universities are Trapped in Their Past', *Mail and Guardian*, 31 August 2017. https://mg.co.za/article/2017-08-31-00-post-colonial-universities-are-trapped-by-their-past (accessed 2 September 2017).
4. Michael Frisch, *Shared Authority: Essays on the Craft and Meaning of Oral and Public History* (Albany: State University of New York Press, 1990), p. viii.
5. Thomas Cauvin, *Public History, A Textbook of Practice* (New York: Routledge, 2016), p. 2.
6. Leslie Witz, Gary Minkley and Ciraj Rassool, *Unsettled History, Making South African Public Pasts* (Ann Arbor: University of Michigan Press, 2017), p. 213.
7. Bernhard Makhosezwe Magubane, 'Whose Memory – Whose History? The Illusion of Liberal and Radical Historical Debates', in *History Making and Present Day Politics: The Meaning of Collective Memory in South Africa*, ed. Hans Eric Stolten (Uppsala: Nordiska Afrikainstitutet, 2007), p. 251.
8. Magubane, 'Whose Memory?', 274.
9. Philip Bonner, 'New Nation, New History: The History Workshop in South Africa, 1977–1994', *Journal of American History* (December 1994): 981.

10. Andrew Hall and Cynthia Kros, 'New Premises for Public History in South Africa', *Public Historian* 16, no. 2 (1994): 26–7.

11. *The District Six Museum*. www.districtsix.co.za (accessed 27 August 2017).

12. Christopher Saunders and Cynthia Kros, 'Conversations with Historians', *South African Historical Journal* 51 (2004): 7.

13. Colin Bundy, 'New Nation, New History? Constructing the Past in Post-apartheid South Africa', in *History Making and Present Day Politics: The Meaning of Collective Memory in South Africa*, p. 74.

14. Ibid., p. 77.

15. Lynn Meskell and Collette Sheermeyer, 'Heritage as Therapy: Set Pieces from the New South Africa', *Journal of Material Culture* 13, no. 2 (2008): 154.

16. 'Revised White Paper on Arts, Culture and Heritage', third draft, February 2017, *Department of Arts and Culture (South Africa)*. www.dac.gov.za/sites/default/files/Legislations%20Files/Revised%203rd%20Draft%20RWP%20on%20ACH%20FEBRUARY%202017_0.pdf (accessed 27 August 2017).

17. Sibongile Khumalo, 'Our Stories, Our Heritage', *Discover Heritage* 1 (2017): 11.

18. Siba Mtongana, 'Our Stories, Our Heritage', *Discover Heritage* 10 (2017).

19. Hugh Masekela, 'Our Stories, Our Heritage', *Discover Heritage* 8 (2017).

20. Derek Peterson, 'Introduction: Heritage Management in Colonial and Contemporary Africa', in *The Politics of Heritage in Africa, Economies, Histories, and Infrastructures*, ed. Derek Peterson, Kodzo Gavua and Ciraj Rassool (London: Cambridge University Press, 2015).

21. Ibid., p. 2.

22. The term 'rainbow nation' was first used by Archbishop Desmond Tutu, the chairperson of the Truth and Reconciliation Commission, which sat from 1996 to 1997. It became widely embraced in public discourse.

23. Sabine Marschall, 'Public Holidays as *lieux de memoire*: Nation-building and the Politics of Public Memory in South Africa', *Anthropology Southern Africa* 36, nos. 1–2 (2013): 11–21.

24. The Legacy projects include: Robben Island Museum (1996); the Ncome Monument (1999) to a famous battle between Afrikaners and Zulus; the Women's Memorial (2000) to commemorate a famous 1956 march of 20,000 black women to the Parliament; the Nelson Mandela Museum (2001); and the Albert Luthuli Museum (2005).

25. Bundy, 'New Nation', 93. He criticizes the African Renaissance, as it 'sought to unmake, to invert, that legacy [of the Rainbow Nation] through social and psychological engineering'.

26. Personal interview, Mongane Serote, former CEO of Freedom Park, Midrand, 7 September 2014; and personal interview, Sonwabile

Mancotywa, CEO of National Heritage Council, Pretoria, 6 September 2014. Both stated that they viewed projects relating to Indigenous Knowledge Systems as the most important thing on the heritage agenda.

27. Witz, Minkley and Rassool, *Unsettled History*, p. 23.

28. 'Revised White Paper on Arts, Culture and Heritage', 23.

29. 'Revised White Paper on Arts, Culture and Heritage', 21.

30. Gary Baines, 'The Politics of Public History in Post-apartheid South Africa', in *History Making and Present Day Politics: The Meaning of Collective Memory in South Africa*, p. 173.

31. Ibid., p. 183

32. Ibid.

33. Christopher Saunders, 'The Transformation of Heritage in the New South Africa', in *History Making and Present Day Politics: The Meaning of Collective Memory in South Africa*, p. 183.

34. Bundy, 'New Nation', 78.

35. Hans Eric Stolten (ed.), 'History in the New South Africa: An Introduction', in *History Making and Present Day Politics: The Meaning of Collective Memory in South Africa*, p. 38.

36. Vuyisile Msila, 'The Liberatory Function of a Museum: The Case of New Brighton's Red Location Museum', *Anthropologist* 15, no. 2 (2013): 209–18; Meskell and Sheermeyer, 'Heritage as Therapy', 161–4; and Christa Kuljian, 'The Congress of the People and the Walter Sisulu Square of Dedication: From Public Deliberation to Bureaucratic Imposition in Kliptown', *Social Dynamics* 35, no. 2 (2009): 450–64.

37. Gary Baines, 'Site of struggle: The Freedom Park Fracas and the Divisive Legacy of South Africa's Border War/Liberation Struggle', *Social Dynamics* 35, no. 2 (2009): 330–44; Nick Shepherd, 'Archaeology Dreaming: Post-apartheid Imaginaries and the Bones of the Prestwich Street Dead', *Journal of Social Archaeology* 7 (2007): 3–28.

38. Lynn Meskell, *The Nature of Heritage, The New South Africa* (Hoboken, NJ: Wiley-Blackwell, 2012), p. 206.

39. Ibid., p. 205.

40. 'Revised White Paper on Arts, Culture and Heritage', 36.

41. See, for example, Saunders and Kros, 'Conversations', 9; Peterson, 'Heritage Management', 18; and John Comaroff and Jean Comaroff, *Ethnicity, Inc.* (Chicago: University of Chicago Press, 2009), p. 1.

42. Witz, Minkley and Rassool, *Unsettled History*, p. 221.

43. Ibid.

44. Ibid.

45. Stolten, 'History', 43.

46. Philip Bonner, 'Apartheid, Memory and Other Occluded Pasts', *Culture, Memory, and Trauma* (2006): 18.

47. Sean Field, 'Disappointed Remains: Trauma, Testimony and Reconciliation in Post-Apartheid South Africa', in *The Oral History Handbook*, ed. Donald Ritchie (New York: Oxford University Press, 2010), p. 52.
48. Ibid., pp. 147–8.
49. Noor Nieftagodien, 'Rethinking Public History in a Time of Decolonisation', seminar presentation to Rhodes University History Department, 14 April 2016, cited in Julia C. Wells, ' "Deep Wounds … Left … in Hearts and Minds": South African Public History', *Public History Review* 24 (2017): 1–21.
50. Philippe Denis (ed.), *Never Too Small to Remember: Memory Work and Resilience in Times of AIDS* (Pietermaritzburg: Cluster, 2005).
51. *Centre for Popular Memory*. www.arc.uct.ac.za/the_visual_university/?lid= 262 (accessed 27 August 2017).
52. Nieftagodien, 'Rethinking Public History'.

11

Public History in the United States: Institutionalizing Old Practices

Thomas Cauvin

Freshly minted by American historian Robert Kelley in the 1970s, the term 'public history' is now under the global spotlight. Public history has developed in Canada, Australia, South Africa, Europe and other parts of the world. In all of these regions, public history has had a connected but distinctly different gestation, and the nature of how public history is practiced, taught and approached is unique to each of them. The internationalization of public history encourages comparative analysis of what is specific to the history of public history in the United States.[1] While public history is, today, more international than ever, the United States possess the strongest network of professional practitioners, especially through university training programs.[2]

Public history in the United States is, then, sometimes seen as a coherent and uniform field. During a conference arranged in Italy in 2015, a panel explored 'Public History in the USA'.[3] However, there have been many different approaches to public history that have changed over times. Likewise, the title of this chapter should not hide how practices and definitions have changed. For instance, it is important to distinguish between public history and public practices. What was born in the United States in the 1970s was not public practices, but their institutionalization through university programs. Exploring long-term public practices and their impact on the rise of public history helps understanding the internal debates and evolution of the field since the 1970s.

The ambiguous ivory tower

Inventor of the modern term 'public history', Robert Kelley, wrote in 1978 that 'public history refers to the employment of historians and historical method outside of academia'.[4] The creation of public history was based on a wish to reconnect historians with non-academic audiences. In 1978, G. Wesley Johnson, another founding member of the public history movement, explained that 'increasingly the academy, rather than historical society or public arena, became the habitat of the historian, who literally retreated into the proverbial ivory tower'.[5] From the beginning, the public history movement proposed to create new historians who would break the 'ivory tower' in which academic historians had been working. The situation was, actually, more complex.

Kelley and Johnson were right in the sense that the long professionalization of history had consequences on the role of historians. During the late nineteenth century, historians adopted a more scientific stance based on archives and critical analysis. In order to reach scientific objectivity, the professionalization of the discipline encouraged historians to disconnect from present-day issues, actors and conceptions. As Robert Townshend writes about the United States in the 1930s, 'the various professions of history set off on distinct trajectories – firming up their own networks and identities in increasing isolation from each other, while embarking on separate processes of specialization and technical refinement of their own'.[6] Professional historians began to address more and more specific audiences – their academic peers – with a wish to move away from popular writing style.[7] The public history movement emerged in the 1970s partly in opposition to the gap between academic and non-academic audiences.

However, this perception of the birth of public history is only valid if we focus on academic historians. As Ian Tyrrell underlines, 'scholars tend to see public history as something new' but 'the roots run much deeper ... historians have long addressed public issues'.[8] There is no lack of examples of historians who participated in public debates, especially through local history. Oral historian Ronald Grele points out that 'prior to the emergence of public history, it was the local history movement which offered the most thoroughgoing alternative to the historical work done in the academy'.[9] Those local historians worked mostly in archives and historical societies whose number greatly increased in the 1920s and 1930s. The creation of archives – such as the United States National

Archives in 1934 – was part of a wider growth of historically related institutions. Likewise, the American Association for State and Local History was created in 1940, long before the creation of the National Council on Public History in 1979.

Another aspect of public practices deals with the use of history for present-day issues. In an article about the pragmatic roots of public history, Rebecca Conard reminds us that discussions about the public uses of the past had a long history.[10] Figures such as Franklin Jameson, at Carnegie Institution of Washington; Herbert Friedenwald, at the Library of Congress; and Benjamin Schambaugh, at the State Historical Society of Iowa, embodied this utilitarian aspect of history-making and defended 'the value of using history to explain contemporary issues, to make history relevant to the present'.[11] In the United States, this trend materialized in what Schambaugh called applied history. Other historians progressively entered political and federal activities. Arnita Jones writes that 'as early as 1916, the Department of Agriculture had established a history office'.[12] After 1945, the Historical Division of the War Department was 'set to writing the official history of the army in World War II' and became the Office, Chief of Military History in 1950.[13] The role of historians in policy-making has remained active as attested by the creation of the Society for History in the federal government in 1979.

The vision of public history as a new movement in the 1970s was partly due to the wish that the founding members had to demonstrate the specificity of their movement. While academic historians tended to lose track of the general public, other historians outside of academic circles had connected with their audiences in other manners. Many historians were working outside of academia in archives, historical societies, national parks, museums, federal agencies, or in corporate societies. However, those practitioners were not considered professional historians. There was no agreed common denominator for those historians outside academia. Academic historians were both isolated from popular audiences, as well as isolated from other non-professional practitioners who worked in local, cultural, and political institutions.

Institutionalization of the public history movement

The development of public history in the United States was – much more than anywhere else – the result of an alliance between academic programs

and applied history practices. The rise of public history deeply related to a crisis in higher education. In a context of global economic depression in the 1970s, universities entered a major job crisis that triggered poor employment prospects for historians. Due to a decreasing number of students in liberal arts, jobs for historians in higher education dramatically dropped.[14] By 1976, the crisis had reached such a level that major historical institutions established programs and committees to provide new answers – and hopefully new opportunities – for historians. The National Coordinating Committee for the Promotion of History (NCCPH) was set up in 1977.

Arnita Jones, head of the NCCPH, rightly explained that because 'in the late 1950's and 1960's the fundamental preoccupation of the profession was to produce sufficient numbers to fill the steadily increasing need for college classroom teachers of history' then 'for both the profession and the public, to be an historian was to be a teacher and the training of an historian came to be exclusively training for an academic career'.[15] However, by the 1970s, universities were training more history teachers than schools and high education needed. Focusing on the career issues, the NCCPH worked at building bridges between universities and non-academic worlds. Its goals were to 'promote historical studies generally ... to broaden historical knowledge among the general public, to restore confidence in the discipline of history throughout society, and to educate employers in the public and private sectors to the value of employing professional historians'.[16] This was very much in line with the rise of the public history movement. Jones explained in 1978 that 'if the current employment crisis provokes an identity crisis in the historical profession it may be to the lasting benefit of both historians and the public'.[17] The rise of public history as a response to historians' isolation was actually also connected to a particular context of crisis for higher education that requested new approaches for the whole profession.

Kelley was Professor of history at the University of California at Santa Barbara (UCSB), consultant and expert witness for the state on matters related to water rights. He was symbolic of the new attempts to link academic and non-academic historians. Kelley was convinced that a different academic training would help historians to find new jobs. He stressed 'that the best method was to begin training small groups of graduate students in public history skills, imbuing them with the idea of a public rather than an academic career, and sending them out, one by one, to demonstrate their value by their work'.[18] Kelley applied for a grant from the Rockefeller Foundation to build a program that would encourage the links between history and public

policy. He also asked G. Wesley Johnson, fellow historian at UCSB and expert in public policy, to join. Johnson recalls that public history 'meant to us that historians had skills that could be used for public benefit, whether in business, government, foundations, historical societies, or wherever'.[19] The first graduate program in public history opened at UCSB in 1976. In 1978, while acknowledging that 'the variety of sectors may suggest that Public History is a collection of unrelated sub-fields', Wesley Johnson explained that 'this is not the case, when examined from the point of view of training the historians'.[20] The development of public history as academic training programs was both a mark of fabric and the unifying factor of the movement in the United States.

The institutionalization of public history also came from the creation of a council and a journal. Johnson, then the main architect of the movement, received a grant from the Arizona Humanities Council to organize several conferences about public history. Organized between 1978 and 1980, these contributed to the creation of the National Council on Public History (NCPH) in 1979. The choice of the name 'council' and not the typical 'association' or 'organization' came from the original goals pf the founding members. Historian Ted Karamanski recalls that the objective in the 1970s was to reform the way history was practiced across the entire profession.[21] In September 1979, during the first meeting of the steering committee, it was decided that the council would represent various constituent groups of people rather than individuals.[22] Those constituents groups included historical organizations such as the American Historical Association and the Organization of American Historians but also groups connected to public history practices such as the Society of American Archivists or the American Associations of Museums, university training programs and business-related groups such as Wells Fargo.[23] As a council composed of various constituents, the initial objectives were to change the overall history profession to include public history as a genuine activity.

Nevertheless, the NCPH rapidly evolved into one among other historical associations. Wesley Johnson used part of the Rockefeller Foundation grant in 1978 to publish a new journal *Public Historian*. As the name of the journal denoted, the founding members of the public history movement proposed to create a new public historian. Rather than changing the whole profession, the NCPH became the symbol of a new category of historians able to work outside universities. It would be indeed misleading to put into opposition – as the founding members may have – academic and public history. Many supporters of public history in the United States – Robert Kelley, Wesley

Johnson and Joel Tarr among others – had academic positions in universities. Their own profiles demonstrated that such a division was rather artificial. The public history movement came from a desire to offer new academic programs to train history students to work outside education.

Public history as applied history in the 1980s

Led by the creation of public history training programs in universities, the public history movement developed as practice-oriented. In 1984, while reflecting on the rise of public history in the United States, French historian Henry Rousso opposed a sort of American pragmatism to a more theoretical approach in France and Europe.[24] Public history was not born ex-nihilo; the focus on practices resulted from a long tradition of applied history and public policy in the United States.

Public history in the 1970s was marked by two – not mutually exclusive – practices: consulting and public policy. The first companies of consulting historians in the United States emerged in the 1970s.[25] The first Directory of Historical Consultants, published in 1981, listed approximately thirty individuals or firms. The links between consulting and public history included many historians working for the federal government. As civil servants or temporary contractors, federal historians worked for the federal government as official agency historians in the executive branch or worked for Congress or the Supreme Court. After a decrease in the 1960s, the number of federal historians rose again in the 1970s and 1980s, similarly to the public history movement.[26]

Both consulting historians and federal historians organized themselves at the same time as the NCPH was created. Philip Cantelon, co-founder of History Associates in 1980, was also the inaugural executive secretary (1979) and the executive director (1981–3) of the NCPH. The proximity came from a similar interest in non-academic works. Federal historian Jack Holl remembers that, in the late 1970s, he 'did not believe that the professional concerns of federal historians could ever be satisfied in the Organisation of American Historians (OAH) overwhelmingly dominated by academic historians who regarded our employment as "alternative careers".'[27] The Society for History in the federal government has provided organizational strength for historians often isolated from their colleagues.

The links between the NCPH and consulting and federal historians reflected how public history was initially conceived. As historian Alan Schroder has stressed, applied history was an early form of public history.[28] Although the terms applied and public history have often been used interchangeably, the former has focused more on the application of history to present-day policy issues while the latter has also included heritage management, historic preservation and other cultural fields. In the 1970s, Robert Kelley perceived public history training as being, first of all, targeting positions into government offices and public policy. This came from his work as expert in public policy and environmental issues. Likewise, in his introduction to the first volume of the *Public Historian*, Wesley Johnson listed the eight sectors in which public historians usually work. Although he included history-linked institutions such as museums and archives, he clearly stressed governmental administration and corporate business as the two main fields.[29] In an article in 1981 about applied history, Joel Tarr, director of the Applied History program at Carnegie-Mellon University, acknowledged that the program was 'not primarily concerned with records or artefacts, or with reaching a broader public by new methods of presentation'.[30] The program was designed to train historians for policy work. This focus on public policy and corporate management reflected the backgrounds of some founding members – Kelley, Johnson, Tarr – who had been working as consultant in addition to their academic positions much more than with heritage management.

Shared authority, activism and social justice

Although consulting and public policy still offer lots of opportunities for historians, new fields of public history have emerged in the last twenty years. Public History has partly moved from working for to working with partners. Public history has become more participatory, more collaborative and more inclusive. First developed through oral history, the concept of shared authority – in which historians share authority with narrators – highlighted the new participatory history-making process in the late 1980s.[31] Even though the United States was far from being revolutionary – British historian Raphael Samuel developed people's history in the early 1970s – public participation affected historical practices. Shared authority does not

come from pure generosity from historians. As Alexandra Lord, president of the NCPH (2016–18), observed, 'We can learn as much, if not more, from those outside the academy as we can learn from our colleagues in higher education.'[32] Symbolized by crowdsourced projects, public participation considerably increased through the rise of the internet and new media in the 1990s and 2000s. Because of the global access to and production of shareable data, the internet has questioned the role of the historian in a participatory construction of knowledge. For instance, the National Park Service developed a public training program called 'Co-Creating Narratives in Public Spaces', based on the manner in which shared authority affects day-to-day work in heritage sites.[33]

Interest in the public also led to activism and advocacy. Activists argue that history can be used to improve the present and, therefore, the future.[34] Although there is, according to this definition, a long tradition of activism among historians in the United States, the trend developed in other postcolonial societies such as Australia and Canada. In Canada, a conference in 2008 entitled 'Active History: History for the Future' resulted in the creation of Active History, an organization that intends to 'make a tangible difference in people's lives' through a 'history that makes an intervention and is transformative to both practitioners and communities'.[35] Likewise, in a 2014 National Council on Public History's working group entitled 'Toward a History of Civic Engagement and the Progressive Impulse in Public History', Denise Meringolo and Daniel Kerr questioned how public historians could more effectively use historical work to foster change.[36] The idea is no longer to simply engage the public but to act for better social relations.

The shift from civic engagement to activism usually focuses on underrepresented minorities. Some historians consider their role as social activists and advocate for a multitude of groups who have been marginalized, economically and/or socially, and whose histories have been devalued or ignored by mainstream history, in the preservation of historic places, and in the interpretation of history for the public. Museums have been among the most active participants. The Social Justice Alliance for Museum explains, 'We acknowledge that many museums have for many years failed to operate for the wider public benefit, and instead have catered primarily for educated minorities. We reject this approach.'[37] The objective is not to adapt the past to present issues, but to provide more complex representations by giving voice to underrepresented aspects and actors of the past.

Public history's future in the United States

Because public history is based on the role of historians, uses of the past and media, its criteria and practices keep changing. Public history is an unstable process, even in the United States where more than 250 university programs contribute to its institutionalization. Public history's success in universities has even raised some interrogations. Some historians have started to wonder whether 'there are now too many public history programs in colleges and universities'.[38] The increasing number of students graduating from university public history programs does not reflect the job market and students may find it increasingly difficult to secure jobs in the future. Despite debates about the sustainability of the number of programs, it is clear that public history has contributed to reconfiguring the whole history profession.

Through public history, some universities have (re)connected with their local communities. For instance, under the lead of the Humanities Action Lab (New School, New York City), twenty universities have participated in *States of Incarceration: A National Dialogue of Local Histories* that explores the explosion of prisons and incarcerated people in the United States. Following the initial wish from the founding members, public history helps historians to challenge any possible ivory tower situations.

Nevertheless, if historians want to participate in public projects, they need some specific skills. Designing an exhibit, doing oral history or nominating a site for historic preservation requires specific tools and skills. In a recent survey on public history education and employment undertaken by the three main historical associations, hundreds of institutions and individuals who have hired public history students answered a question as to what they believe will be the most demanded skills for public history students in the future.[39] The top five skills in descending order were: fundraising, digital media development and production, project management, written and oral communication and public programming and interpretation. In clear second place were historical and historiographical knowledge, historical research, historical writing, proposal writing and quantitative literacy. Although the survey was not exhaustive, we might wonder if public history students may need to develop more communication skills or, perhaps better, be able to translate historical research and methodology to a variety of media and partners.[40]

The acquisition of these skills should not be restricted to public history practitioners. Following the initial objective of the NCPH, public history should contribute to a larger shift in the history profession. Public history training not only provides historians with new skills but it also engages in the long tradition of self-reflectivity and the changing role of historians. In doing so, public history projects, courses and assignments can be integrated with regular courses on historiography, methodology and/or didactics. The creation of new public history programs should only be one step in the broader development of public (and digital) humanities.

Notes

1. Thomas Cauvin and Serge Noiret, 'Internationalizing Public History', in *The Oxford Handbook of Public History*, ed. James B. Gardner and Paula Hamilton (Oxford: Oxford University Press, 2017).
2. NCPH lists more than 200 public history programs in the United States and Canada, and the figures keep increasing every year. See ncph.org/program-guide/ (accessed 4 September 2017). Every online resource was accessed 4 September 2017.
3. *Public History and the Media*, conference organized at the European University Institute, February 2015. www.eui.eu/events/detail?eventid=101227 (accessed 4 September 2017).
4. Robert Kelley, 'Public History: Its Origins, Nature, and Prospects', *Public Historian* 1 (1978): 16. The term 'public history' was first used in print in 1794 by English theologian William Paley. See Paul Ashton and Meg Foster, 'Public Histories', in *New Directions in Social and Cultural History*, ed. Sasha Handley, Rohan McWilliam and Lucy Noakes (London: Bloomsbury, 2017), p. 152.
5. Wesley G. Johnson, 'Editor's Preface', *Public Historian* 1, no. 1 (1978): 6.
6. Robert Townsend, *History's Babel: Scholarship, Professionalization, and the Historical Enterprise in the United States, 1880–1940* (Chicago: University of Chicago Press, 2013), p. 181.
7. Peter Novick, *That Noble Dream: The 'Objectivity Question' and the American Historical Profession* (Cambridge: Cambridge University Press, 1988), p. 43.
8. Ian Tyrrell, *Historians in Public: The Practice of American History, 1890–1970* (Chicago: University of Chicago Press, 2005), p. 154.
9. Ronald J. Grele, 'Whose Public? Whose History? What Is the Goal of a Public Historian?', *Public Historian* 3, no. 1 (1981): 43.

10. Rebecca Conard, 'The Pragmatic Roots of Public History Education in the United States', *Public Historian* 37, no. 1 (February 2015): 105–20.

11. Rebecca Conard, *Benjamin Shambaugh and the Intellectual Foundations of Public History* (Iowa City: University of Iowa Press, 2002), p. 10.

12. Arnita Jones, 'Public History Now and Then', *Public Historian* 21, no. 3 (1999): 23.

13. Conard, *Benjamin Shambaugh*, p. 156.

14. Arnita Jones, 'The National Coordinating Committee: Programs and Possibilities', *Public Historian* 1 (1978): 49–50.

15. Jones, 'The National Coordinating Committee', 51.

16. Ibid., 52.

17. Ibid., 50.

18. Conard, *Benjamin Shambaugh*, p. 164.

19. Denise D. Meringolgo, *Museums, Monuments and National Parks: Towards a New Genealogy of Public History* (Amherst and Boston: University of Massachusetts Press, 2012), p. xvii.

20. Johnson, 'Editor's Preface', 7.

21. Ted Karamanski, 'Comment to Joana Wojdon', *Public History Weekly* 33, no. 4 (2016). public-history-weekly.degruyter.com/4-2016-33/do-we-need-public-history-study-programs (accessed 4 September 2017).

22. Report from David Trask, 2 November 1979, Board of Directors Minutes (April 1980), Archives of the National Council on Public History.

23. Ibid.

24. Henry Rousso, 'Applied History, or the Historian as Miracle-Worker', *Public Historian* 6, no. 4 (1984): 65–85.

25. *Historical Research Associates* and *The History Group, Inc.* were created in 1974 and 1975, respectively.

26. For instance, Raymond Smock became the first official historian of the House of Representatives in 1983.

27. Jack M. Holl, 'Getting on Track: Coupling the Society for History in the Federal Government to the Public History Train', *Public Historian* 21, no. 3 (1999): 50.

28. Alan M. Schroder, 'Applied History: An Early Form of Public History', *Public Works Historical Society Newsletter* 17 (1980): 3–4.

29. Johnson, 'Editor's Preface', 6.

30. Peter Stearns and Joel Tarr, 'Applied History: A New-Old Departure', *History Teacher* 14, no. 4 (1981): 517.

31. Michael Frisch, *A Shared Authority: Essays on the Craft and Meaning of Oral and Public History* (Albany: New York University Press, 1990).

32. Alexandra M. Lord, 'History Matters', *Perspectives on History* 49, no. 8 (December 2011): 5–7. www.historians.org/publications-and-directories/

perspectives-on-history/december-2011/history-matters (accessed 4 September 2017).

33. Archived video webcast, 'Co-Creative Narratives in Public Spaces', September 2014. connectlive.com/events/publicspaces (accessed 4 September 2017).

34. Pam Korza and Barbara Schaffer Bacon, *History as a Catalyst for Civic Dialogue: Case Studies from Animating Democracy* (Washington, DC: Americans for the Arts, 2005).

35. 'Homepage', *Active History.* activehistory.ca (accessed 27 August 2015).

36. National Council on Public History, 'Call for Working Group Discussants', 2014. ncph.org/cms/wp-content/uploads/Call-for-Working-Group-discussants.pdf (accessed 31 August 2015).

37. *Social Justice Alliance for Museum.* sjam.org/about-us and sjam.org/case-studies (accessed 15 November 2015).

38. Robert R. Weyeneth and Daniel J. Vivian, 'Public History Pedagogy: Charting the Course: Challenges in Public History Education, Guidance for Developing Strong Public History Programs', *Public Historian* 38, no. 3 (2016): 26.

39. Philip Scarpino and Daniel Vivian, 'What Do Public History Employers Want? Report of the Joint AASLH-AHA-NCPH-OAH Task Force on Public History Education and Employment' (unpublished), 2017. drive.google.com/file/d/0B-biwE1hFJQJdmdsTTlMbGc2Rkk/view (accessed 4 September 2017).

40. Scarpino and Vivian, 'What Do Public History Employers Want?'.

Part II

Approaches and Methods

Part II

Approaches and Methods

12

First Encounters: Approaching the Public Past

Meg Foster

In March 2011, a mass of second- and third-year students pushed through the wooden doors of the Merewether Building at the University of Sydney and filed into the tiers of the second lecture hall. It was 12 o'clock, so thankfully neither a crack of dawn nor a graveyard period. The only discomfort came from the hardwood benches that the students would be plastered to for fifty minutes, but timetables could be changed and courses dropped if this was too much of an issue. As it was, I hardly noticed the numbness because this course was so interesting. It was one of those rare units where the work was not taxing, and I found myself learning about history even after I left the confines of Merewether's 1960s' lecture hall. The subject was 'HSTY 2627: Living Memory: Popular Uses of the Past' and although I was soon to discover that the coordinator, Richard White, was an engaging and passionate lecturer, I was originally drawn to this unit by a few sentences in the course outline:

> This unit considers the ways the past is understood in popular culture. Often beyond the influence of trained historians, the present has used (and abused) the past in film and literature, Anzac commemoration, the heritage industry, tourism, memories of immigration or teenage angst, rose-coloured childhoods, political strategies of nostalgia and amnesia. Students will explore the relationship between history and memory, examine private and public commemoration and, making use of living memory, try out some oral history.[1]

Six more years of study, an Honours Degree and a partially finished PhD later, a lot has happened since that first class. And yet, the questions that I encountered in this course are still as pressing for academic, public and amateur historians today. If our lives are constantly saturated by the past in the present, then what is public history? What makes it special? If the past is used 'beyond the influence of trained historians', then what is the role of public historians?[2] Why do we need them? And who has the authority to speak for the dead? Who should create public history?

Public history, everyday

One of the assessments for 'HSTY 2627: Living Memory' was a portfolio. The aim of the project was to collect as many examples of the past in our everyday lives as possible. As it turned out, this was easy given the abundance of historical references in our world. On the bus ride to university I went under the Sydney Harbour Bridge. This was not only an historical monument, but part of my family history as my great, great grandfather helped to construct it in the Great Depression.[3] As I walked from Wynyard train station I spied the bright flag of a heritage tour about to traverse the city.[4] On television, a Heineken beer ad sent a consumer back to 1873 to discover that the beer had not changed despite the passing of time.[5] The video clip for *Panic! At the Disco*'s 'The Ballad of Mona Lisa' featured steam punk fashion and period settings, while the royal wedding of Kate Middleton to Prince William highlighted the powerful traditions of marriage and the British monarchy.[6] All that this assessment required was a new perspective, not new experiences.

While it was a shock for me to discover that history was literally hidden in plain view, to public historians this is nothing new. The nineteenth century saw the rise of the nation state alongside the birth of academic history. For the first time, historians were specially trained, beholden to rules of evidence and the discipline of history was formed. The creation of nations with distinct identities, sovereignty and geographical boundaries encouraged the growth of academic history, as a shared past was needed to bind these communities together.[7] For nations, the mobilization of symbols and stories is important. These ideas transcend physical distance to create what Benedict Anderson describes as an 'imagined community'.[8] As Anderson has written, 'the members of even the smallest nation will never know most of their fellow-members, meet them, or even hear of them, yet

in the minds of each lives the image of their communion'. Similarly, Eric Hobsbawm and Pierre Nora have demonstrated that commemoration and tradition did not evolve naturally, but were created as tangible reminders of the past in the present. For history to foster a shared sense of identity, it could not be left to the public to interpret at will. Instead, it was institutionalized. Monuments were erected, national days designated and ceremonies observed to set the parameters of the past and tailor the dimensions of public understanding.[9] This is not to say that history was always imposed from the top-down onto the 'public'. There was never one unified 'public' as people's wants, needs and ideas of belonging are as diverse and complex as people are themselves.[10] Moreover, laypeople can use, interpret and interact with the past in ways that are not determined or even anticipated by their professional counterparts.

What this does show, however, is that from its beginning, the discipline of history was concerned with the public past. Ironically, its supposedly 'objective' standards enhanced its authority to cultivate a highly subjective view of national belonging. But the relationship between history and the public goes deeper still. Even before the institutionalization of history, people had a sense of their past. Sometimes stories of times gone by blurred into myth and folklore. But across time, cultures and continents it appears that an interest in the past unites us. This has led some historians to claim that the creation of history is a basic human instinct and that wanting to divine some meaning from the past is inherently human.[11]

There are cave paintings from tens of thousands of years ago that tell the stories of battles.[12] Aboriginal Australians have an oral tradition of history and memory has continued, adapted and changed across the centuries.[13] While there is an evolutionary argument that learning lessons from the past help people to adapt and survive, there is also something less strategic but no less important at work. History helps us to make sense of where we came from, who we are and our place in the world. It allows us to give meaning to our lives.[14] When viewed in this light, it seems natural that

> history can take many forms. It can be constructed at the dinner table, over the back fence, in parliament, in the streets and not just in the tutorial room or at the scholar's desk. It can be represented through museums, historical societies, universities, books, films, recordings, monuments, re-enactments, commemorations, conversations, collections and historic sites and places. History is the fruit of both popular and learned understandings, both amateur and professional socialization.[15]

As Raphael Samuel pithily declared, 'If history was thought of as an activity rather than a profession, then the number of its practitioners would be legion.'[16]

People's understanding of history is powerful and unless you are a professional historian, your historical consciousness – or sense of history – is more likely to be formed outside the realm of academia.[17] Take the example of the BBC sci-fi series, *Doctor Who*. The program follows an alien called 'the Doctor' who travels with a companion through time and space. Although fictional, the show encourages a critical understanding of history. By travelling back in time to when historical figures or pivotal events are placed in jeopardy, the program asks its audience to think what the consequences would be if these people never existed or these events never occurred.[18] What would happen to the world of art if Vincent Van Gogh was killed before he was able to create some of his most famous paintings?[19] In this children's TV program, historical significance is demonstrated in the same manner as counter-factual history.[20] Although this scholarly branch of history is based on evidence and historical probability as opposed to the musings of a fictional, alien time traveller, both *Doctor Who* and historians use 'what if' questions to demonstrate the importance of what actually happened.[21] One of the main differences between the show and scholarly works is their audiences. In the last ten years, *Doctor Who* has reached between 4.73 and 13.31 million viewers per episode in the UK alone and has been broadcast to ninety-four countries worldwide.[22] These are figures that traditional historians could not even dream of reaching.

The middle ground

If public history is broadly defined as 'history in the public domain', or 'a process by which the past is constructed into history ... with some degree of explicit application to the needs of contemporary life', then what is the role of the public historian?[23] If 'outsider' history makers who are not professionally trained have so much influence, where does that leave historians? The first step to answering these questions is to recognize that the definition of public history has not always been so inclusive. Although an interest in the past dates back thousands of years and the nineteenth-century discipline of history was deeply concerned with the public past, public history as a profession came about in the 1970s. This was the first time that there was a distinct group with university degrees in this field who identified themselves as public historians. In the 1970s, public history was defined in relation to

the public historian. 'Real' public history was not undertaken by amateurs or fictional TV series, but was 'the employment of historians and the historical method outside of academia'.[24] It was a professional branch of historical knowledge that relied on the credentials of the historian for its legitimacy. History was something that the historian bestowed upon the public and not a site of conversation, let alone an arena where historians may need to vie with laypeople for the right to speak for the past.[25]

Over time, the definition of public history expanded. In Britain, the tradition of social history and 'histories from below' meant that this country was one of the first to include 'the public' as co-creators of the field. In the UK there was more emphasis on the emancipatory value of history, and public history was seen as a way for ordinary people to reclaim their voices.[26] In 1990, oral historian Michael Frisch coined the term 'shared authority' to reposition history making as a dialogue between the historian and the public. He hoped that if professional historians and laypeople worked together, they could create more satisfying and inclusive narratives about the past.[27] The trend towards seeing the public as meaningful creators of public history was already afoot by the time that Web 2.0 entered the scene in the 2000s. But the proliferation of digital and online platforms irrevocably changed the boundaries of the field. As I have written elsewhere, 'From the more moral arguments that people should be "allowed" to play a role in creating their own history, millions of non-professionals are now actively pursuing history on their own.'[28] The growth of online databases, genealogical sites and projects such as *Internet Archive* mean that amateur historians are connected to unprecedented numbers primary sources. Whether through blogs, websites, Twitter, Facebook or countless other online mediums, laypeople can distribute their version of the past in numbers like never before. This 'legion' of amateur history makers from around the world have led to a refashioning of both public history and the role of the public historian.[29]

Far from waiting quietly for their own demise, public historians have conducted studies into popular uses of the past to understand how ordinary people connect with history. In the United States, Roy Rosensweig and David Thelen were the first to undertake this study of historical consciousness in 1988, but since then there have been iterations all over the world. Despite different national contexts, some of the same findings ran through each study. Ordinary people commonly feel disconnected to big, politically laden terms and official versions of history. They are more likely to relate to the past through family stories, and narratives about individuals are a way that they can tap into larger, national histories. People are more likely to believe

in the validity of history if they see primary sources and historical artefacts.[30] Original sources are regarded as largely authentic, truthful relics of the past, and the history they support is legitimized by this tangible connection to times gone by.[31] Across all studies it was clear that 'people pursue the past actively and make it a part of their everyday life … [people experience] the *presence* of the past – its ubiquity and its connections to current-day concerns – rather than its frequently bemoaned absence'.[32]

Although some historians have lamented the growth of popular histories and see their influence as a threat to the profession, most public historians hold a more positive view.[33] Many are looking to these sources for insights on how to reach a broader public and foster an interest in the past. In 2012 in the *Public Historian*, Benjamin Filene directly addressed this issue. His article entitled 'Passionate Histories: "Outsider" History Makers and What They Can Teach Us' aimed to assimilate the success of 'outsider' histories into professional discourse. According to Filene, one of the first things that public historians must come to terms with is that non-professional history makers do not think of themselves as 'outsiders': 'The truth is more disquieting … instead of defying museums and universities, the outsiders mostly don't think of them at all'.[34] Instead of being disheartened by this state of affairs, Filene suggests that professionals recognize the influence of intimate, passionate histories so that they can harness this power for themselves:

> The outsider projects that tap into the value of place, for instance, reinforce perhaps the most basic point of all: *history happened* and it happened in your own backyard too … The broad messages of outsider history … are so fundamental to professional historians that we rarely feel the need to address them directly.[35]

And this can alienate historians from the wider public.[36]

The public historian

Public historians are incorporating these lessons into their practice. Many work as consultants alongside other stakeholders and negotiate how to depict history to a wider audience. Consider, for example, the popular TV show *Who Do You Think You Are?* This program takes celebrities on a journey of discovery to uncover their family's past. Working in teams with producers, writers, directors and location scouts, historians not only provide the

program with historical information. The way they approach the past is also shaped by the show. *Who Do You Think You Are?* uses history to uncover the experiences of the celebrity's ancestors. As a consequence, historians need to use genealogical stories as their lens for approaching the past. Where the lives of certain ancestors intersect with dramatic or significant events, they provide an accessible snapshot into the bigger picture of history. Although the aims of the show are not created by historians, the story that unfolds is the product of an ongoing conversation between the historian, their sources and the vision of the production team.

This type of history sells. As Tanya Evans has written, 'In Australia, *Who Do You Think You Are?* is the most popular Australian historical TV series. Series One, Three and Four were in the top five highest rating commissioned documentary series in SBS history, the channel on which it is broadcast.'[37] And the show contains the same traits that historians have identified as making history accessible to a non-professional audience: it shows history through the lives individuals; it takes people on an emotional journey; and its revelations hinge on historical documents and places that lend tangibility to the past.[38] All of these features bring home to viewers the fact that *history happened* and allow them to connect to the past.[39]

In the online community historians are no less active. While the growth of digital platforms has seen a proliferation of histories from amateur history makers, professional historians are also riding the digital wave and taking advantage of these new technologies.[40] The farthest reaches of cyberspace are being accessed by #twitterstorians with their tweets. Hashtags enable historians to connect to people with similar interests both inside and outside of the academy. The short word limit allows for punchy statements but this does not make historians' tweets superficial. Retweets, links to other webpages, articles, newspapers and primary source material all ensure that Twitter is a platform to connect people, ideas and issues. It is a site of dialogue between colleagues as well as between professionals and non-professionals with an interest in the past. While some #twitterstorians use their online presence for more professional self-promotion others use it as a site to share their experiential connection to history.[41]

All of this activity has led to increasing self-reflection on the part of historians alongside an awareness that they cannot be the sole voice to speak for the past. Even in the academy these changes are being felt. The Australian Research Council asks applicants for its grants to outline the public significance of their work and develop an outreach component to engage with wider society.[42] Queens University in Belfast recently opened a new

Public History Centre in 2017. The inaugural Public History Conference at this university asks attendees to respond to the theme 'why public history?' and seeks:

> to assess the current state of the discipline. It asks a simple but vital question: in an age of 'fake news', 'history wars', and 'impact agendas', what role do scholars and practitioners have in shaping the relationship between the public and the place of the past?[43]

Public historians are striving to prove their relevance in our rapidly changing world. But more than this; there is also a growing understanding among public historians that they should embrace the ambiguity of their position and use it to facilitate engagement with the past.

In 2007 H-Net, the online platform for the American Historical Association, hosted a digital forum. The aim of the project was to discuss how practitioners defined public history and, consequently, how they saw their relationship with the public. The National Council of Public History was used to start the conversation and not all of its definition was as readily accepted. The Council's statement that public history's 'practitioners embrace a mission to make their special insights accessible and useful to the public' was quickly condemned. Dick Miller and Kathy Corbett challenged the way this definition created a barrier between historians and the public and privileged the knowledge of the professional historian above all else. What was more common in this forum was for public historians to 'include the larger public as both audience and partners in the process of understanding history'. Public historians positioned themselves ' "in the middle" between academic historians and the general population'. One feature that was said to define the field was that 'its practitioners place themselves on borders of various kinds'. It was a 'category of identity, complicated, negotiated, and socially constructed in tension with and opposition to other categories'.[44] These common themes indicate a more inclusive and collaborative vision of public history but they also make the historian's role difficult to define.

It is hard to cultivate a solid professional identity in an ever-shifting field. Graeme Davison connects the birth of professional public history in the 1970s with a desire to create a cohesive identity. At this time, historians' status and authority seemed to rely on them maintaining a distinct role.[45] To a certain extent these fears over identity are still alive today. Some historians have described uneasiness at the prospect of including the public in the creation of history. One fear is that the

historian's authority might be diluted when their voice is just one among many. Another is that if the public are allowed to create their own histories, these will only reinscribe public prejudices; history will be degraded to a parochial past and lose its capacity to reveal critical insights and encourage contextual understanding.[46] Jorma Kalela and Hilda Kean, however, directly combat these bleak predictions. While both agree that finding a compromise between public and professional opinion is difficult, it is not impossible. Historians still provide expert advice, but they also facilitate the creation of history by non-professionals. Historians offer new perspectives, technical skills, and broad historical insights, yet they are also aware of the needs and desires of the public that they work alongside.[47] What public historians ' "let go" of is not expertise but the assumption that [they] have the last word on historical interpretation'.[48]

After this journey from the university lecture hall to the professional arena and forums of public debate, it is easy to see how awkward those first encounters with the public past can be. Public history is a dynamic field and its practitioners vary in size depending on how they are defined. The parameters of the discipline are historically contingent and have changed remarkably over time. But some conclusions can be drawn. Public history, in its broadest sense, concerns the relationship between the past and the present. Public historians are professionals who engage with the public and the past. Although they were once defined as the emissaries of historical knowledge to ordinary people, they are now more likely to be considered as collaborators with the public in the creation of history. While no one has absolute authority to speak for the dead, there is a place for the unique skills of the public historian alongside the ideas and desires of ordinary people. As Hilda Kean has written, 'The past is not settled and decided, but contested and changed ... The past is never dead. It's not even past.'[49] And therein lies public history's ambiguity as well as its promise.

Notes

1. Department of History, University of Sydney, 'HSTY 2627: Popular Uses of the Past', 2011. http://sydney.edu.au/arts/history/undergrad/units_of_study.shtml?u=HSTY_2627_2011_1 (accessed 12 July 2017).
2. Ibid.

3. Peter Spearritt, *The Sydney Harbour Bridge: A Life* (Sydney: University of New South Wales Press, 2007).

4. 'History of Sydney: Highlights'. www.sydney.com/things-to-do/arts-and-culture/history-of-sydney (accessed 25 August 2017).

5. Leo Burnett, 'Past Experience', 2011. www.leoburnett.com.au/Sydney/Work/Detail/14/past-experience (accessed 26 May 2011); Clarice Chiam, 'Heineken's Lessons in History', 2007. www.marketing-interactive.com/news/1008 (accessed 12 August 2011).

6. 'The Ballad of Mona Lisa', *Panic! At the Disco*, 2011. www.youtube.com/watch?v=gOgpdp3lP8M (accessed 25 August 2017); 'What Is Steampunk?', 2011. www.steampunk.com/what-is-steampunk/ (accessed 15 May 2011); Paul Harris, 'The Royal Wedding: How They Watched It Worldwide', *The Guardian*, 30 April 2011. www.guardian.co.uk/uk/2011/apr/30/royal-wedding-world-reaction?INTCMP=ILCNETTXT3487 (accessed 1 May 2011).

7. Chris Lorenz, 'History and Theory', in *The Oxford History of Historical Writing*, vol. 5, ed. Axel Schneider and Daniel Woolf (Oxford: Oxford University Press, 2011), p. 32.

8. Benedict Anderson, *Imagined Communities: Reflections on the Origin and Spread of Nationalism* (London: Verso, 1983), p. 6.

9. Eric Hobsbawm, 'The Nation as Invented Tradition', in *Nationalism*, ed. J. Hutchinson and A. Smith (Oxford: Oxford University Press, 1994), pp. 76–82; Pierre Nora, 'Between Memory and History: Les Lieux de Mémoire', *Representations* 26 (1989): 7–24.

10. 'What Is Public History?' *H-Net* Public Discussion Log (May–June 2007). http://h-net.msu.edu/cgi-bin/logbrowse.pl?trx=lx&list=h-public&month=0705&user=&pw= (accessed 4 September 2015).

11. Greg Dening, 'Ethnography on My Mind', in *Boundaries of the Past*, ed. Bain Attwood (Melbourne: The History Institute, Victoria, 1990), pp. 16–17.

12. Keith Otterbein, *How War Began* (College Station: Texas A&M University Press, 2004), pp. 71–3.

13. Marissa Fessenden, 'Australian Stories Capture 10,000-Year-Old Climate History', *Smithsonian Magazine*, 26 January 2017. www.smithsonianmag.com/smart-news/australian-stories-capture-10000-year-old-climate-history-180954030/ (accessed 12 August 2017); Tony Wright, 'Aboriginal Archaeological Discovery in Kakadu Rewrites the History of Australia', *The Age*, 20 July 2017. www.theage.com.au/technology/sci-tech/aboriginal-archaeological-discovery-in-kakadu-rewrites-the-history-of-australia-20170719-gxe3qy.html (accessed 28 August 2017).

14. Dening, 'Ethnography on My Mind', 16–17.

15. Tom Griffiths, *Hunters and Collectors: The Antiquarian Imagination in Australia* (Cambridge: Cambridge University Press, 1996), p. 1.

16. Raphael Samuel, *Theatres of Memory: Past and Present in Contemporary Culture* (London: Verso, 2012), p. 17.
17. Anna Clark, 'Inheriting the Past: Exploring Historical Consciousness across Generations', *Historical Encounters* 1, no. 1 (2014): 88–9.
18. 'Doctor Who', *BBC*, 2017. www.bbc.co.uk/programmes/b006q2x0 (accessed 25 August 2017).
19. Richard Curtis, 'Vincent and the Doctor', *Doctor Who*, series 5, episode 10 (Cardiff, Wales: BBC, 2010).
20. Martin Bunzl, 'Counterfactual History: A User's Guide', *American Historical Review* 109, no. 3 (June 2004). www.historycooperative.org/journals/ahr/109.3/bunzl_discussion.html (accessed 12 April 2010).
21. Bunzl, 'Counterfactual History'.
22. 'Doctor Who Ratings', *Doctor Who Guide*, 2017. http://guide.doctorwhonews.net/info.php?detail=ratings&type=date (accessed 12 August 2017); Elizabeth Minkel, 'The Global Force of Doctor Who: What Does Britain's Biggest Cultural Export Tell the World?', *New Statesman*, 20 August 2014. www.newstatesman.com/culture/2014/08/global-force-doctor-who-what-does-britain-s-biggest-cultural-export-tell-world (accessed 12 August 2017).
23. Jeremy Black, *Using History* (London: Bloomsbury, 2005), ix; Hilda Kean, 'Introduction', in *The Public History Reader*, ed. Hilda Kean and Paul Martin (Oxon: Routledge, 2013), pp. xiii–xv.
24. Robert Kelley, 'Public History: Its Origins, Nature and Prospects', *Public Historian* 1, no. 1 (1978): 16; Paul Ashton and Paula Hamilton, *History at the Crossroads* (Sydney: Halstead Press, 2010), p. 124.
25. Ibid.
26. Paul Ashton and Meg Foster, 'Public Histories', in *New Directions in Social and Cultural History*, ed. Sasha Handley, Rohan McWilliam and Lucy Noakes (London: Bloomsbury, 2017), pp. 151–70.
27. Michael Frisch, *A Shared Authority: Essays on the Craft and Meaning of Oral and Public History* (New York: State University of New York Press, 1990).
28. Meg Foster, 'Online and Plugged In? Public History and Historians in the Digital Age', *Public History Review* 21 (2014): 4. See also Stephanie Ho, 'Blogging as Popular History Making, Blogs as Public History: A Singapore Case Study', *Public History Review* 14 (2007): 64–79; J. Gordon Daines, III, and Cory L. Nimer, 'Introduction', *Interactive Archivist*, 18 May 2009. http://interactivearchivist.archivists.org/#footnote13 (accessed 12 June 2014); Paul Martin, 'Past in the Present: Who Is Making History?', in *The Public History Reader*, pp. 6–9.
29. Samuel, *Theatres of Memory*, p. 17.
30. Roy Rosenzweig and David Thelen, *The Presence of the Past: Popular Uses of History in American Life* (New York: Colombia University Press, 1988);

Paul Ashton and Paula Hamilton, 'At Home with the Past: Background and Initial Findings from the National Survey', *Australian Cultural History* 22 (2003): 5–30; Ashton and Hamilton, *History at the Crossroads*; Anna Clark, 'Ordinary People's History', *History Australia* 9, no. 1 (2012): 201–16; Anna Clark, *Private Lives, Public History* (Melbourne: Melbourne University Press, 2016); Margaret Conrad, Kadriye Ercikan, Gerald Friesen, Jocelyn Létourneau, D. A. Muise, David Northrup and Peter Seixas, *Canadians and Their Pasts* (Toronto: University of Toronto Press, 2013).

31. Foster, 'Online and Plugged In?', 7. See also Ashton and Hamilton, 'At Home with the Past', 5–30; Ashton and Hamilton, *History at the Crossroads*, 68–99.

32. Rozensweig and Thelen, 'The Presence of the Past', 32.

33. James B. Gardner, 'Trust, Risk and Public History: A View from the United States', *Public History Review* 17 (2010): 52–61.

34. Benjamin Filene, 'Passionate Histories: "Outsider" History Makers and What They Teach Us', *Public Historian* 34, no. 1 (2012): 14.

35. Ibid., 21.

36. Ibid., 23.

37. Tanya Evans, '*Who Do You Think You Are?* Historical Television Consultancy', *Australian Historical Studies* 46, no. 3 (2015): 456.

38. Ibid., 454–67. This interpretation is also drawn from the author's experience as a consultant on the show.

39. Filene, 'Passionate Histories', 23.

40. Foster, 'Online and Plugged In?', 1–19.

41. 'twitterstorians', 2017. https://twitter.com/search?q=%23twitterstorians&src=tyah (accessed 27 August 2017).

42. 'Grants', *Australian Research Council*, 2017. www.arc.gov.au/grants (accessed 12 August 2017).

43. 'First Annual Conference of the Centre for Public History', *Queens University, Belfast*, 24 July 2017. www.qub.ac.uk/schools/happ/News%20and%20Events/ThefirstannualconferenceoftheCentreforPublicHistory.html (accessed 1 August 2017).

44. 'What Is Public History?' H-Net Public Discussion Log.

45. Graeme Davison, 'Paradigms of Public History', *Australian Historical Studies* 24, no. 96 (1991): 9.

46. Gardner, 'Trust, Risk and Public History', 52–61.

47. Jorma Kalela, 'History Making: The Historian as Consultant', *Public History Review* 20 (2013): 24–41; Jorma Kalela, 'Making History: The Historian and the Uses of the Past', in *The Public History Reader*, ed. Hilda Kean and Paul Martin (Oxon: Routledge, 2013), pp. 104–28; Hilda Kean, 'People, Historians, and Public History: Demystifying the Process of History Making', *Public Historian* 32 (2013): 25–38.

48. Bill Adair, Benjamin Filene and Laura Koloski (eds), *Letting Go? Sharing Authority in a User-Generated World* (Philadelphia: The Pew Centre for Arts and Heritage, 2011), p. 13.

49. Kean, 'Introduction', xix, drawing on William Faulkner's famous lines in the play *Requiem for a Nun*.

13

Affective Afterlives: Public History, Archaeology and the Material Turn

Denis Byrne

The women who as girls were internees at the Parramatta Girls Home, Sydney, in the 1960s and 1970s, might be said to 'have history' with that place.[1] It seems clear, from those who have spoken publicly about it, that this history translates as a particular kind of attachment, a bond between themselves and the buildings and spaces that comprised the Girls Home.[2] This was a bleak and bitter connection:

> The atmosphere within the ... [Parramatta Girls Home] was one of fear with all movement within the institution restricted and accompanied with the locking and unlocking of doors supervised by officers. All trace of individuality was removed: no privacy; no doors on toilets or showers; no lockers. Musters and body searches were part of the daily routine, all mail was censored and family visitors were restricted to once a week.[3]

Even for those women who never want to revisit the place, it is not difficult to see why it retains a certain hold on them. For those who do revisit, their re-encounter with the place and its details – a certain doorway, the smell of a particular room, the unyielding solidity of the perimeter wall – has triggered memories, emotions and bodily responses. They may not seek or want this experience but their history with the place seems to permeate the very fabric of the place, endowing it with the agency to affect them whether they want it to or not. Once an object or place is imbued with this affective valency it

cannot simply be switched off. This account of object agency foregrounds the human actor but we understand that objects, materials and places have an independent existence; that they have their own histories and capacities that cannot be encompassed by the human histories they from time to time intersect with or participate in.[4]

Some of us who work in the fields of archaeology and heritage studies are trying to get a better understanding of this kind of 'place attachment' so that we can arrive at an approach to heritage conservation that preserves places not just as bricks and mortar but as sites with which real people have real histories. Relevant to this is a stream of archaeological work which has emerged over recent decades to bring archaeological perspectives and techniques to bear on the period of the recent and contemporary past.[5] Frequently this work overlaps with the field of public history, partly in that publics in various parts of the world now often take an archaeological perspective on their own lives and the histories of their communities.

Wrapped up in this trend is a growing appreciation that human experiences can be sedimented into the material setting of those experiences, and, by extension, that those 'settings' – they may include old buildings, industrial wastelands or pieces of clothing – can provide a kind of testimony that goes beyond words. For the most part, we are dealing here with an archaeology of the surface. By this I mean that rather than being stratified metres below ground surface, the remains of these material settings occupy the same 'horizon' – to use an archaeological term – as ourselves. We excavate these settings not with shovels and trowels but by finding, re-experiencing and reinterpreting them in the surface terrain of our own contemporary landscape. In order to illustrate this kind of archaeological perspective, I draw on my own explorations, first in the landscape of Bali and then in that of Australia.

Bali: A ruptured paradise

For several months after arriving in Bali in 1992 I lived a 'paradise island' kind of existence. As the days drifted by I was lulled into a dreamlike state. I met charming local people with whom I held halting conversations. In the afternoons I rode my motor scooter along country lanes through air that was like warm water. And I cleaned my teeth at night over the giant clamshell that stood in as a hand basin in our thatched bungalow. The spell

was broken several months into this orientalist idyll when I happened upon a black-covered book of essays, edited by the historian Robert Cribb, which dealt with the events of 1965–6 in Indonesia.[6]

In the aftermath of an alleged coup attempt in Jakarta on 30 September 1965, Indonesia's army, led by Major-General Suharto, launched a country-wide purge of communists, alleged communists and their associates which led to the death of at least half a million people in Java, Bali, north Sumatra and Borneo in late 1965 and early 1966. The death toll on Bali is thought to have been around 100,000. Bodies were thrown down wells or buried in mass graves and the landscape of what many Westerners had since the 1920s regaled as a paradise was scarred by blackened areas where entire villages had been burnt to the ground.

Cribb's book led me to understand that there existed a landscape parallel to the one I had been living in. I came to my senses as an archaeologist and went out searching for physical traces of what had occurred in the purge, traces which would join these two terrains together.[7] I failed to find any. Although only three decades separated me from those occurrences, it seemed it was already too late. The tropical vegetation was too adept at covering the wounds represented by mass graves; intensive agriculture covered the gaps in the cultural terrain left by destroyed villages; and, most critically, those Balinese who might have been able to show me exactly where to look were disinclined to speak.

A public silence quickly settled over the events of 1965–6, a silence that seemed to be a product of shock, fear, scrupulous state censorship and the almost complete disappearance – by death and imprisonment – of the country's Left intelligentsia. A generation of Indonesians who had witnessed the events had been silenced by a culture of fear while a subsequent generation was educated with history books from which all mention of both the killings and dissidents had been erased. In the 1990s the killings were most definitely not a topic of public history. And yet, however much the government of General Suharto suppressed public commemoration or even public mention of the killings, in the years after 1966 the landscape of the island must have been full of reminders for those left behind of the campaign of killings and those who had been its victims.

The sight of a particular rice field, for instance, might call up memories of the man or woman who had always worked in it, a village shop might evoke the presence of the vanished shopkeeper, the new houses arising in certain villages might gesture to the houses that had been there before. We all know,

in cases of deep personal loss, how ordinary objects and places can trigger real pain; we know how these objects and places can lie in quiet ambush for us as we move carefully across the terrain of each new day: a shop, a field, but also perhaps every laneway and riverbank, a detail here, a detail there, until the familiar local landscape becomes for the survivor a minefield of memory sites.

For me, this scenario has things in common with the Parramatta Girls Home and its remembrance. Such institutions existed to a great extent beyond the public eye. While the old buildings that housed them have come to be valued as public heritage the nature of their significance to former internees was not investigated or foregrounded by heritage experts. Continuing the comparison with Bali in the mid-1960s, it might be said that a kind of underground heritage results from processes of effacement – 'underground' in the sense of being below or beyond the threshold of public visibility.

Missing persons and the affective afterlives of things

I have tried to imagine how those who survived the events of 1965–6 in Bali experienced this 'heritage' at a private, personal level. In Geoffrey Robinson's 1995 book, *The Dark Side of Paradise*, he evoked the fraught atmosphere of the island at the time when thousands of households lived through the months of terror not knowing if or when the soldiers and their nationalist – Partai Nationalis Indonesia – cohorts would come for them.[8] It was said that it was enough for people associated with the communist party to hear the roar of a truck for their hearts to beat wildly with fear.

I attempted to visualize the scene in those house compounds outside which the trucks had stopped, trying to imagine what it would be like for those inside to watch one of their own – a spouse, a child, a parent, a friend – being taken away. The typical Balinese house consists not of a bulky, single building but of free-standing rooms and open pavilions distributed around the enclosed space of a walled compound. The compound's gateway, typically covered with a small thatched or tiled roof and featuring double wooden doors, takes on the significance a front door would have in a Western house. It is a ritually significant liminal threshold between the inside and outside world, protected by regularly propitiated gate-guardian spirits. Inevitably,

for many Balinese the last sight of their loved ones would have been as they were led away through such a gateway. Would the gateway, in these circumstances, not subsequently become resonant with intimations of the ones who were gone and the trauma of their going?

Built structures are not inert phenomena. They are agentic participants, in particular, human–non-human collectives or imbroglios; they have active roles in the lives of those who built them and dwell in them.[9] Accepting that people experience old things and places by way of sense, affect and emotion at least as much as by an intellectual apprehension of them, our attachments to them can be expected to accrue at least as much from our histories of embodied experience as from deliberative thought. Affect theory has come to play a key role in our understanding of how the past is experienced in and via the built environment. Seigworth and Gregg tell us that 'affect is found in those intensities that pass body to body (human, non-human, part-body, and otherwise), in those resonances that circulate about, between, and sometimes stick to bodies and worlds'.[10]

In the hypothetical case of the gateway, those who survived the killings and continue to live in the house compound, habitually-repetitively passing in and out of the gateway, can be thought to 'inhabit' the gateway, a term that gestures to the kind of customary usage that can lend things a certain invisibility.[11] But the gateway's association with the loss of a beloved ruptures its surface of familiarity: we no longer simply pass through it; the gateway now pulls us into a whole world of affect. Physically unmarked by the events of 1965–6, there is nevertheless something about the gateway's physicality that allows it to transmit affects. Sara Ahmed writes of how an object can become 'sticky' with affect as a result of the history of associations it has with people and they have with it. She observes that what such an object 'picks up on its surface "shows" where it has travelled and what it has come into contact with'.[12]

Australia: Carceral networks

I want to use the above as a background for thinking about the relations to place that former internees at the Parramatta Girls Home may experience. To begin with I look at the likelihood that these relations have a landscape dimension – in other words, that they may come to be dispersed quite widely across space. The girls who were interned at the Parramatta Girls Home were very aware that a network of similar institutions extended

across New South Wales.[13] One node in this network, the Hay Institution for Girls, was particularly feared for its harshness. The fact that girls were often transferred between these sites facilitated the circulation of clandestine intelligence about them. So while some of the girls had first-hand experience of several of the sites, a much larger group had what we might call a 'secondary experience' of them. What comes into view here is a networked constellation of places that is more or less intimately known to a particular group of people in society but which is invisible to the majority population.

A comparison may be made with the network of Aboriginal reserves that existed across New South Wales from the nineteenth century up until the 1970s when most of them were closed.[14] These reserves were blocks of Crown Land where Aboriginal people lived in various degrees of poverty under the control of white bureaucrats. They were typically located far enough away from white population centres to be out of sight and out of mind. But Aboriginal people across and beyond New South Wales shared knowledge of the whole network of these places. They shared a common mental map of the network that was kept 'in mind' and assiduously kept up to date. The similarities in the physical character of these places – they tended to have a standard layout and the huts or houses were made of similar materials and to a standard design – meant that to know one such site was, in a sense, to know them all.

In *Abandon All Hope*, Bonney Djuric tells us that the Hay Institution for Girls, with its reputation for brutality, was a real presence in the lives of the girls at Parramatta. She writes, 'The threat of being sent to Hay had a profound effect on every girl at Parramatta.'[15] Since Hay is more than 700 kilometres from Parramatta we would conventionally think of it as an entirely separate site. But Bonney Djuric's book helps us to see that in fact the site 'enjoyed' a dispersed existence. For the Parramatta girls, the Hay institution appears to have been capable of transmitting effects of fear even at a distance of 700 kilometres. The ingrained tendency of heritage practice to subordinate the social significance of heritage sites to their architectural significance blinds it to such spatially networked associations and flows. A consequence of treating such sites as separate entities, however, is that heritage practice continues the state's strategy of keeping them 'in their place', by which I mean to obfuscate the existence of a spatially extensive carceral regime of detention. Heritage work operates in this sense as a practice of containment, mirroring the function of institutions such as a Girls Home.

Boundary walls

There is another sense in which places come to have a dispersed existence. Bonney Djuric wrote of how, many years after leaving the Parramatta Girls Home, she had enrolled to study at the National Art School, which since 1922 has occupied Sydney's old Darlinghurst gaol, a complex of sandstone buildings and yards set within the confines of a high sandstone perimeter wall. It is located just a kilometre south of the Sydney CBD and twenty-five kilometres from Parramatta. On her first day at the art school Bonney discovered that the place took her right back to the Parramatta Girls Home, with its similar sandstone perimeter wall: 'It was as if I could "read" the walls, sense the presence of those now long forgotten.'[16] It seems the old Darlinghurst gaol – built between 1822 and 1824 – was physically similar enough to the Parramatta site to become a proxy for it, as if the intensity of Bonney's girlhood experience of the Parramatta Girls Home empowered it to broadcast its affective charge across the city to another site. Perhaps sandstone, as a material actor, played a key role here. This is to say that it was not just the walls, as structural elements of the two sites, that brought the places into relation but also the stone itself. In proposing

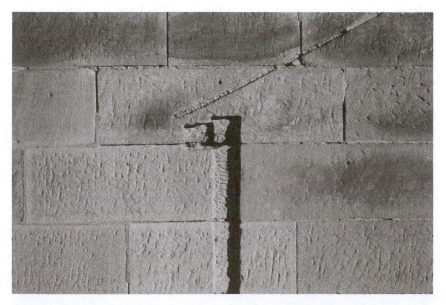

Figure 13.1 One of the Girls Home buildings at the Parramatta Female Factory precinct, 2013. Photo Denis Byrne.

this idea, I also posing the question of whether non-human matter, such that of stone – but also drawing examples from the built environment, glass, water, steel, bricks and concrete – are unacknowledged participants in public history.

Hawkesbury Sandstone, a rock formed during the Triassic Period between 200 and 400 million years ago, forms the bedrock of Sydney, including Parramatta. Extensively quarried from 1788, it immediately became the stone of choice in the colony of New South Wales for the construction of houses and public buildings and for paving, curb stones, walls and bridges. The yellow-brown rock remains a very distinctive feature of the city's built environment, lending it a warmth you would not get from granite or basalt. The sandstone is also highly visible in its natural form around the city, for example, in the form of rock platforms in the intertidal zone around Sydney Harbour and exposed outcrops and cliff formations.[17] A sandstone cliff rises above a street corner just a few city blocks from the old Darlinghurst gaol. Where sandstone buildings and walls lie close to such outcrops and cliffs or where they connect directly with them you are reminded of the continuity between the built and unbuilt.

As the sandstone cliffs and walls erode, the quartz grains (that is, sand) that constitute the stone fall away. You commonly see little piles of this eroded sand at the base of stonewalls in Sydney. These certainly would have been a familiar sight to the inmates of Darlinghurst Gaol and, I assume, to the inmates of the Girls Home at Parramatta.[18] The stone's erodibility belies the implacability of such walls as boundaries between the states of confinement and freedom. In eroding, the Hawkesbury Sandstone gives up its substance relatively quickly, but then again too slowly to offer hope to the inmate. In this sense, the time of stone is incommensurable with the time of servitude.

The history of our entwinement with sandstone mostly escapes us as we go about our lives in the city. It lies below the threshold of everyday visibility. We do not reflect, for example, on the rectangular shape of the sandstone blocks that make up the walls of surviving colonial-era buildings and how that geometry alludes to the technology of colonization itself and the way our own contemporary lives are spatially confined and directed by colonialism's grid.

Surveyors began measuring out the landscape of Sydney shortly after the colony was founded in 1788.[19] A rectangular cadastral grid spread out across the terrain, gradually to be filled in by cottages and farms. The legal system of land title worked in tandem with the technology of cadastral survey to translate the country of the indigenous inhabitants into a tradable

Figure 13.2 The former Darlinghurst Gaol showing the sandstone wall of a cell block now used as art studios, 2013. Photo Denis Byrne.

commodity, a commodity trade they were excluded from and dispossessed by.[20] It takes only a minor stretch of the imagination to see that in the act of quarrying the sandstone into rectangular blocks of various standard sizes, the Cartesian grid of colonialism was being projected in anticipatory form into the colony's bedrock. Once cut free from the bedrock, the stone blocks were aggregated into buildings and walls that were mostly rectangular in shape, the buildings divided internally into rectangular rooms, walls such as those of Darlinghurst Gaol marking the boundaries of rectangular city blocks (not that a square is technically a rectangle). We are all, to an extent, inmates of the colonial spatial order.

All this might seem to fit comfortably within the modern narrative of humanity's mastery of nature. But we see how, in eroding, the sandstone blocks slough off the rectangular dressing given to them by the nineteenth-century quarrymen and take on the sinuous shapes congenial to their matter and to their characteristic mode of decay. Over the last couple of years, at Elizabeth Bay – a kilometre and a half from Darlinghurst – I have been observing the erosion of the sandstone blocks of a seawall that was built in the 1890s to contain a harbourside reclamation and protect it from the sea. In giving up their substance to the harbour waters, these blocks are allowing

the sea to advance inland a millimetre at a time back towards the waterline that existed before the reclamation was carried out.

The eroding wall might be said to be responding to the sea's intentions more than it is to our intention for the wall to serve as an implacable barrier to the sea.[21] This drama being played out on Sydney's waterline is not unrelated to the larger-scale drama of anthropogenic global warming and sea-level rise, which in turn has provided an urgent context for the decisive rejection by many scholars of the kind of culture–nature dualism that has in the past kept us at a distance from the more-than-human world. In reconstruing our relations with this world as symmetrical rather than hierarchical, we are able to acknowledge what a limiting and damaging fiction it has been that our histories are separable from the histories of stone, birds, concrete and water. The list of more-than-human actors we have been involved with over the years and millennia is almost infinite.

Empathy among strangers

Bonney Djuric and other women who were interned when they were young at the Parramatta Girls Home ran a campaign for several years to win recognition as key stakeholders of that place as a heritage site.[22] It was as such a stakeholder that in 2013 Bonney conducted a guided tour of the site, in which I participated. She described not just the function of the various buildings and open spaces but what it felt like to be incarcerated in them – to know them, in other words, from the inside.

In the course of the tour we paused in front of the doorway to the admissions building. Bonney described how the day she was first brought to the Girls Home she was taken through that door. She said she remembered how she felt herself sink into a pit of despair when the door had closed after her. Affective contagion is a term normally used to describe how affect can jump between people, as, for instance, when excitement is transmitted through a crowd.[23] I certainly felt a frisson of something unspoken – despair, horror, fear? – flow from Bonney through the knot of people standing with her in front of the doorway at Parramatta. But my own concern as an archaeologist and sometime heritage professional has been with the way affects can jump not from person to person but from objects to human bodies. As mentioned earlier, in relation to the hypothetical gateway in Bali, this phenomenon is grounded in the objects and people in question having a shared history. It

Figure 13.3 The doorway to the admissions building of the former Parramatta Girls Home. On the left, Bonney Djuric speaks to members of the tour group, 2013. Photo Denis Byrne.

also calls for an understanding of objects as being meaningfully involved in the events of our lives.

The doorway to the admissions building at Parramatta was no neutral bystander to Bonney Djuric's passage through it. She did not, after all, pass through a hole in space but through an opening framed solidly in wood and masonry. This structure has history with the people who have passed through it: the touch of their hands on the doorknob burnish its metal, their feet create patterns of wear on the doorstep. Bonney's fraught history with the doorway had been sedimented into it, sufficiently so, I assume, that upon reencountering it during the 2013 site tour she was subject to an affective charge that resided in that object. In conventional heritage practice, if the significance of the doorway to Bonney Djuric was to be credited as part of the larger site's heritage significance, it would most likely be described in terms of what would be termed the site's intangible heritage. I agree with Þóra Pétursdóttir, however, that the tangible and intangible aspects of an object or place are inseparable.[24] The doorway, with all its material heft, is not an intangible entity and Bonney Djuric's response to it, I surmise, was anchored in its material presence.

If so much of the significance of heritage places lies, as I believe it does, in the affective dimension, and if this stems from the histories that people share with the materiality of these places, then how can those of us who do not have a personal history with these places hope to understand their significance? The answer may lie in an empathy that stems from our own repertoire of emotional and affectual life experiences and of the places and materials enfolded in those experiences. There has been debate in the field of museum and heritage studies about the means and ethics of attempting to elicit empathetic responses among visitors to museums and heritage sites.[25] My own concern is with the possibilities of empathy via materials. It is based on the proposition that we are able to empathize with the past place-centred experiences of others on the grounds that, in our own lives, we too have histories of experience with/in place.

More radically, I propose that we extend the debate to include objects and materials as others that are deserving of our empathy. Hawkesbury Sandstone is a material which warrants such an orientation on the part of those of us living in Sydney. This stone, which in more than one way is the bedrock of our lives, has been carved up and enlisted in carceral projects of violence. At another level, our blithe indifference during the modern era to more-than-human others, including others whose nature is geologic, is now eliciting a crescendo of repercussions that both characterize the Anthropocene epoch and justify the declaration of the beginning of that new geological interval. Our survival as a species now requires a fundamental shift in our orientation to these material others and it seems obvious that this shift should be built partly on a reappraisal of the *histories* we have had with them.[26]

Notes

1. This intitution for the incarceration of girls operated in different forms and under different names from 1887: www.parragirls.org.au/parramatta-girls-home.php
2. For one such account, see Bonney Djuric, 'A Past Revisited', in *Silent System: Forgotten Australians and the Institutionalisation of Women and Children*, ed. Paul Ashton and Jacqueline Z. Wilson (Melbourne: Australian Scholarly Publishing, 2014), pp. 119–31.
3. See www.parragirls.org.au/parramatta-girls-home.php (accessed 1 October 2017).

4. For a discussion of the essential otherness of things, see Bjønar Olsen, 'The Return of What?', in *Reclaiming Archaeology: Beyond the Tropes of Modernity*, ed. Afredo González-Ruibal (London: Routledge, 2013), pp. 289–97.

5. See Victor Buchli and Gavin Lucas (eds), *Archaeologies of the Contemporary Past* (London: Routledge, 2001); and Paul Graves-Brown, Rodney Harrison and Angela Piccini, *The Oxford Handbook of the Archaeology of the Contemporary World* (Oxford: Oxford University Press, 2013).

6. Robert Cribb (ed.), *The Indonesian Killings 1965–1966* (Melbourne: Centre for Southeast Asian Studies, Monash University, 1990).

7. I have written about this experience in my book, *Surface Collection: Archaeological Travels in Southeast Asia* (Lanham, MD: AltaMira, 2007).

8. Geoffrey Robinson, *The Dark Side of Paradise: Political Violence in Bali* (Ithaca, NY: Cornell University Press, 1995).

9. Bruno Latour, *Reassembling the Social: An Introduction to Actor-Network-Theory* (New York: Oxford University Press, 2005).

10. Gregory J. Seigworth and Melissa Gregg, 'An Inventory of Shimmers', in *The Affect Theory Reader*, ed. M. Gregg and G. J. Seigworth (Durham, NC: Duke University Press, 2010), p. 1.

11. Edward S. Casey, *The Fate of Place: A Philosophical History* (Berkeley: University of California Press, 1998), p. 231.

12. Sara Ahmed, *Queer Phenomenology: Orientations, Objects, Others* (Durham, NC: Duke University Press, 2006), p. 40.

13. Former internees of the Parramatta Girls Home mentioned this at a conference in Sydney in September 2013.

14. Heather Goodall, *Invasion to Embassy: Land in Aboriginal Politics in New South Wales, 1770–1972* (Sydney: Allen & Unwin, 1996).

15. Bonney Djuric, *Abandon All Hope: A History of the Parramatta Girls Industrial School* (Perth: Chargan, 2011), p. 182.

16. Ibid. This quotation is taken from the foreword of the book, n.p.

17. Prior to the arrival of the British in 1788, Aboriginal people had engraved animal figures and abstract designs on many of the semi-horizontal sandstone outcrops that occur around the city – see Jo Macdonald, *Dreamtime Superhighway: Sydney Basin Rock Art and Prehistoric Information Exchange* (Canberra: ANU Press).

18. Darlinghurst Gaol functioned as a prison between 1841 and 1914.

19. Paul Ashton and Duncan Waterson, *Sydney Takes Shape: A History in Maps* (Brisbane: Hema Maps, 1977).

20. Denis Byrne, 'Nervous Landscapes: Race and Space in Australia', *Journal of Social Archaeology* 3, no. 2 (2003): 169–93.

21. Denis Byrne, 'Remembering the Elizabeth Bay Reclamation and the Holocene Sunset in Sydney Harbour', *Environmental Humanities* 9, no. 1 (2017): 40–59.

22. Djuric, 'A Past Revisited', 119–31.

23. Teresa Brennon, *The Transmission of Affect* (Ithaca, NY: Cornell University Press. 2004).

24. Þóra Pétursdóttir, 'Concrete Matters: Ruins of Modernity and the Things Called Heritage', *Journal of Social Archaeology* 13, no. 1 (2013): 31–53.

25. See, for example, Silke Arnold-de Simine, *Mediating Memory in the Museum: Trauma, Empathy, Nostalgia* (Hounsmills, Hampshire: Palgrave Macmillan, 2013); Jenny Kidd, 'With New Eyes I See: Embodiment, Empathy and Silence in Digital Heritage Interpretation', *International Journal of Heritage Studies* (2017), doi 10.1080/13527258.2017.1341946.

26. On empathy for coal, see Kathryn Yusoff, 'Queer Coal: Genealogies in/of the Blood', *PhiloSOPHIA* 5 no. 2 (2015): 203–29.

14

The Archaeological Archive: Material Traces and Recovered Histories

Tracy Ireland

During 2011, I conducted an informal interview with archaeologist Jed Levin about his work on the President's House site in Philadelphia, a place that I will return to later in this chapter, and which he had been involved in excavating, preserving and interpreting before it opened to the public in 2010. Jed was eloquent about the power of this place, and of its unexpected archaeological remains, to make a significant impact on social relations, on tensions around the persistence of the past in the present and the emotional potency of its memory in contemporary Philadelphia. 'The archaeological uncovering,' he told me,

> was also the uncovering of something that had been hidden ... the remains themselves were unexpected – they were like the past reaching up to people and jolting them out of the predictability of American life.[1]

In this chapter I explore archaeology and heritage as memory practices that intersect with the domain of public history using the notion of the 'archaeological archive' to focus on material traces as the result of both remembering and forgetting, entropy and residuality, intentionality and accident, social processes and natural forces.[2]

As a counter to approaches in heritage studies that emphasize the past as a discursive product of the present, scholars have recently begun to focus more on the unruly, persistent materiality of the past and on how

objects can be unpredictable in their vibrancy and more-than-human entanglements, noting that old things, with their aura and patina, produce heterotopias – places or 'other spaces' where time is experienced differently, through combinations of 'affect, social relations and dialectical tensions'.[3] The materiality of archaeological traces and places also insists that they are experienced aesthetically, sensuously, through the body and in their immediate, local context. This affective charge characterizes the way in which sites, monuments and places become linked to claims for belonging, restorative social justice and to the politics of identity, locality and recognition, as well as to the way in which they can perform important rhetorical work for nation states. These uses often focus on the archaeological archive as a resource for recovering lost history, or as a corrective to the preoccupations of official histories, and on their potential to work against 'commanded forgetting', to use Paul Ricoeur's term for the processes of amnesia that are not the inevitable erosion of memory by time, but deliberate strategies that maintain power and social control.[4]

When archaeological remains are uncovered, conserved and displayed to the public, they speak to their own ruinous authenticity through their embeddedness in place and their visual, time-worn qualities. Such traces do not just mark or commemorate a place, like a plaque or a monument; they are the enduring material signature of events in the past and this is the essential, ontological difference between the trace and historical testimony.[5] The duration of objects and traces – their complex biographies over time – and the human and non-human processes that lead to their production insist that material traces demand different kinds of narratives from testimonial, documentary-based history. The material past is 'recalcitrant';[6] it has the potential to resist and to confront the present with uncomfortable truths. The archaeological archive does not exist outside discourse and politics. But it can provide opportunities for new kinds of conversations about the present and about ourselves.

The democratization of the past

The rise of public history is mirrored in trends in many other disciplines, including archaeology, heritage studies and museology, where so-called *democratization* involves working towards opening up the official, expert-driven, discipline-based structures which govern, curate and control access to material heritage to various forms of participation, co-production and

collaboration. 'Citizen heritage' movements, often taking advantage of digitized collections and archives and using diverse means of sharing and collaborating online, are also increasingly seen as important ways in which communities identify their own heritage and assemble their own narratives about the past. In addition to these trends, the rise of scholarly interest in the more recent past has seen the expansion of historical archaeology around the globe and the emergence of sub-fields such as contemporary archaeology, conflict archaeology and community archaeology.[7]

While the 'condition of possibility' for the emergence of different kinds of archaeologies is usually understood as a discovery or recognition of the 'otherness' of a particular past,[8] in these cases it is not deep time that is perceived as separating scholars or communities from these recent archaeological remains. But it may be the sense that a past is unrecognized, invisible, forgotten, deliberately hidden or is under threat. More broadly, since the 1970s the practice of historical archaeology has always had a particular focus on the past of settler nations and its potential as a 'democratizing force' in both giving a past to 'people without history' and in revealing history's systematic erasure or distortion of events, has been generally proclaimed. American folklorist Henry Glassie articulated this as historical archaeology's potential to act against the 'superficial and elitist tales of viciousness' which formed 'myths for the contemporary power structure'.[9]

In American historical archaeology studies of slavery and capitalism have been a central theme which aims to 'give back history' to communities without a historical voice.[10] In Australia, postcolonial critiques have been more central to projects engaging with contemporary social justice issues and there has been widespread recognition of the way in which the historical burden of colonialism has shaped discourses concerning Indigenous people both in the past and in the present. In the 1990s there were calls for the development of an historical archaeology of and for Indigenous peoples to counter the tendency to see them as part of 'prehistory', to work towards historicizing their recent experiences, include them in national narratives and make their past visible as a counter to the dominant visibility of colonial heritage in the Australian landscape.[11]

Historical archaeology's focus on a past which is directly involved with present social conditions means that it, more than other forms of archaeology, has always been seen to have the potential to act as what Foucault called a history to 'diagnose the present'.[12] In some contexts, the intersection of historical archaeology and heritage management has led to concerns about the growing use of archaeology to produce visible,

material heritage for particular groups to use in the politics of identity and recognition. For instance, Shannon Lee Dawdy, writing of her experiences of doing cultural heritage work in New Orleans in the aftermath of Hurricane Katrina, has expressed scepticism about the possibility for really meaningful public archaeology. The agenda, she claims, is inevitably set, by archaeologists rather than by community members, suggesting that 'most public archaeology should really be called public relations archaeology'.[13] However, other discussions about heritage are looking more closely at how communities of interest and articulations of social value are created, rather than reflected, through the practices of archaeology, history and heritage, and these studies offer important new directions for better understanding the work that heritage does in society.[14]

This chapter draws on two cases where archaeological traces have created memory places which have created visibility and recognition for social justice struggles and provided resources for recovering history. From Australia, I look at the site of the Wellington Valley convict station, later used as a mission to the Wellington Wiradjuri people, where the landscape and its ephemeral archaeological remains became touchstones for both stolen generation and reconciliation narratives. The second is from the United States where archaeological traces of slavery were found literally in the middle of Philadelphia's Independence National Historical Park, a place dedicated to the celebration of the nation's foundational doctrine of liberty.

Myanggu Ganai

On the outskirts of the small town of Wellington in western New South Wales (NSW) – the most populous of Australia's seven states and territories – is a large grassy paddock signposted, somewhat enigmatically, 'Myanggu Ganai Historic Site'. The site encompasses two low, rolling hills rising from the edge of the rich flood plain of the Bell River. This place contains the archaeological remains of an early colonial agricultural station established in 1823, designed to provide labour and isolation for some of Great Britain's deported convicts. At that time this settlement was the most remote western outpost of this British colony. The establishment was subsequently taken over by the Anglican Church Missionary Society as a mission to the Bell River Wiradjuri people that operated from 1832 to 1844. While the site is likely to be archaeologically rich, and fossicked collections of colonial artefacts deriving from it are well known locally, it has not been formally

excavated. The visible archaeological remains are minimal – a scatter of soft bricks and nineteenth-century artefacts, a well, the odd area of stone flags peeping between grass and thistles. These are all that remains of the quite substantial settlement built by the convicts that was depicted by the now well-known colonial artist Augustus Earle in 1826. His watercolour of the site 'Wellington Valley, N.S. Wales, looking east from Government House' shows just the verandah post of the hilltop 'Government House', the central building of the settlement that was later converted to the missionary house, as well as the cluster of stockade, granary and other buildings of the convict station down in the valley. These are all presided over by the central figure of a Wiradjuri warrior, shown with his full regalia of body decorations and hunting implements.

In addition to the intriguing series of paintings that Earle completed of the Wellington region and Wiradjuri people, the site is further animated by a remarkable documentary archive that resulted from the missionaries' records sent back to the Church Missionary Society (CMS) in London.[15] Their letters, journals and reports – more than a thousand manuscript pages – have been preserved in the archives of the CMS and provide a compelling and immediate source for contact history, observations of Wiradjuri life and language and the experiences and beliefs of the missionary families. As well as the archaeology, the artwork and the archive, the other factor which links past and present in this location is the landscape itself.

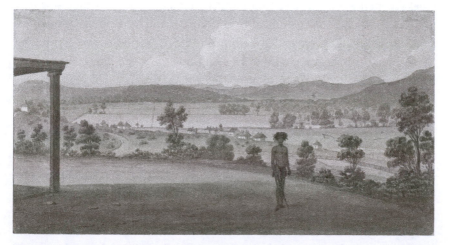

Figure 14.1 Augustus Earle, 1826, 'Wellington Valley, N.S. Wales, looking east from Government House', NK 12/24, National Library of Australia, 1974.

The lack of recent development in the area has meant that the early colonial landscape of the Wellington Valley, as described in the historical documents and depicted in Earle's watercolour, has survived in a recognizable form. The contemporary buildings around the historic site are small scale rural structures while the large fields of crops along the river, as well as the uninterrupted views to the distant mountain ranges, allow the landscape to be experienced today in a manner which conflates past and present. In this context, what people know of the history, and what they remember of the historical images they have seen, work together with the evocative archaeological traces. These fragments are assembled by memory and focused by the affectively charged landscape setting.

This site was purchased in 2001 by the NSW government for its 'archaeological, historical and social heritage significance', providing a rare instance in Australia where the State acquired an archaeological site in order to protect and conserve it in response to community and local government lobbying. A few years after the purchase I worked with a team to prepare a Conservation Management Plan for the site for the NSW National Parks and Wildlife Service.[16] When we did our archaeological and community-based research this was a place many people were passionate about. Its values were contested locally, particularly over the state government's decision to formally name the place Maynggu Ganai Historic Site (MGHS), meaning 'people's place' in Wiradjuri language. However, leading black and white community members had been working together on the heritage management of the place and they claimed it as an important vehicle for the local reconciliation process. Community members said that they saw this as a place which could be valued by both black and white people together, as a symbol of their entangled cultural heritage, and also as a symbol of their shared future as a community living together. The physical traces of the site, as well as the promise of further material that could be produced by archaeological research, were important anchors that forced a discussion about how to recognize and care for this place at the local level.

The MGHS was known locally as a place of 'firsts', making the archaeological evidence particularly potent: the first colonial settlement in the region and also the first in a long succession of Aboriginal missions and settlements. Non-indigenous people valued the site primarily for its association with the convict period and to narratives which cast convicts as founding figures in the national story. As the first white settlement in the region the place provided an origin site and birth myth for the settler community. On the other hand, local Wiradjuri Elders valued the site for its

time as a mission. But they also clearly recognized its importance as the place of the first contact between Wiradjuri and what they termed 'government men', evoking the difficult subsequent history of government agents and policies designed to control and contain the lives of Wiradjuri people.

Although relatively few Wiradjuri people lived in the Wellington Valley Mission when it was operating, it was the first in a long line of mission settlements around Wellington and members of the contemporary community traced their family trees back through these settlements. Some local people had baptism and marriage certificates of ancestors that had been signed by Reverend William Watson, the missionary from Wellington Valley who stayed in the area for the rest of his life, long after the mission had been abandoned. Watson was in fact spoken about familiarly and affectionately by some of the Wellington Wiradjuri Elders. However, younger members of the community saw the importance of the place somewhat differently and were more likely to place it in the context of stolen generation narratives, linking it to much later assimilation policies which involved removing children from their parents and their culture.

The interrelated and sometimes contradictory meanings that have coalesced around this place show that it provides material, aesthetic resources that can be inscribed and re-inscribed as a memory place in light of a range of present community concerns. There is a tendency to see archaeological landscapes – including pre- and postcolonial Indigenous landscapes – as invisible, as absences. Just because the buildings of the convict station and mission were demolished, such places tend to be treated as lost parts of the heritage landscape when notions of heritage focus so heavily on the built and the monumental records of colonialism. However, the materiality of Myanggu Ganai is no less affective for the subtlety of its traces. The landscape and its assemblage of small things is an enduring formation that exerts a quiet, steady pressure that is activated and utilized in dialogues about how the colonial past persists in this place.

The President's House

The President's House monument opened in 2010. It is found within Philadelphia's Independence National Historical Park, the large historical precinct in the centre of this historic city that includes the Independence Hall where the Declaration of Independence was signed. The monument is located immediately adjacent to the Liberty Bell Centre which opened

only seven years earlier. The President's House monument marks the site of the house where the first two presidents of the newly formed independent nation of the United States lived – George Washington – from 1790 to 1797 – and John Adams – from 1797 to 1800. The house itself was gutted in the 1830s and the shell was finally demolished in 1951 to create the large, grassy mall that now forms the heart of this symbolic precinct that commemorates Philadelphia's role in the birth of the nation and its ideals of freedom. However, the archaeological excavation of this site, and the subsequent creation of the President's House monument, came about after the fact was publicized that George Washington's household had included nine enslaved Africans brought from his Mt Vernon Plantation to work for his household in the city. Their names were recorded as Austin, Christopher Sheels, Giles, Hercules, Joe Richardson, Moll, Oney Judge, Paris and Richmond. The irony quickly became apparent that the land visitors walked across to enter the Liberty Bell Centre was actually the site of the quarters constructed by George Washington to accommodate his household's slaves.[17]

Jed Levin is the Chief of the History Branch of Independence National Park in Philadelphia and the archaeologist in charge of the excavation of the site in 2007. He has written that it was this 'jarring, deeply disturbing image of Washington' as a slave owner, as well as the sharp irony of the site's location on the threshold of the Liberty Bell Center, that eventually lead to the excavation of the site in response to community activism and lobbying.[18] In our 2011 interview Jed described how the local African American community and their supporters mobilized around the Independence National Park's plans for the commemoration and interpretation of this site, demanding recognition of the individuals that history had made largely anonymous and invisible. One of the community groups formed was called the 'Avenging the Ancestors Coalition'. It highlighted local people's desire to seek some kind of restorative justice for those enslaved in the past – to make them visible as individuals – and make clear the issues of slavery and race in the National Parks Services' plans to interpret the Liberty Bell Centre precinct. These were absent in plans made prior to the excavation of the house site.

Jed described how important the materiality of the remains of the house were to the communities of interest that formed around this issue. He suggested that the uncovering of the building's foundations gave a physical focus for discussions between visitors, archaeologists and others about race and slavery which can still be tentative and tender in this city. 'Somehow,' Jed said, 'the physicality of the remains made it harder to deny or avoid this

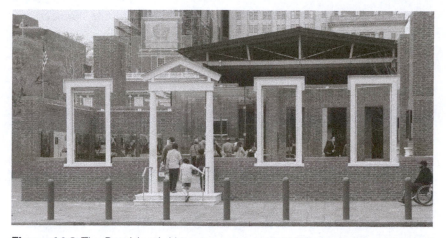

Figure 14.2 The President's House monument in the Independence National Historical Park, Philadelphia, Pennsylvania. The glass cube in the centre of the photograph contains the display of in situ archaeological remains. The gable roof behind the monument is the Liberty. Photo Tracy Ireland.

history.' At the opening ceremony for the archaeological excavation, when the first sod was turned, Jed described how people came and laid their hands on the earth, collected samples of the soil to take home in plastic bags and souvenired fragments of brick. Jed also described how the process of archaeological excavation worked to make the site more relevant to local people: 'Many Philadelphians hadn't been to the Park for years – it was seen as a place for tourists and had lost its local connections in the big national story told there.'

Today, although the archaeological remains have been conserved in situ and are visible to visitors, they are sealed in a glass enclosure that protects them from the extremes of the climate and variations in temperature and humidity. People can no longer lay their hands on the bricks to experience a sense of connection with the past and the people who inhabited it. Jed Levin worries that in the long term this may cut people off from the power of the place as he and others have experienced it over the last decade. The practices of conservation, carried out in order to ensure the long-term survival and endurance of these archaeological traces, can have the unintended consequence of distancing the communities who have invested this material with memories and continue to re-inscribe them with potent meanings. This is perhaps an issue for heritage managers and archaeologists to contend with in the future. What

in fact is being conserved? Is it the material traces or the connections that people make with them that animate them with values? The answer is not straightforward. Material endurance provides ongoing possibilities for the creative and imaginative re-making of memories in ways that are impossible to predict and perhaps unethical to foreclose upon.

Conclusion

An anxiety in contemporary archaeology and heritage studies is what has been termed the 'crisis of accumulation', the notion that our incurably nostalgic societies are drowning under their accumulated weight of archives, collections, lists, places and things.[19] Recent literature calls for greater attention to how memory is actively constructed in dialogue with both past traces and absences. The suggestion that memory is necessarily attached or inherent in material from the past leads to assumptions that material things and places are repositories of memories, rather than resources that are used to work with contemporary concerns and cultural politics, but which, as we have seen, can also cause ruptures and force uncomfortable conversations.

This approach to place, past and memory recognizes that materiality is always multi-temporal and is alert to the material persistence of robust, naturalized structures. Ann Laura Stoler has termed this 'imperial debris' – locations where we can examine the 'political life of imperial debris, the longevity of structures of dominance, and the uneven pace with which people can extricate themselves from the colonial order of things'.[20] Attending to the agency of the archaeological archive helps us to focus on how things are active constituents of communities and collective memory, not simply symbols or signs of identity. At the very least, as Shannon Lee Dawdy has argued,[21] past materials and old things challenge national narratives of progressive, objective history and force acknowledgement of the continuing presence of the past in our social structures in ways that rational, secular society often attempts to deny.

Notes

1. Unpublished interview with Jed Levin, chief of the History Branch of Independence National Park, by Tracy Ireland in Philadelphia, April 2011.

2. This concept was developed by Gavin Lucas in his article 'Time and the Archaeological Archive', *Rethinking History* 14, no. 3 (September 2014): 343–59.

3. This is a key argument made in Shannon Lee Dawdy's book, *Patina: A Profane Archaeology* (Chicago and London: The University of Chicago Press, 2016).

4. Paul Ricouer, *Memory, History, Forgetting*, trans. Kathleen Blamey and David Pellauer (Chicago and London: University of Chicago Press, 2004).

5. As Gavin Lucas explains in 'Time and the Archaeological Archive', drawing on the ideas of Paul Ricouer.

6. Jane Bennett's term as developed in her book *Vibrant Matter: A Political Ecology of Things* (Durham and London: Duke University Press, 2010).

7. See, for example, Alfredo Gonzalez-Ruibal, 'Time to Destroy: An Archaeology of Supermodernity', *Current Anthropology* 49, no. 2 (April 2008): 247–79, and also papers in the *Journal of Community Archaeology and Heritage*, which commenced in 2014. www.tandfonline.com/loi/ycah20.

8. Laurent Olivier, 'The Past of the Present: Archaeological Memory and Time', *Archaeological Dialogues* 10, no. 2 (December 2004): 204–13.

9. Henry Glassie, 'Archaeology and Folklore: Common Anxieties, Common Hopes', in *Archaeology and the Importance of Material Things*, ed. Leland Ferguson (Lansing, MI: Society for Historical Archaeology, 1977), p. 29.

10. See, for example, Charles Orser, *An Historical Archaeology of the Modern World* (New York: Plenum Press, 1996); and Barbara Little, 'People with History: An Update on Historical Archaeology in the United States', *Journal of Archaeological Method and Theory* 1, no. 1 (1994): 5–40.

11. For a survey of this literature, see Alistair Paterson, 'The Archaeology of Historical Indigenous Australia', in *Handbook of Postcolonial Archaeology*, ed. Jane Lydon, and Uzma Z. Rizvi (Walnut Creek, CA: Left Coast Press, 2010), pp. 165–84; and on heritage and visibility, see Tracy Ireland, 'The Ethics of Visibility: Archaeology, Conservation and Memories of Settler Colonialism', in *The Ethics of Cultural Heritage*, ed. Tracy Ireland and John Schofield (New York: Springer, 2015), pp. 105–25.

12. Michel Foucault, 'Kant on Revolution and Enlightenment', *Economy and Society* 15, no. 1 (1986): 96.

13. Shannon Lee Dawdy, 'Millennial Archaeology. Locating the Discipline in the Age of Insecurity', *Archaeological Dialogues* 16, no. 2 (2009): 138.

14. See, for example, Sian Jones, 'Wrestling with Social Value: Problems, Dilemmas and Opportunities', *Journal of Community Archaeology and Heritage* 4, no. 1 (2017): 21–37.

15. These can be found at Hilary Carey and David A. Roberts (eds), *The Wellington Valley Project, Letters and Journals Relating to the Church*

Missionary Society Mission to Wellington Valley, NSW, 1830–45. A Critical Electronic Edition, 2002. www.newcastle.edu.au/group/amrhd/wvp/ (accessed 10 November 2017).

16. See Tracy Ireland, 'From Mission to Myanggu Ganai: The Wellington Valley Convict Station and Mission Site', *International Journal of Historical Archaeology* 14, no. 1 (2010): 136–55.

17. This discussion is based on my 2011 interview with Jed Levin, as well as sources and accounts in Jed Levin, 'Activism Leads to Excavation: The Power of Place and the Power of the People at the President's House in Philadelphia', *Archaeologies: Journal of the World Archaeological Congress* 7, no. 3 (2011): 596–618.

18. Levin, 'Activism Leads to Excavation', 600.

19. Rodney Harrison, 'Forgetting to Remember, Remembering to Forget: Late Modern Heritage Practices, Sustainability, and the "Crisis" of Accumulation of the Past', *International Journal of Heritage Studies* 19, no. 6 (2013): 579–95.

20. Anne Laura Stoler, 'Imperial Debris: Reflections on Ruins and Ruination', *Cultural Anthropology* 23, no. 2 (2008): 193.

21. A key argument in Dawdy's *Patina: A Profane Archaeology*.

15

Archives and Public History: A Developing Partnership

Jeannette A. Bastian and Stephanie Krauss

At the 1970 annual conference of the Society of American Archivists (SAA), historian Howard Zinn called upon archivists 'to collect and preserve papers and to tape record experiences documenting ordinary lives in addition to those of the exceptional – the "lower" classes as well as the prominent'. In a presentation entitled 'The Activist Archivist', Zinn emphasized the need for archivists as well as historians to 'abandon the screen of professionalism and neutrality in order to humanize their ordinary work'.[1] To a great extent, and to a closely related audience, Zinn echoed fellow historian Carl Becker who forty years previously had claimed 'Everyman his own historian', pointing out in his presentation to the 1931 conference of the Association of American Historians that 'the history that does work in the world, the history that influences the course of history, is living history, that pattern of remembered events, whether true or false, that enlarges and enriches the collective specious present, the specious present of Mr. Everyman'.[2]

While the archivists at that SAA conference were electrified and inspired by Zinn's presentation, it nonetheless took several decades and much rethinking for the profession to fully respond. One could argue that the archives discipline is still fashioning that response. Similarly, public history – one manifestation of Becker's vision – continues to develop and

define itself in the twenty-first century. Today, the missions of archives and public history grow closer together. And it seems likely that this confluence is at least partially rooted in these two events that pushed parallel efforts by both archivists and historians to realize common goals of social equity through documenting, recording and opening paths to broader and more accessible understandings of history and heritage.

This chapter explores the state of that confluence today in the United States, focusing more specifically on the archival side of the equation but also acknowledging the public history perspective. The relationship between archives and public history is a complex one, as both professions have struggled to distinguish themselves in the twentieth century and defend their disciplines in the twenty-first, often in a climate that sometimes seems resistant to cultural heritage institutions. However, public historians and archivists increasingly have a great deal in common, as they both work towards documenting and preserving local history, telling untold narratives, aiding in the creation of collective memories and the establishment of identities. This synergy is often expressed through community archives as well as local history and heritage sites.

Through interviews with archivists and public historians who work at heritage centers, community archives and other public history sites we probe that synergy, exploring the evolving public history mission of archives and its increasing intersections with public history. As communities become more invested in discovering and expressing their own histories and identities and as the means to do so becomes readily available and accessible through virtual affordances, are these two disciplines not only supporting one another but even, at times, converging?

Beginning a relationship

In 1986, the American journal the *Public Historian* published a special issue on archives. Thirty-one years later, in 2017, the British journal *Archives and Records* published a special issue on public history. The initial turn towards archives by public historians, and the later turn towards public history by archivists, suggests both an alliance and a juxtaposition.

In 1986, the discipline of public history was relatively new and seeking to characterize itself as well as differentiate itself from academic history. Archives and records, however, had been the purview and the concern of

governments and citizens since ancient times. As archival historian Ernst Posner has noted, 'writing was invented to serve the administrator rather than the man of learning'.[3] Examples of these administrative records have been discovered as far back as the eighth millennia B.C., in the form of bulla – inscribed clay tokens used by the Sumerians for agricultural transactions as forms of identification and proof of authenticity.

Archivists in the Western world generally agree that modern archival thinking is rooted in the French Revolution. The revolutionary government, determined to destroy the secrecy and privilege around records of the ancient regime in favour of public scrutiny, declared that records belonged to the public rather than the state. Public demand for access to their records necessitated methods of organization to meet those demands. The principle of provenance, or organization by the context of creation – also known as *respect des fonds* – was born to meet that need and remains the central organizing principle of archival collections at all levels.

As the generally unpublished by-products of societal actions, interactions and transactions, be it through government records, church records, correspondence, corporate accounts, manuscripts, diaries, blogs, email or electronic records, archives and records serve a multiplicity of purposes. Although their foremost purpose is as evidence, archives are also primary sources for researchers. As cultural records, they are stewards of societal memory.

This thinking was codified into theory and practice by the late nineteenth century and by the mid-twentieth century had been further formalized by Sir Hilary Jenkinson in the United Kingdom and Theodore Schellenberg in the United States. Jenkinson, with his firm belief in maintaining the neutrality of the archives, defined the mission of the archivist thus:

> His Creed, the Sanctity of Evidence; his Task, the Conservation of every scrap of Evidence attaching to the Documents committed to his charge; his Aim, to provide, without prejudice or afterthought, for all who wished to know the Means of Knowledge.[4]

The more pragmatic Schellenberg, defining archival practice for the National Archives of the United States, also supported this neutral role, writing that:

> The archivist's job at all times is to preserve the evidence, impartially, without taint of political or ideological bias ... Archivists are thus the guardians of the truth or, a least of the evidence on the basis of which truth can be established.[5]

Much of the theory and practice developed by Jenkinson and Schellenberg, in particular as it focused on neutrality and impartiality, was adopted by archivists globally, remaining as standard practice through the late twentieth century.

Despite their ancient lineage and their formalized processes, however, throughout the twentieth century archivists continued to clarify their own theory and practice and to further define themselves particularly in relationship to history. That seeking for definition comes through clearly in that 1986 special issue in the *Public Historian*. In the introduction, government archivist Bruce Dearstyne noted that while many archivists are content to work within well-established lines, a growing number are not. 'These archivists,' he wrote, 'sense an undefined field of endeavor, an unfinished mission, unexploited opportunities, and an overwhelming need for better public understanding and support.' At the same time, he identified contentious issues with the emerging public history community: 'Some archivists consider themselves to be public historians, and some public historians see archivy as a mere branch of public history. But other archivists see public historians as interlopers in their professional arena, and some public historians view archivists primarily as rivals for jobs.'[6]

That quest for definition continued into the twenty-first century as archivists began to confront the many complex questions posed by new forms of records created through virtual environments. New societal concerns such as social justice problematized the efficacy and viability of a neutral role for archivists in a global society that demanded more from its records.

Fast forward to 2017 and that special issue on public history in *Archives and Records*. In the years between 1986 and 2017, archival perspectives have changed dramatically. Neutrality has been revealed as an unreliable and unhelpful prophet while the master narratives of traditional archives have proven inequitable and limited. Communities are beginning to create their own archives, records that reflect their voices. No longer considering themselves the 'handmaidens of historians', archivists now see an expanded mission that includes social justice, documenting the undocumented, engaging in political activism and supporting identity and community. This special issue of *Archives and Records* offers examples of archival scholarship that 'explore the diverse roles that archives now play in public history activity, gathering the perspectives of not only archivists but also historians, artists, and sociologists.'[7] Articles focusing on the nexus between public history and community archives explore that relationship through such disparate

issues as housing activists in London and how the archives collated by local historical societies have shaped the 'historical experience of community and belonging in the town'.[8] In the twenty-first century, archivists and public historians, rather than seeing themselves in opposition, or even in competition, find themselves on common ground.

The interviews

To further explore the changing nature of the relationship between archives and public history and, in a sense, to test the scholarship against actual practice, we interviewed public historians and professional archivists during 2017. The interviewees worked in a variety of institutions, from public and private academic archives, to the federal United States National Parks Service, to historic sites, to localized community archives. Participants ranged from new professionals to those who have been in the field for decades. All but one of the interviews was performed in person, with the other on the phone. All the interviewees, whether archivist or public historian, were familiar with both disciplines. Several public historians worked in archival institutions and conversely archivists worked in public history settings. The questions ranged from definitions of public history to personal experiences working in both archives and public history, to characterizing evolving relationships particularly as they related to community identity and memory.[9]

Although the questions were general and open-ended, essentially intended to tease out perceptions of the relationships between archives and public history as well as to explore connections, responses fell into several distinct categories. These included outreach and community relationships, education, digital initiatives and community archives.

Outreach and community relationships

The public historians pointed to the value of archives and archival records in interpretative programing such as exhibitions and educational tours. When asked about the relationship between public history and archives, an archivist with a public history education said, 'I think there's definitely a relationship. I mean there's a relationship between public history and

the original sources wherever you are.' A traditionally trained academic historian and researcher for Colonial Williamsburg, now leading a public history certificate program at the College of William and Mary, expanded on this idea. She had continuously researched primary sources at the Library of Virginia and the National Archives, and later saw those stories come to life throughout Colonial Williamsburg's first-person interpretative programing. Museum exhibitions, first-person interpretation and education field trips rely on archival resources for context and historical narratives. In this scenario, archives are not so much the 'backbones' of historical interpretation and sites as equal partners in engaging the public in historical narratives, relaying the importance and power of history in the present.

Education

The formal education of archivists generally happens in a school of Library and Information Science/Information Science (LIS/IS) or in a History Department. And it generally happens at the master's level. In the United States, the first formal archives course was offered in the History Department at American University by a historian-turned archivist, Ernst Posner.[10] Although an introductory archives course became a staple – often an elective – in many public history programs, by the 1990s, LIS/IS schools had become the primary venue for archival curriculum, with schools offering concentrations with multiple courses. By the end of the century, a masters with an archives concentration had become the degree of choice for students entering an archival career.[11]

Education for our interviewees was split between history and LIS/IS disciplines with often a little of both. As an academic archivist noted:

I had no exposure to public history when I started working. So my first exposure to public history was from Temple University. They had a public history program there and that was really my first encounter with the field, the archival education was through this program. And I think that at first … the public history people were a poor second to the people fully trained archivally. There were two or three courses in the archival direction but they lacked core course in the library courses. But I think that thinking has evolved when comparing archives and public history programs. Public history students are often given a very specific orientation, a public interpretive function that is really the goal of their work.

Synergies between the archival profession and public history in terms of education continue to evolve. Increasingly, archives departments and institutions are working together, providing a broader educational experience for both future public historians and archivists. As archival institutions attempt to look outward, they can benefit even more from including traditionally public history processes. An archivist at Historic New England, an organization that maintains historic houses as well complimentary collections of archival materials notes that,

> even right now we have an intern who is a graduate student in public history and is getting a certificate in archives, so she's already seeing a relationship ... And she's working on a tintype collection and one thing I've been really impressed with is her ability to think beyond the archival methods and really apply the tenets of public history, thinking a lot about that collection in terms of the context and beyond the way an archivist may think about it.

In addition, archivists are broadening their roles, increasingly including 'public history knowledge' in their education, internships and training. An archivist who mentors and works with a numbers of local archival repositories as a roving archivist for the state of Massachusetts noted that the traditional career track post-graduation has been shifting. When she was in library school, she and her peers assumed they would become project-processing archivists after graduation. However, she observed:

> I think that folks who are interested in archives should be thinking more about what their role might be in public history, both in terms of the kinds of jobs they want to look for; they might want to work at historic sites, might want to become involved with historic preservation, or might want to do more [about] ... becoming more of a public historian. And I think we desperately need more people who are interested in being advocates for archives and for cultural heritage institutions and relying the importance of history to the public.

Digital initiatives and social media

The relationship between archives and public history is more complex than simply utilizing archival sources in public history programing and graduate education. Interview participants recognized that the archives community

and the archival profession as a whole is continuously looking outward, attempting to engage the public through programming, collective activities and digital projects. This marks a significant change for the profession and is most apparent through a wide variety of digital initiatives facilitating increased public access to archival holdings.[12]

Digital initiatives, for example, have been a priority at such National Park Service locations as the Olmsted National Historic Site. An archivist there observed, 'We try now to do everything electronically. So we are trying to get as wide access as we can to get that message of stewardship and the information about Olmsted or the Parks Service out as widely as we can.' An academic public historian, as a researcher, appreciated the benefit of this increased digitization. She noted that: 'having so much digitized [will mean that] the connection between archives and public history is going to keep evolving. And the archival part of public history is going to become more apparent and easier for more people, should they want to access it.' These digital initiatives are a major factor in the dissemination of archival information to the public. As archival institutions continually look outward, they are engaging with new communities and audiences, broadening their missions and allowing for greater access.

Along with the digitization of materials, archival institutions are increasingly utilizing social media platforms to market these collections. Digitized materials are not the only avenue to reach wider audiences. Social media is ubiquitous in today's society, with archives, museums and historical societies utilizing platforms such as Twitter, Facebook and Instagram. These digital initiatives often allow for a conversation between archivists and patrons, and sometimes between patron and patron. Since patrons can comment and react to different digital collections and social media initiatives, archival institutions are increasingly hearing and considering feedback from their audiences. The archivist at Historic New England said:

> We're harnessing the internet, people are doing research, people are finding things and we are trying to make our collections as accessible as possible, as quickly as possible, so that they are used, so that they are not hidden gems, which I think is the biggest oxymoron. When we also are processing these collections and are doing that level of description, we get feedback from the public about what they think is important as well.

Increasingly, engagement with communities or public feedback and crowdsourcing are necessary to receive grant funding and support. These conversations, often completed in digital space, builds transparency in the

archival process and allows for more community insight. Archivists are able to learn more about often-unknown aspects of history, and incorporate personal memories in their arrangement and description. As the public becomes more involved with and engaged in these archival processes, archives shed their image as traditional gatekeepers to historic information and work to include more diverse voices in their processes, mitigating the gap between archives and public history.

Community archives and public history

While archives are continually engaging new communities as audiences of their historical information, they are also increasingly doing public history, creating connections between community history and archival practices. Instead of working to relay information to the public, archives and archivists are working with the public to collect and preserve local history and memory. Manifested in grassroots collecting and community archives, these archival projects invite community collaboration and the construction of community identity. For example, the public historian at Williamsburg works with a local history room, a community archive, in the Hilton Village neighbourhood of Newport News, Virginia. The neighbourhood is approaching its centennial and community members are increasingly interested in the neighbourhood's history and its impact on wider Virginian history. She explains how tightly the community's identity is tied to having lived in the same area and the historical memory of that area. This idea is furthered in community collecting days where communities are invited to 'bring in', scan and discuss objects and materials that they believe are important for preservation.

A roving archivist pointed out that several communities she worked with have held community-scanning days. These community archiving practices bring traditional archival activity to a wider audience. By participating in these events, communities and individuals have the opportunity to appraise and preserve materials that are important to them, not just leaving those processes to an institution that may have different collecting priorities. This engagement increases communities' interaction with history, bringing the goals of public history and archives closer together.

Historic New England also collaborates with communities to collect and preserve the histories of under-documented and marginalized populations

and little-known events in New England's history. A recent project, 'Everyone's History', was a multifaceted effort that employed traditional archival techniques, oral histories and videography to capture and make accessible 'diverse stories of life in New England from the twentieth century and beyond'.[13] As the archivist there said:

> Representation matters and I think that part of what we are doing in making collections available to people is also to remind people that there is more than one story in all of our history and that we can help add shades and tones and variations and also help people remember and find some lesser known chapter of history. I think that's critically important.

The idea of archivists doing public history represent current efforts within the archival discipline to move away from traditional patriarchal historical narratives and bring more diverse voices into collections and projects. By working with the public, archivists are not only creating more well-rounded collections, but are engaging in with different communities and performing broader outreach activities, mitigating the theoretical gap between archives and public history.

At the University of Massachusetts, Boston, an archivist and a public historian work together to create and preserve local community history, manifested in the Mass Memories Road Show.[14] They believe that projects such as this bridge the gap between community histories, public history and archives. They explained, 'It's really engaging and affirming; engaging a community, affirming individuals, and encouraging them to share their stories with us and with each other.' The incorporation of these historical narratives in the archival record reaffirms community identity and allows for the preservation of distinct memories.

While archival institutions and archivists are looking outward and doing public history, these projects invariably come with certain challenges. The roving archivist visits small institutions to consult on best archival practices. While she says that doing public history is a goal of many of these institutions, many are still trying to get their feet on the ground. Some need to survey what is in their collections, organize the collections and perform basic preservation techniques. For others, these duties take 100 per cent of personnel time and funding.

The Williamsburg historian also noted boundaries to public programing and initiatives, as the Virginana Room struggles with basic funding and support for preservation. In addition, some archivists fear that without proper archival training for communities, archivists may actually be

harmful to community documentation projects. An academic archivist, while expressing support for community archives was concerned

> about the intent, concerned that these community centers are being set up to fail ... I don't see access as a value that appears, or preservation, or longevity. I think people believe that can throw things into the cloud, the digital sphere, and have a false sense that it will be there forever ... it is important for communities, for the public, to accept or reject on their own terms what archivists and archives do.

While many institutions recognize these challenges, others believe that community engagement is important to stay relevant in a society that does not always value historical memory and cultural heritage institutions. The University of Massachusetts, Boston, archivist argued, 'I think that public history is really in the end, all about engaging a wide audience and reflecting on the past and learning about it, learning about it and reflecting on it. And contributing to it. And kind of finding ways to make history ... present in the lives of everyday people.'[15]

Conclusion

The connection between public history and archives is ever-evolving, changing as both professions seek to reach wider audiences and incorporate new perspectives in historical narratives. In recent years, the archival profession has included more tenets of public history within their missions. Aided by digital projects, initiatives and social media, archives are now able to reach new and diverse audiences, perhaps allowing for two way archival/public history conversations. These are growing as archives are increasingly doing public history, engaging with communities and working to document diverse populations. This meeting of disciplines also suggests the need for collaboration in educational curriculum as archivists prepare for new roles. This forward-looking attitude is not without difficulties, though, as local communities and archives often have trouble finding funding and support. However, as archival institutions work to stay relevant in today's society, they seek new ways to make their collections accessible, engage the people and urge people to use the past in the present.

Today the pleas and predictions made by Becker and Zinn many decades ago are finally coming to fruition. Archivists and public historians are presenting 'living history' and 'documenting ordinary lives'. And they

are doing it together. While the interviews analysed here show a growing alliance between archives and public history particularly in relationship to community history, they also suggest that these alliances are occurring naturally and seamlessly. Through the education of public historians and archivists as well as through their working projects, the values of both archives and public history enhance each other. As one interviewee noted, 'I think that archive in the broadest definition of anything you would protect and preserve is just going to become more and more part of public history sites.'

Notes

1. David J. Delgado, 'The 34th Annual Meeting of the Society of American Archivists', *American Archivist* 34 (January 1971): 45.
2. Carl L. Becker, 'Everyman His Own Historian', annual address of the president of the American Historical Association, delivered at Minneapolis, 29 December 1931), *American Historical Review* 37, no. 2 (1932): 221–36. www.historians.org/about-aha-and-membership/aha-history-and-archives/presidential-addresses/carl-l-becker (accessed 19 August 2017).
3. Ernst Posner, *Archives in the Ancient World* (Cambridge, MA: Harvard University Press, 1972).
4. 'The English Archivist: A New Profession. Inaugural Lecture for a New Course in Archive Administration Delivered at University College, London, 14 October 1947', in *Selected Writings of Sir Hilary Jenkinson*, ed. R. Ellis and P. Walne (Chicago: Society of American Archivists, 2003), p. 258.
5. T. R. Schellenberg, *Modern Archives: Principles and Techniques* (Chicago: Society of American Archivists, 1998), p. 236.
6. Bruce Dearstyne, 'Archives and Public History: Issues, Problems, and Prospects – An Introduction', *Public Historian* 8 (Summer 1986): 8.
7. Dearstyne, 'Archives and Public History', 2.
8. Ibid.
9. The authors wish to acknowledge and thank the archivists and public historians at the following institutions: Historic New England; National Institute of American History and Democracy's College of William and Mary; Olmsted National Historic Site National Parks Service; University of Massachusetts Amherst; University of Massachusetts Boston Archives; University of Massachusetts Boston Archives for Women in Medicine.

The interview material is held by Stephanie Krauss and Jeannette A. Bastian at Simmons College, Boston, Massachusetts. The following two sets of questions were asked:

How would you define public history? Do you see a relationship between public history and archives? How would you characterize that relationship? What is your personal experience working in archives and how has that experience contributed to your understanding of public history?

Or: What is your personal experience working in public history and how has that experience contributed to your understanding of archives? Do you see your archival/public history work relating to community identity and/or collective memory? Since you have started working, do you think the roles of archives and public history sites have evolved? Grown closer? Grown apart? Are the same?

10. Jeannette A. Bastian and Elizabeth Yakel, 'Towards the Development of an Archival Core Curriculum: The United States and Canada', *Archival Science* 6, no. 2 (June 2006): 135.

11. Bastian and Yakel, 'Towards the Development', 146.

12. For a discussion of public history, social media and the virtual, see Meg Foster, 'Online and Plugged In? Public History and Historians in the Digital Age', *Public History Review* 21 (2014): 1–19.

13. 'Everyone's History', *Historic New England*. www.historicnewengland.org/explore/everyones-history/ (accessed 17 August 2017).

14. 'Mass Memories Road Show', *Open Archives: Digital Collections at the University of Massachusetts Boston*. http://openarchives.umb.edu/cdm/landingpage/collection/p15774coll6/ (accessed 17 August 2017).

15. For a British example, at the local government Lambeth Archives, see Jon Newman, 'Harry Jacobs: The Studio Photographer and the Visual Archive', in *Public History and Heritage Today: People and Their Pasts*, ed. Paul Ashton and Hilda Kean (Basingstoke: Palgrave Macmillan, 2012), pp. 260–78.

16

'Speak, Memory': Current Issues in Oral and Public History

Paula Hamilton

In Vladimir Nabokov's famous injunction 'Speak, Memory' which is the title of his 1951 autobiography, his memory 'speaks' loud and clear in the beautiful writing.[1] Here, Nabokov's borrowed words not only underline the importance of social remembering as an act of communication, but beg the question: to whom does memory speak? In the nearly seventy years since then, oral history which is a spoken form of individual memory work or interview, has flourished along with the changing array of technologies to record it. With the subsequent development of infrastructure it has moved from the margins of work in the field of history and scholarship to become respectable as discipline, theory and practice. It is probably the most widely used method in public history work in all its diversity around the world. However, pointing to oral history's worldwide ubiquity might enable us to reflect on its extensive reach but does not tell us much about how it is used, mobilized and produced. Nor does it address issues in those processes or the critical question in the communicative relationship about who listens.

Public historians who use oral history in their work in museums, heritage sites, community projects, documentary films, commissioned works, native land title cases, human rights testimonies, activism for social change, podcasts and witness seminars know who their audiences are through various means. These are becoming more creative as the pressure to be accountable to private and public expenditure increases and include website

hits, downloads, exit surveys, interviews, attendance numbers, observation and audience responses.[2] British historian Toby Butler made a perceptive assessment of his two Thames locative media walks using oral history which drew on 147 questionnaires and interviews he conducted with participants. He found that 'the distinct qualities of listening to voice' (mixed interview segments) on mobile media devices for an hour at the sites where events or experiences occurred could 'evoke empathy and feelings of belonging to places, and can challenge preconceptions about the people who live there'.[3] It also greatly strengthened the understanding of the Thames River's role in the history of the areas it flowed through. Though focused on oral history, Butler calls his walks 'memoryscapes'. The interweaving of experiences from different times across the walking spaces nourishes a broader encompassing of the sensory where the visual surroundings and smells can awaken sound memories.[4]

Butler's work is one of the many instances whereby digital technology is reshaping the fields of oral and public history but it is still uncommon that audiences engage with the public historian's work for the precise purpose of listening to oral history. They may delight in the way it is used to help them reimagine a past on the site, or to make an artefact 'come alive', to entertain, to seduce, to remember, to identify or have empathy, even to be a witness to testimony and support activism, justice and reparation. But it has been utilized more in the service of illuminating already established historical themes or questions than for its own sake.

There are, however, some cases where listening to oral history is precisely the purpose of a visit or a download. Archivists and librarians who sometimes regard themselves as public historians welcome the researchers who listen to other people's oral histories for inclusion in their theses, books, websites or exhibitions. But principally for them oral history is an archival practice, another form of documentation that focuses on preservation issues for the future.[5] This is particularly the case in the United States where the end of the process, placing an interview in the archive, is an essential component of the definition of 'oral history'. In the UK, Europe and Australia among other countries, which have what Ron Grele calls a 'social history' context for the emergence of oral history, the focus is on the life history interview and archiving[6] is an add-on. Does this mean that more memory is lost in these countries than the United States? If the number of repositories in the United States is anything to go by, the answer is probably yes.

In general, despite regional and national differences, oral history remains the most influential tool of the public historian who is now identified as

a professional that may be practicing across a diverse range of forms and institutions. It has in turn shaped what is possible in public history and how the public historian engages with a multitude of audiences. However, you could be forgiven for being confused about the relationship between oral and public history, especially when some are saying that all oral history is public history while oral historians often discuss making oral history 'public'. Moreover, some refer to 'public' when they mean ease of access rather than how many people will listen or are listening. Here I am utilizing a broader notion of 'public' which incorporates a number of possible constituencies and a polyphonic engagement. Oral history also remains an elastic term which describes both the practice of making memories through interview, as well as the outcome in a range of forms.

Differences in definitional emphasis between various regions and countries, however, do not occlude the central conundrum with oral history practice – its dual function – which is thrown into sharp relief in public history work. It operates both as 'information' or evidence of the past, when there is an absence of material generated at the time, or questions have never been asked of a particular subject area or evidence has been destroyed. At the same time it functions as a remembered point of view about individual experience, an act of memory work. It essentially depends on the context to understand its use. But while some pay lip service to memory's unreliability, they often treat the oral history source as centrally 'authentic' or having unmediated access to a past; ripped from its moorings in memory and remembering, it becomes just another source in support of a claim or argument.

The insistence that oral history is valuable to 'fill in gaps' in the record, or supplement the written source, is at one level a viable justification when there are no other sources. At another, oral history is a completely different kind of source unlike any other produced by the historian or interviewer in the present, and should, some say, be addressed largely in the context of 'exploring what it means to remember, misremember, and forget'. This sense of a double vision and multivalent purpose is intrinsic to the history of oral history. Those who only want to use short sections of an interview for 'colour', atmosphere, social attitudes, the texture of experience and an emotional pull therefore, arguably, use it with more awareness than those who harness oral history to supplement 'facts'. In the former instance there is no reflection on its nature as a memory source. Some people want to mobilize oral history in a traditionally positivist framework – as 'data' in the social science understanding of the term.

This can also be a problem in scholarly domains across different disciplines or even within the same field, though scholars more commonly now utilize oral history within the framework of writing about memory and utilizing memory sources to illuminate or to nourish history. However, thinking in terms of oral history as bringing the voice of the past into public memory or remembering is a different approach which is not necessarily a main concern of particular areas of public history practice.[7] One of the most notable examples of such a project which has brought oral histories into public memory, though, is the Canadian public historian Steven High's massive five-year project, Montreal Life Stories. This operated from 2007 to 2012 and was funded by the Canadian Community University Alliance and the Canadian Research Council.[8]

The aim of almost 300 collaborators of various kinds was to interview Montreal people who had been displaced by war, genocide and other human rights violations and it was one of the first projects to draw extensively on digital storytelling resources. A final collection of over 500 multisession interviews using the life story approach, however, was not going to satisfy the project's aim to bring the stories to the public. So High and his colleagues designed a searchable, open source database, and they used parts of the interviews in a range of public history formats including online digital stories, art installations, audio walks, radio programs, animated film, an immersive bus tour, verbatim theatre and 500 Montreal cars equipped with QR-coded audio portraits.[9] High makes a distinction between the 'interpretive and creative value' of online oral histories and the 'public and political value' which emphasizes the strategic purpose of mobilizing oral histories as memories for political use in public.[10]

Nevertheless, the whispered asides emerging from well-known oral historians such as the American Michael Frisch that oral history's 'deep dark secret' is that no one listens to oral histories in their entirety have recently come into the open.[11] The principal focus of the oral history community has traditionally been the production of the interview – how to do it, how to interpret its meaning, how to negotiate the pitfalls or practice – not how to listen or who should listen. Nor has sustained attention been paid as to how to build long-term sustainability into the practice through either the shifts in technologies or generally 'living on' after a project is complete. These issues are especially relevant to the public historian because the questions of communication and audience are central to their work.

For many public historians the principal factor affecting their work is pressure of time. Institutions and independent consultants are involved in

many different kinds of projects, so, when time is money, oral history is generally viewed as time consuming, expensive and an ethical minefield. Thus in this context oral history is confined to short focused interviews or on occasions avoided altogether. Australian professional heritage consultant Sue Hodges, has used *pop vox* snippets on some occasions which are a form of directed questions, similar to journalism. These are mainly harnessed for targeted information gathering to assess the cultural significance of a heritage site. 'As a heritage professional,' she says, 'they are paid only on outcomes so to do any extra work is a waste of time. The story always needs to be related to something we are doing because we are always operating on a time limit or a production schedule.'[12] If Hodges has the opportunity to extended oral histories she now uses video interviews and give interviewees MP4 files and timed summaries: 'They are,' she observed, 'a lot cheaper [than transcripts] and are useful both for archival purposes or pieces of creative entertainment and PR.'

Ironically, the digital revolution which has underpinned the overwhelming dominance of the visual in contemporary societies once again – through websites and social media such as YouTube and Facebook and Instagram – has also fostered the emergence of the first technologies which have encouraged more extended listening to the voice through tools such as locative media and podcasting. Digital technologies are becoming embedded in all kinds of public history and memory practices of storytelling and commemoration. They facilitate both remembering and forgetting on a large scale but they also help to negotiate the present though the lens of the past. However, US oral historian Stephen Sloan is one of the many that has cautioned against increasing use of digitized interview segments for public consumption:

> The long form of oral history matters. Oral historians must resist succumbing to the pull to brevity in sharing interviews online to the point that this impulse distorts the integrity of the interview. Although the mutability of oral history is increased with the turn to digital, we as oral historians, need to work to resist bending our aims to popular culture's desires. Understanding requires a lot of patience and deep listening from users that entertainment does not ... as oral history is segmented and excerpted, it moves further away from the co-authored piece built by investigator and narrator.[13]

Sloan identifies the gap or tension between what he argues is the purpose of the co-authors (interview and interviewee) to make meaning and that of the user. But he leaves out the role of the public historian who often mediates

between the 'raw' interview and the potential consumers (whom he assumes are driven by popular culture). Some try to overcome this difficulty by archiving a complete interview. Michael Frisch calls this the 'raw' source from which small segments are taken to be 'cooked'. But this is not always possible.[14] Douglas Boyd, director of the Louie B. Nunn Center for Oral History at the University of Kentucky, has voiced his frustration with the failure of oral historians, archivists and institutional infrastructure to keep pace with his own belief in new technologies as the driver for change:

> The decades-old struggles to make oral history more usable and accessible have succeeded in the short term, yet mostly failed to change analog paradigms of access and use. Technologies and platforms such as youtube, Vimeo, Soundcloud, Omeka, Drupal, Wordpress and OHMS are now at our fingertips. We must quicken our transition, our mindsets and our paradigms, and our archival workflows and procedures to adapt and accommodate users' expectations. When we do, our interviews will be used.[15]

While many oral historians emphasize the importance of full life histories for future users' study and interpretation, others continue to be disparaging about the uses of oral which they regard as less important or less functional than oral history in the life history form. Nevertheless, these are the primary ways in which public historians create a community of listeners as well as viewers. So we make an important qualification here: the use of oral histories in public history practice is not for the purist of the faint-hearted. The majority of practitioners utilize anything from a single quote of two to three lines in a museum exhibit to a more extended excerpt in, for example, a radio program. While recent improvement in digital sound technologies has mitigated this limited listening, it does not alter what has been a very lukewarm response to these variety of uses from oral historians and muted discussion in the literature.

The harnessing of interviews for public histories is far too divergent to make totalizing judgments about its purpose in relation to interview length. Some projects, perhaps an increasing number, are being what might be called 'oral history led'. These are memory projects where oral histories figure centrally and the project is organized around them. This gives much more scope for extended listening and making memories public rather than being, sometimes uncritically, entwined with histories. So oral history can be used for social change such as the American Dan Kerr's work with the Cleveland homeless;[16] in native title claims as evidence of long attachment in postcolonial countries; and in restorative justice projects such as truth

and reconciliation programs and Royal Commissions. In Australia since the 1990s three major government inquiries have placed memory at the centre of their work: *Bringing Them Home: A National Inquiry into the Separation of Aboriginal and Torres Strait Islander Children from Their Families* (1997), *Lost Innocents: Righting the Record – Report on Child Migration* (2001) and *Forgotten Australians – A Report on Australians Who Experienced Institutional or Out-of-Home Care as Children* (2004).[17] Each of these relied upon first-person testimonies to assess the impact of government practices on the past and present lives of the people affected and in all cases, oral history was core, rather than a supplementary methodology. These are very different ways to work with oral history than being commissioned to write a local history with a few 'voices' or providing a short paragraph on social significance for a developer to enhance the value of a housing site.

Moreover, public historians have an important role in educating their clients about the value of oral history. Sarah Rood, who runs the independent historical company *Way Back When* based in Victoria, Australia, has noticed a significant change in the approach to oral histories by her clients over the last few years. Where once she had a hard time persuading them that oral history should be part of the project they wanted her company to do, now she finds more people commissioning stand-alone oral history projects. And a greater range of clients are insisting that oral histories be utilized as a component in broader histories.[18] Equally, as part of her own education, Sarah has moved from using oral history primarily for content purposes to appreciating its potential as sound in a wider range of applications.

Despite reservations by digital history specialists, the explosion of personal networking technologies, especially and tablets and smart phones in recent times, has had a profound effect on the possibilities for making histories. Michael Frisch, for example, co-founder of Pixstori in collaboration with Talking Pictures, has developed an application for a much shorter from of storytelling.[19] A user starts with a picture on the mobile phone and then records the story and adds a caption. To date the app has been used in the Grammy Museum in California for an exhibit during 2016 on 'The Kingston Trio and the Pop Revival'. It promised a 'new kind of exhibit engagement through social media' using the app to record an audio comment or a story or memory stimulated by the exhibition.[20]

Probably the most important application that fosters extended listening is Podcasting. While touted as 'new' podcasting technology largely extends previous mobile technologies and audio walks. It is characterized by the capacity for being 'on demand' or time shifting and involves digital

audio files being downloaded from the internet to a mobile device. Sioban McHugh, a noted podcast creator in Australia, claims that it has become popular with millions of people because podcasting can cater to a range of quite specific audiences who listen whenever they have time.[21] She has identified at least three different types from the narrative crafted storytelling in an episodic format to chumcasts with experts 'riffing' on a topic or theme, to long form interviews with little editing. McHugh also believes that podcasting has more democratic possibilities than some other audio forms with as yet little gatekeeping. It builds its own listener community, she says, using the power of voice to make the listener's 'own imaginative pictures in the mind'.

Aside from the current and growing interest in podcasting there are a number of other more innovative uses of oral histories emerging. Some of these involve broadening the definition of 'oral history' and others require a more capacious definition of 'public history'. One of the most controversial examples of the former is Story Corps in the United States. Story Corps was set up by Dave Isay in 2003 and involves two people (often related) entering a 'Storybooth' or cubicle and sharing memories which are recorded for about forty-five minutes. There is no intervention from an oral historian. Story Corps then publishes the interviews as books and regular podcasts. In a major collaboration with the new National Museum of African American History and Culture, Storybooth sent and airstream trailer with an installed recording studio on tour around the country to collect 2,000 African American stories of civil rights and war veterans.[22]

Another more recent innovation emerging from Britain is the advent of Witness Seminars.[23] These were devised by Professor Tilli Tansey and seem to have been taken up principally in the history of science and medicine. All of the main participants, with different expertise in a particular event such as development of new drug treatments or medical 'discoveries', come together and collectively remember how it came about, stimulating remembrance between themselves with a moderator. In conjunction with the Wellcome Trust, many of these seminars have been recorded and the transcripts are online. Some have argued that Witness Seminars are particularly apt for exploration of large-scale changes in technologies and social change and there has been some use in relation to political conflict.[24] The challenge of listening in Witness seminars is counterbalanced by overcoming the highly individualized nature of traditional oral history.

Projects that require a broader definition of public history often involve places or space, especially in the context of creating sonic environments.

The increasing use of oral histories by artists both as immersive sound and performance has emerged in community-based art projects which have engaged more frequently with social and political issues. Artists operate between the aesthetics of the environment and its cultural and social use, focusing especially on everyday activities. Arguably, these can be identified as 'public history'.

British historian Karen Harvey has discussed collaborations between artists and historians while she was an academic in residence at the Banks Street Arts in Sheffield. In her view, a more capacious understanding of 'public history' 'can and should draw more directly on the arts elements of the discipline, providing inspiration for creative thinking in the public sphere'. While her particular experience working with artists on a museum project did not involve oral histories, one of the artists, Ian Baxter, created an installation to accompany the exhibition which sought to 'recreate the sounds of being in the buildings such as conversations in other rooms and noise from places next door.' These were played through the walls, ceilings and floors. In general, Harvey found 'most striking ... the power of art to materialize intangible human emotions and motivations.'[25]

A brilliantly imaginative crossover project of this kind is the recent installation from the Times Square Alliance, a public art program in New York. 'Once Upon a Place' by Aman Mojadidi involved salvaging three phone booths which were retrofitted with audio players so that visitors could listen to oral histories through the telephones, choosing them from a made up phone book inside. 'I figured you could imagine all the stories that have already been told through phone booths that are dying out,' said the artist who collected seventy oral histories of migrant experiences of displacement across the city ranging in length from two to fifteen minutes in a number of languages.[26]

The gap between those who focus primarily on the production of memories (oral) and those who ask the questions about who listens and how (aural), is gradually being breached through digital media. This offers new and more creative opportunities for public historians. But the gap is also narrowing as a function of greater knowledge and understanding about the special nature of oral history. In August 2017, the British-based *Guardian* newspaper, now largely online and produced in a number of Anglophone countries, presented an editorial on '*The Guardian* View of Oral History'. The editorial was prompted by the number of historical anniversaries in August and ended with a discussion of the work of the Russian Svetlana Alexievich whose innovative use of oral histories won her the Nobel Prize for

Journalism. The editorial stated, 'Oral history crosses the boundaries of both archive and voice to become something new again: a cultural instrument.'[27] This poetic definition reminds public historians that with oral history we can venture into previously unknown domains of human experience and, with the narrator, make the memories, interpret their meaning and present them through whatever medium is chosen so they can be made to live again in a listener's imagination.

Notes

1. Vladimir Nabokov, *Speak, Memory* (London: Penguin Books, [1951] 1991).
2. See, for example, Beverley Serrell, 'Are They Watching: Visitors and Videos in Exhibitions', *Curator* 45, no. 1 (2002): 50–64; Carolyn Lang and Vicky Woollard (eds), *The Responsive Museum: Working with Audiences in the Twenty-First Century* (London and New York: Routledge, 2007); Divya P. Tolia-Kelly, Emma Waterton and Steve Watson (eds), *Heritage, Affect and Emotion: Politics, Practices and Infrastructures* (London and New York: Routledge, 2017).
3. Toby Butler, 'The Historical Hearing Aid: Located Oral History from the Listener's Perspective', in *Place, Writing and Voice in Oral History*, ed. Shelley Trower (Basingstoke: Palgrave Macmillan, 2011), p. 194.
4. There is a considerable literature on audio walks, soundscapes and memoryscapes. For more discussion, see Helmi Jarviluoma and Noora Vikman, 'On Soundscape Methods and Audiovisual Sensibility', in *The Oxford Handbook of New Audiovisual Aesthetics*, ed. John Richardson, Claudia Gorbman and Carol Vernallis (London: Oxford University Press, 2013), pp. 645–58; and Simon Bradley, 'History to Go: Oral History, Audio Walks and Mobile Media', *Oral History* (Spring 2012): 99–110. See also Mark Tebeau's Curatescape which is a web and mobile app framework that facilitates storytelling particularly across space, available at https://curatescape.org/about; and Karin Bijsterveld, 'Ears-On Exhibitions: Sound in the History Museum', *Public Historian* 37, no. 4 (2015): 73–90.
5. Ellen D. Swain, 'Oral History in the Archives: Its Documentary Role in the Twenty-First Century', *American Archivist* 66, no. 1 (2003): 140.
6. Ron Grele, 'Oral History as Evidence', in *Handbook of Oral History*, ed. Thomas L. Charlton, Lois E. Myers and Rebecca Sharpless (Lanham: AltaMira Press, 2006), pp. 43–101.
7. For a discussion, see Introduction in Paula Hamilton and Linda Shopes (eds), *Oral History and Public Memories* (Philadelphia: Temple University Press, 2010), pp. vii–xvii.

8. Steven High, 'Going Beyond the "Juicy Quotes" Syndrome: Living Archives and Reciprocal Research in Oral History', draft copy, pp. 4–8. This article was initially published as 'Au-delà du syndrome de la "citation payante": Les Archives vivantes et la recherche réciproque en histoire orale', *Revue d'histoire de l'Amérique française* 69, nos. 1–2 (été-automne 2015): 137–64. The English translation is in Elizabeth Miller, Edward Little and Steven High (eds), *Going Public: The Art of Participatory Practice* (Vancouver: UBC Press, 2017).

9. The project website is available at www.lifestoriesmontreal.ca/.

10. High, 'Going Beyond the "Juicy Quote" Syndrome', 2.

11. Steven High refers to this in his article 'Telling Stories: A Reflection on Oral History and New Media', *Oral History* 38, no. 1 (2010): 101–12.

12. Interview with Sue Hodges, director of Sue Hodges Productions, 9 August 2017, available at www.shp.net.au. Thomas Cauvin also makes this point generally in relation to heritage work; see his *Public History: A Textbook of Practice* (New York: Routledge, 2016), p. 57.

13. Stephen M. Sloan, 'Swimming in the Exaflood: Oral History as Information in the Digital Age', in *Oral History and Digital Humanities*, ed. Douglas Boyd and Mary Larson (New York: Palgrave Macmillan, 2014), pp. 180–1.

14. Michael Frisch and Douglas Lambert, 'Case Study: Between the Raw and the Cooked in Oral History: Notes from the Kitchen', in *The Oxford Handbook of Oral History*, ed. Donald A. Ritchie (New York: Oxford University Press, 2010), pp. 333–48.

15. Douglas Boyd, 'Oral History Archives, Orality and Usability', in *Oral History and Digital Humanities*, p. 94.

16. See Dan Kerr's podcast on Oral History for Movement Building where he discusses his work organizing the Cleveland Homelessness Oral History Project and his ideas about mobilizing oral histories for activism and social change: www.engagedhistory.org. See also Mashable Australia, 'This Instagram Account Teaches You the LGBTQ History You Never Learned at School', available at http://mashable.com/2017/06/28/ lgbt-history-instagram/#MPTRxoIRPsqM.

17. A fourth government inquiry established in 2013 by the Gillard Labor government – the Royal Commission into Institutional Responses to Child Sexual Abuse – delivered its final report in December 2017.

18. Interview with Sarah Rood, 'Way Back When', 18 September 2017. www.waybackwhen.com.au/about/.

19. www.pixstori.com.

20. grammymuseum.org.

21. Sioban McHugh, 'How Podcasting Is Changing the Audio Storytelling Genre', *Radio Journal: International Studies in Broadcast and Audio Media* 14, no. 1 (2016): 65–82. See also Doug Boyd's survey of oral

history podcasts on his Digitalomnium blog and the History@Work discussion of the podcast serial 'Memory, Narrative, History' by Kate Preissler, 22 January 2015, available at http://ncph.org/history-at-work/memory-narrative-history-serial/

22. www.washingtonpost.com/wp/dyn/content/article/2007/02/07/AR2007020702117.html.

23. https://storycorps.org/. There has been much discussion about Storycorps among oral historians.

24. The Wellcome Trust has been particularly active in documenting Witness seminars. For an explanation of Witness seminars and how they function, see www.histmodbiomed.org/article/what-is-a-witness-seminar.html.

25. Karen Harvey, 'Envisioning the Past: Art, Historiography and Public History', Cultural and Social History 12, no. 4 (2015): 527–43.

26. Tamara Best, 'Phone Booths Are Back in Times Square. No Quarters Required', New York Times, 5 July 2017. www.nytimes.com/2017/07/05/arts/design/times-square-phone-booths-art-installation.html.

27. 'Editorial. The Guardian View on Oral History: The Power of Witness', The Guardian, 11 August 2017. www.theguardian.com/commentisfree/2017/aug/10/the guardian-view-on-oral-history.

17

Who Do You Think You Are? The Family in Public History

Anna Green

Historians generally have demonstrated a rather inconsistent approach to the family as a research subject. Stories about elite families continue to attract both academic and popular attention, but those of the populace at large attract much less interest. This is surely rather curious given the ubiquity of family structures in human societies and cultures. While it may be organized in different ways, the family universally plays a powerful role in orienting each generation socially and culturally, and in framing its members' collective memory and historical consciousness.[1] Furthermore, there is sufficient evidence to suggest that many people, if not most, think about the past in the context of memories of their forebears' lives. But orthodox historians remain deeply sceptical about responding to public interest by placing the family at the centre of historical enquiry. Some have characterized curiosity about one's personal family past as insular and antithetical to the broader study of history.

At the turn of the millennium American historian Michael Zuckerman memorably described interest in genealogy as representing a 'pathological, nonparticipatory, and ahistorical culture, one which presents daunting dilemmas for promoters of public history'.[2] A few years later in Britain John Tosh deplored the disconnect between past and present in many popular historical leisure activities, including family history research, suggesting that 'none of these activities brings historical perspectives to bear on issues of topical importance'.[3] In contrast Tanya Evans argued in 2011 that social and cultural historians needed to recognize the widely held desire to 'understand

history through the lives of their ancestors' and engage constructively with family historians. She saw great advantages for both professional historians and family historians: the former able to draw upon larger databases of family history and reveal, for example, far greater divergence between prescription and practice in the past. But she also perceived the need for academics to 'help them [family historians] to interpret their data ... add context, complexity and ambiguity to the histories of their families'.[4]

What is missing from these divergent professional responses is recognition of the significant role played by memory in generating the popular interest in genealogy and family history. There is a deep entanglement between history and memory in popular historical consciousness. History here is taken to mean the 'history of historians' – to borrow Ricoeur's phrase – knowledge about the past based upon an empirical research epistemology and archival, predominantly written, evidence. But Raphael Samuel drew our attention to the diverse and fragmented sources of popular historical knowledge in *Theatres of Memory* a quarter of a century ago. Since then Rosenzweig and Thelen's American survey, followed by those in Australia and Canada, have revealed the enduring significance participants attached to family stories about the past, reminding us that the family is a crucial site of memory.[5] Knowledge and understanding of the family past is, therefore, derived from at least two important sources – history and memory. And memory, embedded through the senses and emotions, and the engine of personal identity and sense of self, deeply influences the meaning and significance attached to the family past. Meaning derived from memory, based on a sense of inheritance and affective investment, can prove resistant to the 'history of historians'.

Those, then, are four responses by historians to the immense popular interest in family history, and each raises important questions. What are the implications for the public historian? The following examples, drawn from television, national war commemorations, museum exhibitions, heritage and postcolonial reconciliation ceremonies, have been chosen to represent diverse forms of public history and enable the comments and critiques discussed earlier to be tested. They demonstrate both the problems and potential of family history and memory in the public sphere.

Television

The BBC program *Who Do You Think You Are?* (*WDYTYA*), first broadcast in 2004, was devised in response to the newly available digitized archival

sources available online in the UK.[6] It is almost impossible to overestimate the popularity and international influence of this program, early series of which regularly attracted over seven million viewers per episode in the United Kingdom.[7] Franchised overseas, popular domestic versions followed in the United States, Australia, Canada and Ireland, along with programs following a similar format in many European countries.

While the *WDYTYA* revolves around the reactions of celebrity figures as they are introduced to new information about their forebears, the extensive and the frequently global research involved is undertaken by professional archivists and historians. Nonetheless, the digitization of archival materials also transformed accessibility to research material for nonprofessional historians, and public libraries, archives and regional record offices responded by establishing Family History centres. There is no doubt that many genealogists and family historians acquire immense satisfaction from the detective work involved. But equally this technological transformation of the archives and the unpaid contribution of researchers have enabled the commodification and commercialization of information about the family past. Organizations such as Ancestry or MyHeritage often rely upon, or benefit from, the work of genealogical researchers and volunteers who undertake the painstaking and time-consuming work of transcribing and entering historical sources for inclusion in digitized online databases.

It would be difficult in predominantly non-oral historical cultures to construct a genealogy program without the colossal archives of the state, and this is the case with *WDYTYA*. But the choice of whom to include in the program is driven by both the themes of national history and contemporary media goals and requirements. Participants in *WDYTYA* are required to have family histories that are perceived to contribute to the primary BBC goal for the program, that of creating 'a more inclusive and affirmative vision of our national identity' through linking personal family histories to the grand subjects of British historiography.[8] The programs emotionally engage the viewer through narratives of generational rise and fall of, for example, wealth or poverty, in the context of the major events or themes of British history. These include empire, which featured Billy Connolly; the Irish 'Troubles' or War of Independence, with David Tennant and Brendan O'Carroll; slavery, with Liz Bonnin; or transportation to Van Diemen's Land, which featured Anne Reid.

The success of *WDYTYA* in engaging popular interest suggests that approaching the past through the lens of the family does not, as Zuckerman suggested, place insuperable barriers in the way of popular public history. But

there is a contradiction at the core of the program, reflected in its title: the assumption that genealogy is identity. The highly selective construction of the family tree in *WDYTYA*, driven by the program goals, can only be a partial reflection of the myriad of genetic, cultural and social influences that shape who we are. Second, the confrontational dynamic of the program, while intentionally raising the emotional temperature for both guest and viewer, does a disservice to historical understanding.

While the celebrity guests on *WDYTYA* often search the evidence presented for signs of continuity in positive personality traits and interests, or distinctive physical appearance, they are equally reluctant to acknowledge that members of earlier generations could be guilty as well as innocent, selfish as well as altruistic. Attempts by the celebrity guests to justify or mitigate, often (but not always) accompany evidence of behaviours perceived as morally repugnant in the present. This is hardly surprising when the program's title proposes that the guest's own identity derives from their genealogy and family history. Such a premise reflects, of course, a deeply determinist and essentialist perspective. Genealogy and family history have the capacity to illuminate a family's past, and how aspects of this past may shape or influence the present, but does this knowledge really determine personal identity?

National commemorations

Another example of the link between national and family memory may be found in war commemorations. Over the past five years particular attention has been paid to the centenary of the First World War and New Zealand provides an illuminating case study in the relationship between the state, war commemoration, family memory and public history. There has been a strong relationship between public history and the New Zealand state for eighty years, and since the 1980s the research and publications undertaken by historians employed within the Ministry for Culture and Heritage/ Manatū Taonga have focused very heavily upon New Zealanders at war.[9]

With the approach of the centenary of the First World War the government funded a program of commemorative activities known as ww100. A survey commissioned to explore the extent of public knowledge about the First World War found that while specific knowledge about the war was limited, 'personal connections are a key motivator for New Zealanders to learn more'.[10] The ww100 program of events, therefore, kicked off with a stand

at the Society of Genealogists's 2013 family history fair, held over three days in Auckland. As the ww100 government website commented, 'Some people brought along articles relating to their family members, confirming how powerful personal connections are in helping people "unlock" the significance of the First World War.' Ballots were also held to allocate grants that enabled some family descendants of the Anzac (Australian and New Zealand) soldiers who fought at Gallipoli to attend the commemorative ceremonies in Turkey. The events and memory of Gallipoli in 1915 have been linked by some historians to the development of a specific national identity, and the Anzac myth continues to exert a powerful grasp on the national imagination in both Australia and New Zealand.[11] But a similar instrumental connection between family history and commemoration of the First World War may be found in the programs of many UK museums over the past three or four years. What should we make of this deliberate targeting of family history societies for wartime commemoration?

It again demonstrates that Zuckerman's concern that preoccupation with the family's past constituted an obstacle for public historians is not justified. But the experiential and empathetic approach in war commemorations and exhibitions has limitations and raises some deeper concerns. Let us start with the ambiguity of the phrase, ' "unlock" the significance of the First World War', which could be taken to imply a singular, predetermined understanding of the war, one that reflects dominant national patriotic and heroic discourses. This is a warning that interest in family history can be manipulated in pursuit of national political goals, and 'naturalize ... participation in contemporary wars'.[12]

Second, to what extent have museums, or commemorative activities, included forebears found guilty of wartime morally repugnant behaviour, such as war crimes, or on the home front profiteering or looting, for example? In other words, does this approach sanitize war? Finally, the New Zealand program certainly paid much less attention to those Pākehā (New Zealand Europeans) or Māori who actively dissented from the war. Have the First World War commemorations ultimately, if unintentionally, normalized or valorized war itself?

The inclusive intentions of the First World War commemorative and museum programs are in some respects laudable and family descendants may have learned, perhaps for the first time, about their ancestor's experience of war. But if recourse to war ultimately represents the failure of international political systems and leaders, as many would argue, was it not possible to recognize the undoubted bravery of the soldiers without exculpating the

actions of the nation state? If family historians lack the expertise, in the words of John Tosh referred to earlier, to 'bring historical perspectives to bear on issues of topical importance', surely public historians should do so?

Museum exhibitions and heritage houses

While museums were very keen to include the family descendants of regular soldiers during commemorations of the First World War, this represented in some senses a departure. In general terms, museum exhibitions about specific families usually focus upon cultural, political or business elites although these, too, are closely linked to nationalist discourses and ideologies. For a particularly egregious example, the 2008 exhibition on the history of the Tolstoy family at the State Museum of Alexander Pushkin in Moscow explicitly made this connection. The exhibition focused upon the 'outstanding representatives' of the family, such as military leaders, statesmen, political figures, scientists, writers and others. All, according to the museum, 'contributed much to the development of the Russian state. Studying the history of the Tolstoy family, one is following Russian history, as for centuries the Russian nobility were a class whose main duty was to serve their country, defend it, and make it prosperous.'[13] This approach cannot be said to represent critical thinking in the context of public history, for it sanitizes the past of an individual family, justifies a particular social and economic hierarchy, and conflates the history of an elite family with that of the nation state.

A nationalist frame may also be accompanied by underlying assumptions about the intergenerational transfer of positive family character traits, particularly in exhibitions on leading intellectuals. The Stradiņš University in Riga celebrated the history of its founders with an exhibition in 2012 on the history of this well-known family of scientists. The success of this family is attributed in the museum description to family characteristics that include intelligence, independence, respect for national identity and high aims.[14] In contrast, the presentation of Charles Darwin in both the major international exhibition and at his family home in Britain, offer far more nuanced familial contexts than that above, drawing attention to the wider scientific family culture but without assuming a reified set of character traits or a teleological narrative trajectory.[15]

At this point let us turn to another critique of family history, referred to in the introduction. Tosh argued that the pursuit of family history fails to bring historical perspectives to bear on issues of topical importance. Is this the case? To take one major contemporary debate, the concentration of wealth, growth of inequality and poverty, and rise in political and corporate corruption since the 1980s, has led to the contemporary period being characterized as a new global 'Gilded Age'.[16] To what extent have public historians, for example, explored the role of intergenerational transmission of wealth within the family?

The most visually arresting evidence of wealth, relating to the past, may be found in royal castles, stately houses that belonged (or still do) to aristocratic elites. These range from the country houses and mansions of the National Trust in the United Kingdom to the antebellum plantation houses in the American South built on the proceeds of slavery. In both cases, these buildings are primarily presented in terms of architectural style and original artefacts in an 'uncritical ethos of preservation'.[17] While the economic basis of the family fortune may be acknowledged in the English country house, these heritage sites rarely problematize the deeply unequal or exploitative past, or explore the lives of servants or farm workers in any depth. Laurajane Smith has argued that heritage is 'not so much a "thing", but … a social and cultural process, which engages with acts of remembering that work to create ways to understand and engage with the present'. The profoundly conservative and partial presentation of heritage in these contexts therefore may serve to normalize social hierarchies and economic inequalities not only in the past but also in the present.[18]

In contrast to heritage, the role of the family in the business and capitalist enterprise has received much less attention from public historians. Recently the Smithsonian, the National Museum of American History, opened – and is continuing to develop – an exhibition on American Enterprise, which includes a section on multigenerational family businesses.[19] Arguing that multigenerational family businesses 'play a significant role in America's economy', the exhibition focuses upon four case studies: the Graham family of the *Washington Post*; the Hartman farming family in Idaho; the S. C. Johnson family of cleaning products; and the Zubizarreta family in advertising. The exhibition focus is also signalled in the online introductory text, where emphasis is placed upon the decisions family businesses have made 'based upon their own vision and values'.

These visions and values are articulated through oral history interviews with the current family generation in control of the business, and it is their

perspective and story that frames this exhibition. Only occasionally do the inevitable internal tensions and challenges faced by intergenerational family businesses surface in these short oral history excerpts. An older member of the Hartman family, for example, describes the process through which the members of the next generation are selected to take over, and remarks that 'you have to weed out your own children, it's a little painful, but that happens'. But on the whole the exhibition is celebratory and, as with the earlier example of the Stradiņš family, the continuity of honourable and ethical inherited character traits is perceived to be the driving force behind generational decision making. When discussing the decision to remove CFCs from company aerosol products, for example, a member of the Johnson family remarks that his father was 'of the same DNA as his predecessors were and you do the right thing'. The exhibition, as presented online, celebrates the family businesses as intrinsically morally responsible, and does not include any contextual data or debates over the wider history of family businesses. This is surely a case where public historians have the responsibility, as Evans suggested for historians more generally, to contextualize and add a level of 'complexity and ambiguity' to the narratives?

While most family history exhibitions are celebratory, there are a few that explicitly draw attention to less illustrious aspects of family history or use humour to remind us of the inevitable tensions in family life. To take a light-hearted example first, the online Awkward Family Photos Museum Exhibition actively seeks to represent the clash of personalities or difficult moments in the family through the medium of uncomfortable family photographs.[20] The creators of the exhibition explain their hope that the exhibition will bring families closer together through acknowledging 'those special times when we wished we were a lot farther apart'. In a more serious vein, a touring museum exhibition in Australia, entitled 'A Convict in the Family', focuses upon the connections between convict settlers and their direct descendants through the medium of a key event.[21] The documentary photographer, Mine Konakci, photographed ordinary Australians in contemporary settings with an object representing the crime for which their ancestor was transported. Through this juxtaposition of past and present, she hoped to draw attention to the disproportionate impact the theft of a loaf of bread, for example, could have upon the history of a family. While Konakci's primary goal appears to have been strengthening knowledge of the past and the sense of belonging among her subjects, the exhibition also implicitly challenges the essentialism and determinism evident in the

family exhibitions discussed earlier, and raises broader collective questions concerning the nature of crime and punishment.

Postcolonial reconciliation

The final case studies exploring the relationship between family history and public history are drawn from community-initiated ceremonies to remember the victims of colonial violence in Australia and New Zealand. Every year a ceremony is held at the Myall Creek Memorial near Gwydir river in New South Wales to remember the massacre of unarmed Wirrayaraay people by European colonists in 1838. Descendants of both the Aboriginal victims and the European murderers meet at the memorial in ceremony of reconciliation.[22] The initiative for the memorial and ceremony came from both Aboriginal and non-Aboriginal Australians, on the basis that it would help to 'unite descendants of those who were murdered and descendants of those who carried out the massacre in an act of personal reconciliation'.[23]

The second example is drawn from New Zealand, where an act of colonial aggression in 1881 to dispossess Māori of land in Taranaki was formally remembered for the first time in 2017.[24] By the late nineteenth century Parihaka had become the largest Māori settlement in the country, and the centre of nonviolent resistance to European occupation of confiscated land. In 1881 colonial troops entered the village to be greeted by children, only to have the settlement plundered and razed, the population expelled, leaders arrested and imprisoned, and women raped by the soldiers. The Parihaka-Crown reconciliation ceremony in 2017 included a formal apology for the invasion of Parihaka, and was attended by family descendants of Māori driven from the village, the Native Affairs Minister who signed the proclamation to invade Parihaka, and of the soldiers responsible for destroying the settlement and violence against the women.[25]

This form of public history, that seeks to begin the processes of reconciliation between the descendants of those who both experienced and committed the colonial atrocities, many of whom continue to live in close proximity, moves beyond formal apologies by the state. The evidence of Myall Creek and Parihaka suggest that remembrance and reconciliation for colonial misdeeds may be sought by family descendants of both the victims and perpetrators. These two examples surely challenge the critique of both Zuckerman and Tosh, with which this chapter began, that approaching history through the lens of the family invariably represents a

'non-participatory, ahistorical culture', or neglects issues of contemporary significance. Both ceremonies also reflect the centrality of memory for public history, and the power of the past to haunt the present.[26]

Conclusion

There can be little doubt that genealogy and family history have not, as Zuckerman anticipated, been insurmountable problems for the practice of public history. On the contrary, curiosity about family history has encouraged public historians working in a range of mediums to find ways to connect personal and family lives to the broader currents and events of history. Family history and memory may also make important contributions to topical issues of contemporary significance, contrary to the fears of Tosh, as the reconciliation ceremonies in postcolonial contexts demonstrated. But the potential of family history and memory to inform historical understanding, and provide insight into popular historical consciousness, is far from being fulfilled, and the examples considered in this chapter have demonstrated some serious shortcomings.

The first concerns the interaction between national history, dominated by the interests of the state, and family history. In many public history contexts the family past is approached through the lens of major national themes and events or nationalist discourses. Two consequences in particular emerge from this top-down approach to family history. First it often leads to an emphasis upon elite families, rather than the lives of the majority, and the wider inequalities and oppressive social structures of the past recede into invisibility. Second, popular interest in family history and the emotional and empathetic identification with forebears can be manipulated and exploited in public history for political purposes. This may ultimately lead to the enlistment of family history and memory in the cause of nationalism or militarism.

The national lens also eclipses the internal world, decisions, actions and relationships within the family, a major lacuna in contemporary historical scholarship. This may be the consequence of two dimensions of historical research: the tendency of historians to make a distinction between private and public worlds, with the latter perceived to be of far greater significance, and the availability of sources. With many families lacking substantial written archives, oral history may provide the only way to retrieve information about past experiences and relationships within the family. But even when both

written and oral sources are available, the public representations discussed in this chapter were nearly always partial and celebratory, effectively sanitizing the past.

Public historians must, first of all, contextualize family narratives, as Evans has suggested, or these accounts may convey misleading impressions of the wider social or cultural historical environment. Second, in order to draw appropriately upon family oral histories, public historians need to engage much more deeply with contemporary theorization around memory and oral history. Family memory is not necessarily uncritical or unreflective, but this chapter has demonstrated that when deployed in public history it is too often selective, conservative and celebratory.[27]

The failure of forebears to live up to perceived national ideals, or who engaged in behaviour now considered morally reprehensible, may of course be very difficult for descendants to acknowledge. Reluctance to concede that some ancestors were deeply flawed may reflect fear of public shame, which is surely not surprising when the genealogy and family history enterprise is loaded with essentialist assumptions regarding the inheritance of personal character traits and identities. Yet the postcolonial reconciliation ceremonies described earlier suggest that it is possible for family descendants to reflect upon and publicly acknowledge the appalling or disreputable actions of forebears. Ultimately this reflective capacity and active, critical engagement with the past may be the key not only to reconciliation for past wrongs but also to the cognitive integration of emotional and intellectual historical knowledge.

Notes

1. Maurice Halbwachs, *On Collective Memory*, ed. and trans. Lewis A. Coser (Chicago: University of Chicago Press, 1992), chapter 5.
2. Michael Zuckerman, 'The Presence of the Present, The End of History', *Public Historian* 22, no. 1 (2000): 19.
3. John Tosh, *Why History Matters* (Basingstoke: Palgrave Macmillan, 2008), pp. 5–6.
4. Tanya Evans, 'Secrets and Lies: The Radical Potential of Family History', *History Workshop Journal* 71 (2011): 54–5.
5. Roy Rosenzweig and David Thelen, *The Presence of the Past* (New York: Columbia University Press, 1998), pp. 29–31, 38, 186–7. Similar surveys have been done in Australia and Canada. See Paul Ashton and Paula Hamilton, *History at the Crossroads: Australians and the Past*

(Sydney: Halstead, 2010); Margaret Conrad, Jocelyn Létourneau and David Northrup, 'Canadians and Their Pasts: An Exploration in Historical Consciousness', *Public Historian* 31, no. 1 (February 2009): 15–34.

6. Jerome de Groot, 'On Genealogy', *Public Historian* 37, no. 3 (2015): 113.

7. Cited in Terry Haydn, 'History Magazines in the UK', *International Society of History Didactics: Yearbook* (Wochen Schau Verlag, 2013), 1. https://ueaeprints.uea.ac.uk/55667/ (accessed 4 August 2017).

8. Amy Holdsworth, '*Who Do You Think You Are*? Family History and Memory on British Television', in *Televising History*, ed. E. Bell and A. Gray (Basingstoke: Palgrave Macmillan, 2010), pp. 235, 243.

9. Bronwyn Dalley, 'Shades of Grey: Public History and Government in New Zealand', in *People and Their Pasts: Public History Today*, ed. Paul Ashton and Hilda Kean (Basingstoke: Palgrave Macmillan, 2009), pp. 74–90.

10. https://ww100.govt.nz/about (accessed 1 August 2017).

11. Anna Clark, *Private Lives Public History* (Melbourne: Melbourne University Press, 2016), chapter 4.

12. See Michelle Arrow, 'I Just Feel It's Important to Know Exactly What He Went Through: *In Their Footsteps* and the Role of Emotions in Australian Television History', *Historical Journal of Film, Radio and Television* 33, no. 4 (2013): 594–611; Marilyn Lake and Henry Reynolds, *What's Wrong with Anzac? The Militarization of Australian History* (Sydney: NewSouth Books, 2010).

13. See 'History of the Tolstoy Family', 2008. ypmuseum.ru/en/2011-04-13-17-36-58/53--l-r.html (accessed 26 July 2017).

14. See 'Stradiņš Code', 2012: 'About RSU ›News and Events'. www.rsu.lv (accessed 26 July 2017).

15. 'Darwin', curated by Niles Eldredge at the American Museum of Natural History in collaboration with the Field Museum, Chicago; the Museum of Science, Boston; the Natural History Museum, London; and the Royal Ontario Museum, Toronto, 2005–6; Tori Reeve, *Down House: The Home of Charles Darwin* (London: English Heritage, 2009), p. 32.

16. See Larry M.Bartels, *The New Gilded Age* (Princeton: Princeton University Press, 2012).

17. Cynthia Montgomery, 'Reframing the Plantation House: Preservation Critique in Southern Literature', unpublished PhD, University of North Carolina, 2015, p. 227.

18. Laurajane Smith, *Uses of Heritage* (London: Routledge, 2006), p. 2.

19. The Smithsonian, 'American Enterprise', 2015: http://americanhistory.si.edu/american-enterprise-exhibition/videos/business-families (accessed 30 October 2017).

20. 'Awkward Family Photos Museum Exhibition'. awkwardfamilyphotos.com/the-exhibition (accessed 26 July 2017).

21. 'A Convict in the Family'. https://sydneylivingmuseums.com.au/exhibitions/convict-family (accessed 27 July 2017).

22. www.creativespirits.info/aboriginalculture/history/myall-creek-massacre-1838#ixzz4xDdC86hQ (accessed 26 July 2017).

23. www.environment.gov.au/heritage/places/national/myall-creek (accessed 26 July 2017).

24. Te Miringa Hōhaia, 'Taranaki tribe – Resistance', *Te Ara – The Encyclopedia of New Zealand*. www.TeAra.govt.nz/en/taranaki-tribe/page-4 (accessed 6 November 2017).

25. 'Crown Apologizes for Parihaka Horrors', *Dominion Post*, 10 June 2017, A2.

26. See MarekTamm, *Afterlife of Events: Perspectives on Mnemohistory* (Basingstoke: Palgrave Macmillan, 2015).

27. For an example of a reflective and critical genre of family memory, see Anna Green, 'Intergenerational Family Stories: Private, Parochial, Pathological?', *Journal of Family History* 38, no. 4 (2013): 387–402.

18

Love Thy Neighbour: Local and Community History

Tanya Evans

Local and community history is booming around the world. Local historians have long produced materials for local audiences but many are reaping new opportunities to collaborate with academics on shared passions and in innovative ways and reaching much broader audiences in the process. Academic historians are increasingly engaging with diverse communities in their research and co-producing multimedia outputs.[1] Radical, politically activist history projects and a recent turn to the 'power of place' have all played their part in the reconceptualization and re-energizing of public local and community history.[2] Technological change and digitization have also encouraged academic historians to think beyond books and journal articles when undertaking their research, disseminating the fruits of their labour and researchers outside the academy are reaping the same opportunities. Broader shifts in the academy have also played their part, scholars across the globe are increasingly exhorted to think about 'impact and engagement', how they might make their research 'socially useful' as they formulate their projects and ask the public to fund them.[3]

I teach Australian history and public history in the Department of Modern History at Macquarie University in Sydney, Australia. In late 2016, I established a research Centre for Applied History in the Faculty of Arts. This Centre draws upon Macquarie University's nationally and internationally recognized research and teaching strengths in the field of applied history. We focus on family history, digital history and e-research, cultural heritage, museums, oral history, consultancy work for charities

and non-governmental organizations, policy, television, radio, community, regional and local history.[4] For over twenty years, my disciplinary research has focused on the history of the family, motherhood and sexuality. I have always been passionate about researching ordinary people and places in the past and I have recently become much more interested in incorporating ordinary people and places in the process of my research and the construction of historical knowledge.

My first three books were about the history of 'illegitimacy', poverty and philanthropy. *Fractured Families: Life on the Margins in Colonial New South Wales* was a history of Australia's oldest surviving charity the Benevolent Society established in 1813 and I wrote this in collaboration with family historians while working as a consultant for the charity. Since curating an exhibition in London at the Women's Library in 2008 and working as a consultant on historical documentaries I relish teaching and producing public history and working in teams. I am currently working on a small exhibition with my local library and students in Mosman, a suburb on Sydney's lower North Shore. I try to write for general as well as academic readers, politicians and social policy-makers and I make radio and TV programs based on my scholarship. With each research project that I work on I think about how I can vary my outputs and reach different audiences as a result and I aim to teach my students some of those skills. I pitch my work at a variety of audiences because most of my research is targeted at disrupting people's everyday assumptions about the history of the family, at a local, national and global level. I am committed to the democratization of historical knowledge, to what historians label 'sharing authority' and others call the co-creation of knowledge.

I am also passionate about engaging diverse communities in history and I want my students to collaborate with them. I moved from London to Sydney in October 2008 and soon after I was invited to join the General Council of the History Council of New South Wales by my colleague, Lisa Featherstone, with whom I also shared an office. I am gesturing here towards the serendipitous nature of our research following conversations and connections made with scholars and others in our midst. In 2016 I became President of this small, cash-strapped and mostly volunteer-led organization. We remain indebted to Arts NSW for annual funding which pays the wages of a part-time administrator and part-time Executive Officer as well as the enthusiastic efforts of volunteer Executive and General Council members. The History Council is the peak body in the state for historical organizations and people interested in and concerned

with the past.[5] It provides a forum for identifying and responding to issues relevant to the practice of history, encourages and strengthens the recognition of history, fosters culturally diverse approaches to the past, celebrates excellence in historical practice, and promotes communication within the history sector, among young and old. We aim to transform ordinary people's historical consciousness and for them to immerse themselves in the history that surrounds them every day.

As an academic historian I am familiar with the research undertaken globally that has revealed thousands of 'ordinary' people's thirst for history – watching historical films and documentaries, creating family trees, talking about family history with family members as well as visiting museums. My work with community groups has revealed the different ways in which local history has been popular in a variety of forms for over a hundred years but academics remain largely derisory about its practice, often dismissing it as amateur and antiquarian. However, they should appreciate, as Beverley Kingston argues, that 'even the humblest or most obsessive kind of local history makes its contribution to the great river of historical knowledge'.[6] Local and community history can also have a significant impact on individuals and foster cultural cohesion.

Hundreds of local history societies were established in Europe and the settler world from the mid- to late nineteenth century but local history had been constructed and celebrated in a variety of forms by many cultures for centuries.[7] In settler nations like Australia they were often begun by pioneers, after the gold rushes, keen to establish firm roots in new homelands and to claim powerful local power in the process. Academics became increasingly interested in local history during the 1950s, with local history becoming a distinct discipline in England in 1948 at the University of Leicester, which still has a thriving local history department producing valuable postgraduate research.[8] In his classic *The Making of the English Landscape*, Hoskins argued that local history was a response to social fragmentation and the breakdown of local communities and he was insistent about the 'humanistic potential of historical knowledge for educating the individual'.[9] This has continued but tension between academic and community history intensified during the 1980s as pressure on academia increased across the decade and professional groups competed for status and scant resources. In Australia local history blossomed with the provision of funding from Bicentennial grants such as that enjoyed by UNSW when they established the Local History Coordination Project in the lead up to 1988, the bicentenary of the white settlement of Australia.

Local history shares similarities with family history with regard to content, methodology and perception. Many note its similar relationship to social history and 'history from below'.[10] Academic derision for family and local history is often (if not always) gendered and political.[11] More women than men practice it both in Australia and our society has long devalued female labour. Local history is also sometimes understood as a deeply conservative practice. It is assumed that local historians are searching for supposed golden ages in order to escape the upheavals of the present. My research suggests precisely the opposite. Local history can and should have radical political consequences and profound significance for our present lives. Academics – and others of all ages – need to revalue and recognize the achievements of innovative local and community history projects around the world.[12] Digital technologies have enabled fantastic projects like HistoryPin, the Dictionary of Sydney, TROVE and the construction of many history and community websites and blog posts which have transformed the production of local history around the world, increasing its impact and significance.[13] We need to trouble academic disdain targeted at local historians and recognize the power of local history to transform people's historical consciousness.[14] Australian historians Tom Stannage, David Carment and Graeme Davison have suggested the same.[15]

Louise Prowse, another Australian historian, has revealed that membership of local history societies across NSW grew exponentially from the 1960s but many are now suffering from declining membership due to their aging demographic makeup.[16] There are about 1,000 local historical societies across Australia with about 50,000 members.[17] Perhaps surprising to some, her research has also revealed the radical underbelly of local history across NSW.[18] Since the 1960s there has existed a close link between social history, the History Workshop movement and local history.[19] Community history projects are often about social inclusion, even if they are not always successful in producing this outcome.[20] It is important for young people to be persuaded to engage with local and regional history when most local historical societies are suffering from an ageing membership. Knowledge of local history can have a powerful transformative impact on school and tertiary students as well as life-long learning which is why I suggest academic historians should engage with it more and why we need to focus our efforts on including young people in our research projects when undertaking local and community history. I have also encouraged history teachers across NSW to persuade their students to work with local historical sources, stored in local libraries and archives, to try to transform their knowledge and to

teach them important skills, while producing a deeper knowledge of their local communities. Local libraries can be significant social forces for good. As young people flock to reap the benefits of free and easily available WiFi in local and state libraries we need to teach them the value and significance of the collections which surround them.

From 2014 I led a community history of my local Spit swimming club on the Lower North Shore of Sydney working towards celebrating its centenary in February 2017. We produced a book: *Swimming with the Spit: 100 Years of the Spit Amateur Swimming Club.*[21] This was a community supported and written book, funded by individuals and government and non-government organizations, that encourages readers and swimmers, young and old, to think about their ambles down to the beach, their invigorating morning swims and refreshing afternoon dips on sultry Sydney summer days or crisp winter mornings, with an eye on their history. Passion for a sport in the present can overshadow its fascinating past. Historians Iain McCalman, Ian Hoskins, Kate Fullagar, Leigh Boucher and Nancy Cushing, volunteer researchers, students and local swimmers hoped to persuade readers to don their 'cossies' – bathing costumes; dive into the ocean; and involve themselves with dynamic community organizations such as the Spit Club by celebrating its centenary. Many of us learn how to be good citizens at clubs such as these and I love the fact that my neighbours and colleagues have reflected on the significance of swimming to their lives in the book. The Masi family have appreciated the way in which the club's handicapping system has incorporated their disabled daughter Grace: 'the encouragement that Grace receives every single week from everyone participating is truly special and something for which our family is extremely grateful'. The water relieves Grace 'of all the physical demands associated with staying upright on her feet'.

When she launched the book at Balmoral beach, Australian Broadcasting Commission journalist Geraldine Doogue said that *Swimming with the Spit* might seem like it was just a book about swimming but it was actually a guide on how to be a good citizen. History connects people and communities through stories, shapes identity and citizenship and enhances community well-being. The local provides a powerful vehicle for capturing people's historical imaginations. Personally, I never fail to get excited about the history that I am immersed in everyday, the water in which I swim, the landscapes and buildings I pass every day, the clothes that I wear and the diverse community of friends, family and strangers I share my time with. More citizens of a city as spectacular as Sydney need to catch their breath,

scratch beneath the surface and dive into NSW's glorious historical depths learning more about their neighbours in the process. *Swimming with the Spit* and the project's other outputs are not just a parochial history of a swimming club; they tell us much about the history of Australia across the twentieth century and its relationship with the world. Many other recent innovative local histories reveal how the local is always global and it is important we continue to spread that word, instead of arguing that some historical subjects and approaches are more valuable than others and that local history is bottom of some imaginary historical pecking order.[22]

The History Council's History Week theme in 2016 was 'Neighbours'. With almost ninety events registered, it was remarkable to see the wide variety of History Council members celebrating the best in community and professional history, and highlighting its important role in our cultural life. The History Council's innovative Speaker Connect program continued to link our regional members with professional historians and writers exchanging ideas and expertise across the state. Our diverse communities and members celebrated their history in myriad ways. Highlights included our annual history lecture by Professor Heather Goodall on 'Neighbours and Heroes' at The Mint, our annual Macquarie University symposium at the State Library – including a screening of the film *Scrum*[23] – celebrating and interrogating community sporting history, the City of Sydney focused on disputatious neighbours and our younger audience enjoyed some historical family fun at a weekend fair at Erskineville Public School. Activities such as these should attract the interest of academic historians who must recognize their potential and encourage us to think more carefully about who has authority over the past. Neighbours was the perfect theme for an organization committed to community engagement in the production and consumption of history.

Swimming with the Spit aims to show how a small amateur swim club punched well above its weight and made a significant impact, not just within the social and cultural community of Sydney's lower North Shore but also internationally. In an Olympic year, when the world's eyes were and continue to remain on Australian swimmers, I wanted to celebrate the ways in which Australia helped change the face of swimming. I also hoped we could highlight the value of local historical sources – the treasures hidden away in local studies archives as well as people's attics. I self-consciously wrote the project up in different ways to different audiences. In an academic article on sharing authority and oral history I used feminist oral histories of the Spit's female swimming champions in order to trace the ways in which swimming

and its historical meanings have changed for women in twentieth-century Australia. It revealed the lack of cultural scripts local female swimming stars could call upon to narrate their life stories and sporting success, the different ways in which they want their lives remembered and how historians might approach the complex construction of these histories.[24] As I work towards curating an exhibition on the club's history at Mosman Local Library these tensions with former swimmers continue and I look forward to writing about them in time.

The project certainly unsettled my understanding of community – the historians involved with the project touched on who is included and excluded in community histories and why that might be. Indeed, this was key to our discussions at a History Week symposium on community sporting histories mentioned above. As Sayer suggests, 'The socially and politically created "entity" of community appears on the surface to be temporally stable and geographically coherent, but the realities of how a community defines itself and how it is defined by outsiders often conflict.'[25] Projects such as these can test those boundaries further but also result in important intellectual pay-offs.

This community sporting history began as a feminist project focused on liberating women in the present by understanding their past. I hope that the book and its varied outputs provides a space for women to articulate their sporting success and that it inspires young women to aspire to swimming (or other) glory on the local, national or international stage. The project also used a range of media to construct knowledge including a website, featuring blog posts written by my students and the exhibition in Mosman. I intended for my varied outputs to provide young girls (my daughter, her friends and our neighbours) with some spectacular role models to think about as they swim. These are not just swimmers but also the volunteers who facilitate competitive swimming for those who want to win, and for others less concerned with victory, enjoying their time in or by the water among friends. I hoped that this work would build upon my strengths in women's and feminist social and cultural history. It is my response to Kevin Moore's rallying cry for 'a much greater academic engagement with public sport history, embracing and exploring new ways of communicating the subject, in new collaborations, to new and more diverse audiences'.[26]

I also wanted my research to have another sort of impact. I aimed to provide a platform for several elderly swimmers to reveal their history as champions during periods when few women became sporting stars. I hoped to celebrate these elderly women's lives and to create a space where young

members of the community, current child members of the club and active local swimmers, could learn about the contributions of older members to their local, community and sporting history. I wished to provide a path to intergenerational community dialogue. I hoped that my children, their friends and the local community might discover how the meanings of swimming had changed since the early twentieth century and how women could now enjoy the sport in ways that were not possible for young girls at the start of the twentieth century and why that might be. I want the project's multiple outputs to subvert gendered notions of sporting success. But I also aimed to examine the tensions between the ways in which these elderly champions want their lives remembered and my purpose in writing this history – which was my academic purpose. I hope that this book and its varied outputs provides a space for Sydneysiders to articulate and celebrate their sporting success and that it inspires young and old people to aspire to swimming (or other) glory on the local, national or international stage.

Teaching local and community history: PACE

Macquarie University introduced its Professional and Community Engagement (PACE) program in 2008. Students are encouraged to complete an internship or volunteer work with a range of external partners while undertaking their degree. It emphasizes the importance of practical experience and learning opportunities to undergraduate students.[27] In 2016, 7,100 Macquarie University undergraduates were enrolled in a PACE unit.[28]

I have been responsible for introducing PACE in modern history and for teaching public history at Master of Research (MRes) level since 2012. As I described above, I involved my PACE and MRes students on the Spit community history project from its start. I currently have three students (two PACE undergraduate students and one Year 2 MRes student – we have also been joined by a graduate of another university keen to gain experience in the field) working on the exhibition with Mosman Library. I relish the opportunity to leave the confines of my university to engage with diverse consumers and producers of history, especially if this means I get to spend more time at the beach talking about history with my students. I hope that my passion for communicating with audiences outside academia, writing

and presenting history in a variety of forms on television and radio, improves my teaching as well as educates my students about the importance and value of gaining transferable skills and then using those skills in a variety of ways to educate and help others as well as themselves. I am keen to set my students on a path towards employability but I also want them to value the significance of voluntary work, the importance of being able to work well with others and to become active citizens.

I also want them to acknowledge the ways in which ordinary, everyday people become active citizens and what impact (however minor) that might make on individual lives and communities more broadly. We all need to think carefully about the many ways in which we exist within and might contribute to the world around us. Therefore, there is a strong nexus between my teaching, research and community engagement activities. I try to practice what I preach. I have been undertaking research on my PACE students examining the complex and controversial concepts of employability and active citizenship using survey and interview data gathered from students who participated in modern history PACE units from 2012. This has revealed the ways in which the PACE experience can directly provide students with general skills, job-specific skills, and individual motivation even though it might not directly provide all students with paid employment post-graduation (although it sometimes does). One student who undertook my PACE unit revealed that it 'allowed me to understand the importance of history outside of academia and the role it can play in shaping and strengthening communities'. It revealed that she wants 'to do work that matters, work that makes a difference'. The PACE experience allows students to use and strengthen the general skills that degree work in history produces and to understand how they can be used in the workforce as well as their local communities.[29]

PACE also hones student motivation to pursue history outside of the university context. K's PACE experience curating a museum display on Vietnamese migration to Australia nurtured his sense of social justice. But it also 'pushed me out of my comfort zone, made me a better citizen, I suppose'. It inspired him to become more active in his community, assisting with church band and Bible camps. Perhaps most importantly, it got 'him out of the house' and 'this experience has encouraged me to pursue more volunteer work ... I feel like volunteering is mutually beneficial'. He now understands volunteering as project-based learning 'where the product is a new and improved self'. There is no doubt in my mind that PACE reveals

to students a broad range of job possibilities and that it also fosters active citizenship bound by a respect for diversity and the rights of others.[30]

As I develop PACE and MRes projects in rural and regional NSW, alongside my disciplinary research, I hope my students and many others continue to co-create a variety of community history projects and make significant contributions to knowledge and diverse communities in the process. This form of learning, at all levels, can have a powerful transformative impact on young as well as old learners. Community historians need to continue to work hard to engage diverse producers and consumers of history, of all ages and levels of learning, to help them create history in diverse forms, if local and community history is to thrive. All citizens need to place our 'life experiences in a meaningful social context'.[31] I think it makes sense for all of us to start with the local, the everyday, and the history on our doorstep as we think about the contributions we might make to the wider world. As young and old diverse citizens across the globe are encouraged to consume, co-create and actively participate in local, public history projects alongside academics thinking carefully about the different uses of their research, the future remains bright for collaboration, community and local history across the globe.

Notes

1. Some innovative examples include: http://knowyourbristol.org/; http://outstoriesbristol.org.uk/map/; www.leeds.ac.uk/arts/info/125100/arts_engaged; http://home.dictionaryofsydney.org/; https://livingwithdying.leeds.ac.uk/ (all accessed 3 October 2017).
2. Dolores Hayden, *The Power of Place: Urban Landscapes as Public History* (Boston: MIT Press, 1995); and Jorma Kalela, *Making History: The Historian and Uses of the Past* (Basingstoke: Palgrave Macmillan, 2011).
3. 'Follow-on Funding for Impact and Engagement'. www.ahrc.ac.uk/funding/opportunities/current/followonfunding/; 'Impact Toolkit'. www.esrc.ac.uk/research/impact-toolkit/; 'Engagement and Impact Assessment'. www.arc.gov.au/engagement-and-impact-assessment (all accessed 3 October 2017).
4. 'We Research the Global Production and Consumption of History in the Public Sphere'. www.mq.edu.au/research/research-centres-groups-and-facilities/resilient-societies/centres/centre-for-applied-history (accessed 3 October 2017).
5. http://historycouncilnsw.org.au/ (accessed 5 January 2017).
6. Beverley Kingston, 'The Use and Function of Local History', in *Locating Australia's Past: A Practical Guide to Writing Local History*, ed. The Local

History Co-Ordination Project (Kensington: UNSW Press, 1988), p. 6; Alison Twells, 'Community History', *Institute of Historical Research*, 2008. www.history.ac.uk/makinghistory/resources/articles/community_history. html (accessed 9 January 2017).

7. Sayer, 'Community History', 115.

8. www2.le.ac.uk/centres/elh (accessed 8 January 2017). Chris Dyer, 'Local History, with Special Reference to the Leicester School of Local History', *Institute of Historical Research*, 2008. www.history.ac.uk/makinghistory/ resources/articles/local_history.html (accessed 9 January 2017).

9. See Jerome de Groot, 'The Everyday Historical: Local History, Metal Detecting, Antiques', in *Consuming History* (London: Routledge, 2009), 63ff., pp. 62–3; and W. G. Hoskins, *The Making of the English Landscape* (London: Hodder and Stoughton, 1955).

10. de Groot, 'The Everyday Historical', 64; and Sayer, 'Community History', 117.

11. Joan Thirsk, 'Women Local and Family Historians', in *Oxford Companion to Family and Local History*, ed. David Hey (Oxford and New York: Oxford University Press, 2008), pp. 100–11. See also Tanya Evans, 'Family, Feminism and Empowerment', *Public Historian* (forthcoming).

12. Faye Sayer, 'Community History', in her *Public History: A Practical Guide* (London: Bloomsbury, 2016), pp. 113–46. For a celebration of local history practices and subjects taught at the University of New England, see JanisWilton, 'People and Place: Local History', in *Once Upon a Time: Australian Writers on Using the Past*, ed. Paul Ashton, Anna Clark and Robert Crawford (Melbourne: Australian Scholarly Publishing, 2016), pp. 178–94.

13. Lisa Murray, 'Community Connections: The Renaissance of Local History', paper presented at the Australian Historical Association conference 2012; Paul Ashton and Meg Foster, 'Public Histories', in *New Directions in Social and Cultural History*, ed. Sasha Handley, Rohan McWilliam and Lucy Noakes (London: Bloomsbury, 2017), p. 160.

14. For a critique of the 'scissors-and-paste' method of local history, see Geoffrey Blainey, 'Scissors and Paste in Local History', *Historical Studies: Australia and New Zealand* 6, no. 23 (1954): 339–44.

15. David Carment, 'Local History and Local Historical Societies in Twenty First Century Australia', presidential address to the Royal Australian Historical Society Annual General Meeting, 2012; David Carment, 'For Their Own Purposes of Identity: Tom Stannage and Australian Local History', *Public History Review* 20 (2013): 68–79. https://epress.lib.uts.edu. au/journals/index.php/phrj/article/view/3478/3890 (accessed 21 March 2017).

16. http://sydney.edu.au/arts/history/postgrad_research/projects.shtml# Prowse PhD 2015 (accessed 21 March 2017).

17. Graeme Davison, 'Local History', in *Oxford Companion to Australian History*, p. 400.

18. Louise Prowse, 'Parallels on the Periphery: The Exploration of Aboriginal History by Local Historical Societies in NSW, 1960s–1970s', *History Australia* 12, no. 3 (December 2015): 55–75.

19. Alison Twells, 'Community History', *Institute of Historical Research*, 2008. www.history.ac.uk/makinghistory/resources/articles/community_history.html (accessed 9 January 2017).

20. Sayer, 'Community History', 116–18.

21. www.newsouthbooks.com.au/books/swimming-spit/ (accessed 1 April 2017).

22. See Heather Goodall's foreword in Stephan Gapps, *Cabrogal to Fairfield City: A History of a Multicultural Community* (Fairfield, Sydney: Fairfield City Council, 2010).

23. http://scrumdocumentary.com/ (accessed 8 March 2017).

24. Tanya Evans, 'Swimming with the Spit: Feminist Oral Sport History and the Process of "Sharing Authority" with Twentieth-Century Female Swimming Champions in Sydney', *International Journal of the History of Sport* 33, no. 8 (2016): 860–79.

25. http://historycouncilnsw.org.au/macquarie-uni-history-week/ (accessed 5 January 2017); www.mq.edu.au/about/events/view/history-week-community-sporting-histories-inclusion-exclusion-and-authority-2/ (accessed 9 January 2017). Sayer, 'Community History', 115.

26. Kevin Moore, 'Sport History, Public History, and Popular Culture: A Growing Engagement', *Journal of Sport History* 40, no. 1 (Spring 2013): 39.

27. Judith Sachs, 'Preface: An Act of Faith and Great Experiment: The Antecedents of PACE', in *Learning Through Community Engagement: Vision and Practice in Higher Education*, ed. Judyth Sachs and Lindie Clark (Singapore: Springer, 2016), p. ix.

28. Chelsea Barnett, 'Modern History Graduates for the Workforce and the World: PACE, Employability, and Active Citizenship', unpublished report (Sydney: Macquarie University, January 2017).

29. Ibid., 6.

30. Ibid., 11–12.

31. Tom Stannage, *The People of Perth: A Social History of Western Australia's Capital City* (Perth: Perth City Council, 1979), pp. 8–9. See also Tom Stannage (ed.), *Local History in Western Australia (A Guide to Research): Papers Read at the Local History Seminar Held at Subiaco on 29 August 1974* (Perth: Department of History, University of Western Australia, n.d.), p. 1.

19

Grassroots Activism, Heritage and the Cultural Landscape: The Loud Fences Campaign

Jacqueline Z. Wilson and Keir Reeves

The meaning of cultural, or historic, landscape resides in both its aesthetic qualities and the memories and experiences it embodies. Cultural landscape is a complex of interwoven expressions of ideas, ideals, ideologies and aspirations, of layered and contested narratives, of shifting community identity. The connotations of a landscape are often highly personal, while simultaneously reflecting broad public values and sensibilities. This is especially true in the case of revered institutions of the sort that combine a key role in community history, a consciously profound aesthetic quality and a central place in the community's spiritual life.

Wherever it is present, the Roman Catholic church has long held a deeply significant place in the cultural landscape, in local history-making and in the urban aesthetic. Everywhere the church is strong in terms of numbers of the faithful; its 'penetration' of the social environment makes it highly visible, highly potent as a social agent and centrally important to the local social memory, even among non-Catholic and secular populations. The church embodies tacit narratives of moral and spiritual guidance and of participation in and shaping of the growth of communities' civic historical identity – a dynamic relational status that exemplifies what has been termed 'authorized heritage discourse'.[1]

This notion of heritage as officially sanctioned practice bound up with the community's defining narratives reveals something of a paradox. The very aspects by which it contributes to social stability and identity also render it vulnerable to the socially disruptive effects of any contestation of those narratives, especially when that contestation is revealed in ways that resonate with people's personal connection with a collective historical consciousness. This chapter addresses some of the processes involved, and the issues that arise, when such disruptive histories become public fare.

Histories

In May 2015, in the rural city of Ballarat, Victoria, a number of ribbons of various colours appeared overnight on the fence enclosing the former St Alipius Catholic Boys' School. The ribbons were placed there by a group of local women who wished to express their support for those who had suffered sexual abuse at the hands of school staff up until its closure in 1976. The school was one of a number of Ballarat institutions named in the Australian government's Royal Commission into Institutional Responses to Child Sexual Abuse (2013–17) as having harboured and actively facilitated a group of highly predatory paedophile priests serving the Ballarat Diocese and members of the Christian Brothers who taught at schools in the area.[2] The ribbons were the first visible manifestation of what their installers dubbed the 'Loud Fence' campaign.

The school buildings, which now serve as a parish hall and kindergarten, are located alongside St Alipius Catholic Church, a neo-Gothic basalt edifice that towers above the surrounding residential area on the main approach road into Ballarat from the east. St Alipius school was the first of many sites across Ballarat to be adorned with a damning array of ribbons. Institutions run by or directly associated with the Catholic church had fared especially badly in the Royal Commission, and most of the other Loud Fences installed across the city appeared at Catholic churches, schools and sites of supposed care such as former orphanages. But there was undeniably a certain apposite symbolism in the happenstance of St Alipius being selected for such highly visible public shaming by the Loud Fence campaign's opening salvo. This church has a long and especially intimate relationship with the town's history, and hence with both its sectarian makeup and its secular 'heritage' identity.

The construction of St Alipius's current building began in the mid-1850s and evolved over many decades, reaching completion in the 1920s.[3] Its

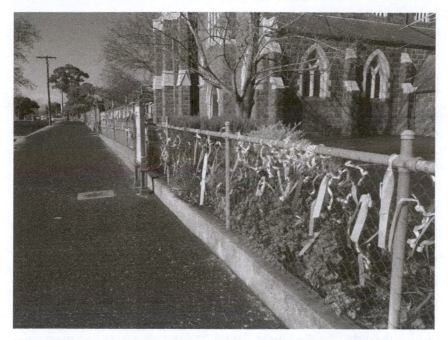

Figure 19.1 Ribbons on the fence at St Alipius Boy's School, Ballarat, 2017, part of the Loud Fences Campaign. Photo Jacqueline Z. Wilson.

imposing form has been a landmark on the main entry route to Ballarat's central business district (CBD) for almost a century. But St Alipius had its beginnings at the start of the Gold Rush in the early 1850s as a 'tent' church. It has the distinction of representing the first institutional Roman Catholic presence in an area that was transformed by gold discoveries into a major regional centre and eventually the state's largest rural city.

Ballarat's Gold Rush narrative is in many ways typical of frontier communities whose growth is driven mainly by the hope of fast wealth. Migrants from other Australian colonies and from overseas flooded into the area in their thousands, and with them came a variety of clergy who saw a pressing need for the dispensing of spiritual guidance to a disparate and rough-hewn itinerant population. And as the Gold Rush demographic had a preponderance of Irish people, the Roman Catholic presence in the area was, unsurprisingly, large.

In one key aspect, however, Ballarat was not typical. In 1854, three years into the Rush, the town became the venue of a revolt among miners against the authoritarian colonial government's iniquitous imposition of miners'

licence fees. This led to the so-called *Eureka Rebellion*, named for the eastern Ballarat district in which its violent culmination was acted out. It remains the only armed mass revolt against government in Australian history, and the only one that resulted in anything like a pitched battle between government forces and white civilians. Somewhere between twenty-two and forty miners and six government soldiers and police were killed when a government force charged the rebels' loosely fortified encampment – dignified in contemporary accounts as a 'stockade', but in fact barely justifying the term – at Eureka. This event became known as the 'Eureka massacre'.[4]

As the rebellion has been widely interpreted ever since as a seminal moment in the development of Australian democracy, Ballarat holds it dear. And it forms a highly important component of the city's and the region's cultural memory. It is of significance, therefore, that many of the rebels were Irish or of Irish background, especially among those most involved in the militant group mown down at Eureka.[5] Many worshipped at St Alipius. And the priest at St Alipius, Father Smyth, was highly active in promoting the miners' cause as a delegate on their behalf to government offices, in visiting the diggers at the Eureka site prior to the massacre,[6] and in secretly harbouring the rebellion's fugitive leader, Peter Lalor, after the event when Lalor had a substantial price on his head.[7]

In a city whose social memory and community identity are intimately bound up with both local and national history, the role of St Alipius' parishioners and clergy in the rebellion cemented the church's standing as an icon in the cultural landscape. And given the church's prominence as the tallest structure by far in the unprepossessing East Ballarat neighbourhood, it cannot help but maintain an equally significant place in the physical landscape. In this it very much accords with the Gold Rush legacy that largely defined Ballarat's urban environment. In the decade after the first gold strike, the town underwent a building boom that transformed the skyline on both grand and domestic scales. In the CBD especially, grand emporiums, banks, hospitals and institutions of administration and governance were erected by a wealthy and aspirational municipality. At the same time, miners were graduating from tents to serviceable weatherboard cottages of simple design which still abound in all but the newest or most affluent residential areas.

To this day, however, Ballarat's architecture includes very few buildings of more than two or three storeys, other than the ornate Victorian clock tower of the town hall, similarly styled ornamental edifices topping the railway station and former post office and, importantly, the castellated bell-towers, spires and high-peaked gables of the city's neo-Gothic churches.

Indeed, the city's churches are consistently the tallest and most visually prominent structures across the urban centre. Given the public aesthetic sensibility that favours 'neo-Gothic' edifices wherever they are found,[8] the city's churches are widely regarded as among the most pleasing to the eye. Such a judgement may also be extended to other church institutions in the area, such as St Patrick's (secondary) College and the former orphanage Nazareth House, both of which, although not 'Gothic', could easily be characterized as stately.

Given the visual, social and historical significance of St Alipius, the revelation of its complicity in the crimes and abuses investigated by the Royal Commission was deeply disturbing for many in the community. If the Loud Fence ribbons had been confined to St Alipius, they might have been seen as little more than an isolated expression of anger (mis)directed at an educational institution that was now defunct anyway. But it was clear, long before the first Loud Ribbons made their overnight appearance, that the Catholic church, in Ballarat and abroad, was deeply tainted. For the Loud Fence campaigners, St Alipius was just the beginning. St Patrick's Cathedral, the city's largest church and Mother Church to the Ballarat Diocese, St Patrick's College and Nazareth House were also identified in the Royal Commission, along with St Alipius, as venues of egregious, long-term abuse of children in their care. All became targets of the Loud Fence campaign.

Gold Rush diggers tend to form itinerant populations, and Ballarat was no exception. But the area's readily accessible gold deposits were sufficiently plentiful to ensure that a significant number of miners stayed on even after the first boom had levelled off. Many went into other businesses. The town prospered. And with the descendants of the Gold Rush Irish bolstering the numbers of practising Catholics significantly above the State average,[9] Ballarat acquired and maintains a reputation as being, statistically and culturally, very much a 'Catholic town'. This status was bolstered by the fact that its largest church, St Patrick's Cathedral, was the first consecrated cathedral in Australia.[10] For the image of the church to be tarnished as it has strikes at a core aspect of community identity.

Shame

To understand the effect on the community of the church's fall from grace, it is important to consider its dual social nature as both sectarian and secular.

Like all Christian denominations, the Roman Catholic church is centrally concerned with redemption. This, nominally at least, is also the prime focus of its adherents. As such, it has a long tradition of providing comfort, succour and hope for believers. But there is another side to this role, which can be explained in terms of Erving Goffman's conceptualization of 'stigma' and which provides clues to the significance and meaning of the Loud Fences.

Goffman, essentially concerned with 'the management of spoiled identity', speaks of stigma as comprising three main types: 'abominations of the body', that is, deformities or other socially intolerable physical defects; 'blemishes of individual character', comprising failings of moral, social or mental integrity; and 'the tribal stigma of race, nation, and religion'.[11] Goffman's thesis rests essentially on an assumption that stigma, so defined, is a perceived attribute imposed by society as a whole, or by relevant sections of society. Its defining features in any specific case are the product of shared societal values and standards (whether these be fair or otherwise). However, we suggest that in certain situations, stigma can be conferred upon individuals by bodies or institutions – 'stigmatizing authorities' – that act under a consensual mandate. This is the case with the church.

For members of the church, there is an implied *potential* stigma that lurks in the background: Goffman's 'blemishes of individual character'.[12] This is consequent upon straying or deviating from the teachings of the church, disloyalty to the church, rebellion against it – whether in deed or mere thought – or, at its most basic, the mere act or thought of sinning. Further, the church, by virtue of its traditional exclusiveness and – in the eyes of many believers – its monopoly on the 'true' path to salvation, has also long acted as an arbiter of 'tribal stigma' – in effect shaming and ostracizing not only those who were not born into the faith, but those who have 'lapsed'.

For most of the faithful, such stigmatization remains very much in the background. The church is seen as essentially benevolent, an upright moral and spiritual arbiter. And its authority – for instance, in matters of ritual requirements pertaining to atonement – is welcomed for the guidance is confers. For some, however, its stigmatizing authority is experienced as intensely and unjustly punitive and profoundly perverse.

The victims of historical child abuse at the hands of priests and other representatives of the church have testified, time after time, to the abiding sense of self-loathing and shame their abusers inflicted upon them. This was done not only through the primary acts of abuse, but by accompanying that abuse with warnings and imprecations based on the authority vested in them as stalwarts of the church. Victims had imposed on them a sense that their

stigma would be immeasurably compounded if they betrayed the church by complaining. (And those who did complain were, almost universally, not believed.) In this way, the process of stigmatization was completed, encompassing imputations of 'blemished character', 'tribal stigma' and even 'abominations of the body'. The latter came about from victims subjectively feeling physically defiled in ways that set them irrevocably apart from other, 'normal' members of society and from the purportedly benevolent care of the church itself.

Goffman speaks of a 'virtual social identity' based upon the unspoken 'demands' and 'expectations' society places upon its members. These become explicit only under certain circumstances, most especially when those expectation are not met.[13] We have been concerned to this point with stigma as a quality, or status, of individual persons. But there is in principle no reason for the concept to be limited in this way. An organization or institution may be equally well suited to receiving social censure commensurate with stigma. The Catholic church and its various institutions has traditionally had a 'virtual social identity' in terms of the assumed moral uprightness of their representatives and the integrity of their administrators. As has become clear over the course of the recent inquiries, those expectations have, most emphatically, not been met. It follows, then, that the church itself stands stigmatized.

The ribbons that appeared first in their dozens on the St Alipius fence, then in their hundreds on other fences across Ballarat, and then in tens of thousands across Australia and the world, can be interpreted as signifiers of the stigma suffered by each victim. In the process the ribbons complete the process begun in the various legal forums over the past decade; they revisit the stigma imposed on each individual victim back onto the physical body of the church. Each ribbon stands as a tangible, highly visible marker of moral outrage, a cry of 'Shame!'

Heritage

Not all those who see the ribbons, nor all those who install them, are followers of the Catholic faith. And a number of other, non-Catholic institutions named in the Royal Commission have also been adorned. Some ribbons have also been installed at sites which themselves have no involvement in the abuses but have chosen to express their support for the campaign. It is here that the church's secular identity in the community must be considered

and the significance of the Loud Fences understood, in terms of the links between historical institutions, the public historical sensibility and the abstract and fluid notion of 'heritage'.

It has been argued elsewhere that heritage is 'practised' as a necessary means of meeting the community's need for identity.[14] Given that point, it follows that a community that is invested heavily in its heritage, and the social and material signifiers that affirm it, may well find itself confronted by a kind of collective cognitive dissonance in the face of a sudden disruption to the familiar, essentially static embodiments of that heritage.

It would be an overstatement to say that the Loud Fences created any significant degree of public reaction in Ballarat, beyond a strong tendency for the numbers of ribbons at certain prominent institutions to grow exponentially, with significant numbers being installed by non-stakeholders in support. Anecdotal evidence suggests that the campaign was profoundly encouraging and empowering for many abuse survivors.[15] And some of the city's non-stakeholder residents found the ribbons unsettling, whether for their disruption of the familiar landscape, or for what they signified as unavoidable visual reminders of the revelations that emerged from the Royal Commission and other sources. As 'performative icons' of disruptive histories, the ribbons' direct effect on the public's sense of their city's heritage is difficult to assess. The campaign itself was diligently covered by the local news media, and its viral uptake onto the national then world stage duly received broader coverage.[16] This in itself implies a judgement on the part of those whose job it is to gauge public interest that the campaign was, at the least, newsworthy. But however perceived by the wider public, there is no doubt that the campaign's potency as a stigmatizing agent, and hence a potential disrupter of established heritage narratives, was readily apprehended by the institutions that received its attention.

Institutional responses to the appearance of the ribbons was varied. Some attempted to reject the campaign outright, only to find that the campaigners were more persistent than they had reckoned on. Ribbons tended to reappear overnight, as often as they were removed. Publicity consequent upon such 'dialogic' exchanges was sufficiently negative to provide an incentive for institutions to deal directly with the campaigners for the sake of public relations.[17] Others – and this applied to some of the Roman Catholic sites – tolerated, and even embraced, the Loud Fence cause. The Bishop of Ballarat made a show of installing his own ribbon among the hundreds of others decorating the fence around St Patrick's Cathedral. This overt *mea culpa* was welcomed by the campaigners and other stakeholders

and certainly constituted a positive public relations exercise.[18] (At this writing, over two years since the first installation, the ribbons remain in their hundreds at both St Alipius and St Patrick's Cathedral.) St Patrick's College hosted the ribbons for some months, before announcing that they were to be 'respectfully' removed in a ceremony attended by Loud Fence campaign leaders.[19] Nazareth House, on the other hand, allowed the ribbons to remain for several months but then suddenly removed them, notably without consultation with or acknowledgement of the campaigners. This action provoked something of a social media storm, as did, too, the instances of outright rejection.[20]

Across this spectrum of apparently disparate responses, ranging as they do from abrupt and censorious rejection, through prevarication and/or grudging, partial or temporary acceptance to wholehearted embracement, a common denominator is discernible. Every site subjected to the Loud Fence campaign has a long-established status as a significant historical entity within the cultural landscape – an established 'heritage identity' in the community. Each had to deal, in its own way, with a highly obvious visual 'intrusion' upon its 'storefront':

> The visual irony of using brightly coloured ribbons, adorning the often sombre peripheral built fabric of a venerable institution, to signify deeds dark enough to permanently blight the lives of many of their victims, seems to contradict the inherent gravitas of the 'classic', or establishment, heritage site. In each case, the institution's mission becomes one of somehow restoring its own narrative in the face of the contradicting one, for the narrative embodied in the establishment heritage entity is presumed to be – is in effect *required* to be – safe, uncontroversial, unchanging and unwavering in its affirmation of community values and identity.[21]

Thus, whatever any given institution's response, all 'stand as attempts of one sort or another to reclaim, re-appropriate and/or assimilate the Loud Fence performance into their own "traditional" heritage identity'.[22] As Laurajane Smith notes, this may be seen as an imperative intrinsic to the 'authorized heritage' paradigm: 'Not only are certain values [that are] embedded in the [authorized heritage discourse] perpetuated, but dissonance is itself regulated and arbitrated by the values and ideologies embedded in the [discourse].'[23]

To return briefly to Goffman and stigma, it is worth noting that he identifies, as a key imperative of the stigmatized entity, the steps taken to gain and maintain control of information regarding the stigma. As he puts

it, 'Control of identity information has a special bearing on relationships.'[24] As the church and other institutions such as schools have strong incentives to preserve positive relationships – centrally in the form of social and moral trust – with their respective 'clienteles' plus the public at large, the various responses to their unwanted inclusion in the Loud Fences campaign are clearly attempts to regain 'control of identity information'.

Our concern here, however, is mainly to do with heritage and the significance of Loud Fences in that context. This immediately raises questions of definition: just what do we mean by 'heritage'?

The type of 'heritage' being dealt with here is concerned primarily with the urban landscape – the material, architectural environment – which is clearly and tangibly 'historical'. In a 'history-minded' city such as Ballarat, much heritage consciousness focuses on this.

In his chapter in this book, Denis Byrne speaks of the implied, 'sub-surface' affect intrinsic to structures and other material remnants that have witnessed deeds of loss and suffering.[25] Byrne describes 'a kind of underground heritage [that] results from processes of effacement – "underground" in the sense of being below or beyond the threshold of public visibility'.[26] This hidden heritage he inhabits with the imagined victims of events that, if they were to be revealed to the collective consciousness, would give the lie to the conventional narrative that inheres to such edifices of establishment grandeur as cathedrals and educational institutions. Loud Fences, we suggest, do precisely this, in that they imbue the visible, tangible surface with equally visible and tangible invocations of the victims.

The commonly perceived 'conventional narrative' that Loud Fences disrupt may be regarded as 'official' heritage. But given that heritage is an expression of social memory, and that social memory is innately fluid, multistranded, contested and intangible, a function of interpretation, heritage itself is at least as much an interpretive *process* as it is a collection of static architectural tableaux and officially sanctioned institutional histories. Further, this dynamic quality inevitability opens up the possibility of heritage as a transformative 'performance' with the potential to radically – yet legitimately – undermine its official counterpart.[27] 'It is in the realm of performative transformation that the ribbons of the Loud Fences have their potency, and in which is revealed their own role and status *as heritage entities in their own right*.'[28] They thus begin, or contribute to, a transformation of the institution as a static bastion of 'authorized heritage' into one whose historical narrative is shifting, uncertain, and markedly less tangible.

Conclusion

We have considered the moral and historical potency of a grassroots activist campaign aimed at a major regional community's institutional icons. The campaign has been examined in the light of its significance both for stakeholders in those institutions, and for the heritage aesthetic. In their role as signifiers of moral stigma, Loud Fences explicitly contradict the established moral authority of the institutions they target. They invert those institutions' unspoken capacity to 'stigmatize' and advertise the stigma inflicted upon the institutions through official inquiries. As dissonant intrusions on the cultural landscape, the ribbons run counter to the 'authorized heritage discourse'. In the process they draw to the built fabric's visible surface narratives of suffering hitherto concealed by denial, shame, and communal forgetting.

In May 2017 the originator of Loud Fences announced the campaign's official end, stating that she believed it had largely achieved its primary aim of raising awareness and supporting survivors.[29] At most of Ballarat's Loud Fence sites, the ribbons remain with no sign of imminent removal (the exception being St Patrick's College, which with the cooperation of the Loud Fence organizers transferred them to a permanent, memorialized location within the school). It is notable, too, that there are now a number of fences here and there around Ballarat that demark nothing more than vacant public or council land, yet which display arrays of ribbons. This indicates that at some point the campaign 'graduated' from its site-specific shaming performance to a more generalized statement of support that implies an assumption, on the part of the installers, of broad community awareness and comprehension of the 'message'. It is understood, in other words, that a ribbon on a fence, any fence, stands as a recognizable idiom of protest and empowerment. To what extent they will remain as accepted components of the landscape remains to be seen.

Notes

1. Laurajane Smith, *Uses of Heritage* (London: Routledge, 2006), p. 87.
2. Konrad Marshall, 'Faith in the Church Was Lost, Faith in Justice Returns to Ballarat', *The Age* (Melbourne), 19 May 2015; Peter McClellan, 'Addressing the Needs of Those Who Have Experienced Abuse in Care as Children: Implications of Findings of the Royal Commission', paper

presented at the Association of Children's Welfare Agencies conference, Sydney, 15 August 2016; Fiona Henderson, 'Child Sex Abuse Victims Name 17 Institutions for Royal Commission Submission', *The Courier* (Ballarat), 23 May 2014.

3. Authentic Heritage Services, 'Churches', n.d. https://authenticheritage. com/services/conservation-management-plans/churches/ (accessed 6 September 2017).

4. John Molony, *Eureka* (Melbourne: Melbourne University Press, 2001); on the difficulties in determining the exact death toll, see Clare Wright, *The Forgotten Rebels of Eureka* (Melbourne: Text, 2013), p. 428.

5. Molony, *Eureka*, pp. 170–2.

6. Ibid., pp. 132–5, 138–40, 147.

7. Ibid., pp. 169.

8. Ibid., pp. 31–47.

9. Peter Wilkinson, 'Who Goes to Mass in Australia in the 21st Century?' *Catholica: A Global Conversation*, 2013. www.catholica.com.au/gc4/ pw/005_pw_print.php (accessed 8 June 2017); see also Australian Bureau of Statistics, 'Census Fact Sheet: Religion', 2011. www.abs.gov.au/ websitedbs/censushome.nsf/home/mediafactsheetsfirst/$file/Census-factsheet-religion.doc (accessed 19 September 2017).

10. Catholic Diocese of Ballarat, 'Our Diocese: Cathedral', 2014. www.ballarat. catholic.org.au/our-diocese/dsp-default.cfm?loadref=133 (accessed 7 June 2017).

11. Erving Goffman, *Stigma: Notes on the Management of Spoiled Identity* (London: Penguin Books, 1963), p. 14.

12. Ibid.

13. Ibid., p. 12.

14. Keir Reeves and Gertjan Plets, 'Cultural Heritage as a Strategy for Social Needs and Community Identity', in *A Companion to Heritage Studies*, ed. W. Logan, M. Craith and U. Kockel (Hoboken, NJ: John Wiley, 2016), p. 203.

15. 'Loud Fence: End of an Era for Symbol of Popular Support', *The Courier* (Ballarat), 27 May 2017.

16. Melissa Cunningham, 'Loud Fence Movement Goes to New York', *The Courier* (Ballarat), 18 November 2015; Melissa Cunningham, 'Loud Fence Throws Support around Survivors'. *The Courier* (Ballarat), 7 November 2015; 'Cardinal Pell Joins Loud Fence Movement', *The Courier* (Ballarat), 28 February 2106; Margaret Burin, 'We Support You: Loud Community Message for Child Sex Abuse Survivors', *Australian Broadcasting Corporation* (Ballarat), 22 May 2015. www.abc.net.au/local/ photos/2015/05/22/4240723.htm (accessed 9 February 2016).

17. Jacqueline Z. Wilson and Frank Golding, 'The Tacit Semantics of "Loud Fences": Tracing the Connections between Activism, Heritage and New Histories', *International Journal of Heritage Studies*, 11 May 2017. https://doi.org.1080/13527258.2017.1325767 (accessed 18 August 2017).

18. Melissa Cunningham, 'Bishop Ties Ribbon of Hope', *The Courier* (Ballarat), 13 January 2016.

19. John Crowley, 'Headmaster's Message', *St Patrick's College* (18 March 2016). www.stpats.vic.edu.au/en/news/article/headmaster-s-message-march-18-2016/ (accessed 10 January 2017); Matthew Dixon, 'Permanent Display on Cards for Loud Fence'. *The Courier* (Ballarat), 6 April 2016.

20. Melissa Cunningham, 'Loud Message of Support for Sex Abuse Victims Won't Be Silenced', *The Courier* (Ballarat), 1 February 2016; Wilson and Golding, 'Tacit Semantics'; Matthew Dixon, 'Church Removes Ribbon from Loud Fence', *The Courier* (Ballarat), 26 February 2016; Loud Fence *Facebook* page, 17 January 2016. www.facebook.com/loudfence/posts/1224790677580135 (accessed 5 March 2017); Loud Fence *Facebook* page, 26 February 2016. https://m.facebook.com/story.php?story_fbid=1247235842002285&id=1106437572748780&p=20&av=100002185735451&refid=52 (accessed 5 March 2017).

21. Wilson and Golding, 'Tacit Semantics'.

22. Ibid.

23. Smith, *Uses of Heritage*, p. 88.

24. Goffman, *Stigma*, p. 107.

25. See Denis Byrne's chapter in this volume.

26. Ibid.

27. Neil A. Silberman, 'Heritage Interpretation and Human Rights: Documenting Diversity, Expressing Identity, or Establishing Universal Principles?' *International Journal of Heritage Studies* 18, no. 3 (2012): 249–50; Denis Byrne, 'A Critique of Unfeeling Heritage', in *Intangible Heritage*, ed. L. Smith and N. Akagawa (London: Routledge, 2009), pp. 240–41, 243; Ahmed Skounti, 'The Authentic Illusion: Humanity's Intangible Cultural Heritage, the Moroccan Experience', in *Intangible Heritage*, p. 75; David C. Harvey, 'Heritage Pasts and Heritage Presents: Temporality, Meaning and the Scope of Heritage Studies', *International Journal of Heritage Studies* 7, no. 4 (2001): 226.

28. Wilson and Golding, 'Tacit Semantics' (emphasis added).

29. 'Loud Fence: End of an Era', *The Courier*, 27 May 2017.

Past Continuous: Digital Public History through Social Media and Photography

Serge Noiret

Social media are 'a group of Internet-based applications that build on the ideological and technological foundations of Web 2.0, and that allow the creation and exchange of user-generated content'.[1] They develop user-generated knowledge in networked communities; they foster peer-to-peer interaction between the public at large, amateurs, academic or public historians through shared authority practices.[2] But since everybody can load directly in the web voluminous memory/history content, this spontaneous activity should not be confused with what is today called Digital Public History (DPH), a subfield of the Digital Humanities.[3] Web 2.0 technologies – also in social media – allow direct public participation in public history projects. From a public historian's point of view, user-generated technology practices involve the direct capacity to govern and exploit these technologies in public history projects.

All activities related to the past in social media need the filtering role of public historians as project mediators and organizers, especially in a post-truth era when all kind of digital content – including unreliable or unscientific material – is shared on the web. This is why the public historian's mediation is an essential aspect of any DPH professional activity as we will see with examples taken from Twitter and Historypin. DPH projects are never about what has been called radical trust about user-generated content dealing with the past.[4] Digital Public Historians use public expertise and contents in their projects, filtered by critical methods adapted to web technologies and

shared authority practices.[5] In this way, public historians take care of who has memoirs and documents, information and expertise and can easily be enrolled in planned DPH projects.

An early example of the way historians integrate people's contents and knowledge is PhotosNormandie, a French project about capturing unexpressed knowledge of an unknown audience interested in D-Day and knowing about places shown in photographs shot in Normandy during the summer of 1944.[6] As a DPH project, PhotosNormandie sought comments for the pictures and suggested enriching and/or changing existing captions of over 3,000 photographs of the landing and the Battle of Normandy which would enable these images to be 'redocumented' as primary sources. The public history aspect of this knowledge comes through the shared authority activity between a group of specialists adding new descriptive metadata to the pictures and the curators of the project. The Flickr archive has found, thanks to the scientific collaboration of local experts, unexpected and rigorous local means of public validation and curation of photographs.[7]

Social media and DPH platforms

Today all individuals become protagonists using social media. Everybody is taking care of promoting themselves. TV 'reality shows' such as Got Talent select unknown people and connect them with an audience. These types of TV reality shows are the most followed TV broadcasts worldwide together with the many X factor national competitions.[8] They reveal unexpressed knowledge, skills and creative capacities the same way online social media platforms do crowdsource knowledge and, in the field of history, reconnect with the past. In this case, individual memories are shared not only as written texts but more often as visual materials, photographs and videos. Like talent TV shows, social media allow different publics to promote themselves and their family history. This is an easy way to gain social promotion, recognition and renown and to feel part of 'big history'.

In the DPH field, social software could be key elements of an interaction between public historians, as mediators, and communities. Social platforms become virtual places to engage in networked behaviours dealing with knowledge of the past. But social media content becomes modern primary source and produces 'big data'. They organize a flux of multimedia – mainly photographs, audio and video – crowdsourced content through specific technologies and facilitate different forms of communications of history between individuals and communities.

They integrate actors in interdisciplinary conversations and facilitate knowledge building; bring users together to discuss common issues, share traces and documents about the past; build online relationships, reinforce identities and consolidate kinship and communities; and allow dispersed communities to reconnect online keeping the memory of common cultural identities, especially when contemporary communities are often not present in physical spaces.[9]

Forgotten collective memories based on forgiven communities' pasts may be reactivated and past cultures consolidated online through Web 2.0 technologies.[10] Participatory knowledge sharing creates public awareness about these past in our present. An 'archaeology' of memories online maintains the past alive through direct public participation in global cultural enterprises.[11] Sharon Leon writes that 'to achieve [the promise of digital technologies for public history], we must focus on the goals of public history and adapt our working practice to the new conditions created by the digital environment'.[12] This is why we have first to understand how different social media function[13] and then be able, as public historian, to critically administer the content they convey online.[14]

As Jo Guildi and David Armitage pointed out,[15] historians should jump into this world of interconnected big data using specific forms of network analysis to provide new epistemological queries based on the online availability of an enormous quantity of information that can now be analysed because of its interconnectedness.[16] Semantic links between digital data can be displayed using graphs[17] as has been done with the fascinating e-Diasporas Atlas which puts together more than 8,000 websites project on migrations.[18]

But because of the volatility and unreliability of web content a strong critical commitment is an essential procedure for historians[19] digging into the digital realm.[20] External and internal source criticism derived from the traditional way medieval historians look at the production of sources and at their context of availability should be adopted in web environments.[21]

Twitter, Big Data and the First World War commemorations

What kind of knowledge and social connectivity about the past and teaching activities[22] can be conveyed with only 140 characters provided by a social software such as Twitter?[23]

Today, public history is often driven by anniversaries and commemorations. Interpreting the way DPH projects are commemorating the First World War[24] allow us to examine the politics of memory into the present.[25] Twitter shares memory, oral history, facts, opinions and multimedia digitized sources. It has often dealt with the First World War arousing new interests and forms of public discussion locally, regionally, nationally and supranationally. Commemorations worldwide produce big digital data, an enormous amount of digital material and digital public activities in websites and projects.[26] Twitter, too, has been affected by this. The hashtags #WW1 or #WW1Centenary[27] are very popular. Twitter accounts were created everywhere looking at the memory of the war. How common people and their families passed through this cataclysm is the lens through which many twitter projects delve into local memories.

DPH projects in Twitter – #WW1 – are often connected with a website project such as Europeana 1914 to 1918[28] or 1914 to 1918 Online, the Encyclopedia of the First World War,[29] which has its own Twitter account. It provides information about events that happened 100 years ago and also retweets information, sources, curiosities or announces debates, exhibitions or book publications.[30] Like the Encyclopedia, Europeana 1914 to 1918 created its Twitter account in 2012[31] with the declared goal to engage directly with the public asking for the crowdsourcing of memories and documents.[32]

In a country such as Belgium, heavily affected by military activities during the First World War,[33] Twitter is used for sharing the history and memory of the occupation by the Germans with the wider public. In France, an important documentation centre and museum for the History of the war like the 'Historial de la Grande Guerre', joined Twitter only in October 2014 several months after the start of the commemoration.[34] The Historial Twitter's account published less than 150 tweets between October 2014 and October 2017 but is followed by more than 1,300 people. Hashtags such as the #centenaire did not enter the wider international or national discussion about the war before 2017. Created in March 2009, the twitter account of the Imperial War Museums in Great Britain[35] tells 'the story of those who have lived, fought and died in conflict, from 1914 to now'. It is extremely popular with more than 108,000 followers and 21,000 tweets by the end of September 2017.[36]

The battlefield seems to largely prevail as a topic in the number of tweets that mention #WW1 in United Kingdom war institutions and museums. French accounts focus more on the life and death of soldiers (the 'Poilu'). Twitter seems often to privilege the military history of the war and is not

open to new forms of social research such as other nation's armies, the colonial armies or the lives of women behind the front. The Encyclopedia of the First World War tried to promote these sort of topics for the centenary.

Crowdsourcing the First World War using Twitter

This section explores how two national projects tried to make the best of Twitter during the centenary's commemorations. The first is a pedagogical project created in Luxembourg with international scope – @RealTimeWW1); the second is a French project crowdsourcing the memory of all fallen single soldier fallen during the war – @1J1poilu.

In 2014 during the US National Council for Public History annual conference in Monterey, California, Benoit Majerus, history professor at the University of Luxembourg, presented an innovative pedagogical project based on Twitter. His goal was to teach and research 'the everyday life of European people' during the First World War. Day by day, history students of the Luxembourg history master's program, studied the war, discovered digitized primary sources in archives or online and applied critical methods to the sources before publishing a new tweet daily about how soldiers or civilians were affected by the war. What is different about @RealTimeWW1 is that daily tweets are about an event which is not past but present and happened hundreds of years ago. Past and present is blurred because of the capacity of social media to bring the past into a permanent present.

Twitter seems to serve better national goals and national memories of the First World War as demonstrated by Frédéric Clavert's current research on #WW1.[37] Clavert monitors the flux of more than two million tweets collected from April 2014 via a selection of the most used the First World War hashtags in German, English and French.[38] He used the software IRAMUTEQ[39] to explore these Big Data from three distinct perspectives, dividing francophone and English tweets. And he analysed the statistics looking first at a chronology of the main events. He then made a textual analysis of the content of the tweets and, finally, visualized the results through a network analysis of the hashtags.[40] It shows that Twitter is not at all used in France like it is being used in Great Britain or in other Anglo-Saxon countries.

The ability to integrate photographs[41] and, from 2014, video[42] in tweets helps a lot historians to add visual primary sources to the 140 characters. It is easy procedure to reproduce any kind of primary sources as an image.

Through Twitter, witnesses speak in the first person, often through a re-enactment of the past or a storytelling, autobiographies, diaries and other personal documents. What 'happened today', a chronological daily engagement with the past, is very common in Twitter in close connection with web sites projects where the timeline is often part of a site's architecture. But a critical approach to the evidence displayed in tweets is often missing in twitter especially when historical photographs are provided. This is the case of the American Twitter project History in Pictures which narrate the past 'sharing the most powerful and entertaining historical photographs ever taken' with very poor captions because of the limited characters in a tweet.[43]

Blurred and active memories through camera lenses

After the pioneering role of Flickr (2004), Facebook and Twitter were launched and some years later, Pinterest, Instagram and Tumblr diversified the number of social media platform dedicated to photography answering to a visual turn centred on the role that images.[44] What role, for example, do selfies[45] play today in narrating our daily lives?

Understanding how people use photography in social media and play with history tells us many things about which pasts are important today. Pictures are used because of the constant need to revisit the past bringing it back in a continuous present. Photography, in social media, describes popular behaviours and, thanks to linked data technologies, Google Maps and Street View, creates timelines, spatial dimensions and time boundaries for individual memories. Old family pictures are key elements for our family and individual memories.[46] But family pictures deal with a self-oriented past – of one's own family. The photographer Irina Werning in *Back to the Future*, for example, shows adults wearing the same clothes they wore when they were children.[47]

Public historians can help ordinary people to use different technologies to create contents online. DPH methods, sustaining a direct, often unmediated, involvement with the past, matter to international publics interested in incorporating their own memories into the present. On the other hand,

genealogy – which is ubiquitous in most social media – has only scratched, as Jerome De Groote has observed, the surface of major events in history and is often disconnected from 'big history' and broader contexts.[48]

The social media platform Historypin, 'a global community collaborating around history',[49] was created by the non-profit company Shift with support from Google and launched at the Museum of the City of New York in July 2011. The company wanted to enable 'networks of people to share and explore local history, make new connections and reduce social isolation'.[50] Linked data and semantic web technology connect digital contents in Historypin, combining primary sources with places. Old pictures can be 'pinned' in the present suppressing time boundaries. Family pasts may be re-enacted in today's urban landscapes. Because technology is easy, lay people can easily use the software in much the same way as the polaroid camera once did. Historypin is emblematic of what is happening with millions of past photographs and personal memories crowdsourced daily in other social media.[51] Collections of images are included in Google maps.[52]

Public historians take Historypin very seriously to engage with specific communities.[53] The US National Archive (NARA) suggests that 'this new media/map mashup site allows ... [people] to ... upload digital files, add descriptive information and personal narratives to these items, and experience how familiar environments have changed over time in front of you'. Thanks to Histortypin, NARA is everywhere in virtual space[54] and solicits everybody's contribution inviting the wider public to 'pin your history to the world'.[55]

Academic historians could use the potentiality of Historypin – an easy tool to re-enact difficult pasts. What about the Israelo-Palestinian war in 1948? Alon Confino tried to reconstruct the invisible Palestinian past of Tantura, a village near Haifa on a beach called Dor in Israel today. Confino publishes images of Palestinians families of Tantura he founds in archive. But social media could be used for crowdsourcing other original documents of the Palestinian diaspora. So re-enacting pre-1948 Palestinian memories into the present is possible.[56]

Historypin is used worldwide. In Florence, during a public exhibition in 2014 commemorating the seventieth anniversary of the end of German occupation in August 1944,[57] citizens brought their stories and documents on site to a project called MemorySharing: 1,944 pictures were scanned and included in Historypin contemporary maps of Florence. New Zealander soldiers are now inscribed directly on Google Street view. You can fade

the vintage picture to see the contemporary layer of the street and back to Florence in 1944.[58]

Patrick Peccatte defines three different ways photos can be assembled to change the relation between past and present in photography.[59] Another project created in 2009 by the photograph Jason Powell, 'Looking into the Past', merges past and present in a unique image.[60] It was inspired by a photograph in Michael Hughes's Flickr project 'Souvenirs'.[61] 'Ghosting family pasts' in social media, using digital technologies, is very popular everywhere for resuscitating memories. Merging old pictures and recent images shortens the digital timeline and activates different regimes of historicity in the present as François Hartog calls it.[62] Emblematic of many other projects around the world, the 'Past Present Project in Tumblr',[63] Instagram[64] and Facebook[65] publish pictures where past and present overlaps.[66] These pictures say much about individual and generational experiences and our incapacity to close up our elusive presents even when fixing it with pictures. Showing the pastness of places shapes a nostalgic present, as with the images of merged urban temporalities by Zoltán Kerényi, a Hungarian artist,[67] or with Hebe Robinson's northern Norway photographic project 'Echoes' which reinserts old family photographs in a Lofoten fishing village in a rural landscape which was abandoned after the Second World War.[68]

Also called rephotography,[69] these new images contain different time layers in one unique image. Sometimes, more rephotographed images are used to resuscitate the old photography at different periods of time. Lost settlements, historical landscape, urban transformations, family experiences and even the First World War images are 'ghosted' in a nostalgic past–present continuum. The author of a website about Krakow in Poland 'looks for very old photos of the city and takes new ones from the very same spot, so my readers can compare and see what has changed'.[70]

Images of the First World War soldiers were created by 'mixing a vintage picture with a shot taken recently from exactly the same spot'. Peter Macdiarmid travelled 3,000 miles through England, France and Belgium to revisit sites, 'standing where history was made and where a photographer stood 100 years ago'.[71] In Keith Jones's Flickr and Facebook Liverpool then and now project,[72] we discover 'blended shots', merged images between then – in black or sepia – and now – in colour.[73] A famous 1963 image of the Beatles – in black and white – staying on the Derby Square central statue was again photographed in 2014.[74]

An Italian photographer, Isabella Balena, took pictures of today's ruins of the Gothic Line[75] where the allied offensive was stopped in central Italy in 1944 and

until the end of the war. Importantly, in Balena's reproduction of monuments remembering this violent past, we see today the place where Mussolini was shot in April 1945 as a new living experience. Only the name remains; this photographic journey is about visual public history narratives in which today's memory of the violent past is often blurred. Many times, present usages of past spaces lose contact with the significance of places and monuments. Disconnection with the past is what Serge Gruzinski shows us in the pictures he chose to illustrate his 2012 book *l'Histoire pour quoi faire?*[76] Young Algerians play football and the goalkeeper uses an old Roman arch that does not mean anything for him today: history and memories of ancient history are lost.

Notes

1. Andreas M. Kaplan and Michael Haenlein, 'Users of the World, Unite! The Challenges and Opportunities of Social Media', *Business Horizons* 53, no. 1 (2010): 59–68.
2. Tatjana Takseva, 'Preface', in *Social Software and the Evolution of User Expertise: Future Trends in Knowledge Creation and Dissemination*, ed. Tatjana Takseva (Hershey, PA: Information Science Reference, 2013), pp. xvi–xxix.
3. Serge Noiret, '*Y a-t-il une Histoire Numérique 2.0?*' in *Les historiens et l'informatique. Un métier à réinventer*, ed. Jean-Philippe Genet and Andrea Zorzi (Rome: École Française de Rome, 2011), pp. 235–88; '*La digital history: histoire et mémoire à la portée de tous*', in *Read/Write Book 2. Une introduction aux humanités numériques*, ed. Pierre Mounier (Marseille, OpenEdition Press, 2012), pp. 151–77. http://press.openedition.org/258; 'Digital History 2.0', in *Contemporary History in the Digital Age*, ed. Frédéric Clavert and Serge Noiret (Bruxelles: Peter Lang, 2013), pp. 155–90; and 'Digital Public History', in *Wiley-Blackwell Companion to Public History*, ed. David M. Dean (London: Wiley Blackwell, March 2018); see also Gerben Zaagsma, 'On Digital History', *BMGN – Low Countries Historical Review* 128, no. 4 (2013): 3–29. http://doi.org/10.18352/bmgn-lchr.9344. All websites have been accessed 9 October 2017.
4. James B. Gardner called 'radical trust' what he thought, in 2010, defined what Web 2.0 practices in DPH projects were about. But DPH projects integrate user-generated and crowdsourcing activities through *supervised* 2.0 Web technologies. See Jim Gardner, 'Trust, Risk and Public History: A View from the United States', *Public History Review* 17 (2010): 52–61. http://epress.lib. uts.edu.au/journals/index.php/phrj/article/view/1852.

5. Sharon M. Leon, 'Complexity and Collaboration: Doing Public History in Digital Environments', in *The Oxford Handbook of Public History*, ed. Jame B. Gardner and Paula Hamilton (Oxford: Oxford University Press, 2017), pp. 44–66.

6. *Then and Now PhotosNormandie* (36 members and 62 published pictures on 9 October 2017). http://www.flickr.com/groups/thenandnowphotosnormandie/.

7. Patrick Peccatte, 'La FAQ du projet PhotosNormandie', *DéjàVu*, 17 January 2017. https://dejavu.hypotheses.org/2998.

8. *America's Got Talent,* 2006. www.nbc.com/americas-got-talent; *La France a un incroyable talent,* 2006. www.m6.fr/emission-la_france_a_un_incroyable_talent/; *Britain's Got Talent,* 2007. www.itv.com/britainsgottalent.

9. Dario Miccoli, 'Digital Museums: Narrating and Preserving the History of Egyptian Jews on the Internet', in *Memory and Ethnicity. Ethnic Museums in Israel and the Diaspora*, ed. Emanuela Trevisan Semi, Dario Miccoli, Tudor Parfitt (Newcastle: Cambridge Scholars, 2013), pp. 195–222.

10. Noiret, 'Digital History 2.0'.

11. Serge Noiret and Thomas Cauvin, 'Internationalizing Public History', in *The Oxford Handbook of Public History*, pp. 25–43.

12. Leon, 'Complexity and Collaboration'.

13. Christian Fuchs, *Social Media. A Critical Introduction* (London: Sage, 2014); Michael Mandiberg (ed.), *The Social Media Reader* (New York: New York University Press, 2012).

14. Wendy Duff, Barbara Craig and Joan Cherry, 'Historians' Use of Archival Sources: Promises and Pitfalls of the Digital Age', *Public Historian* 26, no. 2 (2004): 7–22. www.jstor.org/stable/10.1525/tph.2004.26.2.7.

15. Jo Guldi and David Armitage, *The History Manifesto* (Cambridge: Cambridge University Press, 2015); and Ramses Delafontaine, Serge Noiret, Quentin Verreycken and Eric Arnesen, 'The "History Manifesto": A Discussion', *Memoria e Ricerca* 24, no. 1 (2016): 97–126.

16. Martin Grandjean, 'La connaissance est un réseau, perspective sur l'organisation archivistique et encyclopédique', *Les Cahiers du Numérique* 10, no. 3 (2014): 37–54. http://dx.doi.org/10.3166/LCN.10.3.37-54. Peter Haber used the concept of 'data-driven history' to define the new world of digital history: Peter Haber, *Digital Past: Geschichtswissenschaft im digitalen Zeitalter* (Munich: Oldenbourg, 2011).

17. Martin Grandjean, 'Introduction àla visualisation de données: l'analyse de réseau en histoire', *Geschichte und Informatik* 18/19 (2015): 109–28.

18. Dana Diminescu, *E-Diasporas*. www.e-diasporas.fr/; another example looking at the League of Nations intellectual network: Martin Grandjean,

'Analisi e visualizzazioni delle reti in storia. L'esempio della cooperazione intellettuale della Società delle Nazioni', *Memoria e Ricerca* 25, no. 2 (2017): 371–93.

19. In Italy, between 2001 and 2003, a group of historians, archivists and librarians analysed the circulation of unreliable contents in the Web: Antonino Criscione, Serge Noiret, Carlo Spagnolo and Stefano Vitali (eds), *La Storia a(l) tempo di Internet: indagine sui siti italiani di storia contemporanea, (2001–2003)* (Bologna: Pá tron editore, 2004).

20. Andreas Fickers, 'Towards a New Digital Historicism? Doing History in the Age of Abundance', in 'Making Sense of Digital Sources', ed. Andreas Fickers and Sonja De Leeuw, *Journal of European History and Culture* 1, no. 1 (2012): 12–18. http://journal.euscreen.eu/index.php/view/article/view/jethc004/4; Seth Denbo, 'Googling History: The AHR Explores Implications of Using Digital Sources for Historians', *AHA Today* blog, 16 May 2016. http://blog.historians.org/2016/05/googling-history-the-ahr-explores-implications-of-using-digital-sources-for-historians/.

21. Steff Scagliola, 'Digital Source Criticism in the 21st Century: Reconsidering Ranke's Principles in the Digital Age', *DH Lab* blog, 3 August 2016. www.dhlab.lu/blog-post/digital-source-criticism-in-the-21st-century-reconsidering-rankes-principles-in-the-digital-age/.

22. Emilien Ruiz, 'Faire de l'histoire sur Twitter? Entretien avec @LarrereMathilde', *Devenir Historien-ne. Méthodologie de la Recherche et Historiographie* blog, August 2016. https://devhist.hypotheses.org/3336. The stories conceived by Larrere (August 2016) about 'revolutions' in history are regrouped using the software *Storify*. https://storify.com/LarrereMathilde.

23. José Van Dijck, 'Facebook as a Tool for Producing Sociality and Connectivity', *Television & New Media* 13, no. 2 (2012): 160–76. doi: 10.1177/1527476411415291.

24. Mélanie Bost and Chantal Kesteloot, 'Les commémorations du centenaire de la Première Guerre mondiale', *Courrier hebdomadaire du CRISP* 30–31 (2014): 5–63.

25. Alexander Etkind, 'Mourning and Melancholia in Putin's Russia: An Essay in Mnemonics', in *Memory, Conflict and New Media Web Wars in Post-Socialist States*, ed. Julie Fedor, Ellen Rutten and Vera Zvereva (London: Routledge, 2013), pp. 32–47.

26. 'First World War Websites', *1914–1918 Online. The Encyclopedia of the First World War*. www.1914-1918-online.net/06_first_world_war_websites/index.html.

27. https://twitter.com/hashtag/WW1Centenary.

28. www.europeana1914-1918.eu/.

29. http://encyclopedia.1914-1918-online.net/home.html.

30. *@19141918online* 'is a collaborative international research project designed to develop a virtual reference work on WW1'. https://twitter.com/19141918online.

31. https://twitter.com/Europeana1914.

32. 'The "Europeana 1914–1918" project aims to collect and share material that relates to the Great War (1914–1918) and those involved in or affected by it.' www.europeana1914-1918.eu/.

33. Mélanie Bost and Chantal Kesteloot, *Le Centenaire de la Grande Guerre en Belgique: itinéraire au sein d'un paysage commémoratif fragmenté* (Paris: Observatoire du Centenaire, Université de Paris 1, 2016). www.univ-paris1.fr/fileadmin/IGPS/observatoire-du-centenaire/Bost_et_Kesteloot_-_Belgique.pdf.

34. *Historial 14–18 – @historial1418*. https://twitter.com/historial1418.

35. *Imperial War Museums*. http://www.iwm.org.uk/.

36. *Imperial War Museums – @I_W_M*. https://twitter.com/I_W_M.

37. Frédéric Clavert, 'Les commé morations du centenaire de la Première Guerre Mondiale sur Twitter, avril 2014-avril 2016', in 'I mille volti della Grande Guerra ieri e oggi', ed. Luigi Fontana and Luigi Tomassini, *Ricerche storiche* 65, no. 2 (2016): 147–65.

38. *@RealTimeWW1*. https://twitter.com/RealTimeWW1; 'World War One Goes Twitter', *H-Europe* blog, July 2014. http://h-europe.uni.lu/?page_id=621.

39. www.iramuteq.org.

40. Clavert used mainly the following hashtags: ww1, wwi, wwiafrica, 1gm, 1GM, 1wk, wk1, 1Weltkrieg, centenaire, centenaire14, centenaire1914, GrandeGuerre, centenaire2014, centenary, fww, WW1centenary, 1418Centenary, 1ereGuerreMondiale, WWIcentenary, 1j1p, 11NOV, 11novembre, WWI, poppies, WomenHeroesofWWI, womenofworldwarone, womenofww1, womenofwwi, womenww1, ww1athome, greatwar, 100years, firstworldwar, Verdun, Verdun2016, Somme, PoilusVerdun.

41. 'Posting photos or GIFs on Twitter', *Help Center*. https://support.twitter.com/articles/20156423.

42. 'Sharing and Watching Videos on Twitter', *Help Center*. https://support.twitter.com/articles/20172128.

43. *@HistoryInPics*. https://twitter.com/historyinpics. See Jason Steinhauer, '@HistoryinPics Brings History to the Public. So What's the Problem? (Part 1)', *History@Works* blog, 18 February 2014. http://ncph.org/history-at-work/historyinpics-part-1/; and Kevin Levin, '@HistoryinPics Does It Better Than You', *Civil War Memory* blog, 18 February 2014. http://cwmemory.com/2014/02/18/historyinpics-does-it-better-than-you/.

44. André Gunthert, 'Shared Images. How the Internet Has Transformed the Image Economy', *Études photographiques* 24 (2009): 129–35. http://etudesphotographiques.revues.org/3436.

45. André Gunthert, 'La consécration du *selfie*', *Études photographiques* 32 (2015). http://etudesphotographiques.revues.org/3529.

46. Richard Chalfen, 'La photo de famille et ses usages communicationnels', *Études photographiques* 32 (2015). http://etudesphotographiques.revues.org/3502.

47. Irina Werning, 'Back to the Future', *Irina Werning* blog. http://irinawerning.com/back-to-the-fut/back-to-the-future/ and http://irinawerning.com/bttf2/back-to-the-future-2-2011/.

48. Jerome De Groote, 'International Federation for Public History Plenary Address: On Genealogy', *Public Historian* 37, no. 3 (2015): 102–27.

49. http://www.historypin.com/.

50. http://www.shiftdesign.org.uk/products/historypin/. See also Mark Baggett and Rabia Gibbs, 'Historypin and Pinterest for Digital Collections: Measuring the Impact of Image-Based Social Tools on Discovery and Access', *Journal of Library Administration* 54, no. 1 (2014): 11–22.

51. 'A Short Introduction to Historypin', *YouTube*. www.youtube.com/user/Historypin; 'Historypin: Mapping the past', *Storify*. https://storify.com/brightideasblog/historypin-getting-started.

52. Hunter Skipworth, 'Historypin Turns Google Street View into a Window on the Past', *The Telegraph*, 21 June 2010. www.telegraph.co.uk/technology/google/7854922/Historypin-turns-Google-Street-View-into-a-window-on-the-past.html.

53. Meg Foster, 'Online and Plugged In? Public History and Historians in the Digital Age', *Public History Review* 21 (2014): 1–19. http://epress.lib.uts.edu.au/journals/index.php/phrj/article/view/4295/4601.

54. Kris Jarosik, 'Primary Sources with Some Help from Historypin', *National Archives Eductation Updates*. http://education.blogs.archives.gov/2014/12/16/primary-sources-on-history-pin/.

55. NARA. http://www.archives.gov/social-media/historypin.html.

56. Alon Confino, 'Miracles and Snow in Palestine and Israel: Tantura, a History of 1948', *Israel studies* 17, no. 2 (2012): 25–61.

57. www.regione.toscana.it/-/1940-1944-firenze-in-guerra; Francesco Cavarocchi and Valeria Galimi, *Firenze in Guerra, 1940–1944* (Florence: Firenze University Press, 2014), pp. xxiv–xxv.

58. 'Looking towards the Porta Romana in Southern Florence, Italy – Photograph Taken by George Kaye', *National Library of New Zealand*. http://natlib.govt.nz/records/22827427.

59. 'With a slightly fluctuating terminology, three types of montage are used for different purposes: juxtaposition (Rephotography, Then and Now)

to document, merge (Ghosts, Looking into the Past) and insert (Past in Present) for creating an aesthetic or emotional effect.' Patrick Peccatte, 'Re-photographie et effet de présent', *DéjàVu* blog, 5 December 2012. http://dejavu.hypotheses.org/1268.

60. 'Looking into the Past'. www.flickr.com/groups/lookingintothepast/.

61. www.flickr.com/photos/michael_hughes/sets/346406/.

62. François Hartog, *Regimes of Historicity: Presentism and Experiences of Time* (New York: Columbia University Press, 2015).

63. Christian Carollo, *Past Present Project*. http://pastpresentproject.com.

64. *The Past Present Project*. https://instagram.com/sayhellotoamerica/.

65. *The Past Present Project*. www.facebook.com/pastpresentproject.

66. Christian Carollo, *Past Present Project*. http://pastpresentproject.com/about.

67. Andréa Simoes, '25 photos du passése superposent avec le présent pour vous faire découvrir leurs histoires', *Daily Geek Show* blog, 7 June 2013. http://soocurious.com/fr/25-photos-du-passe-se-superposent-avec-le-present-pour-vous-faire-decouvrir-leurs-histoires/.

68. 'Echoes', *Hebe Robinson*. www.heberobinson.com/#mi=2&pt=1&pi=10000&s=0&p=1&a=0&at=0.

69. Loïc Haÿ, *Quand la rephotographie rencontre le numérique*. https://tackk.com/rephotographie.

70. Kuba Sochacki, *Dawno temu w Krakowie*. www.dawnotemuwkrakowie.pl/english/.

71. Lewis Panther, 'Pictured: Fascinating World War One Photographs Mixed with Today's Modern Landscapes', *Mirror*, 19 April 2014. www.mirror.co.uk/news/uk-news/world-war-one-photographs-mixed-3433146.

72. Keith Jones, *Liverpool Then and Now*. www.flickr.com/photos/keithjones84/sets/72157632063149974/.

73. www.facebook.com/LiverpoolThenAndNow.

74. https://farm8.staticflickr.com/7493/15837175252_ab828c45aa_o.jpg.

75. Isabella Balena, *Ci resta il nome* (Milano: Mazzotta, 2004).

76. Serge Gruzinski, *L'Histoire pour quoi faire?* (Paris: Fayard, 2012), pp. 21–4.

Part III

Sites of Public History

Part III

Sites of Public History

Remembering Dark Pasts and Horrific Places: Sites of Conscience

Paul Ashton and Jacqueline Z. Wilson

In 1947, the Polish government decreed that what remained of the Auschwitz-Birkenau-Monowitz death camps was to be kept to memorialize 'the martyrdom of the Polish nation and other peoples' under the Third Reich during the Second World War. The Oświęcim-Brzezinka State Museum took over around 200 hectares of the camps in that year. Thirty-two years later Auschwitz-Birkenau was listed by the United Nations Educational, Scientific and Cultural Organization as a World Cultural Heritage Site.[1]

A site of conscience movement was to slowly emerge in the second half of the twentieth century in the postcolonial wake of collapsing empires, dictatorships and oppressive regimes. The period after the Second World War was one of profound change in which the movements for human freedom from colonial rule and for human rights, civil rights, land rights, women's rights and children's rights gradually brought about important social and political reforms. On one level this began in 1945 when fifty countries met in San Francisco to form the UN which had a mandate to maintain international peace and foster solutions to international issues. Charters were adopted concerning the civil, cultural, economic, political and social rights to which all human beings were entitled. And on 10 December 1948, members of the UN voted into being the Universal Declaration of Human Rights. Most sites of conscience, however, came into being from the 1990s after decades of local, national and international struggles. Examples abound.

On the sudden demise of the Soviet Union in December 1991, moves were quickly made by a group of historians and human rights activists to stop the erasure of a camp from the Soviet Gulag system. We use the word erasure since this was not simply about the physical destruction of a site but the eradication of a place that harboured powerful memories that the State wished to obliterate. Subsequently, in 1996, the Memorial Centre for the History of Political Repression – Perm-36 – opened within the walls of the former labour camp near Perm, Russia.[2] The District Six Museum was established in 1994 in Cape Town, South Africa, in the year that saw the demise of apartheid and the rise of democratic South Africa. It engages with memories of the removal in 1966 of 60,000 black people when the area was declared white. It also treats forced removals generally.[3] Robben Island, where Nelson Mandela and many others were held as political prisoners – now a UN World Cultural Heritage Site – commenced operating as a museum and national monument in 1997.[4]

Other types of sites emerged. Plantation sites from the antebellum south in the United States proliferated from the 1990s which looked at slavery.[5] Dealing with the abuse and mistreatment of the poor in nineteenth-century Britain, the Workhouse, located in Southwell in the UK Midlands, opened in 2002. The Kigali Genocide Memorial Centre was established a decade after the 1994 Rwanda genocide.[6] Set up in 1999 by a consortium of human rights activists in Argentina, the Memoria Abierta works to promote knowledge and understanding of state terrorism. That year also saw the convening of the first International Conference of Museums of Conscience and the foundation of the International Coalition of Sites of Conscience which today has around 185 member organizations. These range from large, long-established institutions to new memory projects.[7] And this is but a small, and generally higher profile, sample of the many thousands of sites that exist as reminders of disappearance, execution, imprisonment, murder, slavery or torture. So what makes a site of conscience?

Sites of conscience

Out of the first International Conference of Museums of Conscience emerged a commitment by participants 'to assist the public in drawing connections between the history of our sites and their contemporary implications. We view,' their declaration continued, 'stimulating dialogue on pressing social issues and promoting humanitarian and democratic values as a primary function [of heritage sites].'[8]

Thus, sites of conscience are primarily concerned with publically confronting past injustices and their impacts in the present and championing human rights. And they are places that draw on multiple practices including heritage preservation, education, civic engagement, human rights, public art and public history, all of which work to varying degrees with memory.[9]

In her chapter in Helmut Anheler and Yudhishthir Raj Isar's edited collection *Heritage, Memory and Identity*, Liz Ševčenko points to the importance of describing and reassessing the 'values and practices defining this vision' in relation to museums. One touchstone adopted by the International Coalition of Sites of Conscience is the notion of 'never again'. This goes beyond recalling dark pasts to ensure that they do not repeat. It requires an approach 'that would critically analyse the relationships between memory and action, and identify specific strategies for sites in different political contexts to play a more intentional role in addressing current social issues'.[10] There is also the danger that the idea of 'never again' or 'conscience' itself might be utilized for other agendas.

One example from South East Asia is the Museum of Communist Treachery (*Museum Pengkhianatan PKI*) located at Lubang Buaya (Crocodile Hole) on the grounds of the Sacred Pancasila Monument (*Monumen Pancasila Sakti*), the ultimate site of Indonesian nationalism and remembrance. The museum provides this monument to the violent murder of seven high-ranking officers by communist with a context: the wicked history of the Indonesian Communist Party (PKI) in the lead up to the purported Communist led coup on 1 October 1965. The failure of the coup ushered in the highly repressive 'New Order' regime from 1966 to 1998 under General Suharto, the national hero, as the official story goes, who crushed the uprising. Some claim that it was engineered by him.[11]

The Tuol Sleng Genocide Museum in Phnom Penh, Cambodia's capital, provides a very different though in some ways comparable example. A former high school, this harrowing site became the infamous Security Prison 21 – S-21 – where the Khmer Rouge (KR) regime (1975–9) interrogated and tortured between 17,000 and 20,000 prisoners. From here they were removed to the Choeung killing field fifteen kilometres to the southwest of the capital were they were murdered and buried.[12] S-21 was exposed in January 1979 immediately after the Vietnamese invasion of Phnom Phen which brought down the KR regime. Eighteen months later it began operating as a museum to genocide. It contents includes implements of torture, many thousands of individual photographs of victims, an archive and a twelve-metre- squared hanging 'skull map' of Cambodia made up of

more than 300 skulls and bones exhumed from the killing field. (It was eventually removed in 2002.)[13]

Supported by the Socialist Republic of Vietnam – and the Soviet Union – the leftist Salvation front established the People's Republic of Kampuchea (PRK) having toppled Pol Pot's Democratic Kampuchea government. Some have argued that the museum was established largely to turn the Vietnamese forces 'from foreign invaders into liberators'.[14] As Caitlin Brown and Chris Millington have written, from 1979, 'the Vietnamese-backed PRK desired to showcase KR atrocities to the world at the Tuol Sleng site': 'From the appointment of a specialist in the creation of memorial museums as director of the museum and the initial preference given to international visitors, to the focus on visual evidence of the KR genocide, the PRK attempted to control the way in which the genocide was represented and remembered both by the Cambodian population and the international community. The controversial skull map epitomised this preference for visual representation and affective response'.[15] Others have noted the museum's function to 'induce and cultivate collective negative memories'.[16]

Marivic Wyndham and Peter Read have investigated the relationships between civil society 'colectivos' (collectives) and state agencies over the interpretation of Londres 38, a beautiful nineteenth-century mansion and a site of conscience in Santiago, Chile.[17] One of the most notorious of hundreds of disappearance, extermination and torture centres under the Pinochet regime (1975–90) – where eighty-four people are known to have been killed and possibly up to another 1,000 who disappeared and could have been killed there – Londres 38 opened to the public in 2007. As Wyndham and Read note, at the opening itself it was clear that the site would 'remain a contested space not only because of the different factions competing for ownership of the personal memories it holds'.[18] The power of right-wing forces as well as quarrelling left-wing factions divided generationally and by class, education and political affiliations has defied consensus as to what should be remembered – and how it should be remembered. This has been exacerbated by a great tentativeness on the part of a collection of local and state authorities, such as the Council for National Monuments and the Ministry of Interior, to engage critically with such sites in case of a reversion to military rule.

A parallel can be drawn here between nervous bureaucrats and administrators and museum curators and administrators. There is a received wisdom, for example, among many curators that audiences tend to feel discomfort and repulsion with controversy or difficult pasts. This has been successfully challenged by Fiona Cameron. In her chapter 'Moral Land

Reforming Agendas: History Museums, Science Museums, Contentious Topics and Contemporary Society', in the edited collection *Museum Revolutions*, she convincingly concludes that audiences 'want open debate and a range of perspectives'. At the same time, they 'require museums to set moral standards and reforming agendas that can be used to understand and evaluate societal conduct'.[19] 'Ironically,' Liz Ševčenko and Maggie Russell-Ciardi have written, 'despite the growing interest in civic engagement and democracy at museums, the field [in the United States and other western countries] still frowns on anything perceived to be "political".' And they note the 'false opposites of dialogue and controversy, relevance and radicalism', misguided binaries that can lead to self-censorship.[20]

With their focus on human rights and social justice, sites of conscience generate dialogues and give the public places and spaces in which to engage with dark pasts and contemporary issues brought up by the site's history. This is not easy. What will be the main issues and who will bring them up? Whose perspective will be included? The jailers of the jailed? The people or the politicians? The parishioners or the priests? Might the presentation of several views risk sliding into moral relativism? Who was or is accountable for past injustices and their ongoing impacts on the lives or people and communities? How are these sites to be interpreted and, more importantly, used to facilitate civic engagement, understandings of the consequences of past actions in the present and atonement?

As Martin Blatt reported in his introduction to a special issue of *The George Wright Forum*, quoting a former chair of the US National Park System Advisory Board, the 'places that commemorate sad history are not places in which we wallow, or wallow in remorse, but instead places in which we may be moved to a new resolve, to be better citizens'.[21] They, too, are not simply places where we remember abuses and victims. For many, they have the potential to be places of healing.

Sites of conscience in Australia

There is only one site in Australia that has an association with the International Coalition of Sites of Conscience – the Parramatta Female Factory Precinct (PFFP). This sixteen-acre site, located at Fleet Street in North Parramatta in Sydney, has a long and complex history. It was home to the Parramatta Female Factory from 1821 to 1847; accommodated the Roman Catholic Orphan School (1844–86); and housed the Parramatta

Girls Industrial School which took over the orphan school from 1887 until 1974. Kamballa, a 'correctional' centre for young women with 'behavioral' or 'emotional' problems, operated here from 1974 to 1983. And the Norma Parker Centre for 'delinquent' girls aged fifteen to eighteen opened in 1980.[22]

While this highly significant precinct is listed on the New South Wales State Heritage Register and has attracted the attention of the International Coalition for Sites of Conscience, is has not been recognized nationally. Rather than being used as a rich resource to engage people with, in this instance, the ongoing legacies of institutionalization, the place's past has seemingly been 'disappeared'. As Hibberd and Djuric, members of the PFFP Memory Project, have written in *Artlink*:

> Not many Australians know that the first forced removal of children from their mothers in Australia originated in our colonial penal system at the Parramatta Female Factory. Few of us realise the role this intervention played in laying the foundational ideologies in the provision of welfare services for women and children. This site in Parramatta is a crucible, where ideas of female immorality, criminality and insanity melded; realized in a hybrid institutional architecture of the Refuge, Workhouse, Asylum, Penitentiary, Orphanage, Girls Industrial School, Girls Training Home, Children's Shelter and Women's Detention Centre.[23]

In an extract from an interview in the same publication, Djuric asks rhetorically:

> Why is Australia's oldest Female Factory not included on the National Heritage List when similar sites such as Port Arthur, which it pre-dates, are? Why aren't sites associated with violence and control of women, let alone children, remembered and valued as part of the Australian narrative?[24]

There are only a few other places in Australia that describe themselves as a site of conscience.

In an August 2012 media release Mark Krause and Janet Presser of the Willow Court Advocacy Group announced the group's intention to lobby for the Willow Court Precinct, at New Norfolk in Tasmania, to become a site of conscience. Dating from around 1830 and part of the Royal Derwent Hospital, Willow Court – apart from briefly being the first hospital for invalid convicts in the colony – was a 'lunatic asylum' for almost 170 years. Around that time, calls were also being made for the Tasmanian Government to apologize to former patients. It was also being alleged that the Willows Court and the Royal Derwent Hospital had for decades been at the hub

of patient abuse and neglect. It was at the very least abundantly clear that inhumane 'experimental treatments' had been conducted on site for many years. In their media release, Krause and Presser noted that:

> Educating and learning is the key to understanding our past and knowing our future, it's not about 'cleansing the past' but knowing what was normal practice in isolating, incarcerating and in some cases abusing fellow human beings in the name of 'medical treatments'. A Site of Conscience at Willow Court will engage ordinary citizens in an ongoing national dialogue on social issues to build lasting cultures of human rights.[25]

Financial difficulties, however, have plagued this site. And, despite some funding from the federal government to undertake emergency repairs, it is deteriorating. Recently, problems have arisen over the presence of asbestos.[26]

Undoubtedly, many places in Australia would qualify as sites of conscience. The Myall Creek Massacre and Memorial Site is an outstanding example. Located on the traditional lands of the Wirrayaraay people of the Gamilaraay Nation, the site is twenty-three kilometres northeast of the small country town of Bingara on a Crown Land Travelling Stock Route. The 500-metre path memorializes the massacre of around twenty-eight to thirty Aboriginal women, children and old men – whose bodies were subsequently burnt – on 10 June 1838 by twelve stockmen led by a squatter. The manager of the property reported the massacre to authorities and eleven of the twelve perpetrators were tried in Sydney and acquitted. A retrial saw seven of them given death sentences which were carried out.[27] While massacres of Aboriginal people in Australia continued until the 1920s, relatively few of them lead to successful prosecutions. The early hangings of the Myall Creek murderers gave rise to 'pacts of silence'[28] among white people to avoid trials and 'the judicial murder of white men'.[29]

Myall Creek is arguably the best known Aboriginal massacre site in Australia. It is also the least contested. Official narratives about past race relations are compelled to include it due to an abundance of undeniable evidence, notably that generated by the 1838 trials. Myall Creek came back into the public view from the 1960s. In her popular tome *A History of Australia* (1962), Marjorie Barnard wrote about the 'murders'. 'Little,' however, she told her readers, 'is to be gained by recounting all the recorded black and white incidents': 'To bring the two together as one people should be, and I hope will be, one of the advances of the future.'[30] An attempt to establish a memorial in 1965 failed due to local white resistance. Almost forty years later, in 2000, the memorial walkway was opened. It was added to

the National Heritage List in 2008. According to the entry for the site in the Department of Environment and Energy's Australian Heritage Database, 'Since the 1850s, the story of the massacre has been retold in a number of poems and books and has continued to remind and teach Australians about the mistreatment of Aboriginal people during the period of frontier conflict; it has also become part of Australia's reconciliation movement.' The memorial, it continues, 'brought together the descendants of the victims, survivors and perpetrators of the massacre.'[31]

A reconciliation movement began in Australia, Chile and South Africa in the 1990s, paralleling the Sites of Conscience movement. It had its roots in theology. As Andrew Schapp has observed in his book *Political Reconciliation*, there are three approaches to reconciliation in Australia. The first is the conservative style adopted by the Howard Government. This advocates largely forgetting the past – or at least only remembering a whiggish, positivistic past that celebrates collective achievements and the inevitable march of history towards progress and ever-increasing liberty – and focusing on fostering socioeconomic equality. The second approach immediately came into binary opposition with the first. It stressed the need to collectively acknowledge dark pasts and wrong doings, to apologize for past wrongs and to make reparations for them. The third approach involves working towards a treaty, gaining constitutional recognition and promoting self-determination. It all but disappeared as mainstream politics became lodged in a debate between forgetting or downplaying unpalatable pasts and getting on with things on the one hand and striving for restorative justice on the other.[32]

Ultimately, reconciliation came to be seen as a project promoted by the state to minimize social dislocation and reparation for Indigenous people and to bolster the status quo. Divisions over the nature of reconciliation robbed it of any real efficacy, leaving conservative reconciliation to dominate policy and official historical narratives. A similar process occurred with multiculturalism around the same time involving 'retrospective commemoration' and 'participatory memorialisation'.

Retrospective commemoration and participatory memorialization

Retrospective commemoration refers to the effort of state authorities at all levels to express a more inclusive national narrative stemming, among

other things, from multicultural policy, by retrospectively commemorating a wider number of communities and people who have been officially – or irrefutably – identified as having contributed to Australia's 'national development'.[33] In terms of heritage, the Federal Department of Environment under the conservative Turnbull Government currently has the following definition on its website:

> Heritage includes places, values, traditions, events and experiences that capture where we've come from, where we are now and gives context to where we are headed as a community.
>
> Our heritage gives us understanding and conveys the stories of our development as a nation, our spirit and ingenuity, and our unique, living landscapes. Heritage is an inheritance that helps define our future.[34]

New histories, or the emergence of previously hidden histories which cannot be denied, also drive retrospective memorialization. Participatory memorialization concerns a range of vernacular memorials initiated by groups or individuals which have been later taken up or taken over by government authorities, or which have been sustained over short or long periods of time in conflict with them. These can range from the ephemeral to more formal, permanent memorials.[35]

Responses to official public narratives – which Laurajane Smith, in her book *Uses of Heritage*, has termed Official Heritage Discourse – have highlighted the resilience of these state-sponsored narratives which incrementally and gradually accommodates social and historiographical change in a conservative revisionist paradigm.[36] Participatory memorialization and retrospective commemoration can also stem from a desire to 'fit in' with dominant national narratives. As Paula Hamilton and Linda Shopes have observed in their edited collection *Oral History and Public Memory*, cultural heritage in this context can be thought of as a 'socially sanctioned, institutionally supported process of producing *memories* that make certain versions of the past public and render other versions invisible'.[37] Across generations and in a range of social practices, memories are produced, circulated, received and reproduced, shaping cultural or collective memory. Different sites of conscience will encounter varying levels of resistance or acceptance of their histories depending on how difficult or shameful they are deemed to be by both the state and other groups in society at a particular moment in time. Their stories have to contend, as Donald Horne put it in his book *The Public Culture*, with that 'great drama, endlessly playing ... of maintaining definitions of the nation and its social orders ... of what the nation and society are'.[38]

Conclusion

The recreation of cultural memory has become more complex and fraught in Australia, as elsewhere, from the closing decades of the twentieth century.[39] At Federation in 1901, the new nation's heritage was relatively uncomplicated. Leaving aside sectarianism, over 96 per cent of the population were Christians and of its 3.7 million people, around 78 per cent were Australian born and all but 3 per cent of the rest were from Britain. Towards the end of the twentieth century, stories of Stolen Generations of Aboriginal people – brought about by the official policy of removing mixed race children from their families up to the 1970s – of migrants who had faced racial discrimination and exploitation, of segregation and exclusion and of Forgotten Australians – the approximately half-a-million Indigenous, non-Indigenous and migrant children who were taken into institutional or foster care in the twentieth century – were circulating uncomfortably in the culture. These fed Australia's History Wars.[40]

In the Executive Summary of the Forgotten Australians report, it was asserted that there should be:

> Recognition of care leavers and their history in Australia in more tangible ways … through the erection of memorials, creation of memorial gardens, construction of heritage centres and in other forms such as reunions. To ensure that the experiences of care leavers are not lost to current and future generations, the Committee recommends that an oral history project be undertaken to collect life stories and that the Museum of Australia should consider the establishment of a permanent exhibition as part of its collection.[41]

Public history involves the practice of historical work in multiple forums and sites which is aimed at negotiating different understandings of the past and, more importantly, its meanings and uses in the present. And there is much work to be done by a broad range of people – including former children in out-of-home care, historians, artists, archaeologists, film makers, museum practitioners, history school teachers and governmental cultural agencies – to bring the stories of Forgotten and other marginalized Australians to a wide public audience and incorporating it 'warts and all' into the received narrative of Australian history. Such activities will further other similar recommendations relating to 'Questions of identity both for … [Forgotten and other Australians] and of other family members through

locating and accessing records [which] has become very important for many care leavers'.[42]

Australians, David Carter has written, were – and by and large are still – 'not used to thinking about *our* history as contentious, morally compromised or volatile, as dangerous as, say Japanese or South African history, the American Civil War history, or recent Russian history'.[43] From the late twentieth century, the digital age has provided stolen, Forgotten, marginalized and abused Australians with powerful means to challenge official representations of the past though websites, digital publications, social media and access to archives and records. Their cultural authority has also been boosted as history – no longer the preserve of the academic – has become more democratized. There is, however, a very long way to go.

As Tracy Ireland has observed, 'The construction of the concept of heritage in Australia has been part of a political and social definition of nationhood. In identifying our heritage we ask what is most important about our past and how it has determined who we are today'.[44] This is still the case.[45] We need to reconstruct heritage and history in Australia to take account of sad, dark, fearful and angry pasts.

Notes

1. John Lennon and Malcolm Foley, *Dark Tourism: The Attraction of Death and Disaster* (London: Cengage Learning, 2000), pp. 46–56.
2. Sarah Pharaon, Bix Gabriel and Liz Ševčenko, 'Sites of Conscience: Connecting Past to Present, Memory to Action', *Exhibitionist* (Fall 2011): 15–16. See also Alessandra Stanley, 'Lest Russians Forget, a Museum of the Gulag', *New York Times*, 29 October 1997, p. 8.
3. Charmaine Ruth McEachern, 'Mapping the Memories: Politics, Place and Identity in the District Six Museum, Cape Town', *Social Identities* 4, no. 3 (1988): 499–521; Valmont Layne, 'The District Six Museum: An Ordinary People's Place', *Public Historian* 30, no. 1 (2008): 53–62.
4. UNESCO, 'Robben Island Listing'. http://whc.unesco.org/en/list/916 (accessed 3 November 2016).
5. Derek H. Alderman, David L. Butler and Stephen P. Hanna, 'Memory, Slavery, and Plantation Museums: The River Road Project', *Journal of Heritage Tourism* 11, no. 3 (2016): 209–18.
6. An excellent list of genocide memorials across the world, generated by students at the Lick-Wilmerding High School at San Francisco, California,

is available at https://genocidememorialproject.wordpress.com/genocide-memorials-around-the-world/ (accessed 15 November 2016).

7. George M. Anderson, 'Sites of Conscience', *America: The National Catholic Review*, 9 October 2006. www.americamagazine.org/issue/586/article/sites-conscience (accessed 3 November 2016).

8. Liz Ševčenko, 'International Coalition of History Sites of Conscience'. www.memorial.krsk.ru/eng/Dokument/Artcles/Shevchenko.htm (accessed 11 November 2016).

9. See, for example, Barbara J. Little and Paula A. Shackel (eds), *Archaeology as a Tool of Civic Engagement* (Lanham, MD: AltaMira Press, 2007).

10. Liz Ševčenko, 'Sites of Conscience: Heritage of and for Human Rights', in *Heritage, Memory and Identity*, ed. Helmut Anheler and Yudhishthir Raj Isar (London and Thousand Oaks, CA: Sage, 2012), p. 138.

11. See John Roosa, *Pretext for Mass Murder: The September 30th Movement and Suharto's Coup d'Etat in Indonesia* (Madison: University of Wisconsin Press, 2006); Katharine E. McGregor, *History in Uniform: Military Ideology and the Construction of Indonesia's Past* (Singapore: National University of Singapore Press, 2007).

12. Judy Ledgerwood, 'The Cambodian Tuol Sleng Museum of Genocide Crimes: National Narratives', in *Genocide, Collective Violence, and Popular Memory: The Politics of Remembrance in the Twentieth Century*, ed. D. E. Lorey and W. H. Beezley (Wilmington, DE: Scholarly Resources, 2002), pp. 103–22.

13. Samnang Ham and Bill Myers, 'Tuol Sleng Workers Dismantle Skull Map', *Cambodian Daily*, 11 March 2002. www.cambodiandaily.com/archives/tuol-sleng-workers-dismantle-skull-map-30335/ (accessed 16 November 2016).

14. Patrizia Violi, 'Trauma Site Museums and the Politics of Memory: Tuol Sleng, Villa Grimaldi and the Bologna Ustica Museum', *Theory, Culture and Society* 29 (2012): 36.

15. Caitlin Brown and Chris Millington, 'The Memory of the Cambodian Genocide: The Tuol Sleng Genocide Museum', *History Compass* 13, no. 2 (2015): 36.

16. David Chandler, *Voices from S-21: Terror and History in Pol Pot's Secret Prison* (Berkeley: University of California Press, 2000).

17. Peter Read and Marivic Wyndham, *Narrow but Endlessly Deep: The Struggle for Memorialisation in Chile Since the Transition to Democracy* (Canberra: ANU Press, 2016).

18. Marivic Wyndham and Peter Read, 'The Day Londres 38 Opened Its Doors: A Milestone in Chilean Reconciliation', *Universitas Humanistica* 71 (2011): 210.

19. Fiona Cameron, 'Moral Lessons and Reforming Agendas: History Museums, Science Museums, Contentious Topics and Contemporary Society', in *Museum Revolutions: How Museums Change and Are Changed*, ed. Simon J. Knell, Suzanne MacLeod and Sheila Watson (London and New York: Routledge, 2007), p. 340.

20. Liz Ševčenko and Maggie Russell-Ciardi, 'Sites of Conscience: Opening Historic Sites for Civic Dialogue', *Public Historian* 30, no. 1 (2008): 11.

21. Martin Blatt (ed.), *Civic Engagement at Sites of Conscience* (special issue), *George Wright Forum* 19, no. 4 (2002): 10.

22. See Bonney Djuric, *Abandon All Hope: A History of Parramatta Girls Industrial School* (Perth: Chargan, 2011); Annette Salt, *These Outcast Women* (Sydney: Hale & Iremonger, 1984); Naomi Parry, 'The Parramatta Girls Home, Dictionary of Sydney', 2015. http://dictionaryofsydney.org/entry/the_parramatta_girls_home (accessed 22 November 2016); chapters 2, 10, 11 and 16 in Paul Ashton and Jacqueline Z. Wilson (eds), *Silent System: Forgotten Australians and the Institutionalisation of Women and Children* (North Melbourne: Australian Scholarly Publishing, 2014). These and many other similar sites are listed on the 'Find and Connect' website which contains historical and other information about Australian orphanages, children's homes and other institutions. www.findandconnect.gov.au (accessed 22 November 2016).

23. Lily Hibberd and Bonney Djuric, 'Factory Precinct Memory Project', *Artlink* 33, no. 3 (2013). www.artlink.com.au/articles/4011/the-parramatta-female-factory-precinct-memory-proj/ (accessed 11 November 2016).

24. Ibid.

25. Mark Krause and Janet Presser, 'What Is a Site of Conscience?', 6 August 2012. www.willowcourttasmania.org/wp-content/uploads/2012/07/Media-Release.pdf (accessed 11 November 2016).

26. www.willowcourttasmania.org/tag/royal-derwent-hospital/ (accessed 22 November 2016).

27. S. K. Barker, 'The Governorship of Sir George Gipps', *Journal of the Royal Australian Historical Society* 16, nos. 3–4 (1930): 264–5.

28. Bruce Elder, *Blood on the Wattle: Massacres and Maltreatment of Aboriginal Australians since 1788* (Sydney: New Holland, 1998), introduction and chapter 7.

29. *Brisbane Courier*, 26 July 1861, pp. 2–3.

30. Marjorie Barnard, *A History of Australia* (Sydney: Angus and Robertson, 1966), p. 654.

31. Australian Government, Department of Environment and Energy, National Heritage Places, 'Myall Creek Massacre and Memorial Site'. www.environment.gov.au/heritage/places/national/myall-creek (accessed 9 November 2016).

32. Andrew Schaap, *Political Reconciliation* (London and New York: Routledge, 2005), pp. 139–41.

33. See Paul Ashton and Paula Hamilton, 'Landscape and Memory: Historic Sites, Memorials and Cultural Tourism', in *History at the Crossroads: Australians and the Past* (Sydney: Halstead, 2010), pp. 87–99, chapter 8; Sanford Levinson, *Written in Stone: Public Monuments in Changing Societies* (Durham, NC, and London: Duke University Press, 1988).

34. Australian Government, Department of Environment and Energy, 'About Australia's Heritage'. www.environment.gov.au/heritage/about (accessed 9 November 2016).

35. Paul Ashton, '"The Birthplace of Australian Multiculturalism"? Retrospective Commemoration, Participatory Memorialisation and Official Heritage', *International Journal of Heritage Studies* 15, no. 5 (2009): 382.

36. Laura-Jane Smith, *Uses of Heritage* (London: Routledge, 2006), p. 11.

37. Paula Hamilton and Linda Shopes (eds), *Oral History and Public Memories* (Philadelphia: Temple University Press, 2008), p. 3.

38. Donald Horne, *The Public Culture: The Triumph of Industrialism* (London: Pluto Press, 1986), p. 21.

39. See, for example, Chris Healy, *From the Ruins of Colonialism: History as Social Memory* (Melbourne: Cambridge University Press, 1997).

40. Anna Clark, 'The History Wars', in *Australian History Now*, ed. Anna Clark and Paul Ashton (Sydney: NewSouth, 2013), pp. 151–66.

41. Commonwealth of Australia (Senate Community Affairs Reference Committee), *Forgotten Australians: A Report on Australians Who Experienced Institutional or Out-of-Home Care as Children* (Canberra: Senate Printing Unit, 2004), p. xvii.

42. Ibid.

43. David Carter, 'Working on the Past, Working on the Future', in *Becoming Australia: The Woodford Forum*, ed. Richard Nile and Michael Petersen (St. Lucia: University of Queensland Press, 1998), p. 10. See also Jacqueline Z. Wilson, *Prison: Cultural, Memory and Dark Tourism* (New York: Peter Lang, 2008).

44. Tracy Ireland, 'Excavating National Identity', in *Sites: Nailing the Debate: Archaeology and Interpretation in Museums* (Glebe: Museum of Sydney, 1996), p. 88.

45. Paul Ashton and Jennifer Cornwall, 'Corralling Conflict: The Politics of Australian Heritage Legislation since the 1970s', in *Conflicted Heritage*, ed. Alexander Trapeznik (special issue), *Public History Review* 13 (2006): 53–65.

22

#Fake History: The State of Heritage Interpretation

Sue Hodges

Getting historians involved in site interpretation is challenging. The few historians working in the field are either left on the sidelines or not even asked to participate in the game by the architects, archaeologists, natural environment specialists and sociologists who dominate site interpretation in both theory and practice. But isn't history what heritage is all about?

Many thousands of words have been written about problems with heritage interpretation. It is a field lacking sophisticated theory or detailed guidelines that features multidisciplinary teams with multiple outcomes and delivered through every possible form of media. What could possibly go wrong?

The simplest definition of heritage interpretation is that it communicates the natural and cultural values of an historic place to a wide range of audiences, which include tourists and residents who live at or near a site. The theoretical underpinnings of heritage interpretation are drawn from the United States National Park Service, where heritage interpretation as a profession began. Harking back to the creation of the first National Park – Yellowstone – in 1872, there is a strong emphasis on the wonders of the natural environment and the role of the interpreter as the voice for the site. The field is vastly undertheorized: its main exponent, journalist Freeman Tilden, is still regarded as the founding 'father' of interpretation theory by many people today. But the late twentieth century saw a reframing of the discipline in terms of cognitive psychology, in particular communication theory and visitor research studies.[1] David Uzzell, one of the few professionals to address this issue, voiced his disenchantment with this model when he

said, 'Interpretation is … stuck in a rut where the *how* has become more important than the *why*.'[2]

From this traditional perspective, the sites to be interpreted have settled or defined meanings that staff such as tour guides, rangers and curators transmit to the public. There is a limited understanding of exactly what is being interpreted; sites 'speak' for themselves to the public and messages are used to create identity.[3] These messages are often determined by natural environment specialists who boldly step in where historians fear to tread. Take, for instance, this text panel from an international site:

> We find ourselves attracted to the sea. We are in awe of its vastness and power. Its predicable rhythms are soothing, but its changing moods can stir up powerful emotions. It is often playful, beautiful and uplifting; sometimes sullen and threatening – but always invigorating. How does the sea make you feel today?

The 'we' in this case is clearly the interpreter who, with a nineteenth-century sensibility, assumes the audience will respond to nature in the same way they do. This form of interpretation is very common, and perhaps evocative for middle-class, western, literate audiences. But ignores sweeping post-war mass immigration and the fact that most immigrants have made the cities their home. As Brian Goodey has pointed out, 'a new generation of visitors, both native and immigrant, is now emerging with few, if any, personal links to the dominant forces that shaped our city centres',[4] let alone the countryside. A new interpretive language – one derived from a deeper understanding of audiences and their backgrounds – is needed for both urban and rural heritage sites.

Heritage interpretation is also the province of the heritage profession, where historians fare little better. Few, if any, have been involved in leading the field, its work or its outcomes. Instead, historians have sometimes been falsely accused of bad practice. Take, for instance, this statement by Laurajane Smith, author of the seminal work on Authorized Heritage Discourse, *Uses of Heritage*:

> Expert values and knowledge, such as those embedded in archaeology, history and architecture amongst others, often set the agendas or provide the epistemological frameworks that define debates about the meaning and nature of the past and its heritage.[5]

Smith claims that experts often have a vested interest in maintaining their privileged positions[6] and that the use of the term 'the past', which is vague,

'immediately works to render it subject to the judgement of archaeologists and historians'.[7] But who are these historians of whom Smith writes?

A quick Google search of the Internet reveals very few jobs advertised for historians in heritage interpretation. The US National Park Service and the American Historical Association are exceptions to the rule. There are only twenty-three historians who have listed their qualifications with Australia ICOMOS (AICOMOS), whereas eighty-two members claim to practise some form of history in their professional work.[8] Of those who have listed their qualifications with AICOMOS, architects who are not trained in history have the highest listing for doing historical work (approximately 40 per cent), followed by historians (17 per cent) and archaeologists (15 per cent). Of these historians, only two were involved in heritage interpretation.[9] Yet employing an historian can lead to the pot of gold at the end of the interpretation rainbow.

Because historians are not prominent in the field of heritage interpretation, theoretical discussions have been dominated by specialists from other fields. Some of these are theoretically recursive and read 'history' in Smith's sense of a premodern discipline with 'objective' truths, fixed meanings, a fixation on nationalism and identity and authority over the interpretation of the past. This kind of thinking does not fit the needs of site interpretation in the twenty-first century. Very few places in the world today can boast of only one history, still fewer of histories that have not been questioned or thrown up for scrutiny. However, the dominance of architecture in the heritage sector, in particular, has led to 'history-lite' interpretation that deals with the appearance and fabric of a site but does not probe into its more profound and complex meanings.[10] This process is captured by the words architects and designers use to describe historical material: 'assets' and 'content'. By contrast, depicting history in heritage sites demands both fluency in historical theory and an understanding of how history can be communicated through a variety of media. The latter challenges history in its current form. As Paul Ashton and Paula Hamilton have commented, the greatest threat to the authority of traditional history is the recognition that formal written history is only one mode of understanding the past.[11]

As Ashton and Hamilton have also observed, academic historians have struggled to engage with public history or local communities,[12] leading to heated arguments between professional/public and academic historians and resulting in history becoming increasingly marginalized and irrelevant outside the academy. The American Historical Association writes that an historian's skills are still necessary 'amidst the atmosphere

of slick production and dazzling computer interactive programs' and that 'only thoroughly researched and well-written exhibits are able to hold the attention of the visitor and express an understandable and compelling interpretation of a historic subject'. But it does not extend the historian's role beyond this.[13] Similarly, Open Universities Australia defines history in nineteenth-century terms:

> Historians study historical events and conduct research into the nature of these events. They write academic reports publishing their findings and muse on the implications of history for their future. Often, historians will be involved in teaching or education.[14]

'Musing' won't position historians as relevant on any project. The missed opportunity here is in shaping the outcomes of historical research and analysis, which is integral to heritage interpretation. To quote Marshall McLuhan, the medium is the message. Unless historians understand the role of interpretive media in communicating historical ideas, their role on heritage sites will be limited to poorly paid contextual histories or a few words on signs. The ICOMOS International Committee on the Interpretation and Presentation of Cultural Heritage Sites has recently attempted to rethink this false binary between theory and practice by interrogating the distinction between interpretation and presentation. Into the mix also comes historical work by communities associated with heritage sites and the accessibility of research sources on the Internet. Both of these put research and interpretation into the hands of non-specialists and therefore question the historian's authority and role in interpreting heritage sites. Astute public historians have understood this for many years.

Most academic courses have neither engaged with the entirety of public history nor ventured far into the field of heritage interpretation. The first MA in Public History course in Australia, which began in 1988 at Monash University, displayed an intractable tendency to focus on the 'history' part of public history rather what public history actually looked like in its final form or who constituted 'the public' – which I would suggest is generally people uninterested in heritage theory or just the architectural features of heritage sites. Seemingly little has changed in thirty years. The 2017 Unit on Heritage Interpretation in Deakin University's Master of Cultural Heritage course approaches interpretation from a highly theoretical level:

> Interpretive communication forms are coloured by the political implications of constructing versions of meaning, such as national identity. This unit

addresses the ethical challenges of shaping public knowledge of cultural heritage via interpretation – grounded in the concepts of significance, authenticity and learning. Key issues are public accountability, cultural diversity and social justice.[15]

These are genuinely important issues. But historians need a seat at the implementation table of a project – at the exhausting and detailed meetings about specifications, delivery mechanisms, materials, design, construction, installation, programming and coding – before they can have any influence at all in shaping historical communication at a heritage site. No client will pay for statements about heritage theory unless they can be shown to relate to the way the site will be used and valued by the public, either economically or socially. In these crucial decisions about who will deliver the final product, historians have traditionally been absent. This means that the past represented on site is owned and determined by architects, archaeologists, designers, tourism specialists, marketers and planners – the current masters of the interpretation universe.

Unfortunately, Professional Historians Associations in Australia have also shown little or no interest in heritage interpretation in its most public formats. Historians work largely on commissioned publications, collection and significance assessments and contextual histories for conservation management plans. The media in which history is enjoyed by the public – films, novels, TV shows, landscape interpretation, heritage-based sculpture and art, virtual reality, immersive reality and digital and social media – has been ignored. In the case of social media, heated debates about the meaning of the past and the interpretation of events such as Gallipoli occur daily in comment threads on platforms such as Facebook. But historians' voices are rarely heard.

Those historians who do work in the minefield of heritage interpretation emerge scarred from encounters with designers asking them to write 'fifty words' for a predesigned sign – it does not matter which fifty, as long as it fits the design aesthetic – architects claiming expertise in heritage interpretation and trying to cut them out of jobs or a host of specialists from other fields saying that historians should not operate at all in community interpretations as 'everyone has an equal voice'. In all of these cases – and this have happened in my business too many times to mention – it is a blend of competition for money and ignorance about what history can offer as a form of public knowledge. This is a double-bind. Many historians not only have little expertise in communicating in a variety of media but have not advocated for

their work as an important component of the heritage profession. So, while the field of heritage interpretation is burgeoning at present, the vacuum left by qualified and skilled historians in the market is being filled by a range of commercially savvy non-historians. This is detrimental not only to the site, but also to the pay packets of historians.

But what happens if historians step up and introduce the idea that history is a 'hot mess' to heritage sites?

For over forty years, historians have responded to the ideas that most sites have contested and multilayered meanings, and that only a limited number of voices have traditionally been heard in stories about the past. From the 1960s, exponents of the New Social History advocated for 'history from below' and postcolonial scholars have reproached academic historians in relation to the absence of non-Western groups traditionally excluded from both power and the writing of history.[16] In 1990, Michael Frisch and others promoted the concept of 'shared authority'.[17] This involves the co-creation of meaning, dialogue between groups arguing about the meaning of a site, participative methodologies and asking the audience to determine their own meanings from interpretation. These are now standard tropes used by professionals looking to incorporate historical method into their work, although this is often unconscious. What many people do not realize is that Authorized Heritage Discourse has been practised largely by non-historians. And this is confirmed by the paucity of historians employed on site interpretation projects around the world. Take the case of heritage interpretation in a site of 'dark history' in my home town of Melbourne, Victoria.

In 2012, the developers of the former Her Majesty's (HM) Prison Pentridge engaged my business to secure a heritage interpretation permit for the site and we are now engaged in producing all of the interpretation. This has involved working collaboratively and creatively with the client to discuss how the histories of Pentridge, many of which are dark and disturbing, can be fully represented in a site that is being recast into a major residential and commercial precinct.

HM Prison Pentridge began in northern Melbourne in 1850 as a stockade that received prisoners from the overcrowded Melbourne Gaol and is significant to the State of Victoria for both architectural and historical reasons. Pentridge was transformed into a Pentonville-style prison between 1857 and 1864 and was a mixed men's and women's prison until 1956, when the women were transferred to Fairlea women's prison. Until its closure in 1997, Pentridge housed some of Melbourne's most notorious criminals,

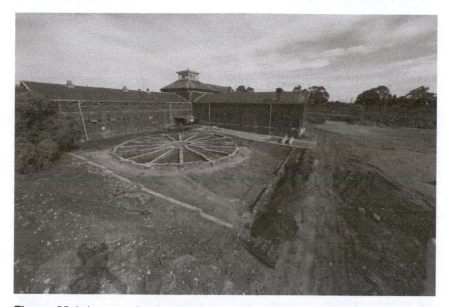

Figure 22.1 Interpreting heritage at a site under development: the former A Division Panopticon exercise yards at Pentridge Prison, revealed during an archaeological dig in 2014. Of the three Panopticon exercise yards, only one will be kept. Photo Ashleigh MacLeod for SHP.

including Ronald Ryan, the last man hanged in Victoria, and Mark 'Chopper' Read, whose life of crime was depicted in the film 'Chopper'. Bushranger Ned Kelly – Australia's equivalent to the US outlaw Jessie James – is also buried there.

There has been heated and vocal opposition to the prison's redevelopment by the National Trust of Victoria and other community groups, who have insisted that its famous high bluestone walls, watchtower and other built fabric are inseparable from the social history of the site.[18] While much of the public outcry has centred upon the construction of a massive residential tower and nineteen-storey hotel – which will overshadow the site's boundaries and guards' watchtower – it has become clear that the physical fabric of the site evokes a visceral response for some residents who have lived near it for years and for past inmates, warders and their relatives. For instance, in 2016 the *Green Left* stated that the social history of Pentridge, including Aboriginal history, would be 'lost forever' if the demolition of some parts of the site proceeded.[19] The part of the site on which my firm, SHP, is working did not house the Aboriginal murals to which the *Green Left* was referring. But many other statements by concerned opponents of

the development proposal have conflated social with built history, indicating that the trenchant separation between built fabric and social history in the heritage sector is long overdue for revision.

The physicality of the site is what people remember most, and this was our task to convey. It was not only the walls that triggered profound memories of place for the prison community and local residents, but also the area near H (or 'Hell') Division where prisoners arriving from other divisions were hit by batons until they fell (known as 'the reception biff')[20]; the Rock-Breaking Yard where prisoners mindlessly broke up bluestone into marble-sized chunks for no real reason; the Panopticon exercise yards, where prisoners from B Division were allowed to move around a wedge-shaped for an hour a day in the nineteenth century; and the 'condemned man's cell' in D Division where Ronald Ryan spent his last night before being hanged in 1967. The floor and walls of the prison, together with the bluestone in all its configurations, had been spattered with blood, sweat, tears, urine, faeces and semen and borne witness to extreme acts of violent acts and the worst human suffering imaginable.

Ideally, all of the prison's fabric would have been preserved but economic decisions about heritage could not be ignored. The site had no future as a standard tourism one, both because of its location seven kilometres from Melbourne and competition from Old Melbourne Gaol. But, because the prison is an important site of memory, heritage interpretation at Pentridge has had to be synecdochal: the remaining parts of the prison stand for the greater whole, some of which has now been bulldozed.

Interpretive planning is research-based, spatial and involved all possible forms of media. First of all, we looked at the site's significance, or cultural value, and how this was expressed in both the tangible and intangible cultural heritage of the site. To depict the prison's built and social history, we then researched sources from the metanarratives of Australian history as well as those anchored in the archaeological remains, buildings and relics on site. Pentridge has many histories that pre-date and surround it: the histories of the Wurunderji and Boon Wurrung Aboriginal peoples; of the Irish migration to Melbourne during the potato famine; of the working class in 'Marvellous Melbourne'; of women; of the influx of immigrants to Victoria during the gold rush; of the overcrowding of gaols; and, in the twentieth century, of Melbourne's notorious gangsters. These wider narratives intersect with the stories of the local people from the nearby suburb, once called 'Pentridge' but renamed 'Coburg' soon after the prison was built. Local residents did not want to be associated with it.

Figure 22.2 Interpretation of this cell in A Division at Pentridge is based on historical research and delivered through a recreation of the cell interior and 'text as graphic' projected onto the walls. This is one of many cell installations, photographed in 2016, which work as a unit to interpret the lives of the prisoners and warders. Photo Jackie Malter for SHP.

We dug out every possible story about the prison and divided them into stories to be told in the public realm and those to be told in age-restricted areas. During our many discussions in the site office and walking around the site, we continually debated history with the client. Why was Aboriginal consultation important when Pentridge was built after colonization? How should the stories of Aboriginal people be represented? How can we tell the stories of violence and Melbourne's underbelly in a public space? How do we balance the interpretation of the prisoners with that of the warders? Whose voices should be heard in the interpretation? How can we tell the history through architectural form and digital media in a way that does not trivialize it? What stories do we tell in the public realm, parts of which were sites of murder, sodomy and violence, which might become a café, a shop or public open space?

In this process, the importance of explaining historical theory cannot be overstated. Given the huge number of stories to be told on site, we decided that the contextual history should be told in forms that allowed greater narrative complexity and more detail, such as a book, a film, on a Smartphone App/mobile website or in a purpose-built interpretation centre. For prison cells in A and B Divisions, we not only interviewed people associated with the prison on film but also found first-person contemporary quotations from prisoners and warders and positioned each quotation outside a prison door. Visitors can lift up an interpretive flap, which is a modern twist on old prison cell flaps, to see a series of static and multimedia installations inside the cells. Each one elucidates or questions the prisoners' words. In this, the interpretation is intended to provoke discussion and debate, encourage reflection and inspire curiosity. We have authored this work at various points, commented on the difficulties with research and provided primary source information at certain points so people can see how we have interpreted the evidence. In future stages, we will consult with the Aboriginal groups, who will determine how their history is represented on site, and interview as many local people as possible to ensure their voices are heard in the modern iteration of the site.

But heritage interpretation at Pentridge also needs to link together around the whole site and provide a varied and integrated experience for residents and visitors. Our team worked with the architects to zone historical themes and stories spatially across the site, differentiating between events that happened in particular places and broader stories that could be told at any part of the site or off-site in digital and print media. We used relatively anodyne first-person quotations in architectural features such as

stair-risers, the footpath and floors, in a purpose-built light fitting and in sculptural work. To ensure that the material was not just as a 'dressing' of the site, we created contextual interpretation in the form of a timeline that is fixed to two walls in an alley and signs that explain our approach. Potentially distressing aspects of the prison's history are reserved for the purpose-built interpretation centre, digital media and for some of the prison cells. Other options for site interpretation include virtual and augmented reality. But all interpretive communication required us work to with all the media many people consume, and are consumed by, in their daily lives.

But is this desirable? The answer is a resounding 'yes' in my opinion. If historians want to make a difference to society, that difference will be made in the public sphere and the locus of control will lie in the interpretation of heritage sites, which are often the first point of public contact with the history of a place. 'Who owns the past?' is not just a rhetorical question for heritage interpreters. Heritage sites are owned by a variety of national, state and local bodies and private sector organizations, each of which can jostle for a particular view of the past to be told. It is the historian's role to 'keep the bastards honest', for it can be immensely painful if the meaning of the past is reduced to 'what happened' and a triumphal or even racist view of it.

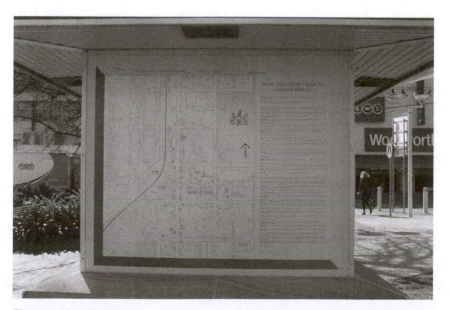

Figure 22.3 Traditional heritage interpretation at Gosford, 2016. Photo Jackie Malter for SHP.

In the mid-2010s, one regional Western Australian museum applied 'worst practice' to its interpretation of Aboriginal history. It refused to consult with Indigenous people and used disparaging eighteenth- and nineteenth-century historical quotations, without context, as a way of depicting Aboriginal culture. In another case, a property developer at a former Magdalene laundry site stopped a proposed sculptural interpretation of the girls who worked there from going ahead because the nuns who still controlled the site refused to allow this part of the history to be interpreted. But, given prominence of social media today, the biggest risk lies in failing to address the dark history of a place.

Heritage sites such as these evoke powerful memories and associations and deep wounds in case of war, conscience and memory. It is the historian's task to help work through these with a wide range of stakeholders and community members. The conflict over history at the Meiji industrial heritage sites in Japan has emphasized the importance of the historian's role in heritage interpretation as never before. The 'Sites of Japan's Meiji Industrial Revolution: Iron and Steel, Shipbuilding and Coal Mining' were inscribed as a joint listing of eleven sites with component parts on the UNESCO World Heritage List in 2015. However, the inscription has been hotly contested by Korea UNESCO which claims that one of these sites, Gunkanjima Island – or 'Battleship Island' – was a place where Korean forced labourers were tortured. Emotional YouTube videos have been released on both sides. But defusing the situation is the task of a historian and requires careful research into archival, oral and video histories, combined with an understanding of the limitations of each form of evidence and the pressures of political agendas on the interpretation of history, to resolve the matter of 'what really happened'. And that is exactly what has occurred. At the time of writing, both Korea UNESCO and Japan UNESCO are beginning a research process that will hopefully create a shared, if disputed, understanding of whether Gunkanjima was really 'hell island'.

Heritage interpretation needs history. People respond to stories and the most powerful and compelling stories are those based on detailed original research and an understanding of where a particular place sits within the wider pattern of world history. Ned Kelly's family built their house from wood rather than stone because wood was all they could afford; many Europeans travelled to Melbourne after the war because it reminded them of home. But historians working on heritage sites can do more than this. If they are bold and brave, they can be part of a better future for the world. They can help countries such as India – which has commissioned heritage

interpretation under Asian Development Bank funding – make the best economic use of their history; they can create a sense of place for immigrants to a new Melbourne suburb by drawing on histories of place; they can assist in reconciliation efforts by explaining to the broader community why Aboriginal history is relevant today; they can even be involved in designing, producing and building heritage interpretation. The scope is unlimited. But historians need to move their gaze away from the book to embrace history in all of its possible forms.

Notes

1. Phillip Gordon Ablett and Pamela K. Dyer, 'Heritage and Hermeneutics: Towards a Broader Interpretation of Interpretation', *Current Issues in Tourism* 12, no. 3 (2009): 211
2. David Uzzell cited in Neil Silberman, 'Heritage Interpretation as Public Discourse: Towards a New Paradigm', in *Understanding Heritage: Perspectives in Heritage Studies*, ed. Marie-Theres Albert, Roland Bernecker and Britta Rudolf (Berlin: De Gruyter, 2013), p. 22.
3. Ablett and Dyer, 'Heritage and Hermeneutics', 211.
4. Brian Goodey, 'Interpreting Urban Heritage', in *Heritage Interpretation*, ed. Alison Helms and Marion Blockley (New York: Routledge, 2006), p. 25.
5. Laurajane Smith, *Uses of Heritage* (London and New York: Routledge, 2006), p. 51.
6. Ibid.
7. Ibid., p. 29.
8. Data provided by Australia ICOMOS to Sue Hodges, 10 October 2017, deidentified. Not all members have listed their qualifications, which makes it impossible to find accurate information on either the correlation between qualified historians and their practice in the heritage sector or the number of practising professionals who work in history without qualifications. This section is intended to provide a snapshot of the issues from the available data.
9. Data provided by Australia ICOMOS to Sue Hodges, 10 October 2017.
10. See Chapter 13 by Denis Byrne in this volume.
11. Paul Ashton and Paula Hamilton, *History at the Crossroads: Australians and the Past* (Ultimo, Sydney: Halstead Press, 2010), p. 17.
12. Ibid., 128.
13. 'Historians and Museums: Overview of the Field'. www.historians.org/jobs-and-professional-development/career-resources/careers-for-students-of-history/historians-in-museums (accessed 30 October 2017).

14. https://www.open.edu.au (accessed 30 October 2017).
15. 'AIM723: Heritage Interpretation'. www.deakin.edu.au/courses-search/unit.php?unit=AIM723&year=2017 (accessed 30 October 2017).
16. Ashton and Hamilton, *History at the Crossroads*, pp. 11–12.
17. Ibid., 24.
18. Martin Smith, 'Save Pentridge Prison's Social Heritage'. www.greenleft.org.au/content/save-pentridge-prisons-social-heritage (accessed 25 October 2017).
19. Ibid.
20. 'Behind the Walls of H Division'. www.theage.com.au/victoria/behind-the-walls-of-hdivision-20140612-3a06o.html (accessed 25 October 2017).

23

'The Air Still Rings with the Excitement of Spanish Life': Ybor City and the Cuban Cigar

Christopher J. Castañeda

Brooklyn resident Agustín Castañeda sent a telegram to his cigar-maker colleagues in Ybor City on 16 January 1895: 'Huelga continua, urgen recursos [Strike continues, require resources]'.[1] Castañeda, a Spanish immigrant cigar-maker, was a member of *La Defensa*, a Latino cigar-makers' organization located in Brooklyn that was coordinating a month-long strike against New York City cigar manufacturers who had lowered their workers' wages. The New York cigar-makers were closely aligned with those in Ybor City, each community providing needed financial assistance during their respective strikes. This particular strike ended badly for the New Yorkers. But the generous support offered by those from Ybor City was possible because it was then a thriving Latino 'company town' that strongly identified with other Latino cigar-making enclaves throughout the United States.[2]

I first became interested in Ybor City, located northeast of downtown Tampa, Florida, when my family history side-project led me to the fascinating history of the early Cuban cigar-making business. The cigar-makers' world quickly became the focus of a new academic research venture for me, one that still included a family history element but extended far beyond direct filial connections. And as a side note for this chapter, I have found that

engaging in family history research will more than likely open doors to other engaging topics that may or may not be directly related to one's own family history. Researching history that is personally meaningful can be a great motivator for sustaining intensive and sometimes meticulous research that often results in deeply gratifying work and connects with broader historical themes.

In my search for information about my great-grandfather, I discovered the transnational Spanish-language anarchist print network. Cigar-makers played an important role in establishing and maintaining this network and the New York–Ybor City connection was strong. In this context, it was almost natural to find the names of active anarchists from New York and Ybor City in these newspapers. The anarchists were disgusted with the dramatic social and economic inequalities of capitalist society. Generally, they believed that a society without a formal government, church and capitalist economy would be best for workers and everyone else. The anarchists were particularly active in labour-related groups and their associated periodicals through which they reached other cigar workers and sympathetic Spanish-language readers, either locally, in other states or even across national borders.

My foray into family history led to me to Ybor City. The calling card was *El Esclavo* (1894–8), the city's anarchist paper that was established to combat economic inequality while supporting *Cuba Libre*. Through its pages, I learned much more about my great-grandfather but even more importantly I discovered this vibrant company town built around the famous Cuban cigar. I can almost imagine sitting in a small dark room in Ybor City, reading the telegram that Agustín Castañeda wrote more than 100 years earlier asking his colleagues for help. They enthusiastically and positively responded.

In many respects, Ybor City still reflects its vibrant Latino company town past; indeed, the district contains more than 950 historic structures including cigar factory buildings and restored 'casitas', or workers' housing.[3] Thanks to efforts by residents, descendants and historic and heritage preservation professionals, Ybor City became a National Historic District in 1974. While the district's cigar industry past is its historical anchor, the present is complex and contested. As Timothy Simpson observed, the historic district designation in particular 'generated economic, social, cultural, and aesthetic interests in the neighbourhood, and various people and interest groups are vying for their part of Ybor City. Conflicts among these groups often rely on different interpretations of Ybor City's past and different hopes for its future.'[4]

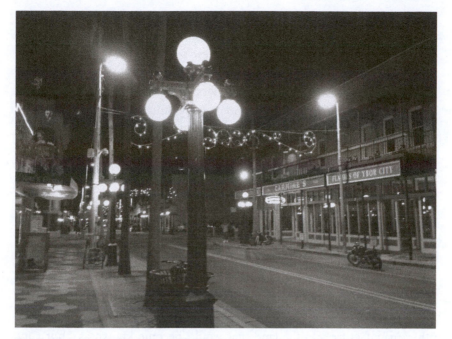

Figure 23.1 Ybor City's 7th Avenue at night. Photo Christopher J. Castañeda.

Ybor City's heyday as a Latino cigar-making centre entered a steep decline in the 1930s, due in part to the Great Depression but even more so to automation which had decimated the hand-rolled cigar-maker's artisanal craft. As happened in many once vibrant urban areas, lack of investment and opportunity caused the City to fall into decay. Attempts to revitalize and rehabilitate it began in the 1950s. But it was a slow process that only accelerated in the 1970s and 1980s. Ybor City now merges its unique historic heritage with an effort to attract tourists, residents and nightlife, but it remains unique among other historic US company towns including Lowell, in Massachusetts, Hershey in Pennsylvania and Pullman in Chicago.[5]

Origins

Vicente Martinez Ybor (1818–96) founded Ybor City in 1885. Born in Valencia, Spain, Ybor migrated to Cuba when he was fourteen, and he began making cigars. Later, he built his own manufacturing operation.[6] Forced out of Cuba due to the intense civil strife and fighting of the Ten Years War

(1868–78) when separatists unsuccessfully tried to free Cuba from Spanish control, Ybor moved his business from Havana to Key West, Florida, during the mid-1870s. He also built a factory in New York City, but he soon returned to Key West due to the crippling strikes at his New York plant. By the mid-1880s, in the midst of more strikes and labor troubles, Ybor decided to move again and the final choices were between Galveston in Texas and Tampa in Florida. With the encouragement of Gavino Gutiérrez, an entrepreneurial Spanish civil engineer then residing in New York, Ybor chose the Tampa site. He bought a forty-acre plot of land for $9,000 with a $4,000 subsidy from the Tampa Board of Trade.[7]

Gutiérrez had earlier thought that this particular area near Tampa would be a good location for growing guava trees. But he subsequently realized that it would be an even better cigar manufacturing zone. Tampa Bay had a deep port, access to new rail lines and a tropical climate suitable for tobacco processing. Gutiérrez helped swing Ybor's choice to Tampa and, in partnership with Ignacio Haya, a New York–based cigar manufacturer, Ybor began building a new business empire from scratch. He also invited other manufacturers to the land that would become known as Ybor City just outside the existing border of Tampa, 'a swampy, malarial village of 700 people'.[8] Gutiérrez designed Ybor City's original street grid and began transforming the 'alligator-infested plot where little grew but palmettos and scrub pines' into a town.[9] It was not Ybor, however, who made the first cigar in Ybor City. The newly established firm of Sanchez & Haya Cigar Co produced the first cigar on 13 April 1886.[10]

The town grew rapidly. From less than a thousand residents in 1880, the US Census in 1890 counted 233 Spaniards and 1,313 Cubans in Tampa. By 1900, these numbers had increased to approximately 1,000 Spaniards, 3,533 Cubans and 1,315 Italians. Five years later the town hosted about 130 cigar factories.[11] But Tampa's city government had already been wary of this fast-growing immigrant community: its 'city leaders … worried about maintaining social control over foreign workers who were pouring into Ybor City'.[12] As a result, Tampa annexed Ybor City in 1887, 'extending Anglo political control over the infant community'.[13] As Gary Mormino and George Pozzetta have noted, Ybor City's first decade 'reflected the rawness of a mining camp and the dangers of a frontier presidio' rather than an idealized master-planned company town. Yet the company town feel was always there, and the Ybor City Land Improvement Company even marketed inexpensive housing to workers and prospective workers.[14] Despite the possibility of a personally owned or rented home, up to one-third of Spanish cigar-makers

lived in boarding houses during 1900. By 1910 less than 19 per cent of the city's Spaniards spoke English. But the cigar industry had turned Ybor City, including Tampa, into one of Florida's major economic powerhouses.[15]

This vibrant Latino enclave, despite the existence of subgroups within it, developed an impressive and distinctive social structure that included mutual aid institutions, hospitals and schools. La Igual, a type of medical cooperative, began operating in 1887, and in 1891 residents established the Centro Español. In the following year, Spaniards established the Centro Asturiano. In 1904, the Centro Español built a $90,000 hospital for its members and the community, reflecting the ongoing practice of mutual aid.[16]

For the revolution

Ybor City was not only a company town; it was the Florida headquarters for José Martí and his effort to free Cuba from Spanish domination. During 1891, Martí began visiting Ybor City to raise moral and financial support for Cuba Libre. He worked hard to promote Cuba Libre among the Cuban and Spanish cigar workers there, and he visited Tampa about twenty times between 1891 and 1894.[17] He was even careful to avoid alienating the anarchists who tended to be Spaniards and viewed Cuba Libre as nothing more than an effort to replace one repressive regime with another. Cuban separatists were not happy with the anarchist viewpoint, but Martí sought to attract support from both camps, which he did with reasonable success. Martí, however, was killed in Ciba soon after launching his war for Cuban independence in the spring of 1895. But his death did not end Cuba Libre, and in the case of many martyrs, it may well have emboldened his followers to continue the struggle.[18]

Although Martí did not live to see the Spanish-American War (1898) or Cuban independence from Spain, he undoubtedly would have been pleased – if not amazed – that after the US Congress declared war on Cuba on 25 April 1898, the US Army used the port of Tampa as the disembarkation zone for American troops. Ironically, the same convenient transportation logistics that attracted Martinez Ybor more than twenty years earlier had become the basis for ferrying US troops to Cuba to battle the Spanish army. Yet, ethnic tensions were rife. The US army had taken control of the Centro Español in April and kept it under its management through August. All the while, American soldiers reportedly expressed displeasure at Ybor City's pervasive

Spanish language community that they had commandeered on their way to fighting the Spanish troops in Cuba.[19]

Up to the 1920s the Tampa cigar industry fared reasonably well. Conflict between management and labor sometimes flared up, and there were some debilitating strikes. In one infamous episode, a vigilante posse kidnapped a group of outspoken labor activists and forcibly transferred them to Honduras. The victims of this crime eventually returned to Ybor City, but the brazen act of vigilantism made it clear that radicals of any stripes should beware.[20]

Cuban cigar manufacturing, even though it was a traditionally artisanal business, was an industry. There were as many as 12,000 people employed in it and the vitality of the community was self-sustaining. But after the stock market crash of 1929 and subsequent downward spiral of the US economy, the cigar market declined propitiously. The efficacy of employing large numbers of cigar rollers had become antiquated for large-scale manufacturers. In Tampa, during the first two years of the Great Depression, cigar production dropped by 17 per cent, payroll declined by 30 per cent and wages plummeted.[21] The ensuing labor strife reenergized the left and communist organizers emerged in force.[22]

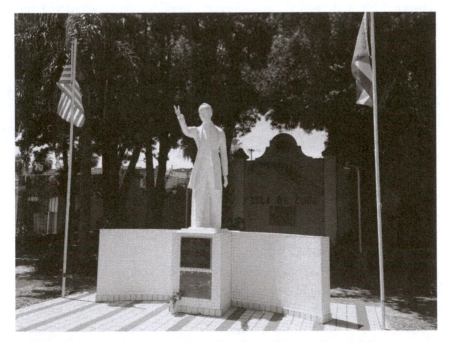

Figure 23.2 Jose Marti Park, Ybor City. Photo Terri A. Castaneda.

At the height of the Great Depression, working conditions in Ybor City as elsewhere hit a very low point. Lay-offs and declining wages exacerbated already bad economic conditions. Workers ultimately believed that they had no choice other than going on strike or leaving town to find work elsewhere. Among the city's cigar workers, a series of mass meetings, protests and strikes hit the manufacturers where it counted most. Manufacturers blamed extremists for the agitation and targeted 'communist agitators', in particular, for the debilitating strike that began on 7 November 1931. The manufacturers fought back, directing blame not at the terrible economic conditions or their own policies but on the *lectors*, the men – and rarely but sometimes women – who read news stories, poetry and political tracts to cigar workers while they rolled cigars. They accused the *lectors* for inciting rebellion.[23] The group of manufacturers who met on 26 November 'decided to discontinue reading in the factories … as a means of curbing communistic agitation'.[24] In a prepared statement they claimed that:

> all of the trouble is originating from the readers' stand where fiery communistic translations from anarchistic publications have been constantly poured into the workers.[25]

Of course, it was not the readers who had created the terrible economic conditions of the Great Depression. But they received the blame. No one could have single-handedly ameliorated the economic downturn, and Ybor City's economic fortunes continued to decline. Some cigar factories remained in business, but its Latino company town heyday that had lasted about forty years had passed.

Revitalization

The process of memorializing Ybor City began after the First World War. While it is certain that many long-time residents as well as those who had left remembered Ybor City's unique Latino company town ambience, the process of publically commemorating this heritage through historic preservation, monuments and official historic designations took time. One of the first and entirely unique efforts to commemorate Ybor City's multidimensional Latino past took place in the early 1950s.

During 1952, a group affiliated with the Ybor City Rotary Club, led by historian Tony Pizzo, began a project that led to the creation of José Martí Park (Parque Amigos de José Martí). Pizzo had heard a story that José Martí

during his visits to Ybor City often stayed in a boarding house located on the southwest corner of 8th Avenue and 13th Street that had been operated by cigar-makers Ruperto and Paulina Pedroso, his Afro-Cuban wife. While that structure was then still standing, it was so dilapidated that it could not be saved. The Ybor City group travelled to Cuba and met with President Fulgencio Batista who offered financial support to restore the structure and memorialize Martí. With a $25,000 contribution from the Cuban government, Colonel Manuel Quevedo purchased the land surrounding the former boarding house. On 10 September 1956, Quevedo ceded the land title to the Cuban government. To add authenticity to this Cuban property, 'Soil from each of the Cuban provinces was placed there.'[26] A unique park and statute dedicated to the memory of Martí and Cuba, it commemorates the place where Martí wrote many of his speeches extolling the virtue of Cuba Libre.[27]

After the Second World War, America began to engage with urban revitalization and opportunities for economically beneficial redevelopment. Ybor City's historical and cultural significant led the City of Tampa to hire the firm of planning consultants Milo Smith + Associates to 'identify the unique assets Tampa has in Ybor City'.[28] The firm presented its report in October 1963. It identified 'the unique assets Tampa has in Ybor City. It [was] … a statement of the flavor and spirit of this individual characteristic of Tampa's that is lively and genuine.' And it was 'to contribute to a sense of direction, understood and cherished by many Tampans, toward the goal of inscribing this statement of our rich heritage on the form and plan of this city'.[29]

The report noted, 'Some tobacco factories are still active, but there is very little office activity in evidence. Retail trade is supported primarily by the residents of the Ybor City area.'[30] It lamented that 'much of the Latin population moved to areas of better housing' and employment opportunity while 'non-Latin low-income groups [had] started to move in'.[31] The report celebrated Tampa's 'Latin' population: 'The Latin composition of Ybor City,' it observed, 'constituted a constructive, healthy and prosperous community. Mutual health centres (the first in the United States), social clubs giving recreation to all social and economic classes, housing projects with advanced financial administration, and many other facilities were created. In short, it contributed many necessary elements for Tampa to develop into a cosmopolitan city.'[32] But it was less kind to other groups of people. It observed that as Latin people were moving out, 'Negro occupancy' in Ybor City between 1950 and 1960 increased a

'startling' 38 per cent. The majority of residents were black and the City was said to be surrounded by Tampa's most depressed black ghettos. In the same period, 'owner occupied homes [had] dropped from about 39% to only 25% in Ybor City', while owner occupancy in Tampa generally had been increasing substantially.[33] It also stated that in '1958 retail sales in the Ybor City Business District amounted to $14 million – barely twice the amount of sales generated by a medium-sized shopping center in West Hillsborough County'.[34]

Anthropologist Susan Greenbaum later examined the ethnic and racial dynamics in Ybor City leading up to its revitalization. She noted that historic preservation efforts had centred on valuing and restoring the area's 'Latin influence'. The term 'Latin' commonly referred to all of immigrants from Cuba, Spain and Italy.[35] Greenbaum also acknowledged, 'In many respects, Ybor City does seem to hold great potential. Even after decades of policies that neglected and abused it, the area still has considerable charm, a convenient location adjacent to the downtown, and good access from two major expressways'.[36]

That the overwhelming majority of Ybor City's residents were poor black people contributed to Tampa's decision to reinvest in Ybor City's Latino heritage.[37] Greenbaum argued that many of the city's current inhabitants were descendants from the original black Cuban (or Afro-Cuban) immigrants who came to Ybor City beginning in the late nineteenth century to work in the cigar industry. Thus Greenbaum stated, 'Afro-Cubans are arguably the most "authentic" ethnic group in Ybor City ... [yet] they have had difficulty winning acceptance or recognition of their part in Ybor City's cultural heritage'.[38] Later, historian Nancy Hewitt examined these same often overlooked themes in her excellent book, *Southern Discomfort*, on Tampa's early history.[39]

After years of planning, reports and preparation, the Ybor City Historic District became a US National Historic Landmark District on 28 August 1974. It is bounded by 6th Avenue, 13th Street, 10th Avenue and 22nd Street and includes East Broadway between 13th and 22nd Street including 956 historic buildings. The process of acknowledging and preserving Ybor City's heritage received an important boost in 1982 when the Ybor City Museum Society formed in order to support 'the Ybor City Museum State Park by creating exhibits, programming, educational tours, cultural and historical resources, and research tools to ensure that Ybor City's significant history remains at the forefront of Tampa culture'.[40] Visitors to Ybor City can now visit the museum and take walking tours of the town and its historic sites.

Presenting the past

Ybor City is a prime example of post-industrial urban revitalization within a transnational context. This international heritage, including historical examples of non-assimilation, makes Ybor City a unique and sometimes ignored US public history site.[41] Indeed, the district's immigrant labor past is sometimes amplified by stark contrasts in the present. One remarkable juxtaposition literally evokes cognitive dissonance, when walking past one of the district's most historic structures. The case in point is Martinez Ybor's first cigar factory located in a brick building constructed in 1886 on 14th Street between 8th and 9th Avenues which occupied almost the entire block. It was on the steps of this building in 1893 that Jose Martí gave an impassioned speech imploring Ybor City's cigar workers to support Cuba's struggle for independence. In 2010, the Church of Scientology spent about $7 million to purchase the same factory building, then a three-building complex. Spending an additional $6 million on restoration and renovation, the Church transformed the iconic factory into its new Tampa Church, part of Ybor Square.[42] It opened on 13 March 2011 on the centenary of Scientology founder L. Ron Hubbard's birth. It is open to tours while operating as the Church office.[43]

In recent years, many historians as well as descendants of Ybor City's Hispanic cigar-makers have sought to document, remember and popularize Ybor City's heritage. Frank T. Lastra's book, *Ybor City: The Making of a Landmark Town*, is by far the most comprehensive treatment of Ybor City's history.[44] Lastra's book clearly represents a deeply felt connection to his birthplace and community. Dr Wallace Reyes was another devoted historian of Ybor City. Born in Puerto Rico where he learned the cigar-making trade, he later relocated to Tampa and became Vice President of the Gonzalez Habano Cigar Company. He has written two books on the history of Ybor City, and he also gives walking tours in collaboration with the Ybor City Museum State Park and the Ybor City Chamber of Commerce.[45]

Other recent public historical endeavours to memorialize Tampa's Hispanic cigar-making heritage include two films produced and directed by Luis Argeo and James D. Fernández. The first, *A Legacy of Smoke*, is a poignant montage of personal moments of remembrance and heritage including one in which two Tampeños recount over a thousand nicknames of local Latino residents. In the second, *The Weight of Remembering*, Tampeño Anthony Careño guides a fictional character through Tampa as he tries to retrace his

grandfather's path from Spain to Cuba and then to Ybor City before moving on to New York.[46]

The last cigar?

In recent years, there have been numerous newspaper stories about the likely end of cigar production in Ybor City. Even if that happens, the reality is that large-scale cigar production has been absent already for many years. Cigar shops located on Ybor City's 7th Avenue and other streets still sell a wide variety of handcrafted cigars, and some employ cigar-makers who continue to make cigars in the traditional manner, demonstrating the patient skills of the traditional artisanal cigar-maker. The Columbia Restaurant which opened in 1905 is another popular historic landmark connecting past and present.

It has been well over 100 years since my great-grandfather received needed support from his colleagues in Ybor City to help the striking tabaqueros in Brooklyn. Much has changed in the world, in the United States and in cigar business since then. But the Cuban cigar remains a universally recognized symbol of Latino character, business acumen and activism; Ybor City was the virtual headquarters for Cuban leaf cigar production in the United States. It was home to a vibrant Latino community where wealthy entrepreneurs, workers struggling to survive, anarchists and families worked, lived and – when they could – enjoyed life. Ybor City is certainly a different place today, and it faces the same challenges of any historic area striving to continue the process of revitalization in an ever more complex era. Physical remnants of the Latino company town remain, but there is more than that – even if illusory like cigar smoke, 'The air still rings with the excitement of Spanish life.'[47]

Notes

1. 'La huelga de New York,' *El Esclavo*, 23 January 1895. The title is a quote from 'Statement of Purpose', in *A Plan for Redevelopment for Ybor City* (Tampa: Milo Smith + Associates, 1963), p. 20.
2. Technically a 'one-industry' town.
3. National Park Service, 'Ybor City Historic District Tampa Florida'. www.nps. gov/nr/travel/american_latino_heritage/Ybor_City_Historic_District.html (accessed 22 September 2017).

4. Timothy A. Simpson, *Contesting Community: Memory, Place and Culture in Ybor City, Florida*, PhD dissertation, University of South Florida, 1996, p. 3.

5. Lowell, in particular, has received a great deal of attention from public historians. See Cathy Stanton, *The Lowell Experiment: Public History in a Postindustrial City* (Amherst: University of Massachusetts Press, 2006); and Martha K. Norkunas, *Monuments and Memory: History and Representation in Lowell, Massachusetts* (Washington, DC: Smithsonian Institution Press, 2002).

6. For background on Don Vicente Martínez Ybor, see L. Glenn Westfall, *Don Vicente Martinez Ybor, the Man and His Empire: Development of the Clear Havana Industry in Cuba and Florida in the Nineteenth Century*, PhD dissertation, University of Florida, 1977; and Frank Trebín Lastra, *Ybor City: The Making of a Landmark Town* (Tampa: University of Tampa Press, 2006), pp. 4–5.

7. Evagene H. Bond, 'A Community in the Process of Change: Ybor City, Tampa, Florida', in *La Comunidad: Design, Development, and Self-Determination in Hispanic Communities* (Washington, DC: Partners for Livable Places, 1982), p. 42.

8. Ibid.

9. Lastra, *Ybor City*, 15 and 52; Bond, 'A Community in the Process of Change', 42.

10. Wallace Reyes, *Once Upon a Time in Tampa ... Rise and Fall of the Cigar Industry...* (CreateSpace Independent Publishing Platform, 2013), p. 12.

11. Gary R. Mormino and George E. Pozzetta, 'Spanish Anarchism in Tampa, Florida, 1886–1931', in *Struggle a Hard Battle*, ed. Dirk Hoerder (DeKalk: Northern Illinois University Press, 1986), pp. 177, 184.

12. Robert P. Ingalls and Louis A. Peréz, Jr, *Tampa Cigar Workers: A Pictorial History* (Gainesville: University of Florida Press, 2003), p. 3.

13. Ibid.

14. Mormino and Pozzetta, 'Spanish Anarchism in Tampa', 177.

15. Ibid., 178, 184.

16. Ibid., 178–9.

17. Paul Guzzo, 'Tampa Showcases Role in Martí History with Trail in Ybor, UT Center', *Tampa Bay Times*, 14 April 2016.

18. Mormino and Pozzetta, 'Spanish Anarchism in Tampa', 182–4.

19. Ibid., 183.

20. Kirk Shaffer, 'Tropical Libertarians: Anarchist Movements and Networks in the Caribbean, Southern United States, and Mexico, 1890s–1920s', in *Anarchism and Syndicalism in the Colonial and Postcolonial World, 1870–1940* (Leiden: Brill, 2014), p. 290.

21. Robert P. Ingalls, 'Radicals and Vigilantes: The 1931 Strike of Tampa Cigar Workers', in *Southern Workers and Their Unions, 1880-1975: Selected*

Papers, The Second Southern Labor History Conference, 1978, ed. Gary M. Fink and Leslie S. Hough (New York: Praeger, 1981), p. 45.

22. Ingalls, 'Radicals and Vigilantes', 45–53.
23. Also see Louis A. Pérez, Jr, 'Reminiscences of a Lector: Cuban Cigar Workers in Tampa', *Florida Historical Quarterly* 53, no. 4 (April 1975): 443–9.
24. 'Industry Here Stops Cigar Plant Reading', *Tampa Morning Tribune*, 27 November 1931.
25. Ibid.
26. Lastra, *Ybor City*, pp. 309–10.
27. Reyes, *Once Upon a Time in Tampa*, pp. 293–5.
28. 'Statement of Purpose'.
29. Ibid.
30. Ibid., 14.
31. Ibid., 16.
32. Ibid., 19.
33. Ibid., 20. The report noted that the overall percentage of owner-occupied homes in Tampa had increased from 48 to 68 per cent from 1950 to 1960.
34. Ibid., 14.
35. Susan D. Greenbaum, 'Marketing Ybor City: Race, Ethnicity, and Historic Preservation in the Sunbelt', *City & Society* 4 (1990): 58.
36. Greenbaum, 'Marketing Ybor City', 59.
37. Ibid.
38. Ibid., 59–60.
39. Nancy A. Hewitt, *Southern Discomfort: Women's Activism in Tampa, Florida, 1880s–1920s* (Urbana: University of Illinois Press, 2004).
40. www.ybormuseum.org/the-society (accessed 20 August 2017).
41. See Andrew Hurley, *Beyond Preservation: Using Public History to Revitalize Inner Cities* (Philadelphia: Temple University Press, 2010).
42. 'Scientology Gets Neighborly in Ybor City', *Tampa Bay Times*, 31 July 2013. www.tbo.com/news/business/scientology-neighborly-in-ybor-20130730/ (accessed 21 August 2017).
43. www.scientology-tampa.org/inside-our-church/ (accessed 21 August 2017).
44. Frank Trebín Lastra, *Ybor City: The Making of a Landmark Town* (Tampa: University of Tampa Press, 2006).
45. Reyes, *Once Upon a Time in Tampa*; and also *Cigar City Architecture and Legacy* (CreateSpace Independent Publishing Platform, 2015).
46. Luis Argeo and James D. Fernández, *A Legacy of Smoke* (Whitestone Productions, 2017 [DVD]); Luis Argeo and James D. Fernández, *The Weight of Remembering* (Whitestone Productions, 2017 [DVD]).
47. 'Statement of Purpose', 20.

24

Forgetting and Remembering in Bhopal: Architects as Agents of Memory

Amritha Ballal and Moulshri Joshi

Public history and public memory are both representations of the past. The former is largely understood to be concerned with recording the past and the latter with remembering it in the present.[1] Critiquing the power structures that underpin the traditional understanding of history as seemingly authoritative, objective and rationalist, Pierre Nora states that history 'belongs to everyone and to no one, whence its claim to historical authority'.[2] Yet as postcolonial, indigenous, feminist, minority and many other traditionally overlooked, hidden, excluded narratives emerge, history is increasingly seen as an outcome of altering perspectives and dynamics between different groups.

Bernard Lewis postulates that history can be collectively 'remembered, invented, and recovered'[3] by those who have the power to shape the historical narrative within their spheres of influence. Memory, however, has a quicksilver nature specific to each individual. We constantly filter our past; consciously and subconsciously altering recollections. Drawing from a collective pool of personal memories in flux, public memory as Zelizer notes,[4] remains a constantly unpredictable and incomplete work in progress. This brings public history closer to the conception of public memory which acknowledges the conflicted coexistence of multiple, dynamic narratives.

Engaging with both history and memory, memorials record the past while creating a space to remember it collectively. Pierre Nora notes the complexity of such sites which he terms as '*lieux de mémoire*' or 'memory space', defining them as 'complex things at once natural and artificial, simple and ambiguous, concrete and abstract'.[5] Such a 'site operates primarily by introducing doubt, by running a knife between the tree of memory and the bark of history'.[6] Sites of memory, such as the Union Carbide memorial site in Bhopal, inhabit a fluid, interpretive space at the intersection of intangible memory and tangible artefacts of a historic event.

Placing the gas tragedy in the spatial memory of Bhopal

On the night of 2 December 1984, winds laden with 46,000 tons of methyl isocyanate gas (MIC) quietly swept into the neighbourhoods near the Union Carbide India Limited (UCIL) pesticide plant at Bhopal, a major Indian city in the state of Madhya Pradesh, travelling south, staying close to the ground and maiming hundreds in their sleep. The rest of the city woke up to mayhem and ghastly scenes of death which continued for weeks. The tragedy paralysed the state to lead a response. Accounts differ as to the

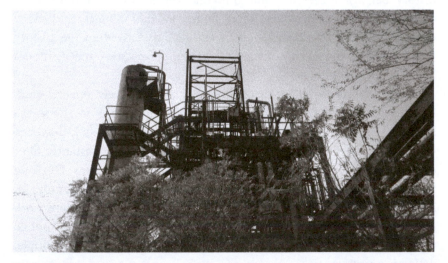

Figure 24.1 MIC plant at Union Carbide factory of Bhopal. Photo SpaceMatters.

exact number of deaths. But most estimates say that within two weeks, up to 10,000 people had perished with at least a further 500,000 having been exposed to the gas.[7]

As a visitor, one expects Bhopal to draw you into a conversation about this painful past. Yet Bhopal provides few spaces to delve into this. More than three decades after the tragedy, which by many accounts is the worst industrial disaster seen on the planet, there are hardly any commemorative structures, especially on an urban public scale, to remind us of this event. The passage of time aids forces of forgetting, especially if the memory is anchored solely in individual human lifetimes. Each survivor presents a battle against the tragedy as well as against time, becoming in process a living repository of the legacy of Bhopal. Where can the coming generations revisit these memory in the time to come?

Physical space provides an enduring anchor for human testimonies, where memory can be reactivated across different lifetimes providing a more sustained resistance to forgetting. The original generation of survivors and activists at the forefront of the struggle for remembrance are aging. Like the survivors of the tragedy, the factory structures are both the 'witness and residue'[8] of the tragedy, marking its epicentre.[9] But these structures, too, are losing the battle against time.

Remembering and forgetting in Bhopal

A memorial for the Bhopal gas tragedy had been a long-standing demand of survivors. In 2005 the state government announced an open national competition for a design.[10] SpaceMatters, an Indian architectural and design firm based in New Delhi, was awarded the project based on a winning entry by Suditya Sinha with team members Amritha Ballal, Moulshri Joshi, Sanjeet Wahi and Uttiya Bhattacharya.[11] The memorial was to be erected on the UCIL site, a sprawling postindustrial complex of almost sixty acres of contaminated, brownfield land located in the poorer parts of Bhopal. Many of the neighbourhoods worst affected by the tragedy lived here.[12] No interim space for commemoration had been created by the state in the twenty years that took for the memorial project to be announced. The memorial had to find means to subvert years of neglect and forgetting. Paul Connerton's study[13] distinguishing and identifying the impacts of different types of

forgetting provide us a relevant framework to describe strategic steps the memorial design takes in this regard.[14]

From erasure to emblem

The physical deterioration of the site can be placed within the process of erasing the tragedy. Many covert and overt activities saw the gradual deterioration of the factory, including neglect, pilfering of metals and supposed detoxification processes.[15] The open-ended memorial design brief was noncommittal on the position of the iconic factory structures on site: 'participants ... [could] integrate them or replace them in any suitable form and function'.[16] The memorial design upended the sustained denial of the factory structures' importance by placing these sole surviving witnesses of the disaster at the heart of the memorial complex.[17] A similar approach can be seen at the Hiroshima peace memorial.[18]

From prescriptive forgetting to space as legacy

A history of complicity and collusion, implicating state and society, can be traced from the setting up of the hazardous industrial complex near heavily

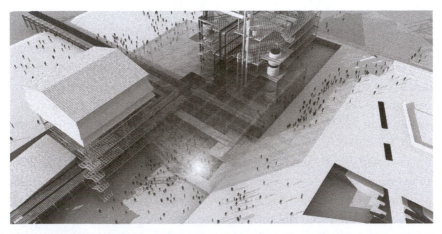

Figure 24.2 Proposed design for Bhopal Gas Tragedy Memorial. Photo SpaceMatters.

populated urban areas, not acting on reports of flouting safety standards by UCIL, being unprepared for the ensuing disaster and then failing to adequately address its environmental, legal, medical and humanitarian fallout. The design emphasizes the importance of remembering over the temptation to forget a shameful legacy. In doing so it counteracts the 'to move ahead is to forget' mindset. 'No Hiroshima, No Bhopal, We Want to Live'[19] is a rallying cry of survivors. The Bhopal tragedy site is a touchstone for issues related to industrial disasters and contamination, just as Hiroshima is for the global discourse on nuclear disarmament.

Reconciling remembering while constituting new identities

Zelizer[20] and Connerton[21] note that the act of forgetting replaces one memory for another; this can be an act of self-preservation in pursuit of new identities. Bhopal imagines its future as a 'Smart City' – a 'city of lakes, tradition and heritage'[22] – one of the hundred others that are envisioned under an ambitious national government planning program. The disaster finds no mention in the articulation of Bhopal's history or aspiration for future development.[23] This sociospatial distancing from the tragedy has been gradual and steady. Over the years Bhopal has expanded southwards, away from the old city in the north where the factory site is located. In contrast to the old city, the newer parts are formally laid out as per state planning guidelines. They are less dense, more prosperous and generally have better urban services and infrastructure.

The memorial master plan provides an opportunity to introduce urban amenities and open space that the area lacks on the large, neglected site. Almost a third of it is dedicated to providing sociospatial infrastructure for the surrounding neighbourhoods. The factory structures also lie deep within the site, cut off visually and physically by an extended boundary wall. By removing the wall, the memorial realigns the city road inside the site in a manner that makes all vehicular traffic pass through its heart.[24] The design weaves landscaped public pedestrian access over the road and a subterranean museum underneath it, a metaphor for a history that some would prefer to hide. This uninterrupted access to the site means that the city and its inhabitants become part of experiencing the landscape of the tragedy for the visitor. Even subterranean parts of the museum frame views

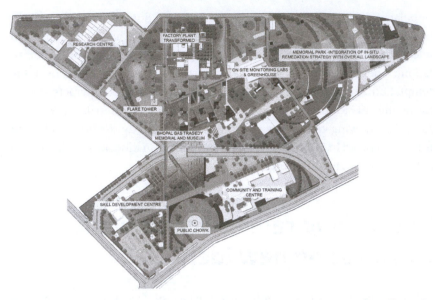

Figure 24.3 Site plan of the proposed design for Bhopal Gas Tragedy Memorial. Photo SpaceMatters.

of the site and structures. The museum provides information to the visitor and offers an emotive experience. It is a progressive journey below ground where spaces go from exhibits and interactive installations to spaces meant for contemplation and homage. Rising above also provides opportunities to make meaning. Access atop the flare tower provides unprecedented views to the surrounding city. This view is telling of one primary causes of the disaster – the factory was placed too close to habitation.

From structural amnesia to narrative networks

Deputy Station Superintendent of Bhopal junction railway station, Ghulam Dastagir, saved many lives during the night of 2–3 December by diverting passenger trains away from the UCIL factory at north Bhopal.[25] Dastagir passed away in 2004 from chronic ill effects of the gas.[26] A stone plaque on the Bhopal junction platform remembers those who died in the line of duty, though Dastagir's name is absent. His actions remain in public memory as tributes on some online portals. One post has been shared more than 13,000 times.

Besides deliberate erasures, names and incidents such as these have been forgotten because of the sheer size of the tragedy. In three decades there have been many documentaries, photography, films, books, writings and art works about the disaster. There is also a mass of media reports, legal documents and medical and other records. Each of these fragments documents a part of the history while others are forgotten.

The act of positioning the site as an accessible public space instead of a gated complex links it to the spatial gestures of commemoration outside of the site and the official framework. The powerful and poignant Mother and Child statue by artist Ruth Waterman, installed by survivors on a crowded footpath close to the factory, reclaims public space in a defiant act of shaping public memory.[27] The Remember Bhopal Museum,[28] again established by some survivor and activist groups in a repurposed apartment near the factory site, creates a space for remembrance and resistance. The site's boundary wall itself acts as a canvas for commemoration. Defiant graffiti appears on it and which is constantly erased. By weaving the site into Bhopal's public urban fabric, the memorial locates itself in the connected landscape of remembrance disrupting the dichotomy of 'inside' versus 'outside'. The memorial is not presented to the visitor in isolation but in relation to various acts of commemoration that form Bhopal's landscape of memory.

From forgetting as annulment to site as palimpsest

Disposal of industrial and urban waste has been generally overlooked in the production of material culture.[29] One of the least known aspects of the Bhopal site is as an ecological wastescape containing an uncertain chemical cocktail; environmental information the exact nature of which remains contested and elusive to date. Digging and dumping before and after the tragedy, as well as exposure to natural elements, has transmitted the chemical waste beyond the site. Paradoxically while the site is marked as contaminated[30] and remains uninhabited within its physical boundaries, the *basti* or shanty settlements right outside the factory have grown exponentially. The so-called solar evaporation ponds – UCIL's secret dumping grounds for toxic waste which is supposed to turn them benign – lies outside the site and across the railway track. It has largely been sequestered into plotted housing and shanties.

The soil and vegetation documents the layers of degradation the site has undergone and serve as an illustration of the process of renewal and restoration. At Seveso in Italy, the site of one of Europe's worst environmental disasters,[31] a forest of oak, maple, pine and poplar mark the material remains of the tragedy.[32] Thousands of tonnes of demolished houses and carcasses of slaughtered animals lie buried with personal possessions of the residents. The tree cover growing atop a mountain of 'waste' marks the event and transmits the memory of what lies beneath to the world above. At the Gas Tragedy Memorial, the soil marks this powerful conversation between 'above' and 'below' transmitting the problematic legacy and contested place to the public. In the Bhopal memorial, monitoring stations, field laboratories, embankments and landscape structures to contain and clean the soil serve to document what lies beneath. They are public signs of how nature contains and transmits information, in this case the toxins.

Trees at site, the other witness, and residue of the gas leak are conserved as a case study in botanical/ecological resilience. The inventory of flora at the site has been the first step to acknowledging the role of existing trees beyond a simple tree cover to living artefacts.[33] The information gained from the site's soil and vegetation is valuable for future research into soil and water reclamation will be housed at a research centre proposed at the site. The scarred landscape becomes a metaphor of the city and its people; its slow, non-violent, in situ regeneration becomes symbolic of a process of catharsis.

From forgetting as planned obsolescence to participative commemoration

In the absence of physical space, most information on Bhopal is gleaned from virtual space. The number of those who perished due to the tragedy differs by thousands depending on whose account you read. How does one address a tragedy where even the most basic facts have been consciously, consistently obscured? This example is illustrative of both the possibilities and limitations of architecture in the context of Bhopal. The memorial cannot present a clear delineation of the number of those who perished in the absence of proper records. Architecture, however, with its power to express the intangible, can seek to evoke for the visitor the magnitude of loss.

The memorial design envisions a large scale urban art installation by indigenous craftsmen such as Bastar artisans[34] at the base of the factory structures, a permanent art installation of life-size, life-like human figures numbering in the thousands in and around the plant structures as homage to those who died in the 1984 tragedy. It is visible to everyone walking or driving through the site and the first thing that visitors see as they emerge from the partly subterranean memorial museum. The art installation, using highly refined nonferrous metal casting uses techniques that date back thousands of years, derive inspiration from the daily lives of the traditionally forest dwelling communities and provide a symbolic counter balance to the steel industrial structure.

The memorial design combines functional and abstract aspects of architecture to address the past legacy, present challenges and future relevance of the site. A basic guiding principle for design has been the transfer of agency to various stakeholders based on the recognition that the buildings themselves form only a part of the memorial process. This includes the survivors, visitors, researchers, surrounding communities, the state administration, researchers, the global community of activists and the city of Bhopal. As architects we cannot control who runs the memorial in the future and how. But by unambiguously declaring the site a public space, programming and providing for a space for functions that require frameworks for active participation such as community infrastructure and research facilities and by deigning the memorial as a container to be inhabited and experienced not as an object to be passively viewed, but as a space for critical participation. The memorial architecture is not designed for abrupt closing of unresolved chapters but for continued engagement.

Methods and metaphors in the architecture of memory

The 1979 Vietnam Veterans Memorial organizers saw the memorial as a symbol of reconciliation after a war that had split and scarred American society. Towards this end, the competition brief specifically stated the Bhopal memorial design was to make 'no political statements'.[35] The 2003 National September 11 Memorial competition brief noted that the permanent memorial had to honour 'those lost, while affirming the democratic values that came under attack on September 11, 2001 and February 26, 1993'.[36] These

vision statements desire architecture that goes beyond marking the past to addressing its present context and fallout. They prescribe the exclusions of some narratives as seen in the case of the Vietnam Veterans Memorial, or through affirmative inclusion such as reconfirming 'democratic values' as in the case of the September 11 Memorial. These directives, however, can be seen simultaneously as being fraught with ambiguity while prescribing certain dominant notions of the past; their euphemistic nature reveals a low threshold for radical concepts. This sets a challenge for architects.

Architects have to straddle engagement with various stakeholder groups that are themselves rarely entirely united or predictable. The situation is further confounding when structures for engagement do not exist. The Bhopal Memorial is a good example. Commissioned twenty years after the disaster, the project inherits a fractured relationship between the state and civil society led by survivor groups and activists, where the state is both a part stakeholder in the UCIL[37] and the legal guardian of the factory site. The passage of time has blurred the definition of actors and stakeholders while the media has amplified and reinforced roles and positions. Over three decades, UCIL merged into Dow Chemical and recently Dow Chemical merged with DuPont to form one of the largest chemical company in the world.[38] The 'state' has seen changes in governments, political parties, departments, ministers and bureaucrats. Activists belong to myriad groups and differing affiliations, some lead by survivors, others by different segments of civil society whose agendas, reach and resources differ widely. At the heart of the disaster are the memories of those who experienced personal loss and trauma. Should these inform the best ways to publicly commemorate the tragedy? While the design calls for public participation, the call exists in an administrative vacuum, with no precedence of engaging with the public in rebuilding sites that have had profound impacts on people.

Architects with their spatial intelligence are only one of the several crucial agents defining this landscape of memory. However, this runs against the grain of traditional architectural practice in India. It is hard to let go of professional authority. The agile master plan of the memorial has remained relevant in the face of uncertainty: new discoveries at the site both above- and belowground, change in aspirations of the various communities defined by the disaster and the latest political rhetoric operating in the city – assimilating change through discourse and negotiation. All of these things shape the memories of the tragedy and collective remembrance. Like a parchment, it is written over multiple times, through forced, wilful and accidental erasures and additions. The architectural imagination of

the Bhopal Gas Tragedy Memorial presents a method where architects try to reconcile the overwhelming narrative of the tragedy with its physical remains to narrate multiple stories through space and across time. At Bhopal, the architecture – pushing against traditional boundaries – engages, deploys, sculpts and transgresses the site of the tragedy to weave multiple, simultaneous narrations. In the process, whatever is available at the site, the tangible and intangible, is ascribed and described. In this process, architecture becomes an act of meaning-making and architects, its agents who shape the performative aspects of collective remembrance.

In 2011, an international workshop and symposium[39] brought together multiple disciplines to connect different ways of seeing the factory site and contextualizing its position in the larger discourse on dealing with contemporary sites of painful pasts. Architects, planners, artists, historians, policy makers and students spent a fortnight in Bhopal, starting at the factory site and moving outwards to draw the city into a conversation about the tragedy. It compelled the state to reconsider plans for the demolition of the factory structures.

Discourse on the nature of the memorial is in itself part of the process of memorialization. At the heart of the Bhopal project is the reimagining of the memorial as a public space. Access to public space might not be denied outright in our nation, yet claims to it are increasingly tolerated, if not seen as a right. Reclaiming the Bhopal site as a public space sees the memorial as a participatory space which will foster the democratization of the public history of Bhopal.

Notes

1. Barbie Zelizer, 'Reading the Past against the Grain: The Shape of Memory Studies', *Critical Studies in Mass Communication* 17 (1995): 214–38. See also Robert Kelley, 'Public History: Its Origins, Nature, and Prospects', *Public Historian* 1, no. 1 (1978): 16–28.
2. Pierre Nora, 'Between Memory and History: Les Lieux de Mémoire', *Representations Special Issue: Memory and Counter-Memory* 26 (1989): 9.
3. B. Lewis quoted in Zelizer, 'Reading the Past against the Grain', 215.
4. Zelizer, 'Reading the Past against the Grain', 214–38.
5. Nora, 'Between Memory and History'.
6. Ibid., 10.
7. Ingrid Eckerman, *The Bhopal Saga: Causes and Consequences of the World's Largest Industrial Disaster* (Hyderabad: Universities Press, 2005).

8. Excerpt from 'The Bhide Committee Report', in *Bhopal: A Report from the Future*, n.d., n.p.

9. Moulshri Joshi, 'The Case for Salvaging the Remains of the World's Worst Industrial Disaster at Bhopal, India', *TICCIH Bulletin* (2008). http://ticcih.org/wp-content/uploads/2013/04/1253515074_b43.pdf (accessed 2017).

10. EPCO Bhopal, *Development of Memorial Complex for the Bhopal Gas Tragedy Victims* (Bhopal: EPCO, 2005).

11. S. Sinha, A. Ballal, U. Bhattacharya, M. Joshi and S. Wahi, Competition Entry for Development of Memorial Complex for the Bhopal Gas Tragedy Victims, 2005.

12. 'Municipal Wards of Bhopal as on 3rd December 1984', *Bhopal Gas Tragedy Relief and Rehabilitation, Government of Madhya Pradesh*, 9 September 2017. www.bgtrrdmp.mp.gov.in/profile.html (accessed 2017).

13. Paul Connerton explores the process of remembrance and states that the seven types of forgetting are repressive erasure; prescriptive forgetting; forgetting that is constitutive in the formation of a new identity; structural amnesia; forgetting as annulment; forgetting as planned obsolescence; and forgetting as humiliated silence. See Paul Connerton, 'Seven Types of Forgetting', *Memory Studies* 1, no. 1 (2008): 59–71.

14. Sinha et al., Competition Entry.

15. Indian Institute of Chemical Technology, *Technical and Tender Document for Detoxification, Decommissioning and Dismantling of Union Carbide Plant (UCIL Bhopal)* (Bhopal: The Directorate of Gas Relief and Rehabilitation, Government of Madhya Pradesh, 2010).

16. EPCO Bhopal, *Development of Memorial Complex*, ii.

17. See also Amritha Ballal and Moulshri Joshi, 'Bhopal Gas Tragedy: Dissonant History, Difficult Heritage', *Context: Built, Living and Natural* 8, no. 2 (2011): 7–14.

18. UNESCO World Heritage Centre, 'Hiroshima Peace Memorial (Genbaku Dome)', n.d. http://whc.unesco.org/en/list/775/ (accessed 2017).

19. 'No Hiroshima, No Bhopal, We Want to Live' is inscribed at the base of 'The Statue of Mother and Child' by Ruth Waterman. See Sanjeeb Mukherjee, 'Bhopal Gas Tragedy: JP Nagar Has Moved On, Yet Memories Linger', *Business Standard*, 2 December 2014. www.business-standard.com/article/current-affairs/bhopal-gas-tragedy-jp-nagar-has-moved-on-yet-memories-linger-114120101120_1.html (accessed 2017).

20. Zelizer, 'Reading the Past against the Grain', 214–38.

21. Connerton, 'Seven Types of Forgetting'.

22. Bhopal Smart City Development Corporation Limited, 'About Us', *Smart City Bhopal*, 2017. http://smartbhopal.city/page/2 (accessed 2017).

23. State Institute for Town Planning, Bhopal, M.P., 'Bhopal Master Plan 2005', *Directorate of Town and Country Planning, Madhya Pradesh*, 2013. http://emptownplan.gov.in:9999/MasterPlanBhopal/index.html (accessed 2017).

24. Anna Storm postulates that fear of an industrial site and activity increases with distance. By reducing the distance between the UCIL factory structures and the city, the design attempts to mitigate this 'fear' of the site. See Anna Storm, *Post-Industrial Landscape Scars* (New York: Palgrave Macmillan, 2014).

25. Sanchari Pal, 'The Forgotten Stationmaster Who Saved Countless Lives during the Bhopal Gas Tragedy', *The Better India*, 28 October 2016. www.thebetterindia.com/73257/ghulam-dastagir-stationmaster-bhopal-gas-tragedy-hero/ (accessed 2017).

26. Faisal Mohammad Ali, 'Forgotten Hero of Bhopal's Tragedy', *BBC News*, 2 December 2004. http://news.bbc.co.uk/2/hi/south_asia/4051755.stm (accessed 2017).

27. Remember Bhopal Trust, *Remember Bhopal*, 2015. http://rememberbhopal.net/ (accessed 2017).

28. Storm, *Post-Industrial Landscape Scars*.

29. See, for example, Gay Hawkins and Stephen Meucke (eds), *Culture and Waste: The Creation and Destruction of Value* (Lanham, MD: Rowman & Littlefield, 2003).

30. EPCO Bhopal, *Development of Memorial Complex*.

31. Health and Safety Executive, 'Icmesa Chemical Company, Seveso, Italy, 10th July 1976', n.d. www.hse.gov.uk/comah/sragtech/caseseveso76.htmc (accessed 2017).

32. DelleQuerce Bosco, *Oak Forest: A Place of Memory*, 2017. www.boscodellequerce.it/bdq/english-pages/ (accessed 2017).

33. Storm, *Post-Industrial Landscape Scars*, 101.

34. R. M. Nayal and Neelanjan Khatua, 'Traditional Iron Making Techniques in India', in *Tradition and Innovation in the History of Iron Making: An Indo European Perspective*, ed. Girija Pande and Jan af Geijerstam (Nainital: Pahar, 2002), pp. 250–7.

35. Mike Yawn, 'Revolutionary Wall: James Reston Jr. Revisits Story of Maya Lin's Vietnam Memorial', *Houstan Chronicle*, 29 September 2017. www.houstonchronicle.com/entertainment/books/article/Revolutionary-wall-James-Reston-Jr-revisits-12241574.php (accessed 2017).

36. See https://www.911memorial.org/about-memorial.

37. Union Carbide Corporation, *Bhopal Plant History and Ownership*, 2016. www.bhopal.com/Bhopal-Plant-History-and-Ownership (accessed 2017).

38. American Chemical Society, 'Global Top 50 Chemical Companies of 2016', *Chemical & Engineering News*, 2017.

39. SpaceMatters, *Bhopal2011: Landscapes of Memory* (Delhi: SpaceMatters, 2012). www.bhopal2011.in/index.html (accessed 2017).

Bibliography

Adair, Bill, Benjamin Filene and Laura Koloski (eds). *Letting Go? Sharing Authority in a User-Generated World*. Philadelphia, PA: Pew Centre for Arts and Heritage, 2011.

Ahmed, Sara. *Queer Phenomenology: Orientations, Objects, Others*. Durham, NC: Duke University Press, 2006.

Alderman, Derek H., David L. Butler and Stephen P. Hanna. 'Memory, Slavery, and Plantation Museums: The River Road Project'. *Journal of Heritage Tourism* 11, no. 3 (2016): 209–18.

Amin, Shahid, and Dipesh Chakrabarty (eds). *Subaltern Studies IX: Writings on South Asian History and Society*. New Delhi: Oxford University Press, 1996.

Anderson, Benedict. *Imagined Communities: Reflections on the Origin and Spread of Nationalism*. London: Verso, 1983.

Anderson, Benedict. 'Notes on Contemporary Indonesian Political Communication'. *Indonesia* 16 (1973): 39–80.

Andersen, Benedict, and Ruth McVey. *A Preliminary Analysis of the October 1, 1965 Coup in Indonesia*. Ithaca, NY: Cornell University Modern Indonesia Project, 1971.

Anderson, George M. 'Sites of Conscience'. *America: The National Catholic Review*, 9 October 2006. www.americamagazine.org/issue/586/article/sites-conscience.

Anheler, Helmut, and Yudhishthir Raj Isar (eds). *Heritage, Memory and Identity*. London and Thousand Oaks, CA: Sage, 2011.

Ankersmit, Frank, Ewa Domanska and Hans Kellner (eds). *Re-figuring Hayden White*. Stanford, CA: Stanford University Press, 2009.

Anon. 'The Ballad of Mona Lisa'. Panic! At the Disco, 2011. www.youtube.com/watch?v=gOgpdp3lP8M.

Anon. 'Co-Creative Narratives in Public Spaces'. Archived Video Webcast, September 2014. http://connectlive.com/events/publicspaces/.

Anon. 'Doctor Who Ratings'. *Doctor Who Guide*, 2017. http://guide.doctorwhonews.net/info.php?detail=ratings&type=date.

Anon. 'The English Archivist: A New Profession, Inaugural Lecture for a New Course in Archive Administration Delivered at University College, London,

14 October 1947'. In *Selected Writings of Sir Hilary Jenkinson*, ed. R. Ellis and P. Walne. Chicago: Society of American Archivists, 2003.

Anon. 'Everyone's History'. *Historic New England*. www.historicnewengland. org/explore/everyones-history/.

Anon. 'First Annual Conference of the Centre for Public History'. Queens University, Belfast, 24 July 2017. www.qub.ac.uk/schools/happ/News%20 and%20Events/ThefirstannualconferenceoftheCentreforPublicHistory.html.

Anon. 'Grants'. Australian Research Council, 2017. www.arc.gov.au/grants.

Anon. 'History of Sydney: Highlights'. Destination NSW, 2017. www.sydney. com/things-to-do/arts-and-culture/history-of-sydney.

Anon. 'Industry Here Stops Cigar Plant Reading'. *Tampa Morning Tribune*, 27 November 1931.

Anon. 'La huelga de New York'. *El Esclavo*, 23 January 1895.

Anon. 'Loud Fence: End of an Era for Symbol of Popular Support'. *The Courier* (Ballarat), 27 May 2017.

Anon. 'Mass Memories Road Show'. Open Archives: Digital Collections at the University of Massachusetts, Boston. http://openarchives.umb.edu/cdm/ landingpage/collection/p15774coll6/.

Anon. 'Scientology Gets Neighborly in Ybor City'. *Tampa Bay Times*, 31 July 2013. www.tbo.com/news/business/scientology-neighborly-in-ybor-20130730/.

Anon. 'Tuol Sleng Workers Dismantly Skull Map'. *Cambodian Daily*, 11 March 2002. www.cambodiandaily.com/archives/ tuol-sleng-workers-dismantle-skull-map-30335/.

Anon. 'twitterstorians'. 2017. https://twitter.com/search?q=%23twitterstorians &src=tyah.

Anon. 'What Is Public History?' H-Net Public Discussion Log, May–June 2007. http://h-net.msu.edu/cgi-bin/logbrowse.pl?trx=lx&list=h-public&mo nth=0705&user=&pw=.

Anon. 'What Is Steampunk?'. 2011. www.steampunk.com/what-is-steampunk/.

Argeo, Luis, and James D. Fernández. *A Legacy of Smoke* (DVD). Whitestone Productions, 2017.

Argeo, Luis, and James D. Fernández. *The Weight of Remembering* (DVD). Whitestone Productions, 2017.

Arnold-de Simine, Silke. *Mediating Memory in the Museum: Trauma, Empathy, Nostalgia*. Basingstoke: Palgrave Macmillan, 2013.

Ashton, Paul. ' "The Birthplace of Australian Multiculturalism"? Retrospective Commemoration, Participatory Memorialisation and Official Heritage'. *International Journal of Heritage Studies* 15, no. 5 (2009): 381–98.

Ashton, Paul, Anna Clark and Robert Crawford. *Once Upon a Time: Australian Writers on Using the Past*. Melbourne: Australian Scholarly Publishing, 2016.

Ashton, Paul, and Duncan Waterson. *Sydney Takes Shape: A History in Maps*. Brisbane: Hema Maps, 2000.

Ashton, Paul, and Hilda Kean (eds). *People and Their Pasts: Public History Today*. Basingstoke: Palgrave Macmillan, 2009.

Ashton, Paul, and Jacqueline Z. Wilson (eds). *Silent System: Forgotten Australians and the Institutionalisation of Women and Children*. North Melbourne: Australian Scholarly Publishing, 2014.

Ashton, Paul, and Jennifer Cornwall. 'Corralling Conflict: The Politics of Australian Heritage Legislation since the 1970s'. In *Conflicted Heritage* (special issue), ed. Alexander Trapeznik. *Public History Review* 13 (2006): 53–65.

Ashton, Paul, and Meg Foster. 'Public Histories'. In *New Directions in Social and Cultural History*, ed. Sasha Handley, Rohan McWilliam and Lucy Noakes, 152–70. London: Bloomsbury, 2017.

Ashton, Paul, and Paula Hamilton. 'At Home with the Past: Background and Initial Findings from the National Survey'. *Australian Cultural History* 22 (2003): 5–30.

Ashton, Paul, and Paula Hamilton. *History at the Crossroads: Australians and the Past*. Sydney: Halstead Press, 2010.

Ashton, Paul, Paula Hamilton and Rose Searby. *Places of the Heart: Memorials in Australia*. Melbourne: Australian Scholarly Publishing, 2012.

Australian Government, Department of Environment and Energy. 'About Australia's Heritage'. 2016. www.environment.gov.au/heritage/about.

Australian Government, Department of Environment and Energy. 'Myall Creek Massacre and Memorial Site'. 2016. www.environment.gov.au/heritage/places/national/myall-creek.

Backman, Michael. *Asian Eclipse: Exposing the Dark Side of Business in Asia*. Singapore: John Wiley, 2001.

Baines, Gary. 'Site of Struggle: The Freedom Park Fracas and the Divisive Legacy of South Africa's Border War/Liberation Struggle'. *Social Dynamics* 35, no. 2 (2009): 330–44.

Barnard, Marjorie. *A History of Australia*. Sydney: Angus and Robertson, 1966.

Barnett, Chelsea. 'Modern History Graduates for the Workforce and the World: PACE, Employability, and Active Citizenship'. Unpublished Report. January 2017.

Barthes, Roland. *Camera Lucida: Reflections on Photography*. London: Fontana Paperbooks, 1984.

Bastian, Jeannette A., and Elizabeth Yakel. 'Towards the Development of an Archival Core Curriculum: The United States and Canada'. *Archival Science* 6, no. 2 (June 2006): 133–50.

BBC. 'Doctor Who'. 2017. www.bbc.co.uk/programmes/b006q2x0.

Becker, Carl L. 'Everyman His Own Historian'. Annual address of the president of the American Historical Association, delivered at Minneapolis, 29 December 1931. *American Historical Review* 37, no. 2 (1931): 221–36.

Berger, Carl. *The Writing of Canadian History: Aspects of English-Canadian Historical Writing: 1900–1970*. Toronto: Oxford University Press, 1976.

Berger, Carl. *The Writing of Canadian History: Aspects of English-Canadian Historical Writing since 1900*, 2nd edn. Toronto: University of Toronto Press, 1986.

Bevir, Mark. 'Post-foundationalism and Social Democracy'. In *Rewriting Democracy: Cultural Politics in Postmodernity*, ed. Elizabeth Deeds Ermarth, 48–63. Aldershot: Ashgate, 2007.

Bharucha, Rustom. *Rajasthan, an Oral History: Conversations with Komal Kothari*. Delhi: Penguin, 2003.

Black, Jeremy. *Contesting History: Narratives of Public History*. London and New York: Bloomsbury, 2014.

Black, Jeremy. *Using History*. London: Bloomsbury, 2005.

Blackburn, Susan. *Women and the State in Modern Indonesia*. Cambridge: Cambridge University Press, 2004.

Blainey, Geoffrey. 'Scissors and Paste in Local History'. *Historical Studies: Australia and New Zealand* 6, no. 23 (1954): 339–44.

Blatt, Martin (ed.). 'Civic Engagement at Sites of Conscience', special issue. *George Wright Forum* 19, no. 4 (2002).

Bliss, Michael. 'Review of Report of the Royal Commission on Corporate Concentration and of Research Studies'. *Canadian Historical Review* 60, no. 4 (1979): 529–53.

Bonner, Philip. 'Apartheid, Memory and Other Occluded Pasts'. *Culture, Memory, and Trauma* (2006).

Bonner, Philip. 'New Nation, New History: The History Workshop in South Africa, 1977–1994'. *Journal of American History* 81, no. 3 (December 1994): 977–85.

Bonner, Philip, and Noor Nieftagodien. *Alexandra: A History*. Johannesburg: Witwatersrand University Press, 2008.

Bourrie, Mark. *Kill the Messengers: Stephen Harper's Assault on Your Right to Know*. Toronto: Harper Collins, 2015.

Brennon, Teresa. *The Transmission of Affect*. Ithaca, NY: Cornell University Press, 2004.

Brown, Caitlin, and Chris Millington. 'The Memory of the Cambodian Genocide: The Tuol Sleng Genocide Museum'. *History Compass* 13, no. 2 (2015): 267–89.

Buchli, Victor, and Gavin Lucas (eds). *Archaeologies of the Contemporary Past*. London: Routledge, 2001.

Bunzl, Martin. 'Counterfactual History: A User's Guide'. *American Historical Review* 109, no. 3 (June 2004): 845–58.

Burnett, Leo. 'Past Experience'. 2011. www.leoburnett.com.au/Sydney/Work/ Detail/14/past-experience.

Butalia, Urvashi. *The Other Side of Silence: Voices from the Partition of India.* New Delhi: Penguin Books, 1998.

Byrne, Denis. 'A Critique of Unfeeling Heritage'. In *Intangible Heritage*, ed. L. Smith and N. Akagawa, 229–59. London: Routledge, 2009.

Byrne, Denis. 'Nervous Landscapes: Race and Space in Australia'. *Journal of Social Archaeology* 3, no. 2 (2003): 169–93.

Byrne, Denis. 'Remembering the Elizabeth Bay Reclamation and the Holocene Sunset in Sydney Harbour'. *Environmental Humanities* 9, no. 1 (2017): 40–59.

Byrne, Denis. *Surface Collection: Archaeological Travels in Southeast Asia.* Lanham, MD: AltaMira, 2007.

Calhoun, Craig (ed.). *Habermas and the Public* Sphere. Cambridge, MA: MIT Press, 1992.

Canadian Historical Association. 'What Is the CHA?'. www.cha-shc.ca/english/ about-the-cha/what-is-the-ha.html#sthash.baNM8Cy2.dpbs.

Carment, David. 'For Their Own Purposes of Identity: Tom Stannage and Australian Local History'. *Public History Review* 20 (2013): 68–79.

Carment, David. 'Local History and Local Historical Societies in Twenty First Century Australia'. Presidential address to the Royal Australian Historical Society Annual General Meeting, 2012.

Carr, Graham. 'Rules of Engagement: Public History and the Drama of Legitimation'. *Canadian Historical Review* 86, no. 2 (2005): 317–54.

Carter, David. 'Working on the Past, Working on the Future'. In *Becoming Australia: The Woodford Forum*, ed. Richard Nile and Michael Petersen, 9–18. St. Lucia: University of Queensland Press, 1998.

Casey, Edward S. *The Fate of Place: A Philosophical History.* Berkeley: University of California Press, 1998.

Cauvin, Thomas. *Public History, A Textbook of Practice.* New York: Routledge, 2016.

Centre for Historical Studies, Jawaharlal Nehru University, New Delhi. 'The Political Abuse of History: The Babri Masjid–Rama Janmabhumi Dispute'. *Social Scientist* 18, nos. 1–2 (1990): 76–81.

Centre for Public History and ARCH@Srishti. *The Lives of Objects: Stories from the Indian Museum.* Kolkata: Indian Museum, 2017.

Chakrabarty, Dipesh. 'The Public Life of History: An Argument Out of India'. *Postcolonial Studies* 11, no. 2 (2008): 169–90.

Chakrabarty, Dipesh. *The Calling of History: Sir Jadunath Sarkar and His Empire of Truth.* Chicago: University of Chicago Press, 2015.

Chambert-Loir, Henri, and Hasan Muarif Ambary (eds). *Panggung Sejarah: Persembahan kepada Prof. Dr. Denys Lombard.* Jakarta: Yayasan Obor, 1999.

Chandler, David. *Voices from S-21: Terror and History in Pol Pot's Secret Prison*. Berkeley: University of California Press, 2000.

Chiam, Clarice. 'Heineken's Lessons in History'. 2007. www.marketing-interactive.com/news/1008.

Clark, Anna, and Carla Peck (eds). *Contemplating Historical Consciousness: Notes from the Field (Making Sense of History)*. New York and London: Berghahn, 2018.

Clark, Anna, and Paul Ashton (eds). *Australian History Now*. Sydney: NewSouth, 2013.

Clark, Anna. 'Inheriting the Past: Exploring Historical Consciousness across Generations'. *Historical Encounters* 1, no. 1 (2014): 88–9.

Clark, Anna. 'Ordinary People's History'. *History Australia* 9, no. 1 (2012): 201–16.

Clark, Anna. 'The History Wars'. In *Australian History Now*, ed. Anna Clark and Paul Ashton, 151–66. Sydney: NewSouth, 2013.

Clark, Anna. *Private Lives, Public History*. Melbourne: Melbourne University Press, 2016.

Clifford, Jim. 'What Is Active History?' *Left History* 15, no. 1 (2010): 12–36.

Comaroff, John, and Jean Comaroff. *Ethnicity, Inc*. Chicago: University of Chicago Press, 2009.

Commonwealth of Australia, Senate Community Affairs Reference Committee. *Forgotten Australians: A Report on Australians Who Experienced Institutional or Out-of-Home Care as Children*. Canberra: Senate Printing Unit, 2004.

Conard, Rebecca. 'The Pragmatic Roots of Public History Education in the United States'. *Public Historian* 37, no. 1 (February 2015): 105–20.

Conard, Rebecca. *Benjamin Shambaugh and the Intellectual Foundations of Public History*. Iowa City: University of Iowa Press, 2002.

Conrad, Margaret, Kadriye Ercikan, Gerald Friesen, Jocelyn Létourneau, Delphin Muise, David Northrup and Peter Seixas. *Canadians and Their Pasts*. Toronto: University of Toronto Press, 2013.

Conrad, Margaret, Jocelyn Létourneau and David Northrup. 'Canadians and Their Pasts: An Exploration in Historical Consciousness'. *Public Historian* 31, no. 1 (2009): 15–34.

Conrad, Margaret. 'Public History and Its Discontents or History in the Age of Wikipedia'. *Journal of the Canadian Historical Association* 18, no. 1 (2007): 1–26.

Cribb, Robert (ed.). *The Indonesian Killings 1965–1966*. Melbourne: Centre for Southeast Asian Studies, Monash University, 1990.

Crooke, E. 'The Politics of Community Heritage: Motivations, Authority and Control'. *International Journal of Heritage Studies* 16, nos. 1–2 (2010): 16–29.

Cunningham, M. 'Bishop Ties Ribbon of Hope'. *The Courier* (Ballarat), 13 January 2016.

Curtis, Richard. 'Vincent and the Doctor'. *Doctor Who*, series 5, episode 10. Cardiff: BBC, 2010.

Daines, J. Gordon, III, and Cory L. Nimer. 'Introduction'. *The Interactive Archivist*. 18 May 2009. http://interactivearchivist.archivists.org/# footnote13.

Dalley, Bronwyn, and Jock Phillips (eds). *Going Public*. Auckland: Auckland University Press, 2001.

Darmaputera, Eka. *Pancasila and the Search for Identity and Modernity in Indonesian Society*. Leiden: E. J. Brill, 1988.

David, Bourchier. 'Lineages of Organicist Political Thought in Indonesia'. PhD dissertation, Monash University, 1996.

Davidson, Graeme. *The Use and Abuse of Australian History*. Sydney: Allen & Unwin, 2000.

Davies, Martin. *Historics: Why History Dominates Contemporary Society*. Abingdon: Routledge, 2006.

Davies, Martin. *Imprisoned by History: Aspects of Historicized Life*. Abingdon: Routledge, 2010.

de B'Béri, Boulou, Nina Reid-Maroney and Handel Kashope Wright (eds). *The Promised Land: History and Historiography of the Black Experience in Chatham-Kent's Settlements and Beyond*. Toronto: University of Toronto Press, 2014.

Dening, Greg. 'Ethnography on My Mind'. In *Boundaries of the Past*, ed. Bain Attwood, 16–17. Melbourne: History Institute, Victoria, 1990.

Denis, Philippe (ed.). *Never Too Small to Remember: Memory Work and Resilience in Times of AIDS*. Pietermaritzburg: Cluster, 2005.

Department of Business, Innovation and Skills. *Business–University Collaboration: The Wilson Review*. London: The Department, 2012.

Department of History, University of Sydney. 'HSTY 2627: Popular Uses of the Past'. 2011. http://sydney.edu.au/arts/history/undergrad/units_of_study. shtml?u=HSTY_2627_2011_1.

Dick, Lyle. 'Public History in Canada: An Introduction'. *Public Historian* 31, no. 1 (2009): 1–8.

Dittmer, Lowell, and Samuel S. Kim (eds). *China's Quest for National Identity*. Ithaca, NY: Cornell University Press, 1993.

Djuric, Bonney. 'A Past Revisited'. In *Silent System: Forgotten Australians and the Institutionalisation of Women and Children*, ed. Paul Ashton and Jacqueline Z. Wilson, 119–31. Melbourne: Australian Scholarly Publishing, 2014.

Djuric, Bonney. *Abandon All Hope: A History of the Parramatta Girls Industrial School*. Perth: Chargan, 2011.

Doran, R. (ed.). *The Fiction of Narrative: Essays on History, Literature and Theory, 1957–2007*. Baltimore, MD: Johns Hopkins University Press, 2010.

Drakely, Steven. 'Lubang Buaya: Myth, Misogyny and Massacre'. *Nebula* 4, no. 4 (2007): 1–12.

Dresser, Madge. 'Politics, Populism and Professionalism: Reflections on the Role of the Academic Historian in the Production of Public History'. *Public Historian* 32, no. 3 (2010): 39–63.

Dyer, Chris. 'Local History, with Special Reference to the Leicester School of Local History'. *Institute of Historical Research*. 2008. www.history.ac.uk/makinghistory/resources/articles/local_history.html.

Elder, Bruce. *Blood on the Wattle: Massacres and Maltreatment of Aboriginal Australians since 1788*. Sydney: New Holland, 1998.

English, John R. 'The Tradition of Public History in Canada'. *Public Historian* 5, no. 1 (1983): 46–59.

Ermarth, Elizabeth Deeds (ed.). *Rewriting Democracy: Cultural Politics in Postmodernity*. Aldershot: Ashgate, 2007.

Evans, Tanya. 'Family, Feminism and Empowerment'. *Public Historian*, forthcoming.

Evans, Tanya. 'Swimming with the Spit: Feminist Oral Sport History and the Process of Sharing Authority…'. *International Journal of the History of Sport* 33, no. 8 (2016): 860–79.

Evans, Tanya. '*Who Do You Think You Are?* Historical Television Consultancy'. *Australian Historical Studies* 46, no. 3 (2015): 454–67.

Fentress, James, and Chris Wickham. *Social Memory*. Oxford: Blackwell, 1992.

Fessenden, Marissa. 'Australian Stories Capture 10,000-Year-Old Climate History'. *Smithsonian Magazine* (26 January 2017).

Field, Sean. 'Disappointed Remains: Trauma, Testimony and Reconciliation in Post-Apartheid South Africa'. In *The Oral History Handbook*, ed. Donald Ritchie, 142–58. New York: Oxford University Press, 2010.

Filene, Benjamin. 'Passionate Histories: "Outsider" History Makers and What They Teach Us'. *Public Historian* 34, no. 1 (2012): 11–33.

Fleishman, Mark. '"For a Little Road It Is Not. For It Is a Great Road; It Is Long": Performing Heritage for Development in the Cape'. In *Performing Heritage: Research Practice and Innovation in Museum Theatre and Live Interpretation*, ed. Anthony Jackson and Jenny Kidd, 234–48. Manchester: University of Manchester Press, 2011.

Foster, Meg. 'Online and Plugged In? Public History and Historians in the Digital Age'. *Public History Review* 21 (2014): 1–19.

Fraser, Nancy. 'Rethinking the Public Sphere: A Contribution to the Critique of Actually Existing Democracy'. In *Habermas and the Public Sphere*, ed. Craig Calhoun, 109–42. Cambridge, MA: MIT Press, 1992.

Frisch, Michael. *A Shared Authority: Essays on the Craft and Meaning of Oral and Public History*. Albany: New York State University Press, 1990.

Gardner, James B. 'Trust, Risk and Public History: A View from the United States'. *Public History Review* 17 (2010): 52–61.

Gardner, James B., and Paula Hamilton (eds). *The Oxford Handbook of Public History*. Oxford: Oxford University Press, 2018.

Gendreau, Andrée. 'Museums and Media: A View from Canada'. *Public Historian* 31, no. 1 (special issue, 2009): 35–45.

Genocide Memorial Project. 'Genocide Memorials Around the World'. 2016. https://genocidememorialproject.wordpress.com/genocide-memorials-around-the-world/.

Gillam, Robyn. *Hall of Mirrors: Museums and the Canadian Public*. Banff: Banff Centre Press, 2001.

Goffman, Erving. *Stigma: Notes on the Management of Spoiled Identity*. London: Penguin, 1963.

González-Ruibal, Afredo (ed.). *Reclaiming Archaeology: Beyond the Tropes of Modernity*. London: Routledge, 2013.

Good, Luke. *Jürgen Habermas: Democracy and the Public Sphere*. London: Pluto Press, 2005.

Goodall, Heather. *Invasion to Embassy: Land in Aboriginal Politics in New South Wales, 1770–1972*. Sydney: Allen and Unwin, 1996.

Gopal, Sarvepalli (ed.). *Anatomy of a Confrontation: The Rise of Communal Politics in India*. Delhi: Penguin, 1991.

Granatstein, J. L. *Who Killed Canadian History?* Toronto: HarperCollins, 1998.

Graves-Brown, Paul, Rodney Harrison and Angela Piccini. *The Oxford Handbook of the Archaeology of the Contemporary World*. Oxford: Oxford University Press, 2013.

Green, Alix, *History, Policy and Public Purpose: Historians and Historical Thinking in Government*. Basingstoke: Palgrave Macmillan, 2016.

Gregg, M., and G. J. Seigworth (eds). *The Affect Theory Reader*. Durham, NC: Duke University Press, 2010.

Grele, Ronald J. 'Whose Public? Whose History? What Is the Goal of a Public Historian?' *Public Historian* 3, no. 1 (1981): 44–8.

Griffiths, Tom. *Hunters and Collectors: The Antiquarian Imagination in Australia*. Cambridge: Cambridge University Press, 1996.

Guha-Thakurta, Tapati. *Monuments, Objects, Histories: Institutions of Art in Colonial and Postcolonial India*. New York: Columbia University Press, 2004.

Gunn, Simon, and Stuart Rawnsley. 'Practising Reflexivity: The Place of Theory in University History'. *Rethinking History* 10, no. 3 (2006): 369–90.

Hall, Andrew, and Cynthia Kros. 'New Premises for Public History in South Africa'. *Public Historian* 16, no. 2 (1994): 15–32.

Hall, C. Michael, and Simon McArthur (eds). *Heritage Management in New Zealand and Australia: Visitor Management, Interpretation and Marketing.* Auckland: Oxford University Press, 1993.

Hamilton, Paula, and Linda Shopes (eds). *Oral History and Public Memories.* Philadelphia, PA: Temple University Press, 2008.

Harris, Paul. 'The Royal Wedding: How They Watched It Worldwide'. *The Guardian* (30 April 2011). www.guardian.co.uk/uk/2011/apr/30/royal-wedding-world-reaction?INTCMP=ILCNETTXT3487.

Harvey, D. C. 'Heritage Pasts and Heritage Presents: Temporality, Meaning and the Scope of Heritage Studies'. *International Journal of Heritage Studies* 7, no. 4 (2001): 319–38.

Hayden, Dolores. *The Power of Place: Urban Landscapes as Public History.* Boston, MA: MIT Press, 1995.

Healy, Chris. *From the Ruins of Colonialism: History as Social Memory.* Melbourne: Cambridge University Press, 1997.

Hein, Treena. 'History for the People: The Field of "Public History" Gains Ground in Canada'. *University Affairs* (9 October 2007).

Hendy, J. *The Orient Strikes Back.* Oxford: Berg, 2000.

Heritage Lottery Fund. *Broadening the Horizons of Heritage: The Heritage Lottery Fund Strategic Plan 2002–2007.* London: Heritage Lottery Fund, 2002.

Hewitt, Nancy A. *Southern Discomfort: Women's Activism in Tampa, Florida, 1880s–1920s.* Urbana, IL: University of Illinois Press, 2004.

Hibberd, Lily, and Bonney Djuric. 'Factory Precinct Memory Project'. *Artlink* 33, no. 3 (2013): 66–9.

Hillmer, Norman, and Adam Chapnick (eds). *Canadas of the Mind: The Making and Unmaking Canadian Nationalism in the Twentieth Century.* Montreal and Kingston: McGill-Queen's University Press, 2007.

Ho, Stephanie. 'Blogging as Popular History Making, Blogs as Public History: A Singapore Case Study'. *Public History Review* 14 (2007): 64–79.

Hobsbawm, Eric. 'The Nation as Invented Tradition'. In *Nationalism*, ed. J. Hutchinson and A. Smith, 76–82. Oxford: Oxford University Press, 1994.

Hoerder, Dirk (ed.). *Struggle a Hard Battle.* DeKalk: Northern Illinois University Press, 1986.

Holl, Jack M. 'Getting on Track: Coupling the Society for History in the Federal Government to the Public History Train'. *Public Historian* 21, no. 3 (1999): 43–55.

'Homepage'. http://activehistory.ca/.

Hoock, Holger. 'Introduction'. *Public Historian* 32, no. 3 (2010): 7–22.

Horne, Donald. *The Public Culture: The Triumph of Industrialism.* London: Pluto Press, 1986.

Hoskins, W. G. *The Making of the English Landscape*. London: Hodder & Stoughton, 1955.

Howe, Barbara J., and Emory L. Kemp (eds). *Public History: An Introduction*. Malabar, FL: Robert E. Krieger, 1986.

Hurley, Andrew. *Beyond Preservation: Using Public History to Revitalize Inner Cities*. Philadelphia, PA: Temple University Press, 2010.

Ingalls, Robert P. 'Radicals and Vigilantes: The 1931 Strike of Tampa Cigar Workers'. In *Southern Unions and Their Workers, 1880-1975: The Second Southern Labor History Conference, Selected Papers*, ed. Merle Reed, Leslie S. Hough and Gary M. Fink, 44–53. West Port, CT: Greenwood Press, 1981.

Ingalls, Robert P., and Louis A. Peréz, Jr. *Tampa Cigar Workers: A Pictorial History*. Gainesville: University of Florida Press, 2003.

Ireland, Tracy. 'Excavating National Identity'. In *Sites: Nailing the Debate: Archaeology and Interpretation in Museums*, 67–88. Glebe: Museum of Sydney, 1996.

Jones, Arnita. 'Public History Now and Then'. *Public Historian* 21, no. 3 (1999): 21–8.

Jones, Arnita. 'The National Coordinating Committee: Programs and Possibilities'. *Public Historian* 1 (1978): 49–50.

Jordanova, Ludmilla. *History in Practice*, 2nd edn. London: Hodder Arnold, 2006.

Jowell, Tessa. *Better Places to Live. Government, Identity and the Value of the Historic and Built Environment*. London: Department for Culture, Media and Sport, 2005.

Kalela, Jorma. 'History Making: The Historian as Consultant'. *Public History Review* 20 (2013): 24–41.

Kalela, Jorma. 'Making History: The Historian and the Uses of the Past'. In *The Public History Reader*, ed. Hilda Kean and Paul Martin, 104–28. Abington and New York: Routledge, 2013.

Kalela, Jorma. *Making History: The Historian and Uses of the Past*. Basingstoke: Palgrave Macmillan, 2012.

Kean, Hilda, Paul Martin and Sally J. Morgan (eds). *Seeing History: Public History in Britain Now*. London: Francis Boutle, 2000.

Kean, Hilda. 'People, Historians, and Public History: Demystifying the Process of History Making'. *Public Historian* 32 (2013): 25–38.

Kelley, Robert. 'Public History: Its Origins, Nature, and Prospects'. *Public Historian* 1 (1978): 16–28.

Khumalo, Sibongile. 'Our Stories, Our Heritage'. *Discover Heritage* 1 (2017): 11.

Kidd, Jenny. 'With New Eyes I See: Embodiment, Empathy and Silence in Digital Heritage Interpretation'. *International Journal of Heritage Studies* (4 July 2017): 1–13.

Killan, Gerald. *Preserving Ontario's Heritage: A History of the Ontario Historical Society*. Ottawa: Ontario Historical Society, 1976.

Knell, Simon J., Suzanne MacLeod, and Sheila Watson (eds). *Museum Revolutions: How Museums Change and Are Changed*. London and New York: Routledge, 2007.

Korza, Pam, and Barbara Schaffer Bacon. *History as a Catalyst for Civic Dialogue: Case Studies from Animating Democracy*. Washington, DC: Americans for the Arts, 2005.

Krause, Mark, and Janet Presser. 'What Is a Site of Conscience?'. 6 August 2012. www.willowcourttasmania.org/wp-content/uploads/2012/07/Media-Release.pdf.

Kros, Cynthia. 'Rhodes Must Fall: Archives and Counter-archives'. *Critical Arts: A South–North Journal of Cultural and Media Studies* 29, no. 1 (2015): 150–65.

Kuljian, Christa. 'The Congress of the People and the Walter Sisulu Square of Dedication: From Public Deliberation to Bureaucratic Imposition in Kliptown'. *Social Dynamics* 35, no. 2 (2009): 450–64.

Kyvig, David E. 'Public or Perish: Thoughts on Historians' Responsibilities'. *Public Historian* 13, no. 4 (1991): 11–23.

Lakshmi, Rama. 'Curating a Bhopal People's Movement: An Opportunity for Indian Museums'. *Museum Journal* 55, no. 1 (2012): 35–50.

Lastra, Frank Trebín. *Ybor City: The Making of a Landmark Town*. Tampa, FL: University of Tampa Press, 2006.

Latour, Bruno. *Reassembling the Social: An Introduction to Actor-Network-Theory*. New York: Oxford University Press, 2005.

Layne, Valmont. 'The District Six Museum: An Ordinary People's Place'. *Public Historian* 30, no. 1 (2008): 53–62.

Ledgerwood, Judy. 'The Cambodian Tuol Sleng Museum of Genocide Crimes: National Narratives'. In *Genocide, Collective Violence, and Popular Memory: The Politics of Remembrance in the Twentieth Century*, ed. D. E. Lorey and W. H. Beezley, 103–22. Wilmington, DE: Scholarly Resources, 2002.

Lennon, John, and Malcolm Foley. *Dark Tourism: The Attraction of Death and Disaster*. London: Cengage Learning, 2000.

Levinson, Sanford. *Written in Stone: Public Monuments in Changing Societies*. Durham, NC, and London: Duke University Press, 1988.

Li, Na, and Martha A. Sandweiss. 'Teaching Public History: A Cross-cultural Experiment: The First Public History Faculty Training Program in China'. *Public Historian* 38, no. 3 (2016): 78–100.

Li, Na. *Kensington Market: Collective Memory, Public History, and Toronto's Urban Landscape*. Toronto: University of Toronto Press, 2015.

Li, Na. 'Nearby History: The Second Public History Faculty Training Program in China' (in Chinese). *Public History* 1, no. 1 (2017): 45–53.

Little, Barbara J., and Paula A. Shackel (eds). *Archaeology as a Tool of Civic Engagement*. Lanham, MD: AltaMira, 2007.

Local History Co-ordination Project. *Locating Australia's Past: A Practical Guide to Writing Local History*. Kensington: UNSW Press, 1988.

Lord, Alexandra M. 'History Matters'. *Perspectives on History* 49, no. 8 (December 2011): 5–7.

Lowenthal, David. *The Heritage Crusade and the Spoils of History*. Cambridge: Cambridge University Press, 1998.

Macintyre, Stuart (ed.). *The Historian's Conscience: Australian Historians on the Ethics of History*. Melbourne: Melbourne University Press, 2004.

MacIntyre, Stuart, and Anna Clark, *The History Wars*, 2nd edn. Melbourne: Melbourne University Press, 2004.

Manatu Maori. *He Kakano I Ruia Mai I Rangiatea: Maori Values and Environmental Management*. Wellington: Department of Internal Affairs, 1991.

Marschall, Sabin. 'Public Holidays as *lieux de memoire*: Nation-building and the Politics of Public Memory in South Africa'. *Anthropology Southern Africa* 36, nos. 1–2 (2013): 11–21.

Marschall, Sabine. 'Collective Memory and Cultural Difference: Official vs. Vernacular Forms of Commemorating the Past'. *Safundi, The Journal of South African and American Studies* 14, no. 1 (2013): 77–92.

Martyn, Elizabeth. *The Women's Movement in Post Colonial Indonesia: Gender and Nation in a New Democracy*. New York: Routledge Curzon, 2005.

May, Todd. *The Political Philosophy of Poststructuralist Anarchism*. University Park: Pennsylvania State University Press, 1994.

McAuley, G. 'Place, Time and Performance in the Memory Process'. *Australian Studies* 5 (2013): 1–16.

McEachern, Charmaine Ruth. 'Mapping the Memories: Politics, Place and Identity in the District Six Museum, Cape Town'. *Social Identities* 4, no. 3 (2012): 499–521.

McGregor, Katherine E. *History in Uniform: Military Ideology and the Construction of Indonesia's Past*. Singapore: National University of Singapore Press, 2007.

McKillop, A. B. *Pierre Berton: A Biography*. Toronto: McClelland & Stewart, 2008.

Meringolgo, Denise D. *Museums, Monuments and National Parks: Towards a New Genealogy of Public History*. Amherst, MD, and Boston, MA: University of Massachusetts Press, 2012.

Meskell, Lynn, and Collette Sheermeyer. 'Heritage as Therapy: Set Pieces from the New South Africa'. *Journal of Material Culture* 13, no. 2 (2008): 153–73.

Meskell, Lynn. *The Nature of Heritage: The New South Africa*. Hoboken, NJ: Wiley-Blackwell, 2012.

Mgijima, Bongani, and Vusi Buthelezi. 'Mapping Museum–Community Relations in Lwandle'. *Journal of Southern African Studies* 32, no. 4 (2006): 795–806.

Milligan, Ian. 'The Situation for Recent History Graduates: The Job Market, Rethinking the Idea of "Plan B", and Some Ideas for the Future'. *Canadian Historical Association Bulletin* 38, no. 1 (2012): 36–7.

Milloy, John. 'Doing Public History in Canada's Truth and Reconciliation Commission'. *Public Historian* 35, no. 4 (2013): 10–19.

Minkel, Elizabeth. 'The Global Force of Doctor Who: What Does Britain's Biggest Cultural Export Tell the World?' *New Statesman* (20 August 2014).

Moore, Kevin. 'Sport History, Public History, and Popular Culture: A Growing Engagement'. *Journal of Sport History* 40, no. 1 (Spring 2013): 39–55.

Morgan, Cecilia. *Commemorating Canada: History, Heritage, and Memory, 1850s–1990s*. Toronto: University of Toronto Press, 2016.

Mouffe, Chantal. 'For an Agonistic Public Sphere'. In *Radical Democracy: Politics between Abundance and Lack*, ed. Lars Tonder and Lasse Thomassen, 123–32. Manchester: Manchester University Press, 2005.

Msila, Vuyisile. 'The Liberatory Function of a Museum: The Case of New Brighton's Red Location Museum'. *Anthropologist* 15, no. 2 (2013): 209–18.

Murphy, Adrian. 'Partition at 70: World's First Partition Museum Officially Opens in India'. *Museums+Heritage Advisor* (17 August 2017). http://advisor.museumsandheritage.com/news/partition-70-worlds-first-partition-museum-officially-opens-india/.

Murray, Lisa. 'Community Connections: The Renaissance of Local History'. Unpublished paper presented at the Australian Historical Association conference, 2012.

Narayan, Badri. *Women Heroes and Dalit Assertion in North India: Culture, Identity and Politics*. New Delhi: Sage, 2006.

National Council on Public History. 'Call for Working Group Discussants'. 2014. http://ncph.org/cms/ wp-content/uploads/Call-vfor-Working-Group-discussants.pdf.

National Council on Public History. 'Program Guide'. 2017. http://ncph.org/program-guide/.

Neatby, Nicole, and Peter Hodgins (eds). *Settling and Unsettling Memories: Essays in Canadian Public History*. Toronto: University of Toronto Press, 2012.

Newman, Jon. 'Harry Jacobs: The Studio Photographer and the Visual Archive'. In *Public History and Heritage Today: People and Their Pasts*, ed. Paul Ashton and Hilda Kean, 260–78. Basingstoke: Palgrave Macmillan, 2012.

Newman, Saul. *Unstable Universalities: Poststructuralism and Radical Politics.* Manchester: Manchester University Press, 2007.

Nieftagodien, Noor. 'Reconstituting Activism at the Borders of Contemporary South Africa'. *ACME: An International E-Journal for Critical Geographies* 2, no. 2 (2012): 222–8.

Nieftagodien, Noor. 'The Place of "The Local" in History Workshop's Local History'. *African Studies* 69, no. 1 (2010): 41–61.

Nora, Pierre. 'Between Memory and History: Les Lieux de Mémoire'. *Representations* 26 (1989): 7–24.

Norkunas, Martha K. *Monuments and Memory: History and Representation in Lowell, Massachusetts.* Washington, DC: Smithsonian Institution Press, 2002.

Novick, Peter. *That Noble Dream: The 'Objectivity Question' and the American Historical Profession.* Cambridge: Cambridge University Press, 1988.

Nye, Joseph S. *Soft Power: The Means to Success in World Politics.* New York: Public Affairs, 2004.

Odendaal, Andre. 'Heritage and the Arrival of Post-Colonial History in South Africa'. Paper presented to the African Studies Association Annual Conference, Washington, DC, 5–8 December 2002.

Otterbein, Keith. *How War Began.* College Station: Texas A&M University Press, 2004.

Parry, Naomi. 'The Parramatta Girls Home'. *Dictionary of Sydney.* 2015. http://dictionaryofsydney.org/entry/the_parramatta_girls_home.

Paul, Herman. 'Hayden White and the Crisis of Historicism'. In *Re-Figuring Hayden White*, ed. Frank Ankersmit, Ewa Domanska and Hans Kellner, 54–73. Stanford, CA: Stanford University Press, 2009.

Pérez, Louis A., Jr. 'Reminiscences of a Lector: Cuban Cigar Workers in Tampa'. *Florida Historical Quarterly* 53, no. 4 (April 1975): 443–9.

Peterson, Derek, Kodzo Gavua and Ciraj Rassool (eds). *The Politics of Heritage in Africa, Economies, Histories, and Infrastructures.* London: International African Institute, and Cambridge University Press, 2015.

Peterson, Derek. 'Introduction: Heritage Management in Colonial and Contemporary Africa'. In *The Politics of Heritage in Africa, Economies, Histories, and Infrastructures*, ed. Derek Peterson, Kodzo Gavua and Ciraj Rassool, 1–36. Cambridge and New York: Cambridge University Press, 2015.

Pétursdóttir, Þóra. 'Concrete Matters: Ruins of Modernity and the Things Called Heritage'. *Journal of Social Archaeology* 13, no. 1 (2013): 31–53.

Pharaon, Sarah, Bix Gabriel and Liz Ševčenko. 'Sites of Conscience: Connecting Past to Present, Memory to Action'. *Exhibitionist* (Fall 2011): 15–16.

Phillips, Jock. *To the Memory: New Zealand's War Memorials*. Nelson: Potter & Burton, 2016.

Pihlainen, Kalle. 'Historians and "the Current Situation"'. *Rethinking History* 20, no. 2 (2016): 143–53.

Posner, Ernst. *Archives in the Ancient World*. Cambridge, MA: Harvard University Press, 1972.

Prakash, Gyan. 'Museum Matters'. In *Museum Studies: An Anthology of Contexts*, ed. Bettina Messias Carbonell, 208–16. Oxford: Wiley Blackwell, 2003.

Prakash, Gyan. 'Science "Gone Native" in Colonial India'. *Representations* 40 (1992): 153–78.

Prowse, Louise. 'Parallels on the Periphery: The Exploration of Aboriginal History by Local Historical Societies in NSW, 1960s–1970s'. *History Australia* 12, no. 3 (December 2015): 55–75.

Rassool, Ciraj. 'Making the District Six Museum in Cape Town'. *Museum International* 58, no. 1 (2006): 9–18.

Read, Peter, and Marivic Wyndham. *Narrow but Endlessly Deep: The Struggle for Memorialisation in Chile since the Transition to Democracy*. Canberra: Australian National University Press, 2016.

Reeves, Keir, and Gertjan Plets. 'Cultural Heritage as a Strategy for Social Needs and Community Identity'. In *A Companion to Heritage Studies*, ed. W. Logan, M. Craith and U. Kockel. Hoboken, NJ: John Wile, 2016.

Ritchie, Donald (ed.). *The Oral History Handbook*. New York: Oxford University Press, 2010.

Robinson, Geoffrey. *The Dark Side of Paradise: Political Violence in Bali*. Ithaca, NY: Cornell University Press, 1995.

Roosa, John. *Pretext for Mass Murder: The September 30th Movement and Suharto's Coup d'Etat in Indonesia*. Madison: University of Wisconsin Press, 2006.

Rosenzweig, Roy, and David Thelen. *The Presence of the Past: Popular Uses of History in American Life*. New York: Colombia University Press, 1988.

Rousso, Henry. 'Applied History, or the Historian as Miracle-Worker'. *Public Historian* 6, no. 4 (1984): 65–85.

Salt, Annette. *These Outcast Women*. Sydney: Hale & Iremonger, 1984.

Samuel, Raphael (ed.). *History Workshop Journal: A Collectanea 1967–1991*. Oxford: History Workshop, 1991.

Samuel, Raphael (ed.). *People's History and Socialist Theory*. London: Routledge and Kegan Paul, 1981.

Samuel, Raphael. *Theatres of Memory: Past and Present in Contemporary Culture*. London: Verso, 2012.

Sandwell, Ruth (ed.). *To the Past: History Education, Public Memory, and Citizenship in Canada*. Toronto: University of Toronto Press, 2006.

Saunders, Christopher, and Cynthia Kros. 'Conversations with Historians'. *South African Historical Journal* 51 (2004): 1–23.

Sayer, Faye. *Public History: A Practical Guide*. London: Bloomsbury, 2015.

Scarpino, Philip, and Daniel Vivian. *What Do Public History Employers Want? Report of the Joint AASLH-AHA-NCPH-OAH Task Force on Public History Education and Employment*. Unpublished. 2017. https://drive.google.com/file/d/0B-biwE1hFJQJdmdsTTlMbGc2Rkk/view.

Schellenberg, T. R. *Modern Archives: Principles and Techniques*. Chicago: Society of American Archivists, 1998.

Schneider, Axel, and Daniel Woolf (eds). *The Oxford History of Historical Writing*, vol. 5. Oxford: Oxford University Press, 2011.

Schroder, Alan M. 'Applied History: An Early Form of Public History'. *Public Works Historical Society Newsletter* 17 (1980): 3–4.

Scott, Joan Wallach (ed.). *The Fantasy of Feminist History*. Durham, NC, and London: Duke University Press, 2011.

Sears, Laurie Jo (ed.). *Fantasizing the Feminine in Indonesia*. Durham, NC, and London: Duke University Press, 1999.

Ševčenko, Liz, and Maggie Russell-Ciardi. 'Sites of Conscience: Opening Historic Sites for Civic Dialogue'. *Public Historian* 30, no 1 (2009): 9–15.

Ševčenko, Liz. 'International Coalition of History Sites of Conscience'. 2016. www.memorial.krsk.ru/eng/Dokument/Artcles/Shevchenko.htm.

Shepherd, Nick. 'Archaeology Dreaming: Post-Apartheid Imaginaries and the Bones of the Prestwich Street Dead'. *Journal of Social Archaeology* 7 (2007): 3–28.

Silberman, N. A. 'Heritage Interpretation and Human Rights: Documenting Diversity, Expressing Identity, or Establishing Universal Principles?' *International Journal of Heritage Studies* 18, no. 3 (2012): 245–56.

Simpson, Timothy A. 'Contesting Community: Memory, Place and Culture in Ybor City, Florida'. PhD dissertation, University of South Florida, Tampa, 1996.

Singh, Kavita. 'The Museum Is National'. *India International Centre Quarterly* 29, nos. 3–4 (2003): 176–92.

Skounti, A. 'The Authentic Illusion: Humanity's Intangible Cultural Heritage, the Moroccan Experience'. In *Intangible Heritage*, ed. L. Smith and N. Akagawa, ch 4. London: Routledge, 2009.

Smith, Laurajane. *Uses of Heritage*. London: Routledge, 2006.

Smith, M. S. 'Using the Past: Learning Histories, Public Histories and Possibilities'. PhD dissertation, University of Waikato, 2011.

Smith, Milo M. *A Plan for Redevelopment for Ybor City*. Tampa, FL: Milo Smith + Associates, 1963.

Social Justice Alliance for Museum. 'Case studies'. 2015. http://sjam.org/case-studies/.

Spearritt, Peter. *The Sydney Harbour Bridge: A Life*. Sydney: UNSW
 Press, 2007.
Stanley, Alessandra. 'Lest Russians Forget, a Museum of the Gulag'. *New York
 Times* (29 October 1997).
Stannage, Tom. *The People of Perth: A Social History of Western Australia's
 Capital City*. Perth: Perth City Council, 1979.
Stanton, Cathy. *The Lowell Experiment: Public History in a Postindustrial City*.
 Amherst: University of Massachusetts Press, 2006.
Stolten, Hans Eric (ed.). *History Making and Present Day Politics: The
 Meaning of Collective Memory in South Africa*. Uppsala: Nordiska
 Afrikainstitutet, 2007.
Suryakusuma, Julia. *State Ibuism: The Social Construction of Womanhood in
 New Order Indonesia*. Komunitas Bambu: Depok, 2011.
Swarbrick, Nancy. 'Public History'. *Te Ara: The Encyclopedia of New Zealand*.
 30 September 2014. www.TeAra.govt.nz/en/public-history/print.
Tau, T., A. Goodall, D. Palmer and R. Rau. *Te Whakatau Kaupapa: Ngai
 Tahu Resource Management Strategy for the Canterbury Region*.
 Wellington: Department of Internal Affairs, 1990.
Taylor, C. J. *Negotiating the Past: The Making of Canada's National Historic
 Parks and Sites*. Montréal and Kingston: McGill-Queen's University
 Press, 1990.
Thapar, Romila. 'In Defence of History'. *Seminar* 521 (2003). www.india-
 seminar.com/2003/521/521%20romila%20thapar.htm.
Thapar, Romila. 'The History Debate and School Textbooks in India: A
 Personal Memoir'. *History Workshop Journal* 67 (2009): 87–98.
The Pasts Collective (Margaret Conrad, Kadriye Ercikan, Gerald Friesen,
 Jocelyn Létourneau, Delphin Muise, David Northrup and Peter Seixas).
 Canadians and Their Pasts. Toronto: University of Toronto Press, 2013.
Thelen, David. 'The Nation and Beyond: Transnational Perspectives on United
 States History'. *Journal of American History* 86, no. 3 (1999): 965–75.
Thorpe, F. J. 'Public History: What Every Public Historian Must Know'.
 Canadian Historical Association Newsletter (Winter 1989): 3.
Tonder, Lars, and Lasse Thomassen (eds). *Radical Democracy: Politics between
 Abundance and Lack*. Manchester: Manchester University Press, 2005.
Townsend, Robert. *History's Babel: Scholarship, Professionalization, and the
 Historical Enterprise in the United States, 1880–1940*. Chicago: University of
 Chicago Press, 2013.
Tranter, Richard. 'Indonesia's Dangerous Silence'. *Inside Story* (28 April 2011).
 http://inside.org.au/indonesia-dangerous-silence.
Truth and Reconciliation Commission of Canada. *Honouring the Truth,
 Reconciling for the Future*. 2015. www.trc.ca/websites/trcinstitution/index.
 php?p=890.

Twells, Alison. 'Community History'. *Institute of Historical Research*. 2008. www.history.ac.uk/makinghistory/resources/articles/community_history. html.

Tyrrell, Ian. *Historians in Public: The Practice of American History, 1890–1970*. Chicago: University of Chicago Press, 2005.

UNESCO. 'Robben Island Listing'. 2016. http://whc.unesco.org/en/list/916.

Universities UK and the UK Commission for Employment and Skills. *Forging Futures: Building Higher Level Skills through University and Employer Collaboration*. London: Universities UK, 2014.

Vance, Jonathan. *A History of Canadian Culture*. Toronto: Oxford University Press, 2009.

Wells, Julia. 'When the Past Transforms: A Case Study from a Western Cape Wine Farm'. *South African Historical Journal* 69, no. 3 (2017): 345–60.

Weyeneth, Robert R., and Daniel J. Vivian. 'Public History Pedagogy: Charting the Course: Challenges in Public History Education, Guidance for Developing Strong Public History Programs'. *Public Historian* 38, no. 3 (2016): 25–49.

White, Hayden. 'What Is a Historical System?' In *The Fiction of Narrative: Essays on History, Literature and Theory, 1957–2007*, ed. R. Doran, 126–35. Baltimore, MD: Johns Hopkins University Press, 2010.

White, Hayden. *Metahistory: The Historical Imagination in Nineteenth-Century Europe*. Baltimore, MD: Johns Hopkins University Press, 1973.

White, Hayden. *The Practical Past*. Evanston, IL: Northwestern University Press, 2014.

White, Hayden. *Tropics of Discourse: Essays in Cultural Criticism*. Baltimore, MD: Johns Hopkins University Press, 1978.

Wiebe, Robert H. *Who We Are: A History of Popular Nationalism*. Princeton, NJ: Princeton University Press, 2002.

Wieringa, Saskia. *Sexual Politics in Indonesia*. New York: Palgrave, 2002.

Wilson, J. Z. *Prison: Cultural Memory and Dark Tourism*. New York: Peter Lang, 2008.

Wilson, J. Z., and F. Golding. 'The Tacit Semantics of "Loud Fences": Tracing the Connections between Activism, Heritage and New Histories'. *International Journal of Heritage Studies* (May 2017): 1–13.

Wilson, Jacqueline Z. *Prison: Cultural, Memory and Dark Tourism*. New York: Peter Lang, 2008.

Wilton, Janis. 'People and Place: Local History'. In *Once Upon a Time: Australian Writers on Using the Past*, ed. Paul Ashton, Anna Clark and Robert Crawford, 178–94. Melbourne: Australian Scholarly Publishing, 2016.

Witz, Lexlie, Gary Minkley and Ciraj Rassool. *Unsettled History: Making South African Public Pasts*. Ann Arbor: University of Michigan Press, 2017.

Wright, Donald, *The Professionalization of History in English Canada*.
 Toronto: University of Toronto Press, 2005.
Wright, Donald. *The Canadian Historical Association: A History*. Ottawa: The
 Association, 2003.
Wright, Tony. 'Aboriginal Archaeological Discovery in Kakadu Rewrites
 the History of Australia'. *The Age* (20 July 2017). www.theage.com.au/
 technology/sci-tech/aboriginal-archaeological-discovery-in-kakadu-
 rewrites-the-history-of-australia-20170719-gxe3qy.html.
Wyndham, Marivic, and Peter Read. 'The Day Londres 38 Opened Its
 Doors: A Milestone in Chilean Reconciliation'. *Universitas Humanistica* 71
 (2011): 191–212.
Yerxa, Donald A. (ed.). *Recent Themes in Historical Thinking: Historians in
 Conversation*. Columbia: University of South Carolina Press, 2008.
Yusoff, Kathryn. 'Queer Coal: Genealogies in/of the Blood'. *PhiloSOPHIA* 5
 no. 2 (2015): 203–29.
Zurbuchen, Mary S. 'History, Memory and the "1965 Incident" in Indonesia'.
 Asian Survey 24, no. 4 (2002): 564–81.

Index